2019
第六届丝绸之路国际艺术节
The Sixth Silk Road International Arts Festival

今日丝绸之路 国际美术展
Today Silk Road Special Exhibition of International Art Works

作品集
Work Collection of Arts

任宗哲　蔺宝钢　主编
Zongzhe Ren　Baogang Lin　chief Editor

主办 Host
中华人民共和国文化和旅游部
Ministry of Culture and Tourism of the People's Republic of China
陕西省人民政府
The People's Government of Shaanxi Province

承办 Organizer
陕西省文化和旅游厅
Department of Culture and Tourism of Shaanxi province

协办 Co-Organizer
西安建筑科技大学
Xi'an University of Architecture and Technology

中国建筑工业出版社
China Architecture & Building Press

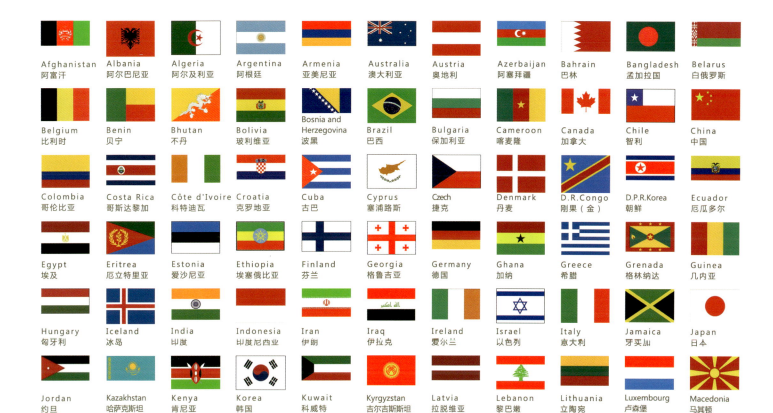

115 Countries

304 Artworks

115 个国家参展 共计 304 幅作品

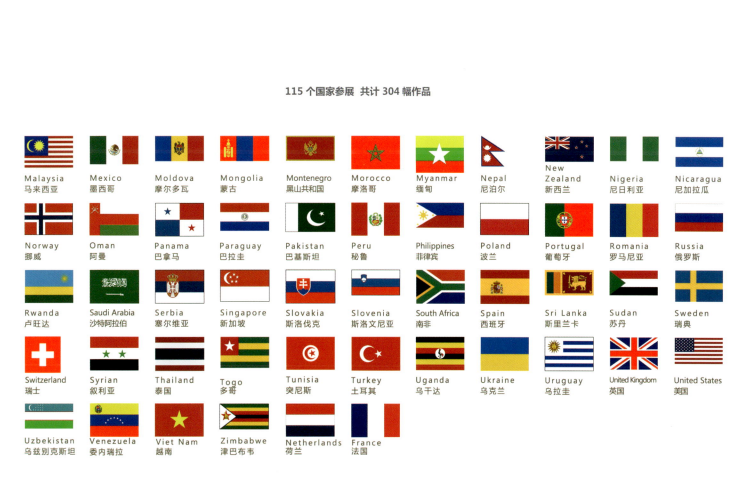

2019 第六届丝绸之路国际艺术节今日丝绸之路国际美术展 参展艺术家
2019 the Sixth Silk Road International Arts Festival Today Silk Road
Special Exhibition of International Art Works Participating Artists

丝绸之路国际艺术节
The Silk Road International Arts Festival

陕西美术博物馆
Shaanxi Provincial Museum Art Museum
中国·西安
XI'AN·CHINA
2019 年 9 月 7–21 日
September 7, 2019–September 21, 2019

前　言

2019年丝绸之路国际艺术节国际美术邀请展于9月7日又将迎来第六届的盛大开幕。六年间的丝绸之路艺术节发展历程，让世界上120余个国家的艺术家们感受到了丝路节的盛况与美好。

丝绸之路国际艺术节作为国家所倡导的一个文化品牌，历经六年的发展过程。不仅在国内，更是在世界范围内，逐渐产生了广泛的文化影响力。特别是在规模上，经过短短的六年发展历程，已经连续3届有超过百余国家的参与，为丝路艺术节的国际化品牌效应奠定了坚实基础。本届的丝路艺术节，不仅在参展国家与地区数量上继续过百，征集到115个国家及地区的艺术家参与。同时，艺术质量也保持一个较高的水平。作为一个国际化的丝绸之路艺术节中的国际美术展览，既要面向不同的国家，更要面向不同的艺术种类。其丰富的作品内容包括了雕塑、影像、装置、绘画、综合设计等多种艺术风格与样式。开放的丝路节办展情怀，彰显着中国文化自信的魅力，也充分展现了当下国际美术展的一个多元化的交流窗口。

丝绸之路国际艺术节是一个讲述中国故事，展示中国文化的重要平台。保持国际化的传播度不断扩展的同时，其国际影响力也在逐年扩大。今日丝绸之路国际美术展是一个传播文化的平台，更是一个传播友谊的桥梁。

世界需要文明，文化需要传播，人民需要和平，丝路精神需要传承。祝愿丝绸之路国际艺术节圆满成功。

陕西省文化和旅游厅厅长　任宗哲

2019年9月7日

Preface

The 2019 Silk Road International ArtFestival International Art Invitational Exhibition will be held on September 7th. The development of the Silk Road Art Festival in the past six years has made the artists of more than 120 countries around the world feel the grandeur and beauty of the Silk Road Festival.

The Silk Road International Art Festival,as a cultural brand advocated by the country, has undergone a six-yeardevelopment process. It has gradually produced a wide range of cultural influences not only in the country but also in the world. Especially in terms of scale, after a short six-year development process, more than 100 countries have participated for three consecutive years.It laid a solid foundation for the international brand effect of the Silk Road Art Festival. In addition to the number of participating countries and regions, this year's silk road art festival attracted artists from 115 countries and regions participating in the collection.At the same time, the quality of art has also maintained a highlevel. As an international art exhibition in the International Silk Road Art Festival,it is necessary to embrace different countries and art types.Its rich works include sculptures, videos,installations,paintings, comprehensive designs and other artistic styles and patterns.

The open Silk Road Festival shows the charm of Chinese culture and confidence. It fully demonstrates a diversified communication window of the current international art exhibition.The Silk Road International Arts Festivalis an important platform for telling Chinese stories and showing Chineseculture. While maintaining the spread of internationalization, its international influence is also expanding year after year. Today's Silk Road International Art Exhibition is a platform for spreading culture and a bridge for friendship.

The world needs civilization, culture needs to spread, people need peace, and the spirit of Silk Road needs to be passed down. I wish the Silk Road International Arts Festival a complete success.

Department of Culture and Tourism of Shaanxi Province Director
Zongzhe Ren
September 7, 2019

第六届丝绸之路国际艺术节
今日丝绸之路国际美术展

组委会名单

主　任
任宗哲 / 陕西省文化和旅游厅厅长

副主任
蔺宝钢 / 陕西省美术家协会副主席
李象群 / 鲁迅美术学院院长
赵晓强 / 陕西省文化和旅游厅对外文化处副处长

The Sixth Silk Road International Arts Festival

Today Silk Road International Art Exhibition

Organizing Committee List

Director

Zongzhe Ren, Department of Culture and Tourism of Shaanxi Province Director

Vice Chairman

Baogang Lin, Vice Chairman of Shaanxi Artists Association

Xiangqun Li, Vice Dean, Luxun Academy of Fine Arts

Xiaoqiang Zhao, Vice Division Head of International Office, Department of Culture and Tourism of Shaanxi Province Director

第六届丝绸之路国际艺术节
今日丝绸之路国际美术展

组委会名单

艺术总顾问
吴为山
全国政协常委 / 中国美术馆馆长 / 中国美术家协会副主席

The Sixth Silk Road International Arts Festival

Today Silk Road International Art Exhibition

Organizing Committee List

Chief Art Advisor

Weishan Wu

CPPCC National Committee Member & Director of China Art Museum & Vice President of China Artists Association

第六届丝绸之路国际艺术节
今日丝绸之路国际美术展

学术委员会名单

主 任

蔺宝钢（中国）/ 陕西省美术家协会副主席

学术委员

汤姆·哈格曼（荷兰）

马蒂尔德·莫里奥（科特迪瓦）

比利·李（美国）

李象群（中国）

约克·普利卡特（德国）

The Sixth Silk Road International Arts Festival

Today Silk Road International Art Exhibition

Academic Committee List

Director

Baogang Lin, Vice Chairman of Shaanxi Artists Association (China)
Xi'an University of Architecture and Technology

Academic Committee

Tom Hageman (Netherlands)
Mathilde Moreau (Cote d'Ivoire)
Billy Lee (USA)
Xiangqun Li (China)
Jorg Plickat (Germany)

第六届丝绸之路国际艺术节
今日丝绸之路国际美术展

策展委员会名单

总策展人
文集（中国）/ 世界美术同盟发起人

策展委员
宋晓明（德国）
洛伊特·卓卡达（爱沙尼亚）
杨觉昇（马来西亚）
赵莉（中国）
李始珪（韩国）

The Sixth Silk Road International Arts Festival

Today Silk Road International Art Exhibition

List of Strategic Development Committee

Curator/ Collector
Ji Wen, *Founder of the World Art League*

Commissioner of Planning and Development
Xiaoming Song (Germany)
Loit Jõekalda (Estonia)
Juesheng Yang (Malaysia)
Li Zhao (China)
Lee Si Kyu (Korea)

第六届丝绸之路国际艺术节
今日丝绸之路国际美术展

秘书长
姜 涛
副秘书长
刘福龙
杜 喆
媒 体
王永亮
岳士俊
国际联络
崔宁娜
编 务
支少层
刘 丹
翻 译
张雅琪

The Sixth Silk Road International Arts Festival

Today Silk Road International Art Exhibition

Secretary General
Tao Jiang
Deputy Secretary General
Fulong Liu
Zhe Du
Media
Yongliang Wang
Shijun Yue
International Contact
Ningna Cui
Editing Workers
Shaoceng Zhi
Dan Liu
Translator
Yaqi Zhang

Work Collection of Arts | The Sixth Silk Road International Arts Festival
美术作品集 | 第六届丝绸之路国际艺术节

前言 / Preface

阿富汗 / Afghanistan
001 巴比伦 / Babylon
贝拉纳·马苏姆 / Berahna Massoum

阿尔巴尼亚 / Albania
002 春季 / Spring Time
赫里顿·哈利蒂 / Helidon Haliti

阿尔及利亚 / Algeria
003 沙漠上的修道院 / Desert Monastery
德里奇·哈森 / Drici Hassen

阿根廷 / Argentina
004 围带系列 / Shroud Series
爱丽西亚·坎蒂阿尼 / Alicia Candiani

005 短暂的圣丽塔花 / Ephemeral Santa Rita Flower
诺玛比阿特丽斯·西格尔博伊姆 / Norma Beatriz Siguelboim

006 权力 / La Fuerza
索菲亚·若凯罗莉·罗芭德 / Sofia Roncayoli Lombardi

亚美尼亚 / Armenia
007 为大局齐心协力 / Together for the Big Picture
哈古普·苏拉汉 / Hagop Sulahian

008 走钢丝 / Ropewalker
曼努基安·拉斐尔 / Manukyan Rafael

澳大利亚 / Australia
009 丝绸之路文化 / Silk Road Culture
法里德·扎里夫 / Farideh Zariv

010 丝绸之路 - 民族记忆 / Silk Road - Ethnic Memory
纳塞尔·帕兰加 / Nasser Palangi

奥地利 / Austria
011 船体 / Hull
凯瑟琳娜·梅尔斯 / Katharina Moerth

阿塞拜疆 / Azerbaijan
012 构成 / Composition
图拉尔·马尤弗·纳米格 / Tural Moyufov Namig

巴林 / Bahrain
013 花的十一段 / The Eleven Passages of Flowers
阿巴斯·尤西夫 / Abbas Yousif

孟加拉国 / Bangladesh
014 梦想阳光 / Dreaming Sunshine
马哈茂达·阿克特尔·卢特菲 / Mhmuda Akter Lutfa

015 难民儿童 / The Refugee Child
安里斯 / Md Anisul Haque

016 丝绸之光 / The Light of Silk Road
默罕默德雷扎雷曼 / Mohammed Rezaur Ranman

白俄罗斯 / Belarus
017 晨星 / Morning Star
巴里斯·普拉卡彭卡 / Barys Prakapenka

018 开始新的一天 / Start a New Day
达尔亚苏玛拉瓦科帕奇 / Darya Sumarava Kopach

019 记得你 / Remember You
科祖贝克·伊洛娜 / Kosobuko Ilona

020 时间旅行 / Travel in Time
维克塔·科佩奇 / Viktar Kopach

比利时 / Belgium
021 边缘面 / Face on the Edge
德泰尔克·马丁娜 / Deturck Martina

022 布迪 / Budi
玛蒂娜·范帕里什 / Martine Vanparijs

贝宁 / Benin
023 咖啡桌 / Table Basse
马武纳·艾萨克 / Mawuna Isaac

不丹 / Bhutan
024 无题 / Unnamed
滕津·多吉 / Tenzin Dorji

玻利维亚 / Bolivia
025 编织生活 / Weaving Life
艾达·多纳托 / Adda Donato

波黑 / Bosnia and Herzegovina
026 赫拉布雷尼 / Hrabreni
恩迪·波斯科维奇 / Endi Poskovic

巴西 / Brazil
027 等待 / Waiting
欧德斯·科雷亚 / Eudes Correia

028 分享网络，转换！/ Share Net, Transform!
桑德拉·利马·席尔瓦 / Sandra Lima e Silva

保加利亚 / Bulgaria
029 风景 / Landscape
伊万娜·彼得罗娃 / Ivana Petrova

030 丝绸之路 / Silk Road
利利娅·波博尔尼科夫 / Liliya Pobornikova

C

喀麦隆 / Cameroun
031 多重面部 / Multiplex Facial
福斯特 / Amougou Jean Faustin

加拿大 / Canada
032 植物学家的女儿：旗帜 / The Botanist's Daughter :Flag
亚历山德拉·海塞克 / Alexandra Haeseker

033 褶皱阴影 #19 / Shadows of Folds #19
德里克·贝森特 / Derek Besant

034 冰封 / Frozen
唐娜·艾奇逊·朱利特 / Donna Acheson Juillet

035 无题 / Unnamed
玛芮·乔西·勒克斯 / Marie Josée Leroux

036 初雪 / First Snow
游荣光 / Stephen Yau

智利 / Chile
037 无题 / Unnamed
伊冯·嘉·凡 / Ivonne Chia Fan

038 ESB 系列 / ESB Series
曼努埃尔·马汉特 / Manuel Marchant

039 吻风 / Kiss the Wind
马雅·埃斯特拉达 / Maya Estrada

040 ST 系列 / ST Series
莫尼克·沃杜 / Monique Verdu

中国 / China
041 老子 / Lao Tzu
吴为山 / Weishan Wu

042 无题 / Unnamed
宁钢 / Gang Ning

043 带围巾的女孩 / Girl Wearing a Scarf
庞茂琨 / Maokun Pang

044 雨后娇姿 / Petite after the Rain
郭线庐 / Xianlu Guo

045 叙利亚少女 / Syrian Girl
王西京 / Xijng Wang

046 老子圣像 / Lao Tzu Icon
蔺宝钢 / Baogang Lin

047 家园 / Home
文集 / Ji Wen

048 非零度 2018 / Non-Zero 2018
朱尽晖 / Jinhui Zhu

049 惠之云 / Wisdom Clouds
朱尚熹 / Shangxi Zhu

International Art Exhibition
国际美术展

050 雨后 / After Raining
巨石 / Shi Ju

051 无题 / Unnamed
景育民 / Yumin Jing

052 无题 / Unnamed
王犇 / Ben Wang

053 索菲亚 / Sophia
张琨 / Kun Zhang

054 无题 / Unnamed
马国强 / Guoqiang Ma

055 春之舞 / Spring Dance
鲍海宁 / Haining Bao

056 薪火 / Fire
罗小平 / Xiaoping Luo

057 莲语 / Lotus
王志刚 / Zhigang Wang

058 平衡的温度 / Balanced Temperature
赵莉 / Li Zhao

059 晨雀 / Morning Bird
石村 / Cun Shi

060 《佛光》之二 / Buddha Light II
李章惠 / Zhanghui Li

061 观沧海 合 / Guanlan He
王志平 / Zhiping Wang

062 古驿今昔 / Current Sane of an Ancient Station
高筠 / Yun Gao

063 士大夫 / Scholar
姜涛 / Tao Jiang

064 西路漫漫 / Long Road to the West
司小刚 / Xiaogang Si

065 第一场雪 / First Snow
韩禹锋 / Yufeng Han

066 兴安岭上牧歌 / Xing'an Mountain Pastoral Song
张士勤 / Shiqin Zhang

067 诗经·变奏的文化记忆之十 / Ten of Cultural Memories of the Change of the Book of Songs
陈艺方 / Yifang Chen

068 实验水墨 / The Experimental Ink Painting
金冈 / Gang Jin

069 无题 / Unnamed
刘福龙 / Fulong Liu

070 圣宴 / Banquet
李哲虎 / Zhehu Li

071 静山无尘 / Quiet Mountain
张洪源 / Hongyuan Zhang

072 游龙戏凤 / Dragon and Phoenix
王海燕 / Haiyan Wang

073 天地间 / Heaven and Earth
胡日查 / Richa Hu

074 秋日夕照 / Autumn Evening
杜力 / Li Du

075 归 / Go Back Home
高子期 / Ziqi Gao

076 古风今韵 / Ancient Style and Modern Charm
李东亮 / Dongliang Li

077 东方姑娘 / Oriental Girl
李东升 / Dongsheng Li

078 落日炊烟 / Sunset Smoke
李方明 / Fangming Li

079 城市之光 / Light of the City
刘昊天 / Haotian Liu

080 能量空间 / Energy Space
彭佳林 / Jialin Peng

081 江南故事 / Jiangnan Story
宋朝 吴景贤 / Chao Song, Jingxian Wu

082 迎接新时代 / Meeting the New Era
王威 / Wei Wang

083 丝路花海 / Silk Road Flower Sea
王运泽 / Yunze Wang

084 秋瑟 / Bleak Autumn
于立宁 / Lining Yu

085 炫彩筑梦 - 和谐家园 / Colorful Dreams - Harmonious Home
周莲荣 周绪行 / Lianrong Zhou, Xuxing Zhou

086 期望远方 / Expecting a Distance
左海瑛 / Haiying Zuo

087 乌镇晨辉 / The Glory of Wuzhen Morning
朱建成 / Jiancheng Zhu

088 众像 / Public Image
宋翰笛 / Handi Song

089 印象月牙泉 / Impression Crescent Spring
李伟明 / Mingo Li

090 无题 / Unnamed
汪蓝 / Lan Wang

091 飞掠 / Flying
李宝龙 / Baolong Li

092 山水 - 飞行 / Landscape-Flight
张书玮 / Shuwei Zhang

093 旧街斜影 / Old Street Shadow
杨治伟 / Zhiwei Yang

094 消失 / Disappear
陈子伊 / Ziyi Chen

哥伦比亚 / Colombia

095 塞蒂奥 / Cetacio
杰西.加布里埃尔.贝尔特伦 / Jesus Gabriel Beltran

哥斯达黎加 / Costa Rica

096 森林的旋律 / Melody of the Forest
尤利西斯.希门尼斯 / Ulises Jimenez

科特迪瓦 / Côte d'Ivoire

097 舞蹈 / La Danse
马蒂尔德.莫劳 / Mathilde Moreau

098 寺庙花园 / Gardiens Du Temple
雅宝.雅宝.帕特里克 / Yapo Yapo Patrick

克罗地亚 / Croatia

099 触摸屏幕可以在里面创造一个生活序列 / Touching the Screen may Create a Life Sequence inside
利奥.卡图纳里克 / Leo Katunaric

100 超级建筑 #133 / Megastructure #133
佩特拉.格里莱蒂克 / Petra Kriletić

古巴 / Cuba

101 发音的斜坡 / Pronounced Slopes
奥斯卡.劳瑞兰诺.艾格瑞.卡门达都 / Oscar Laurelino Aguirre Comendador

塞浦路斯 / Cyprus

102 章鱼 / Octopus
希尔达.凯莱基安 / Hilda Kelekian

捷克 / Czech

103 操纵器 / The Manipulator
吉里.斯塔姆费斯特 / Jiri Stamfest

104 猛禽 1 / Raptor 1
马丁.库查尔 / Martin Kuchař

丹麦 / Denmark

105 多元化 / Diversified
斯蒂芬.佩德森 / Steffie Pedersen

刚果（金）/ D.R.Congo

106 时间和空间 / Time and Space
本琦.克恭喝 / Benj Kinenga

朝鲜 / D.P.R.Korea

107 阿里郎少女 / Arirang Girl
陈明 / Ming Chen

108 壶口瀑布 / Hukou Waterfall
李景天 / Jingtian Li

109 憧憬 / Expectancy
朴英民 / Yingmin Piao

110 牧羊女 / Shepherdess
张贤哲 / Xianzhe Zhang

111 橘子少女 / Orange Girl
张元吉 / Yuanji Zhang

Work Collection of Arts | The Sixth Silk Road International Arts Festival
美术作品集 | 第六届丝绸之路国际艺术节

厄瓜多尔 / Ecuador

112 阿莫尔 / Fryto Del Amor
玛丽亚·德·洛德丝·巴拉雷索 / Maria de Lourdes Balarezo

埃及 / Egypt

113 自然的韵律 / Rhythms of Nature
法蒂玛·艾勒曼 / Fatma Abd Elrahman

114 家庭 / Family
马哈茂德 / Mahmoud

115 橙色的蝴蝶 / The Orange Butterfly
内维尼·法尔加利 / Nevine Farghaly

116 从过去到现在 / Between the Past and Today
希林·阿尔布罗蒂 / Sherin Elbaroudi

117 文化斗争 / Culture Struggle
维亚姆·埃玛斯里 / Weaam ElMasry

厄立特里亚 / Eritrea

118 陌生人 / The Strangers
亚伯拉罕·阿瓦罗 / Abraham Awalom

119 愿景 / Vision
贝尔哈内·采格约翰娜·格布蕾梅谢尔 / Berhane Tsegeyohannes Gebremicheal

爱沙尼亚 / Estonia

120 汉长城系列 / Great Wall of Han Series
洛伊特·卓卡达 / Loit Joekalda

121 吻雪系列 / Kissing Snow Series
维格·卓卡达 / Virge Joekalda

芬兰 / Finland

122 未知丛林 / Unknown Jungle
詹妮·莱恩 / Janne Laine

格鲁吉亚 / Georgia

123 无题 / Unnamed
约翰·戈哥别里什维利 / Jhon Gogaberishvili

德国 / Germany

124 红罂粟系列 / Roter Mohn Series
阿泽米娜·柏冉池 / Azemina Bruch

125 宇宙 / Cosmic
迪特尔·韦斯特普 / Dieter Wystemp

126 彭特西勒亚 / Penthesilea
埃克勒·劳拉 / Eckerl Laura

127 多彩多姿的大象 / Multicolour Elepha
弗里安·沃尔夫 / Florian Wolf

128 无题 / Unnamed
任戎 / Rong Ren

129 桥，不再是一座桥 / Bridge, No Longer Functioning Bridge
斯特凡·米茨拉夫 / Stefan Mitzlaff

加纳 / Ghana

130 我们的威尼斯 / Our Venice
乔纳森·肯瓦吉亚·安格里 / Jonathan Kwegyir Aggrey

希腊 / Greece

131 麦索福的旧门 / Old Door in Metsovo
乔治·波利提斯 / George Politis

132 我的路 / My Way
莉娜·莫尔菲戈尼 / Lena Morfogeni

133 上帝的羔羊 / The Lamb of God
乌拉尼亚·弗拉格口里多 / Ourania Fragkoulidou

格林纳达 / Grenada

134 千日之旅 / Journey of a Thousand Sunsets
泰瑞西亚·毕索 / Tricia Bethel

几内亚 / Guinea

135 女权 / Women in Charge
特劳雷·卡巴 / Traore Kaba

匈牙利 / Hungary

136 奥卡姆剃刀系列 / Occam's Razor Series
多拉·埃兹特·莫纳尔 / Dora Eszter Molnar

137 障碍 / Barrieren
海德·林德·马丁·特罗特 / Heide Linde Martin Traber

冰岛 / Iceland

138 历史守护者 / History Keeper
约翰·菲茨西蒙斯 / John Fitzsimons

139 冰岛 / Iceland
西比利亚·比亚纳森 / Sibilla Bjarnason

印度 / India

140 克雷勒·马勒的影响 / Impact of Kroller Muller
巴比塔·塔莎 / Babita Das

141 静 / Peace within
哈马尼·阿拉瓦特 / Himani Ahlawat

142 亨比眺望台 / Watch Tower Hampi
马杜·库马尔 / Madhu Kumar

143 泡沫人生 / Mood Indigo
普蕾米拉·辛格 / Premila Singh

144 质朴的谈话 / Rustic Conversation
拉玛什·库马·贾沃 / Ramesh Kumar Jhawar

145 花园里的情侣 / Couple in the Garden
桑吉瓦·库马尔 / Sanjeev Kumar

印度尼西亚 / Indonesia

146 丝绸之路，2019 / Silk Road,2019
亚努拉 / Januri

147 两种和谐的文化 / Two Harmonious Culture
乔尼·拉梅兰·沃诺 / Joni Ramlan Wiono

148 BE234se / BE234se
韦恩·苏达索诺·扬森 / Wayan Sudarsana Yansen

伊朗 / Iran

149 丝绸之路 / Silk Road
罗巴贝·德尔科什 / Robabeh Delkhosh

伊拉克 / Iraq

150 乡村之路 / On the Way to the Village
艾博德·奥贝德 / Abed Obed

爱尔兰 / Ireland

151 矩阵系列 / Matrix Series
露丝·奥·唐纳 / Ruth O Donnell

以色列 / Israel

152 死海 / Dead Sea
本尼·加森鲍尔 / Beni Gassenbauer

意大利 / Italy

153 固执和相反的方向 / In Stubborn and Contrary Direction
迪·普洛斯彼罗·马里诺 / Di Prospero Marino

154 永恒 / Eternity
格蒂·塔万克修 / Genti Tavanxhiu

155 茧 / Cocoon
拉拉·史蒂夫 / Lara Steffe

… International Art Exhibition
国际美术展

J

牙买加 / Jamaica
156 丝绸之路在四个轮子上 / Silk Road on Four Wheels
布莱恩·马克·法兰 / Bryan Mc Farlane

日本 / Japan
157 粉红茄子·拥抱 / Pink Eggplant·Hug
明甫多多 / Akiho Tata

158 露水 / Moon Drops
田中等 / Hitoshi Tanaka

159 红伞 II / Red Umbrella II
计子田边 / Keiko Tanabe

160 富十 / Fuji
后藤纯男 / Smi'omio Goto

约旦 / Jordan
161 休憩时间 / Coffee Time
朱曼·阿拉·尼米尔 / Juman Al Nemr

K

哈萨克斯坦 / Kazakhstan
162 沉默 / Silence
马拉·比克也 / Marat Bekeyev

肯尼亚 / Kenya
163 姆威蒂 / Mwiti
安妮·姆威蒂 / Ainine Mwiti

韩国 / Korea
164 时间之旅 / Time Travel
金美兰 / Kim Mi Ran

165 无题 / Unnamed
李范宪 / Lee Bum Hun

166 花开 / Blooming
李成玉 / Lee Seong Ok

167 石心（生命） / Stone Heart (Life)
南鹤浩 / Nan Hak Ho

168 梦想空间 / Dreaming of Space
吴顺美 / Oh Soonmi

科威特 / Kuwait
169 无题 / Unnamed
阿卜杜拉·阿纳瑟 / Abdulla Alnaser

吉尔吉斯斯坦 / Kyrgyzstan
170 花·女孩 / Flower Girl
弗拉基米尔·巴兰茨基科夫 / Wladimir Barantschikov

L

拉脱维亚 / Latvia
171 字符系列 / Characters Series
冈塔拉斯·西丁斯 / Guntars Sietins

172 湖 / The Lake
艾策·斯米尔丁 / Ilze Smildzin

黎巴嫩 / Lebanon
173 一带文化之旅 / Cultural Journey of the Belt
列纳·凯勒基安 / Lena Kelekian

174 岛 / Island
诺哈·萨姆斯丁 / Noha Shamseddine

立陶宛 / Lithuania
175 亚克力文字 -XX / Acrylic Scripts - XX
安塔纳斯·奥博卡萨斯 / Antanas Obcarskas

176 阿维尼翁，法国 / Avignon, France
谢尔盖·雷瑟 / Sergiy Lysyy

卢森堡 / Luxembourg
177 舞蹈系列 / The Dance Series
谢尔盖·科赫 / Serge Koch

M

马其顿 / Macedonia
178 新兴形式 / Emerging Form
安德烈·米特夫斯基 / Andrej Mitevski

马来西亚 / Malaysia
179 阳 #2 / The Sun #2
郑伟翔 / Gray Tay Wei Xiang

180 槟城老街 / Penang Heritage Street
邱昌仁 / Khoo Cheang Jin

181 形色自如 #27 / Liberty #27
杨觉昇 / Yeon Choon Seng

墨西哥 / Mexico
182 印度丝绸婚纱 / Indian Wedding with Silk Dress Crow
加布里埃拉·阿布德 / Gabriela Abud

183 无题 / Unnamed
戈特弗里德·霍尔沃思 / Gottfried Hoellwarth

184 唱歌 / Canto a La Lue
豪尔赫·埃利桑多 / Jorge Elizondo

185 通河蝴蝶墙 / Tonghe Butterfly Wall
佩德罗·马尔蒂尼 / Pedro Martinez

186 女神——秘密 / Goddess - Secrets
罗伯托·乔治 / Roberto Georgge

摩尔多瓦 / Moldova
187 无题 / Unnamed
加霍斯·阿德里安娜·米拉贝拉 / Gajos Adriana Mirabela

蒙古 / Mongolia
188 内体星系 89 / Innerbody Galaxy 89
恩科图夫卡·巴托尔 / Enkhtuvshink Batbaatar

189 商队 / Caravan
巴亚马尼亚·米亚格玛 / Bayarmagnai Myagmar

190 出行前 / Before Go out
明安特塞格.L / Myangantsetseg.L

191 倾听 / Listening
纳桑音格尔·巴颜嗒拉 / Nasantsengel Bayanjargal

192 回家的路 / Way Back Home
特塞格巴丹·巴巴亚尔 / Tsetsegbadam Batbayar

黑山共和国 / Montenegro
193 关于我自己 / About Myself
米尔科娃 / Miljkovac

摩洛哥 / Moroccan
194 超越表面 / Au-dela Des Apparences
布塔勒·蒙尼亚 / Boutalbe Mounia

缅甸 / Myanmar
195 午后的蒲甘 / Afternoon in Bagan
琴芒皂 / Khin Maung Zaw

196 仰光大金塔平台 / Shwedagon Platform
木因特·那英 / Myint Naing

N

尼泊尔 / Nepal
197 一位老妇人的画像 / Portrait of an Old Woman
NB 高隆 / NB Gurung

198 迷宫 / Maze
金晖 / Rabindra Khaniya

新西兰 / New Zealand
199 无题 / Unnamed
陈坚 / Jian Chen

Work Collection of Arts | The Sixth Silk Road International Arts Festival
美术作品集 | 第六届丝绸之路国际艺术节

尼日利亚 / Nigeria
200 无题 / Unnamed
奥拉扬朱·达达 / Olayanju Dada

尼加拉瓜 / Nicaragua
201 LAT12N/LONG86W 系列 / LAT12N/LONG86W Series
帕特丽夏·维拉洛波斯·埃切弗里亚 / Patricia Villalobos Echeverria

202 相亲 / Cita a Ciegas
葛杉明 / Samuel Gadea

挪威 / Norway
203 鱼 / Fish
安琪·金 / Anki King

阿曼 / Oman
204 希望的斗争 / The Struggle of Hope
阿卜杜勒克勒姆 / Abdulkareem

205 指南针 / Compass
阿里·阿尔贾布里 / Ali Aljabri

巴拿马 / Panama
206 逃生计划 / Plan de Escape
安东尼·乔司·古兹曼 / Antonio José Guzman

巴拉圭 / Paraguay
207 缺席 / Absent
卢维埃·卡萨利 / Luvier Casali

巴基斯坦 / Pakistan
208 尘土飞扬的风 / Dusty Windy
阿里·阿巴斯·赛义德 / Ali Abbas Syed

209 身份 / Identity
安雪梅 / Qurat ul Ain

秘鲁 / Peru
210 安第斯祖先的记忆 / Anden Ancestral Memory
巴伯罗·叶塔约 / Pablo Yactayo

菲律宾 / Philippines
211 蓝 / Blue
巴约·迪诺·但丁 / Pajao Dino Dante

波兰 / Poland
212 陆上逃生 –01 / Land Escape – 01
克孜斯托夫·莫伦达 / Krzysztof Molenda

213 旋转木马 / Merry-Go-Round
麦克·加斯威克斯 / Michal Jasiewicz

葡萄牙 / Portugal
214 埃斯特拉达·达·塞达 / Estrada Da Seda
伊洛·苏萨 / Josefa Sousa

215 面对我的村庄 / Faces of My Village
朱利奥·豪尔赫 / Júlio Jorge

罗马尼亚 / Romania
216 我们到了么？ / Are We Where Yet?
克里斯蒂·法卡斯 / Cristi Farcas

217 遗产 2 / Heritaje 2
米雷拉·特雷斯塔鲁 / Mirela Traistaru

218 金色地图 / Golden Map
拉鲁·普普 / Rares Lupu

俄罗斯 / Russia
219 家庭 / Family
格列博·杜萨维茨基 / Gleb Dusavitskiy

220 塔甘斯卡亚广场日落 / Sunset on Taganskaya Square
利特维年科·奥尔加 / Litvinenko Olga

221 三月初拜访舒金先生 / Visit to Mr. Schukin at the Beginning of March
谢尔盖·库尔巴托夫 / Sergei Kurbatov

222 丝绸之路回忆 -1 / Silk Road Reminiscences-1
斯特霍夫·康斯坦丁 / Sterkhov Konstantin

卢旺达 / Rwanda
223 风景 / Landscape
尤马希尔·艾萨卡里 / Umuhire Isakari

沙特阿拉伯 / Saudi Arabia
224 无题 / Unnamed
云芸 / Aisha Yun

225 生命之门 / The Door of Life
纳希瓦·拉希德 / Najwa Rasheed

塞尔维亚 / Serbia
226 父亲 / Father
伽拉·卡克 / Gala Caki

227 花园 / Garden
伊娃·扬科维奇 / Iva Jankovic

228 头 / Head
萨萨·马里亚诺维奇 / Sasa Marjanovic

新加坡 / Singapore
229 新加坡小印度 / Singapore Little Indian
刘奕村 / Wendy Low Nyet Choon

斯洛伐克 / Slovakia
230 SONDE - 在她之前 / SONDE – She before
马丁·埃夫·奥维 / Martin Ševčovič

斯洛文尼亚 / Slovenia
231 灵魂影响力系列 / Soul Impact Series
阿里耶尔·斯特鲁凯尔 / Arijel Strukelj

232 在雨中 / In the Rain
克托米尔·弗里希 / Črtomir Frelih

233 无题 / Unnamed
米尔科·布拉图沙 / Mirko Bratuša

南非 / South Africa
234 并不是所有的南非人都是贫穷的 / Not Everyone in SA is Destitute
卫斯理·佩珀 / Wesley Pepper

西班牙 / Spain
235 春 / Spring
南多·阿尔瓦雷斯 / Nando Alvarez

236 水下洞穴 / Underwater Cave
塞斯克·法雷 / Cesc Farré

237 空气 / Aire
费尔南多·巴里昂诺夫 / Fernando Barrionuevo

238 哨兵 / Sentinel
吉玛·多明戈斯 / Gemma Dominguez

239 人类系列 / Humana Series
胡安·佩迪盖罗 / Juan Perdiguero

240 市场街七号 / Market Street VII
巴布鲁本·洛佩斯·桑兹 / Pablo Ruben Lopez Sanz

斯里兰卡 / Sri Lanka
241 母亲 / Mom
达尔玛 / Dharma

242 时间，精神和空间 -3 / Time, Mind & Space-3
贾加思·拉文德拉 / Jagath Ravindra

苏丹 / Sudan
243 白衣女人 / Women in White
艾哈迈德·拉希德·穆巴拉克·迪亚卜 / Ahmad Rashid Mubarak Diab

International Art Exhibition
国际美术展

瑞典 / Sweden
244 无题 / Unnamed
艾哈迈德·莫迪尔 / Ahmed Modhir

瑞士 / Switzerland
245 25+1 / 25+1
克里斯托夫·提曼 / Christoph Rütimann

叙利亚 / Syrian
246 平衡 19 / Balance 19
塔列克·阿尔法 / Tareq Alghamian

泰国 / Thailand
247 玫瑰 / Rose
莱夫 / Lafe

248 大皇宫 / The Grand Palace
苏比霍沃特·希兰塔维沃特 / Suphawat Hiranthanawiwat

多哥 / Togo
249 玩智能手机 / Fiddling with Smartphone
阿卜杜勒·加尼·德曼尼 / Abdoul Ganiou Dermani

突尼斯 / Tunisia
250 爱丽莎 / Alisa
穆罕默德·博阿茨兹 / Mohamed Bouaziz

251 蓝色的 / Zrog(Blues)
耐洁特·德阿碧 / Najet Dhahbi

252 青年女士 / Young Lady
里姆·阿亚里 / Rim Ayari

253 呼吸 / Breath
瓦罗·托帕可 / Varol Topaç

土耳其 / Turkey
254 铁路 / Railway
路基·贾丽普 / Rukiye Garip

乌干达 / Uganda
255 魅 / Succubus
吉莉安·斯泰西·安倍 / Gillian Stacey Abe

乌克兰 / Ukraine
256 蜘蛛网 / Cobwebs
亚历克斯·鲁巴诺夫 / Alex Rubanov

257 第一场比赛 / First Game
奥莱纳·多达克 / Olena Dodatk

258 月亮之夜 / Moonlight Night
尤尔琴科·伊霍尔 / Yurchenko Ihor

乌拉圭 / Uruguay
259 罗宾 - 面向左 / Robin - Facing Left
里默·卡迪洛 / Rimer Cardillo

260 现代传播学 / Modern Communication
苏珊娜·维达 / Susana Vida

英国 / United Kingdom
261 褪色的记忆 / Fading Memory
安古斯·麦克尤恩 / Angus McEwan

262 剑桥大学站，希克林盆地，威尔金森在测试中 / Cambridge Station，Hickling Basin，Wilkinson on the Test
鲍勃·斯帕汉 / Bob Sparham

263 静如止水 / Quiet Waters
戴维·伯克森 / David Poxon

264 伊斯坦布尔 - 圣索菲亚 / Hagia Sofia-Istanbul
伊恩·斯图尔特 / Iain Stewart

美国 / United States
265 道 / Dao
比利·李 / Billy Lee

266 月落 / Moonset
卡萝尔·特纳 / Carole Turner

267 无题 / Unnamed
恩家·琳达·海永 / Eunjong Linda Hyong

268 无限 IV / Immenduring IV
哈德森·乔恩·巴洛 / Hudson Jon Barlow

269 金牛座的月亮 / Moon of Taurus
约翰·阿特金 / John Atkin

270 板 29 / Plate 29
纳达·科拉佐·洛伦斯 / Nayda Collazo Llorens

271 青蓝色的滑音 / Glissando in Blue
那蓝 / Robert Najlis

272 风景 / Landscape
托马斯·W·夏尔 / Thomas W Schaller

乌兹别克斯坦 / Uzbekistan
273 天使的梦 / The Dream of an Angel
古尔佐尔·苏塔诺娃 / Gulzor Sultanova

委内瑞拉 / Venezuela
274 部落元素 / From the Tribe
拉蒙·莫拉雷斯 / Ramon Morales

275 俯瞰西方 / Glance at the West
罗纳德杰·帕雷德斯瓦佳斯 / Ronald J. Paredes Vargas

越南 / Viet Nam
276 翠 / Thuy
隆平 / Luong Binh

277 长长的美好回忆 / Long Bien Memories
倪奇·万东 / Ngo Van Dung

278 夜晚的音乐 / Night Music
阮敏丹 / Nguyen Minh Tan

279 影 / The Shadow
阮图红 / Nguyen Thu Huong

Z

津巴布韦 / Zimbabwe
280 生命树 6 / Cay Doi 6
特兰·范·尼恩 / Tran Van Ninh

281 玛丽安·尼安·洪戈 - 温努女子弹簧石 2 / Marian Nyanhongo - Winowing Woman Springstone 2
玛利亚·南亚行谷 / Marian S. Nyanhnbgo

Work Collection of Arts | The Sixth Silk Road International Arts Festival
美术作品集 | 第六届丝绸之路国际艺术节

荷兰 / 法国联合特展作品
A Special Exhibition of Netherlands and France Joint Works

荷兰 / Netherlands

283 蓝色线圈 / Blauw Emaille
 本·斯尼杰德斯 / Ben Snijders

284 教堂 / Church
 杜威·埃利亚斯 / Douwe Elias

285 朱莉 / Juli
 埃丝特·勒维宁 / Esther Leuvenink

286 赖特迪普仪式-1 / Staatsie Reitdiep-1
 格鲁特·巴瑟 / Geurt Busser

287 栎 2 / Quercus 2
 吉塔·帕多尔 / Gitta Pardoel

288 中式柜子 / Chinese Cabinet
 亨克·海尔曼特尔 / Henk Helmantel

289 赫尔曼肖像 / Herman Portrait
 赫尔曼·范·胡格达伦 / Herman Van Hoogdalem

290 蒂姆·哈曼 / Tim Hamann
 尼克·威廉 / Nick Willems

291 闪耀的光芒 / Sparking Light
 奥贝尔斯·皮特 / Obels Pieter

292 游行 / Procession
 彼得·哈特维格 / Peter Hartwig

293 艺术书柜 / Cabinet with Art Book
 赖因·波尔 / Rein Pol

294 观音风景 / Landscape with Quang Yins
 汤姆·哈格曼 / Tom Hageman

295 忙碌三角关系 / Busy Triangular Relationship
 维姆·琼克曼 / Wim Jonkman

296 宾能威，鹿特丹 / Binnenweg, Rotterdam
 扎瓦恩·斯托克 / Zwaan Stoker

法国 / France

297 未知的景观 / Landscape of the Unknown
 鲍弗雷·马克 / Baufrère Marc

298 逃到未知的地方 / Flee to the Unknown
 布勒让·霍普夫纳·埃德维热 / Bregent Hopfner Edwige

299 西安的夜晚回忆 / Xi'an Nights' Memories
 比捷·沙尔特兰·穆里尔 / Buthier Chartrain Muriel

300 神经系统的治愈 / Neurologic Rescue
 克劳德·吉纳德 / Claude Guenard

301 丝绸之路上的蝴蝶 / Butterfly on Silk Road
 埃玛努埃莱·鲍丁 / Emmanuelle Baudin

302 穆特鲁姆 / Mutterturm
 詹妮·科茨·温特罗普 / Janine Kortz Waintrop

303 踪迹 / Traces
 罗梅罗·勒罗伊·米丽娅姆 / Romero Leroy Myriam

304 无题 / Unnamed
 马克·坦古伊 / Marc Tanguy

305 潮 / Tide
 藏渊 / Yuan Zang

结语 / Conclusion

Sixth

Afghanistan

阿富汗

International Art Exhibition

国际美术展

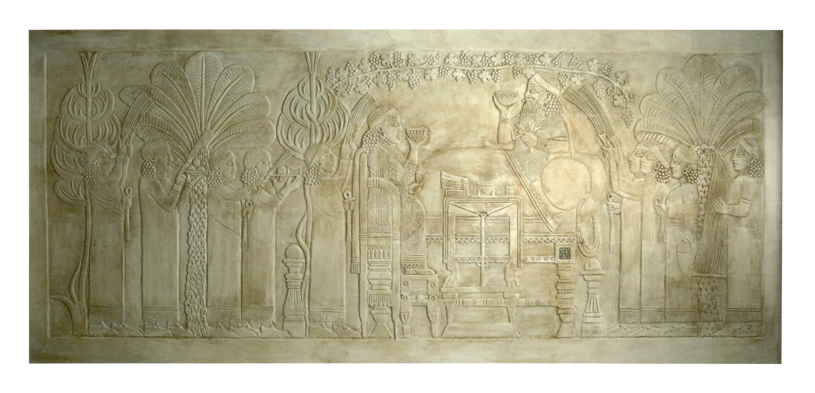

巴比伦 / Babylon
1800mm x 600mm

贝拉纳·马苏姆 | Berahna Massoum
阿富汗 | Afghanistan
雕塑 | Sculpture

001

Work Collection of Arts | The Sixth Silk Road International Arts Festival | Albania
美术作品集 | 第六届丝绸之路国际艺术节 | 阿尔巴尼亚

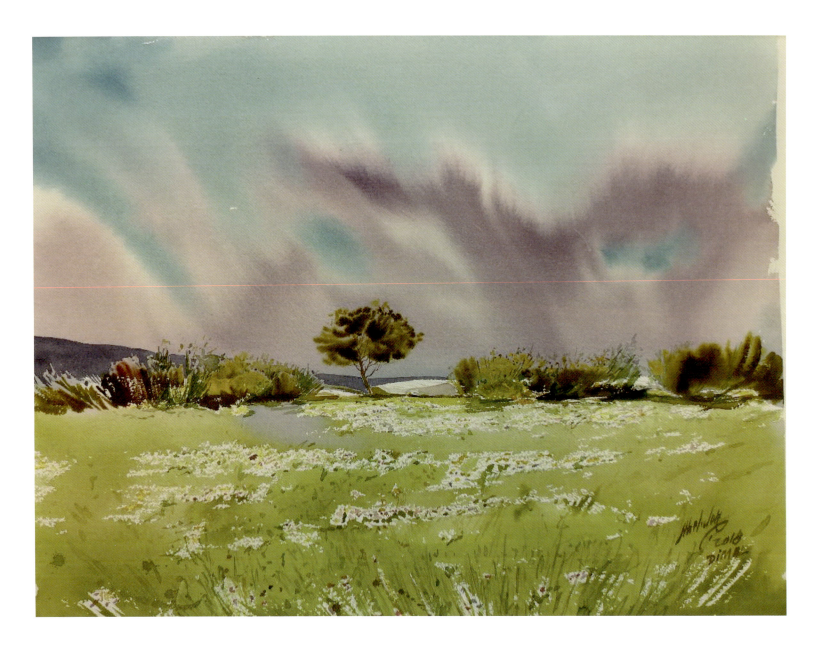

春季 / Spring Time
600mm x 420mm

赫里顿·哈利蒂	Helidon Haliti
阿尔巴尼亚	Albania
绘画	Painting

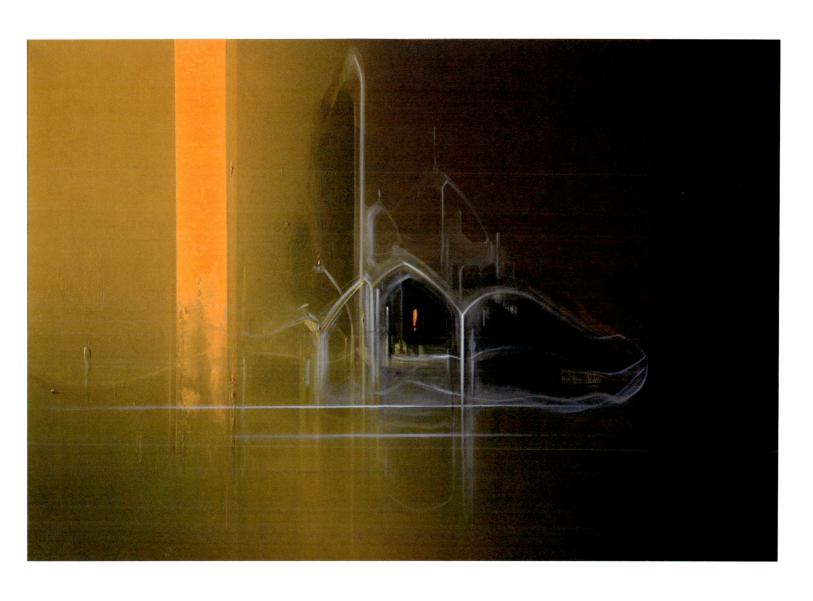

沙漠上的修道院 / Desert Monastery
800mm x 1000mm

德里奇·哈森 | Drici Hassen
阿尔及利亚 | Algeria
绘画 | Painting

Work Collection of Arts | The Sixth Silk Road International Arts Festival | Argentina
美术作品集 | 第六届丝绸之路国际艺术节 | 阿根廷

围带系列 / Shroud Series

760mm x 560mm

爱丽西亚·坎蒂阿尼 | Alicia Candiani
阿根廷 | Argentina
绘画 | Painting

Argentina / 阿根廷 — International Art Exhibition / 国际美术展

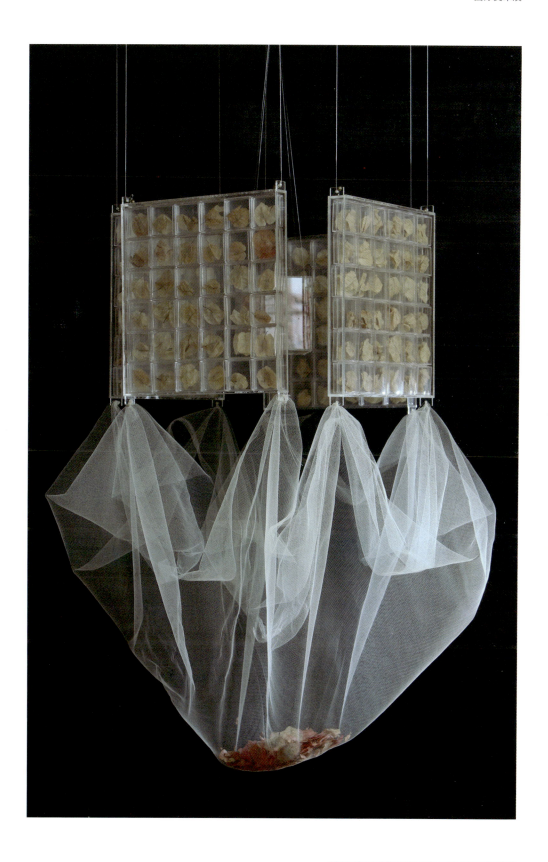

短暂的圣丽塔花 / Ephimeral Santa Rita Flower
1000mm x 400mm x 400mm

诺玛·比阿特丽斯·西格尔博伊姆 | Norma Beatriz Siguelboim
阿根廷 | Argentina
雕塑 | Sculpture

| Work Collection of Arts | The Sixth Silk Road International Arts Festival | Argentina |
| 美术作品集 | 第六届丝绸之路国际艺术节 | 阿根廷 |

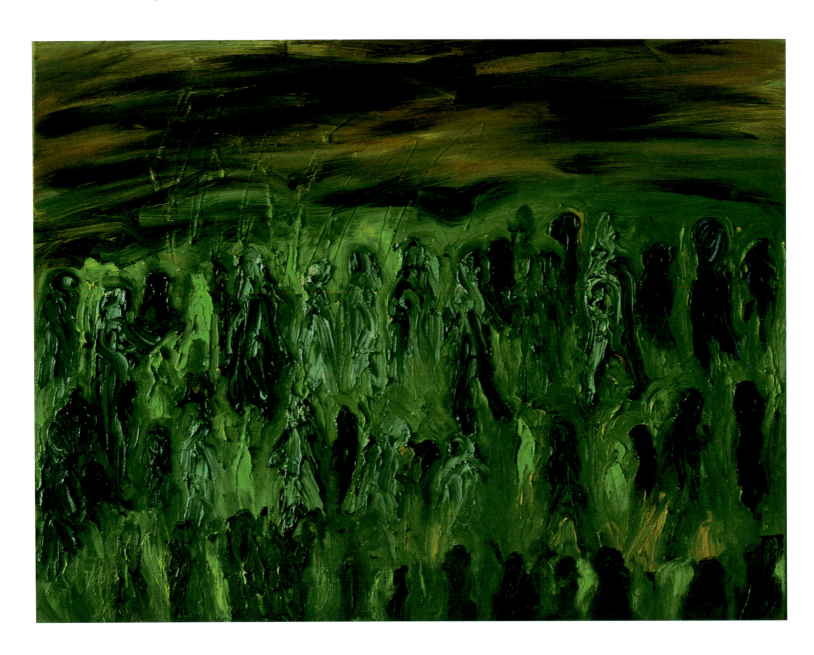

权力 / La Fuerza

800mm x 600mm

索菲亚·若凯罗莉·罗芭德 | Sofia Roncayoli Lombardi
阿根廷 | Argentina
绘画 | Painting

Armenia
亚美尼亚

International Art Exhibition
国际美术展

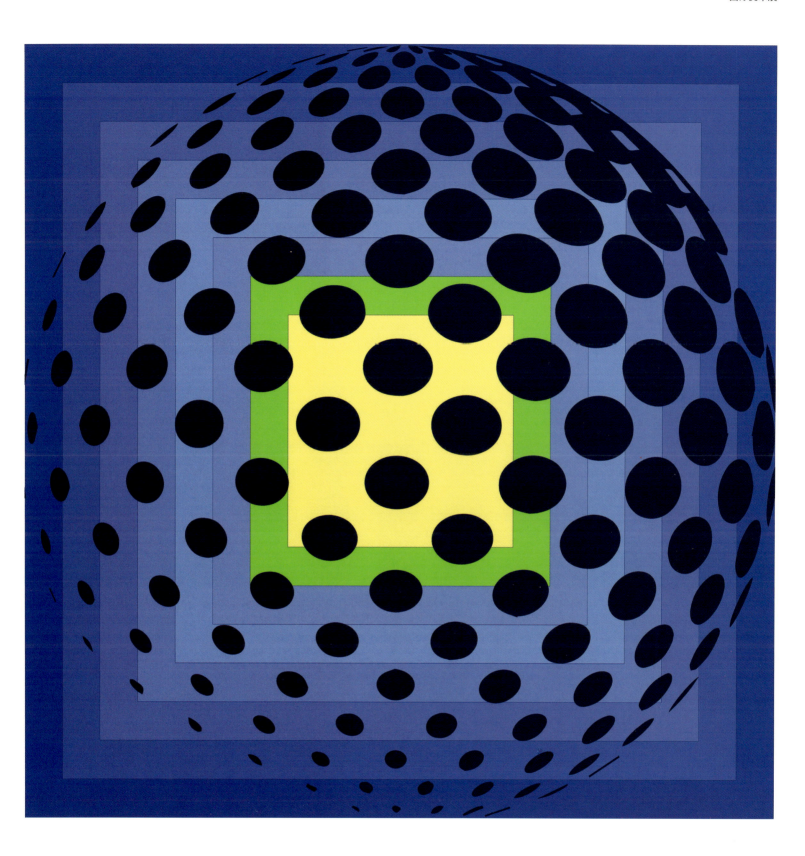

为大局齐心协力 / Together for the Big Picture

800mm x 800mm

哈古普·苏拉汉 | Hagop Sulahian
亚美尼亚 | Armenia
混合材料 | Comprehensive Material

Work Collection of Arts	The Sixth Silk Road International Arts Festival	Armenia
美术作品集	第六届丝绸之路国际艺术节	亚美尼亚

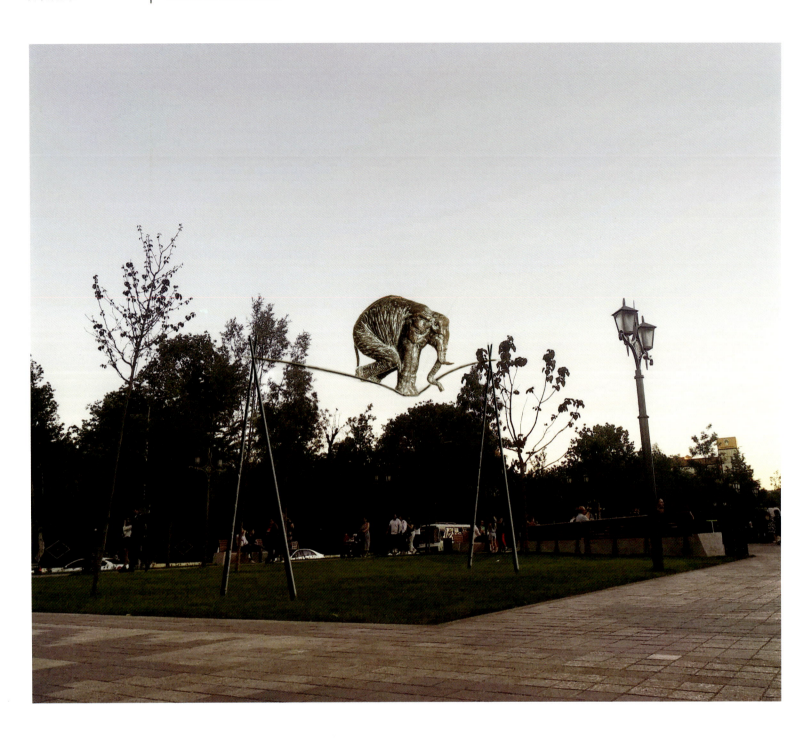

走钢丝 / Ropewalker

2200mm x 2000mm x 850mm

曼努基安·拉斐尔	Manukyan Rafael
亚美尼亚	Armenia
雕塑	Sculpture

Australia 澳大利亚 — International Art Exhibition 国际美术展

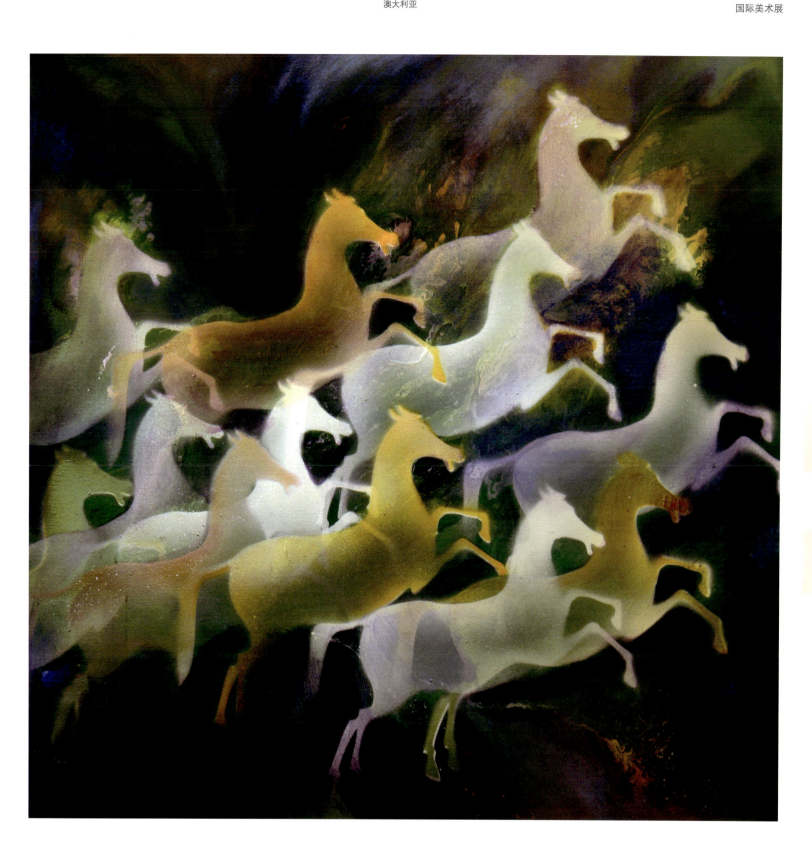

丝绸之路文化 / Silk Road Culture
900mm x 900mm

法里德·扎里夫 | Farideh Zariv
澳大利亚 | Australia
绘画 | Painting

| Work Collection of Arts | The Sixth Silk Road International Arts Festival | Australia |
| 美术作品集 | 第六届丝绸之路国际艺术节 | 澳大利亚 |

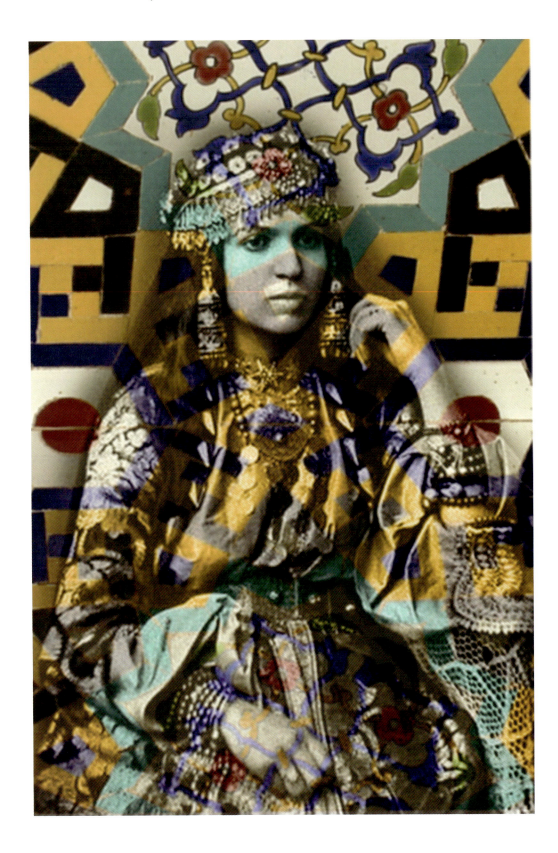

丝绸之路 – 民族记忆 / Silk Road – Ethnic Memory

1000mm x 800mm

纳塞尔·帕兰加	Nasser Palangi
澳大利亚	Australia
绘画	Painting

Austria / 奥地利 — International Art Exhibition / 国际美术展

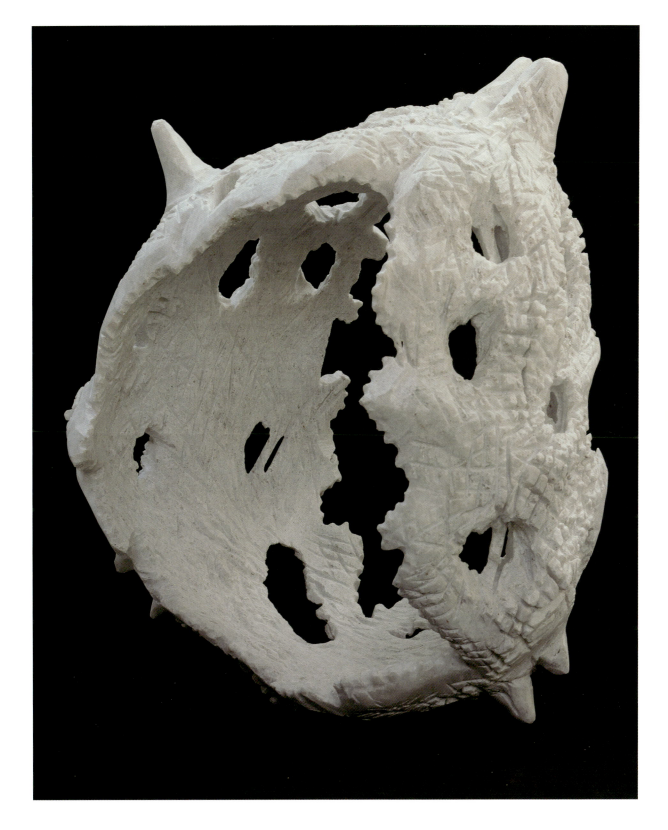

船体 / Hull
600mm x 450mm x 480mm

凯瑟琳娜·梅尔斯 | Katharina Moerth
奥地利 | Austria
雕塑 | Sculpture

Work Collection of Arts	The Sixth Silk Road International Arts Festival	Azerbaijan
美术作品集	第六届丝绸之路国际艺术节	阿塞拜疆

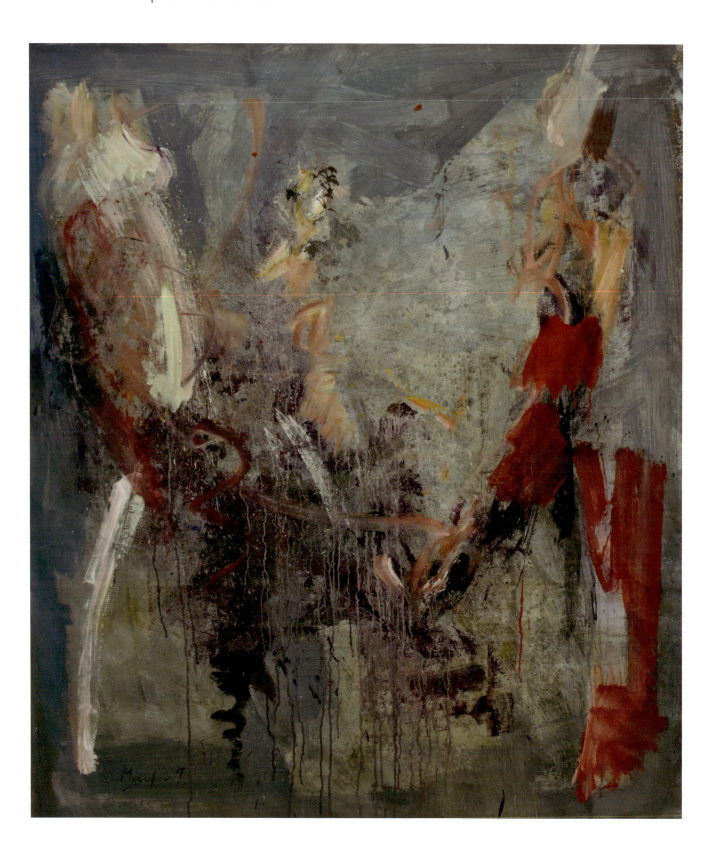

构成 / Composition

105mm x 125mm

图拉尔·马尤弗·纳米格 | Tural Moyufov Namig
阿塞拜疆 | Azerbaijan
绘画 | Painting

Bahrain
巴林

International Art Exhibition
国际美术展

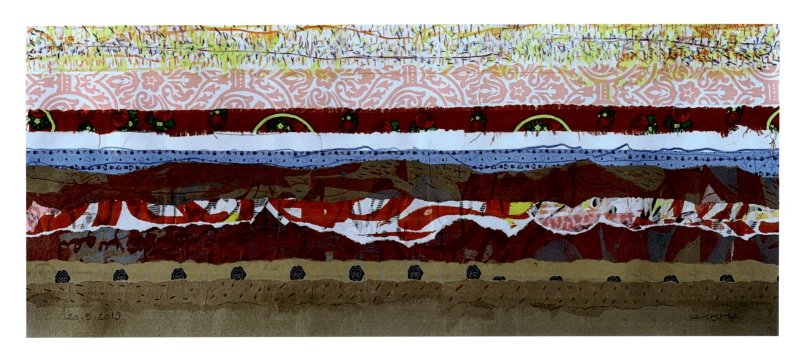

花的十一段 / The Eleven Passages of Flowers
350mm x 850mm

阿巴斯·尤西夫 | Abbas Yousif
巴林 | Bahrain
绘画 | Painting

| Work Collection of Arts | The Sixth Silk Road International Arts Festival | Bangladesh |
| 美术作品集 | 第六届丝绸之路国际艺术节 | 孟加拉国 |

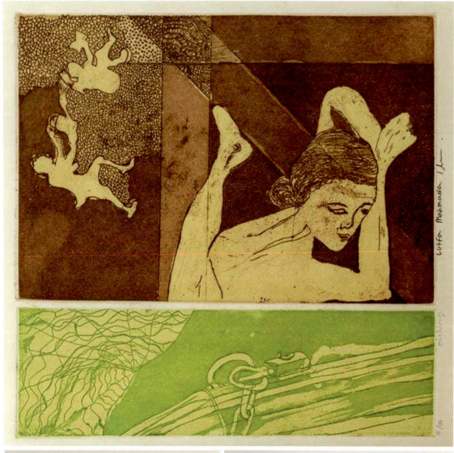

梦想阳光 / Dreaming Sunshine
953mm x 241mm

马哈茂达·阿克特尔·卢特菲	Mhmuda Akter Lutfa
孟加拉国	Bangladesh
绘画	Painting

Bangladesh / 孟加拉国 — International Art Exhibition / 国际美术展

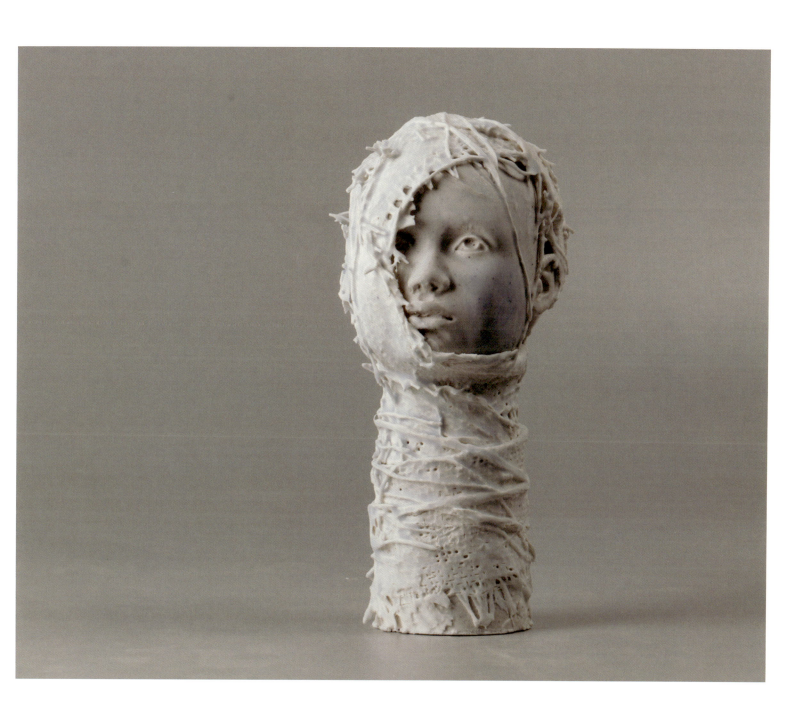

难民儿童 / The Refugee Child
140mm x 120mm x 250mm

安里斯	Md Anisul Haque
孟加拉国	Bangladesh
雕塑	Sculpture

| Work Collection of Arts | The Sixth Silk Road International Arts Festival | Bangladesh |
| 美术作品集 | 第六届丝绸之路国际艺术节 | 孟加拉国 |

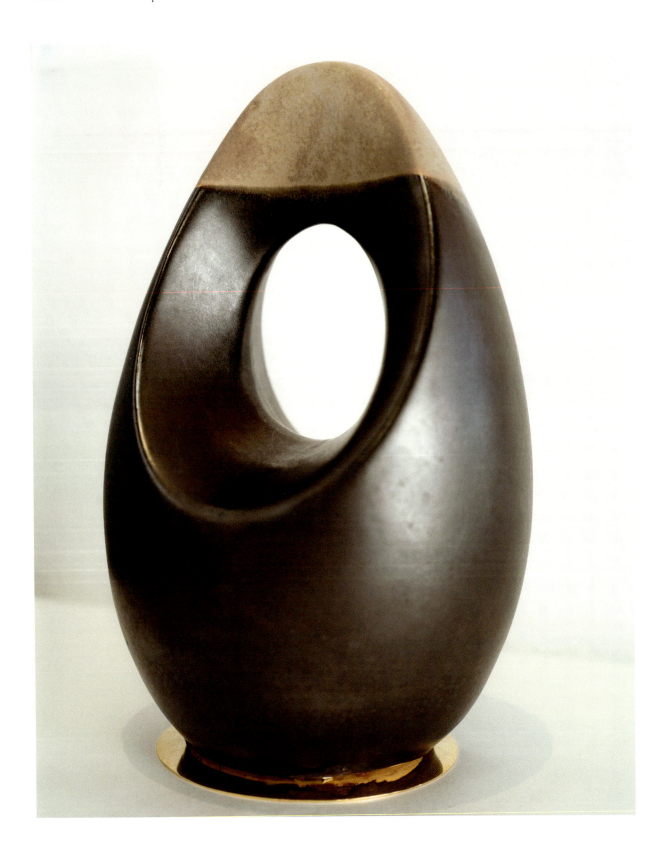

丝路之光 / The Light of Silk Road

300mm x 180mm

默罕默德·雷扎·雷曼　　Mohammed Rezaur Ranman
孟加拉国　　　　　　　Bangladesh
雕塑　　　　　　　　　Sculpture

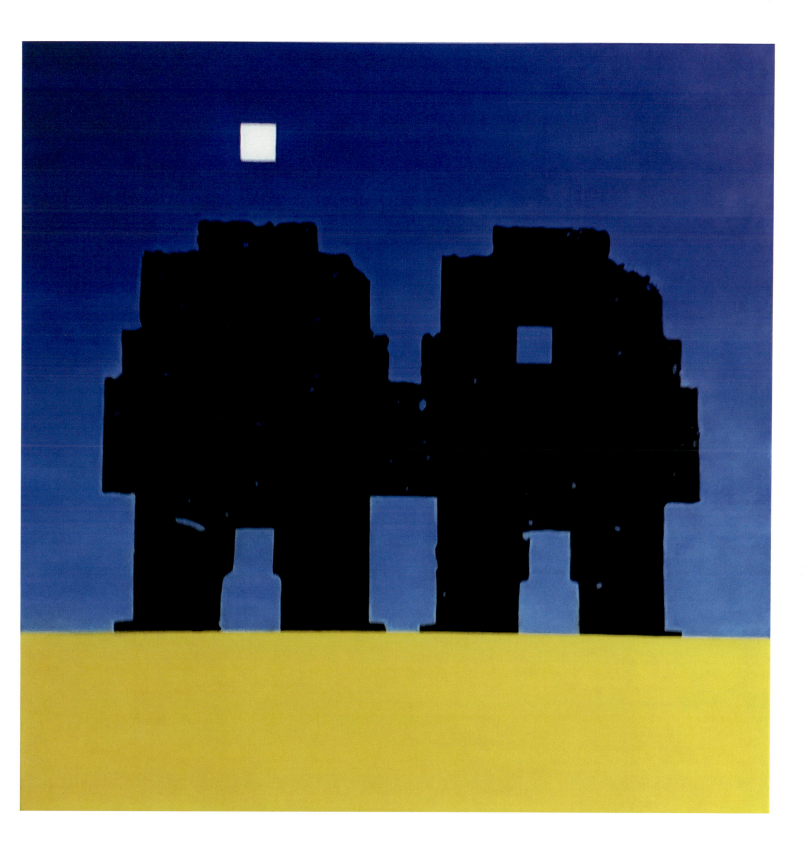

晨星 / Morning Star
610mm x 610mm

巴里斯·普拉卡彭卡 | Barys Prakapenka
白俄罗斯 | Belarus
绘画 | Painting

| Work Collection of Arts | The Sixth Silk Road International Arts Festival | Belarus |
| 美术作品集 | 第六届丝绸之路国际艺术节 | 白俄罗斯 |

开始新的一天 / Start a New Day

500mm x 1000mm

达利亚·苏玛拉瓦·科帕奇 | Darya Sumarava Kopach
白俄罗斯 | Belarus
绘画 | Painting

Belarus / 白俄罗斯 — International Art Exhibition / 国际美术展

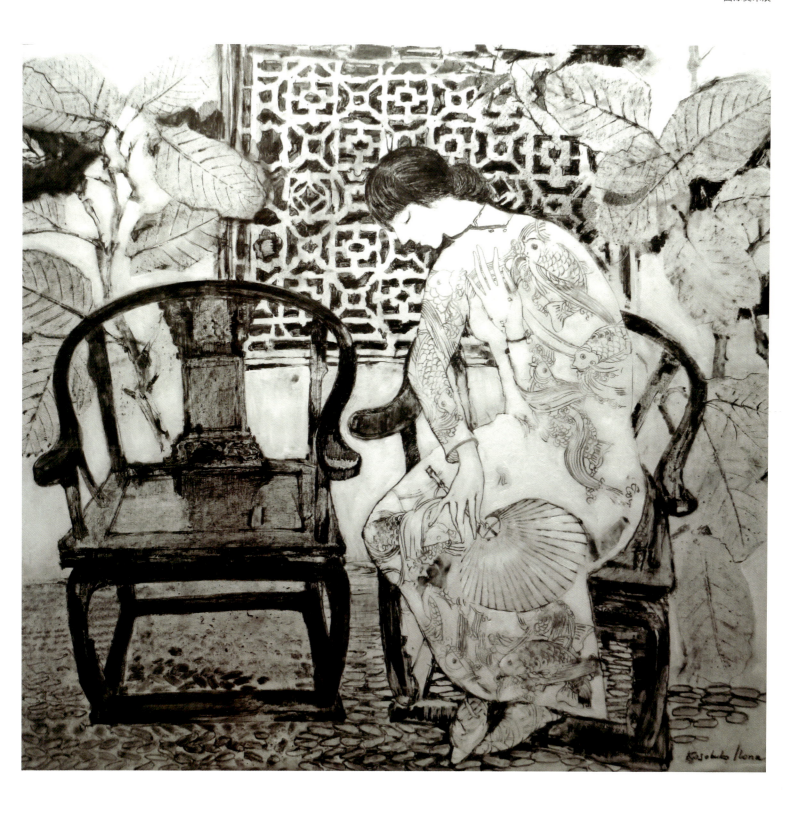

记得你 / Remember You
900mm x 1000mm

科祖贝克·伊洛娜 | Kosobuko Ilona
白俄罗斯 | Belarus
绘画 | Painting

| Work Collection of Arts | The Sixth Silk Road International Arts Festival | Belarus |
| 美术作品集 | 第六届丝绸之路国际艺术节 | 白俄罗斯 |

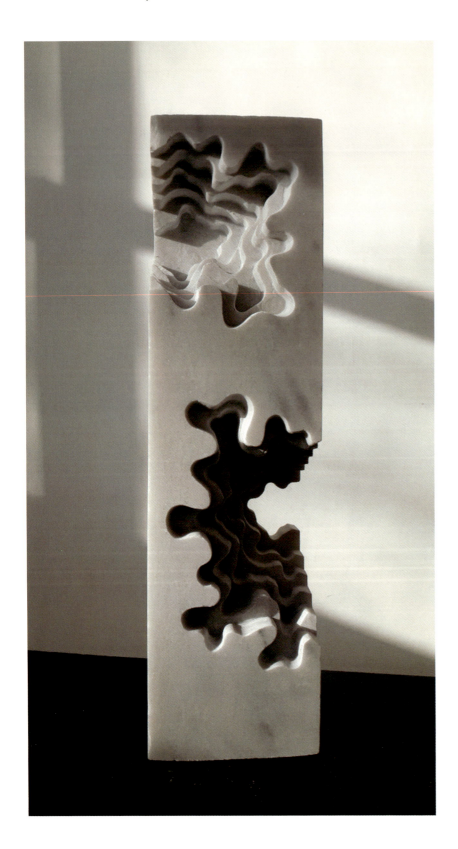

时间旅行 / Travel in Time

620mm x 150mm x 170mm

维克塔·科佩奇	Viktar Kopach
白俄罗斯	Belarus
雕塑	Sculpture

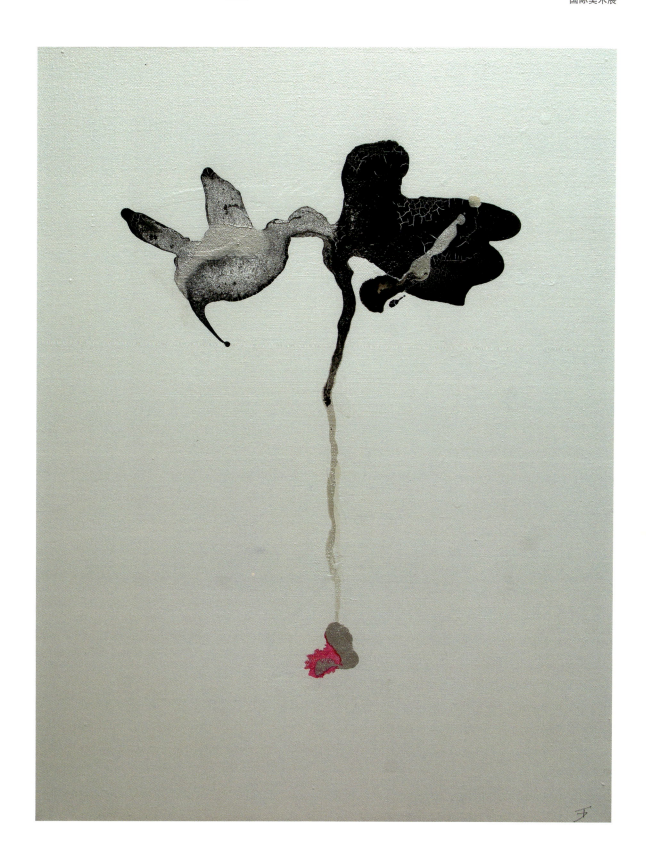

边缘面 / **Face on the Edge**

910mm x 730mm

德泰尔克·马丁娜 | Deturck Martina
比利时 | Belgium
绘画 | Painting

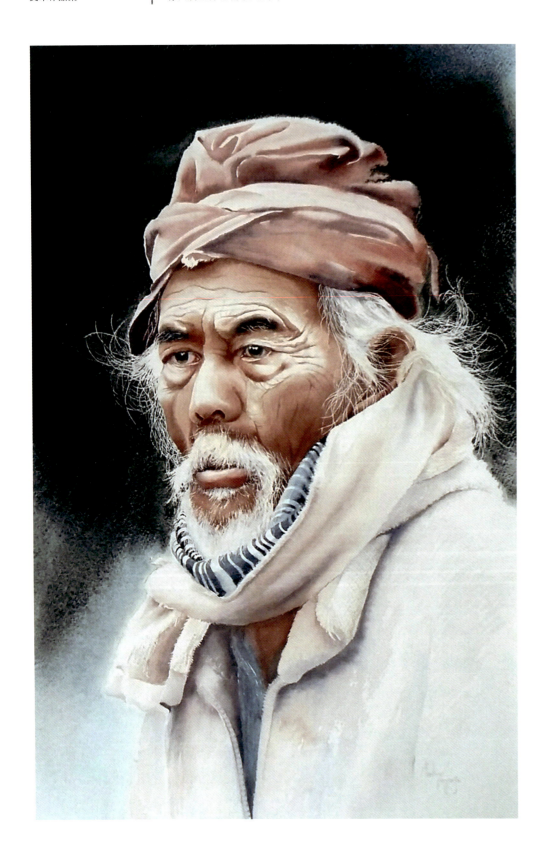

布迪 / Budi
380mm x 560mm

玛蒂娜·范帕里什
比利时
绘画

Martine Vanparijs
Belgium
Painting

Benin | International Art Exhibition
贝宁 | 国际美术展

咖啡桌 / Table Basse
840mm x 560mm

马武纳·艾萨克	Mawuna Isaac
贝宁	Benin
雕塑	Sculpture

023

| Work Collection of Arts | The Sixth Silk Road International Arts Festival | Bhutan |
| 美术作品集 | 第六届丝绸之路国际艺术节 | 不丹 |

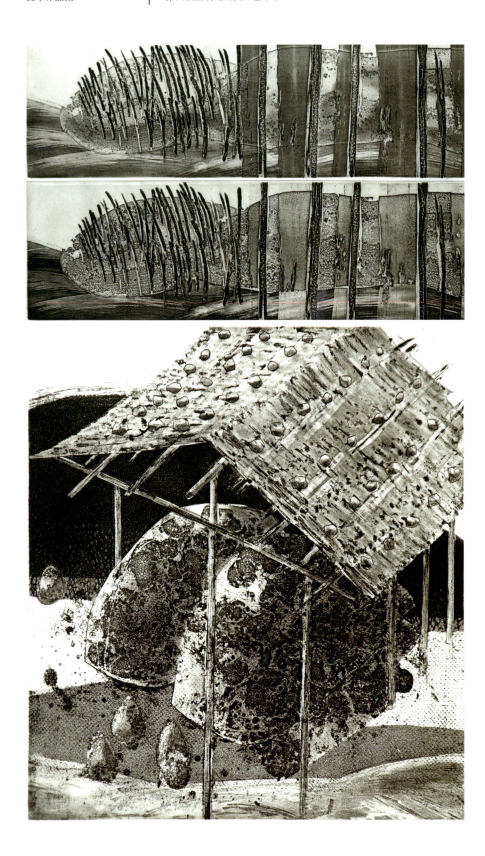

无题 / Unnamed

滕津·多吉	Tenzin Dorji
不丹	Bhutan
绘画	Painting

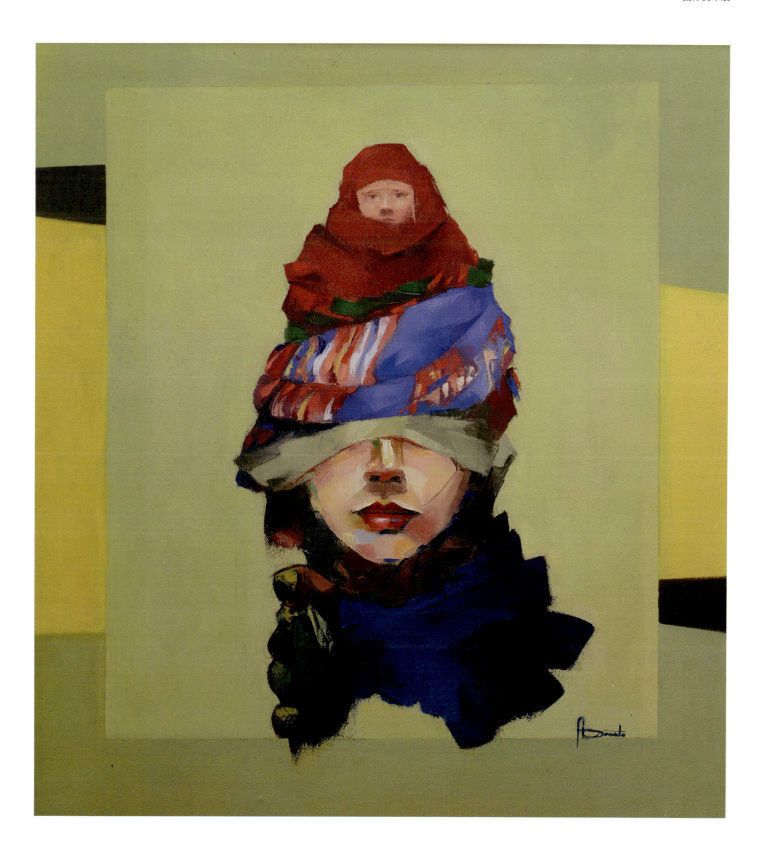

编织生活 / Weaving Life
630mm x 700mm

艾达·多纳托 | Adda Donato
玻利维亚 | Bolivia
绘画 | Painting

| Work Collection of Arts | The Sixth Silk Road International Arts Festival | Bosnia and Herzegovina |
| 美术作品集 | 第六届丝绸之路国际艺术节 | 波黑 |

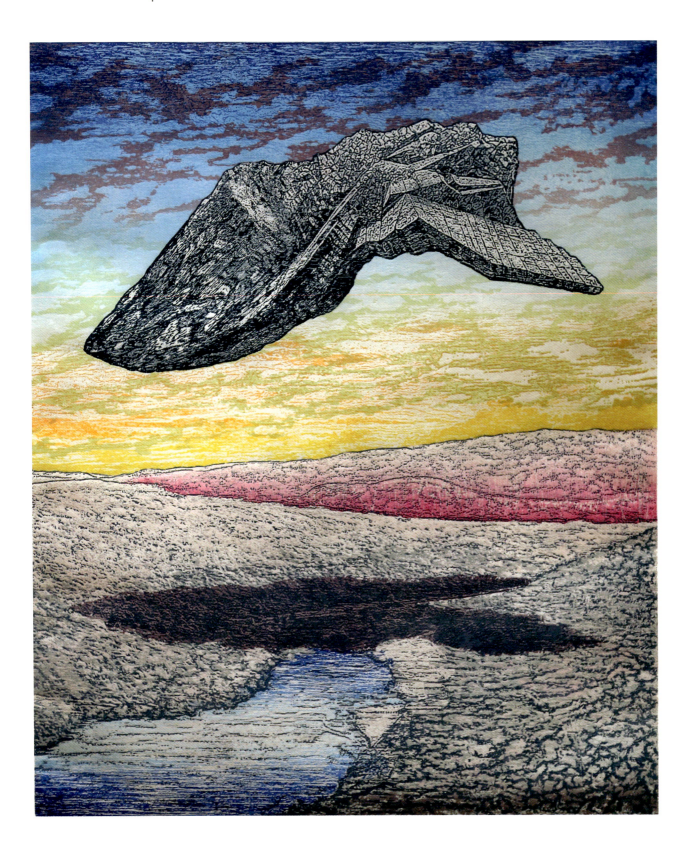

赫拉布瑞尼 / Hrabreni
980mm x 630mm

恩迪 · 波斯科维奇	Endi Poskovic
波黑	Bosnia and Herzegovina
绘画	Painting

Brazil / 巴西 — International Art Exhibition / 国际美术展

等待 / Waiting
380mm x 560mm

欧德斯·科雷亚 | Eudes Correia
巴西 | Brazil
绘画 | Painting

| Work Collection of Arts | The Sixth Silk Road International Arts Festival | Brazil |
| 美术作品集 | 第六届丝绸之路国际艺术节 | 巴西 |

分享网络，转换！/ Share Net, Transform!

1000mm x 800mm

桑德拉·利马·席尔瓦	Sandra Lima e Silva
巴西	Brazil
绘画	Painting

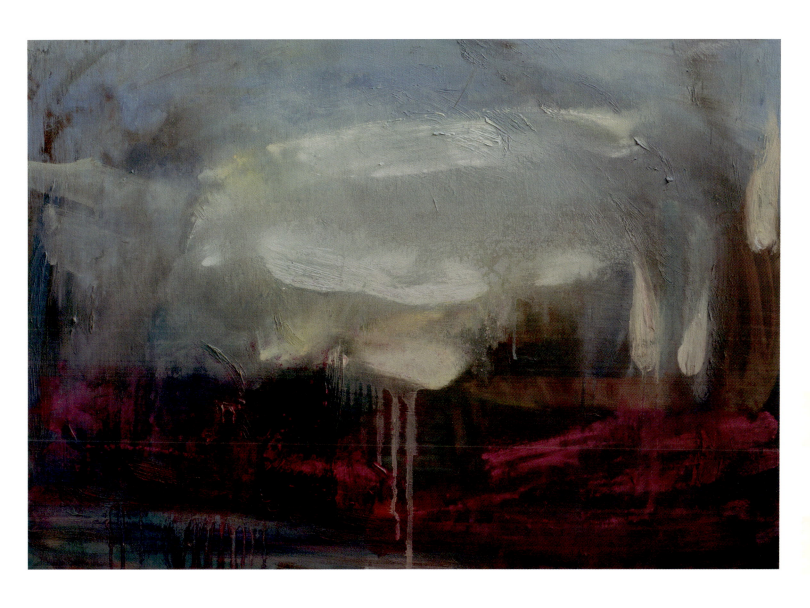

风景 / Landscape
500mm x 730mm

伊万娜·彼得罗娃 | Ivana Petrova
保加利亚 | Bulgaria
绘画 | Painting

| Work Collection of Arts | The Sixth Silk Road International Arts Festival | Bulgaria |
| 美术作品集 | 第六届丝绸之路国际艺术节 | 保加利亚 |

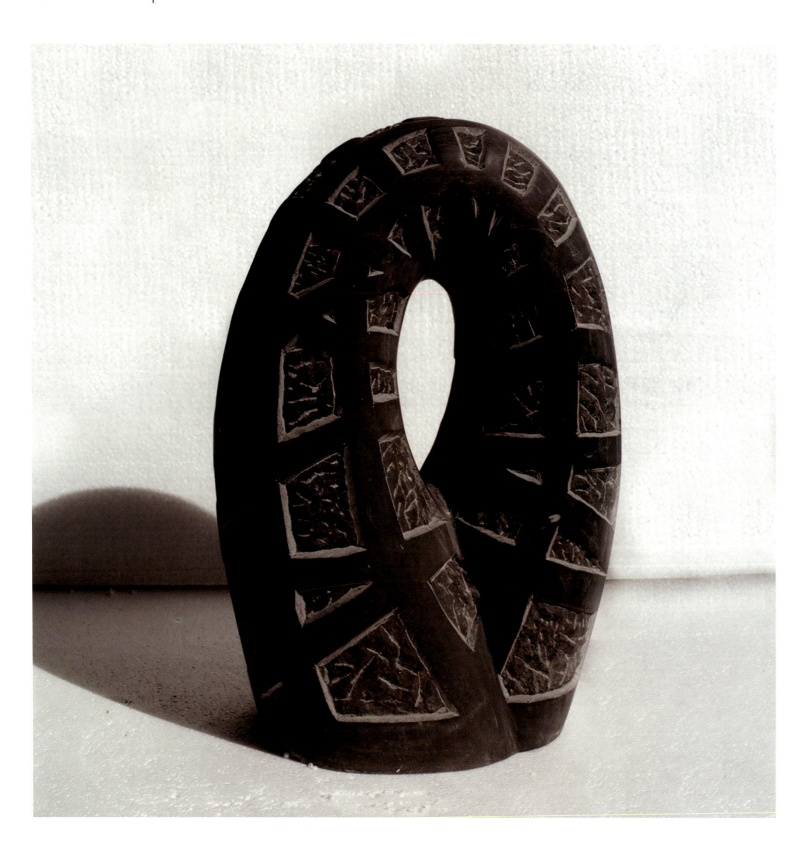

丝绸之路 / Silk Road

600mm x 250mm x 150mm

利利娅·波博尔尼科夫 Liliya Pobornikova
保加利亚 Bulgaria
雕塑 Sculpture

Cameroon
喀麦隆

International Art Exhibition
国际美术展

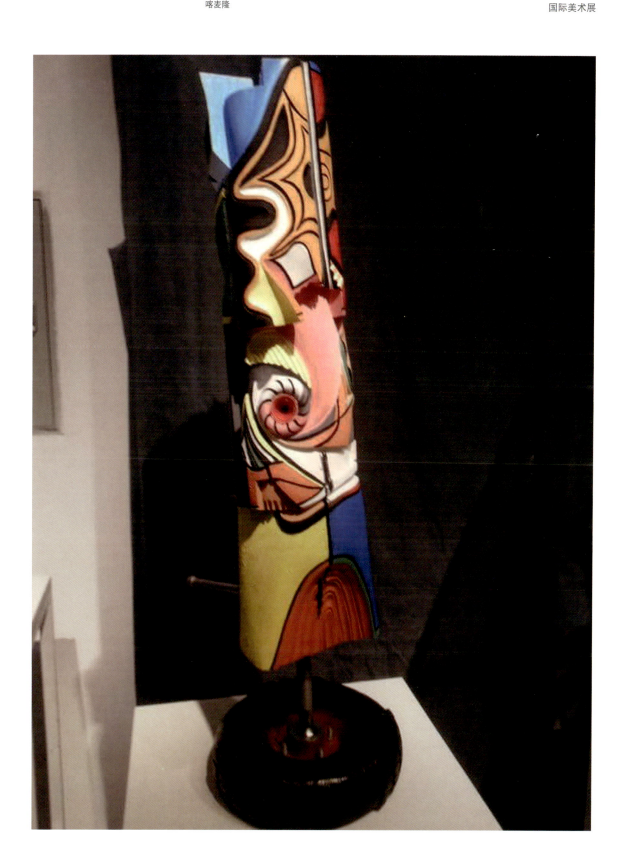

多重面部 / Multiplex Facial
700mm x 200mm x 250mm

福斯特 | Amougou Jean Faustin
喀麦隆 | Cameroon
雕塑 | Sculpture

031

Work Collection of Arts	The Sixth Silk Road International Arts Festival	Canada
美术作品集	第六届丝绸之路国际艺术节	加拿大

植物学家的女儿：旗帜 / The Botanist's Daughter :Flag

220mm x 280mm

亚历山德拉·海塞克	Alexandra Haeseker
加拿大	Canada
印刷	Printing

Canada
加拿大

International Art Exhibition
国际美术展

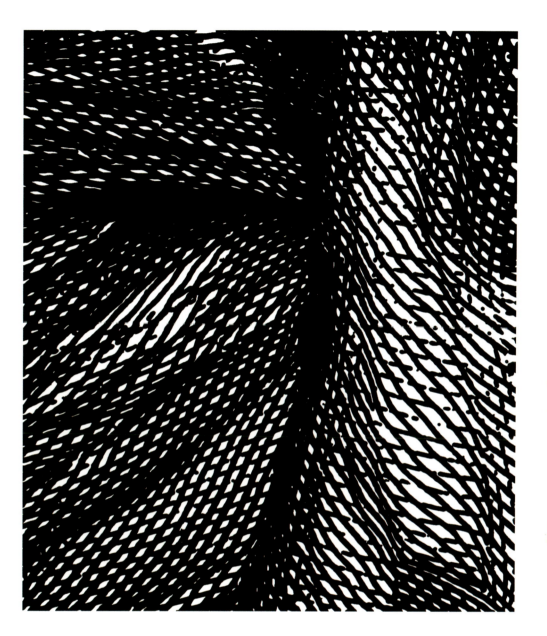

褶皱阴影 #19 / Shadows of Folds #19
100mm x 110mm

德里克·贝森特 | Derek Besant
加拿大 | Canada
版画 | Printing

033

| Work Collection of Arts | The Sixth Silk Road International Arts Festival | Canada |
| 美术作品集 | 第六届丝绸之路国际艺术节 | 加拿大 |

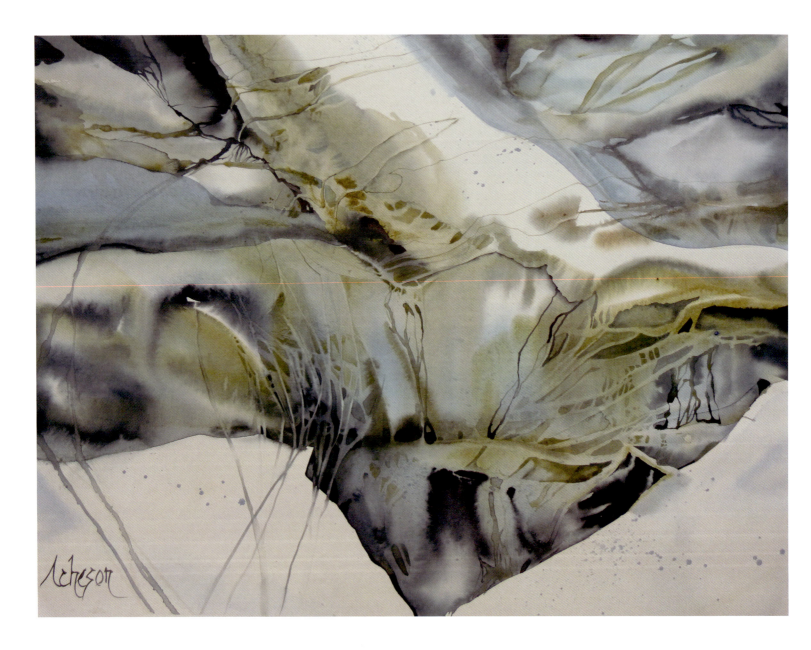

冰封 / Frozen
540mm x 740mm

唐娜·艾奇逊·朱利特
加拿大
绘画

Donna Acheson Juillet
Canada
Painting

Canada / 加拿大 / 雕塑

International Art Exhibition / 国际美术展

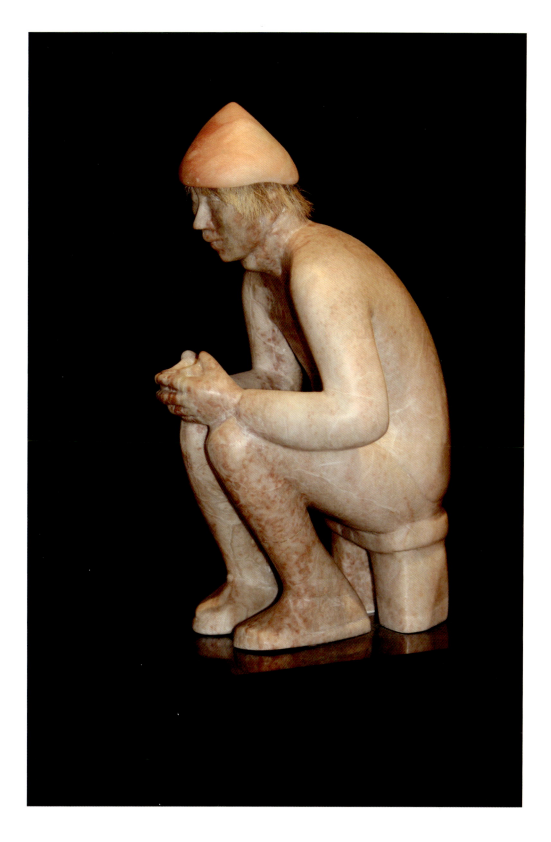

无题 / Unnamed
370mm x 250mm x 250mm

玛芮·乔西·勒克斯 | Marie Josée Leroux
加拿大 | Canada
雕塑 | Sculpture

| Work Collection of Arts | The Sixth Silk Road International Arts Festival | Canada |
| 美术作品集 | 第六届丝绸之路国际艺术节 | 加拿大 |

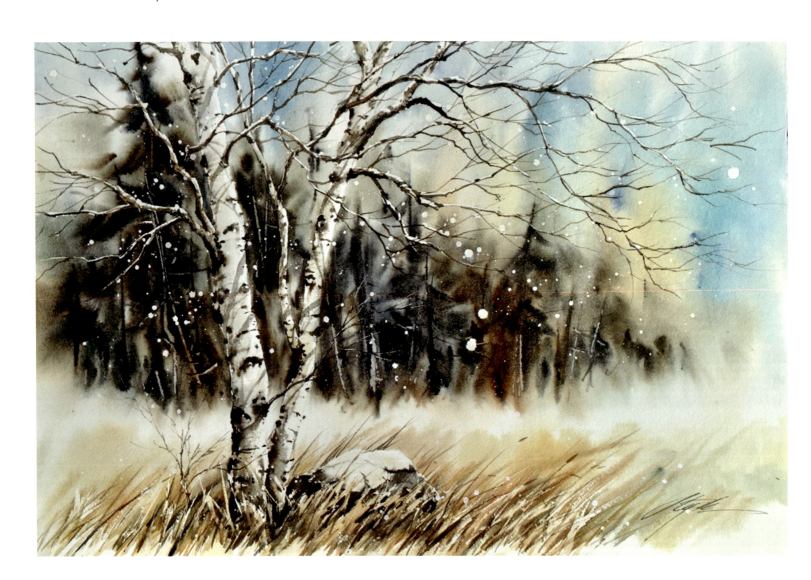

初雪 / First Snow

380mm x 560mm

游荣光	Stephen Yau
加拿大	Canada
绘画	Painting

Chile / 智利 — International Art Exhibition / 国际美术展

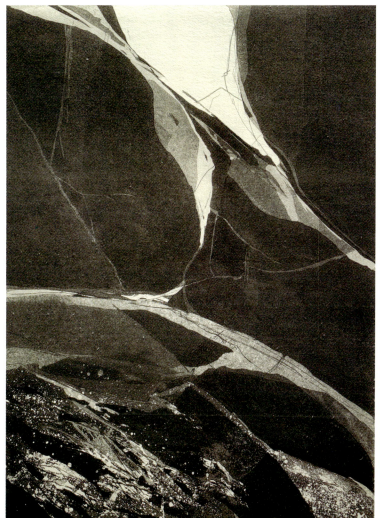
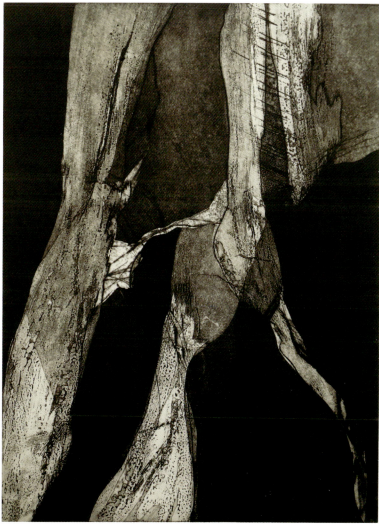

无题 / Unnamed
560mm x 760mm

伊冯·嘉·凡 | Ivonne Chia Fan
智利 | Chile
绘画 | Painting

| Work Collection of Arts | The Sixth Silk Road International Arts Festival | Chile |
| 美术作品集 | 第六届丝绸之路国际艺术节 | 智利 |

ESB 系列 / ESB Series

820mm x 600mm

曼努埃尔·马汉特	Manuel Marchant
智利	Chile
绘画	Painting

Chile / 智利 — International Art Exhibition / 国际美术展

吻风 / Kiss the Wind
1800mm x 1500mm x 1000mm

马雅·埃斯特拉达 | Maya Estrada
智利 | Chile
雕塑 | Sculpture

ST 系列 / ST Series

600mm x 400mm

莫尼克·沃杜	Monique Verdu
智利	Chile
版画	Printing

China
中国

International Art Exhibition
国际美术展

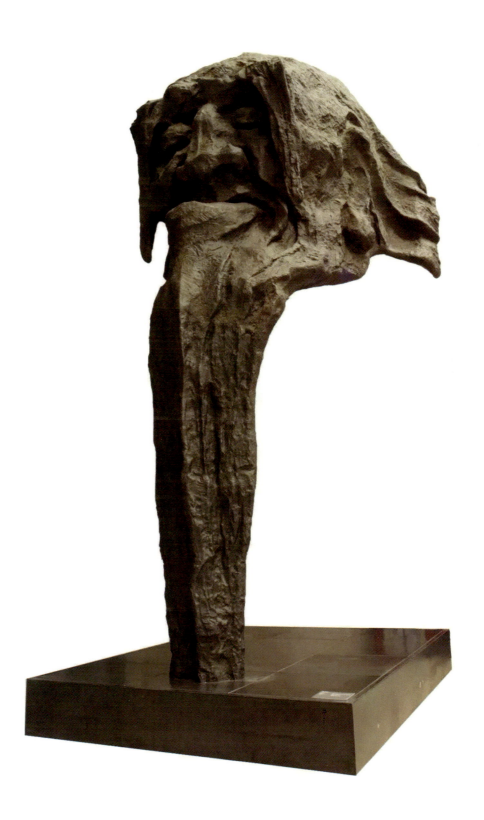

老子 / Lao Tzu

吴为山	Weishan Wu
中国	China
雕塑	Sculpture

Work Collection of Arts
美术作品集

The Sixth Silk Road International Arts Festival
第六届丝绸之路国际艺术节

China
中国

无题 / Unnamed

宁钢 | Gang Ning
中国 | China
陶瓷 | Ceramics

China — International Art Exhibition
中国 — 国际美术展

带围巾的女孩 / Girl Wearing a Scarf
700mm x 500mm

庞茂琨	Maokun Pang
中国	China
绘画	Painting

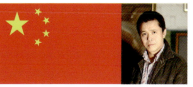

| Work Collection of Arts | The Sixth Silk Road International Arts Festival | China |
| 美术作品集 | 第六届丝绸之路国际艺术节 | 中国 |

雨后娇姿 / Petite after the Rain

900mm x 910mm

郭线庐	Xianlu Guo
中国	China
绘画	Painting

| China | International Art Exhibition |
| 中国 | 国际美术展 |

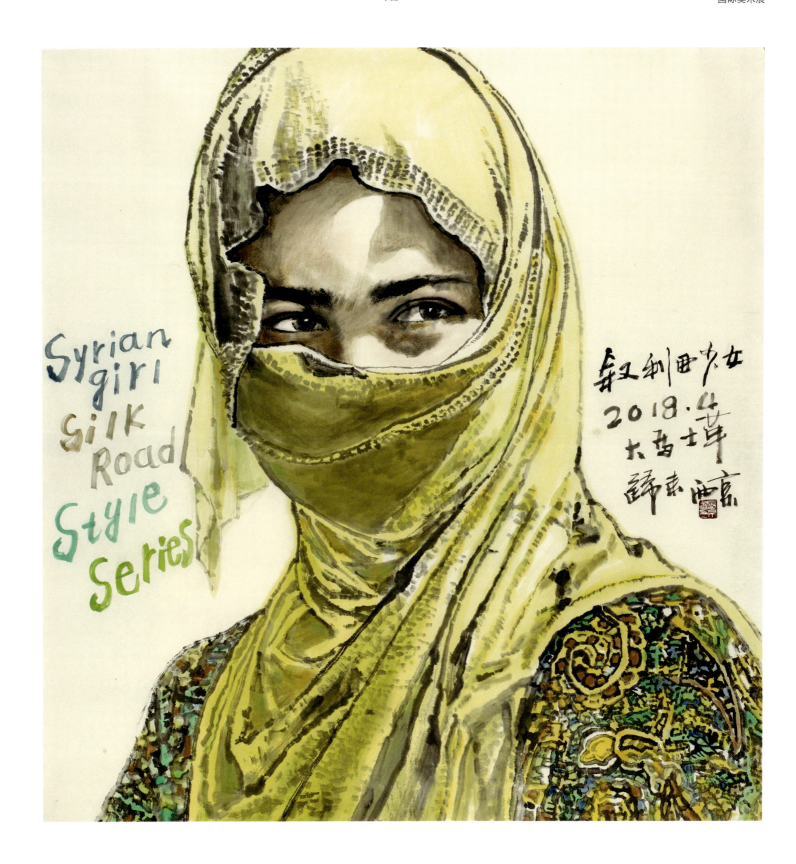

叙利亚少女 / Syrian Girl
1430mm x 1380mm

王西京	Xijing Wang
中国	China
绘画	Painting

Work Collection of Arts	The Sixth Silk Road International Arts Festival	China
美术作品集	第六届丝绸之路国际艺术节	中国

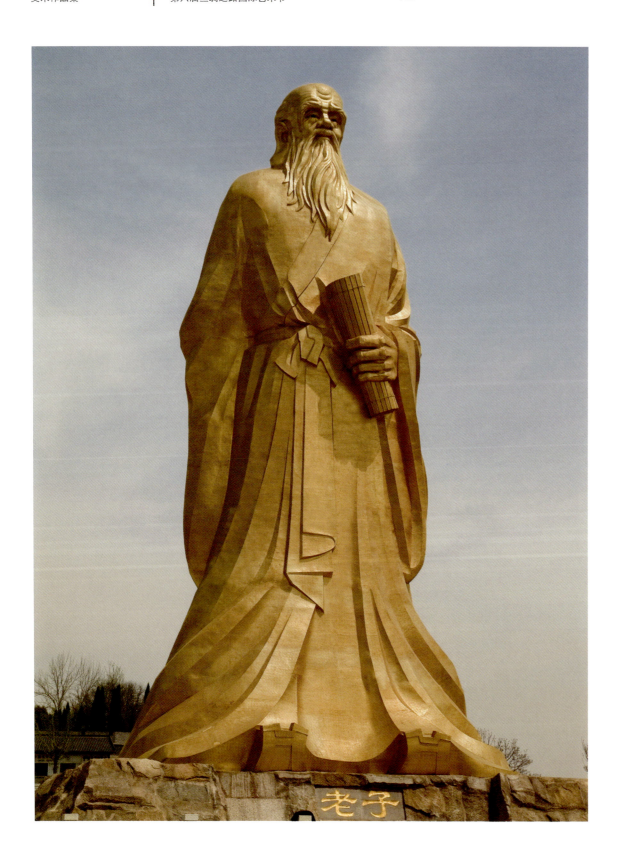

老子圣像 / Lao Tzu Icon

H:28000mm

蔺宝钢	Baogang Lin
中国	China
雕塑	Sculpture

China　中国　International Art Exhibition　国际美术展

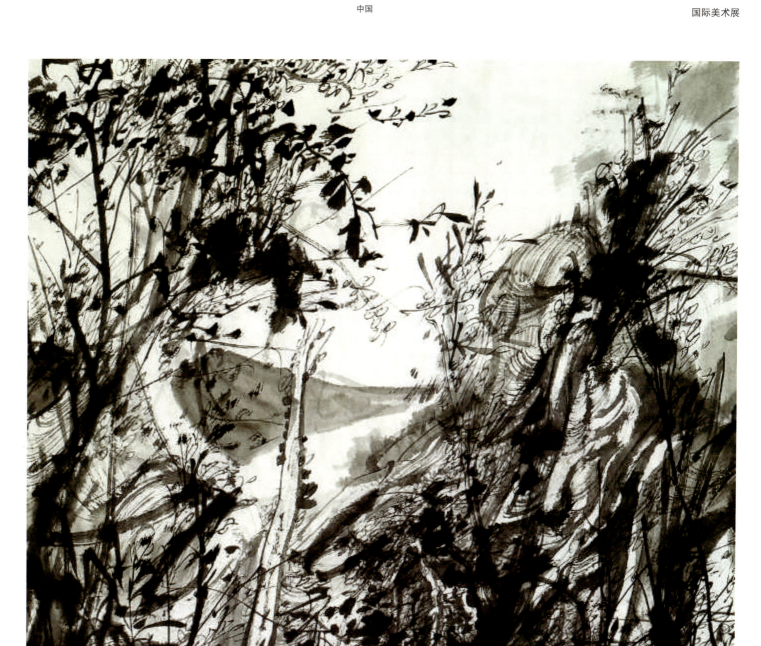

家园 / Home
650mm x 680mm

文集	Ji Wen
中国	China
绘画	Painting

047

Work Collection of Arts | The Sixth Silk Road International Arts Festival | China
美术作品集 | 第六届丝绸之路国际艺术节 | 中国

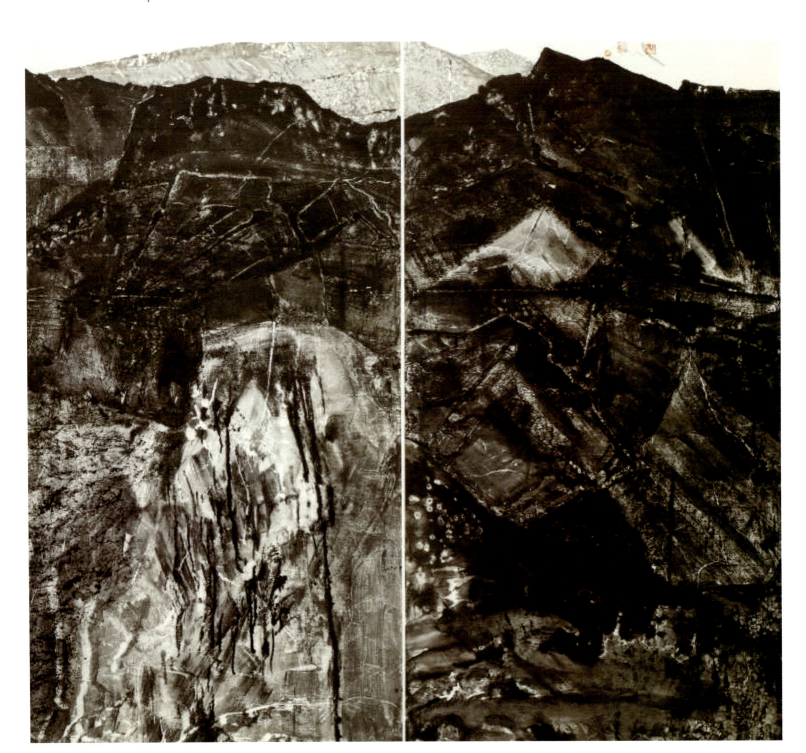

非零度 2018 / Non-Zero 2018
1920mm x 1840mm

朱尽晖 Jinhui Zhu
中国 China
绘画 Painting

China / 中国 — International Art Exhibition / 国际美术展

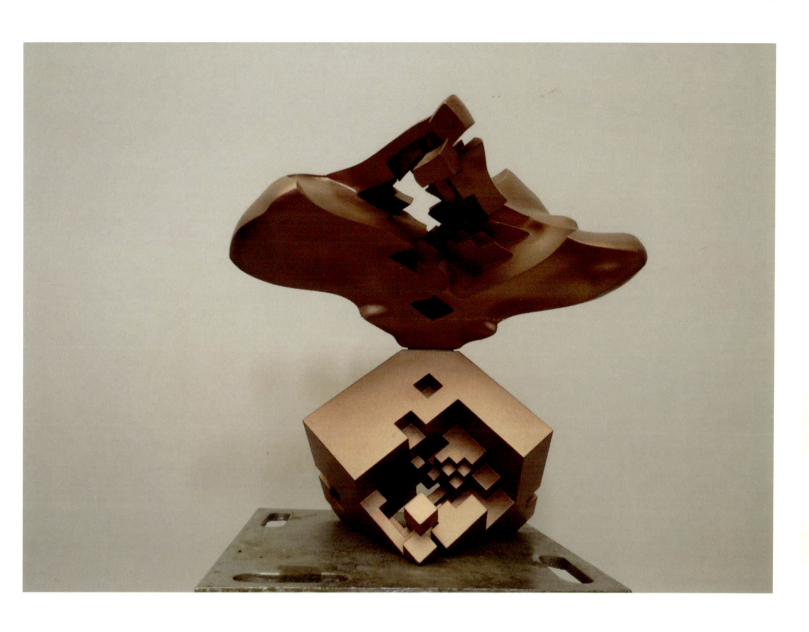

惠之云 / Wisdom Clouds
H:300mm

朱尚熹 | Shangxi Zhu
中国 | China
雕塑 | Sculpture

Work Collection of Arts	The Sixth Silk Road International Arts Festival	China
美术作品集	第六届丝绸之路国际艺术节	中国

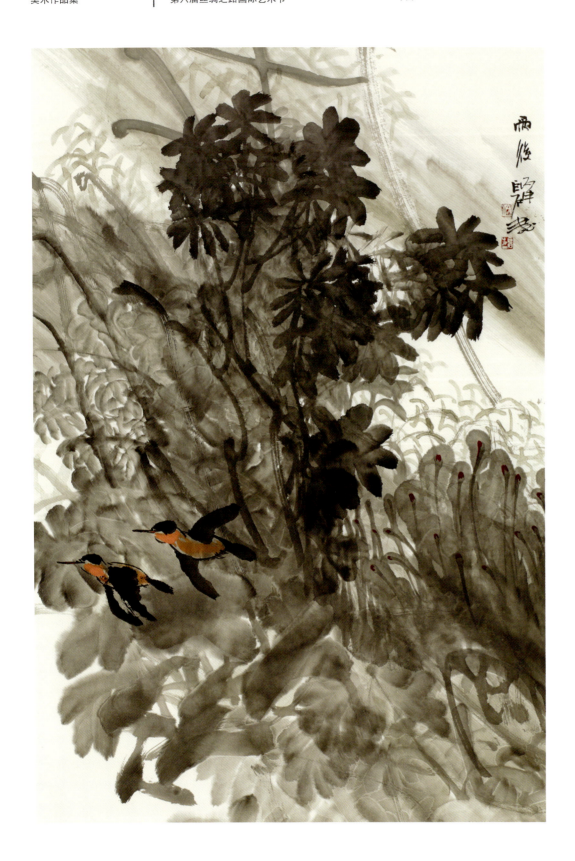

雨后 / After Raining

1380mm x 690mm

巨石	Shi Ju
中国	China
绘画	Painting

China　　　　　　　　　　　　　　　　　　　　　　　　　　　　International Art Exhibition
中国　　　　　　　　　　　　　　　　　　　　　　　　　　　　　国际美术展

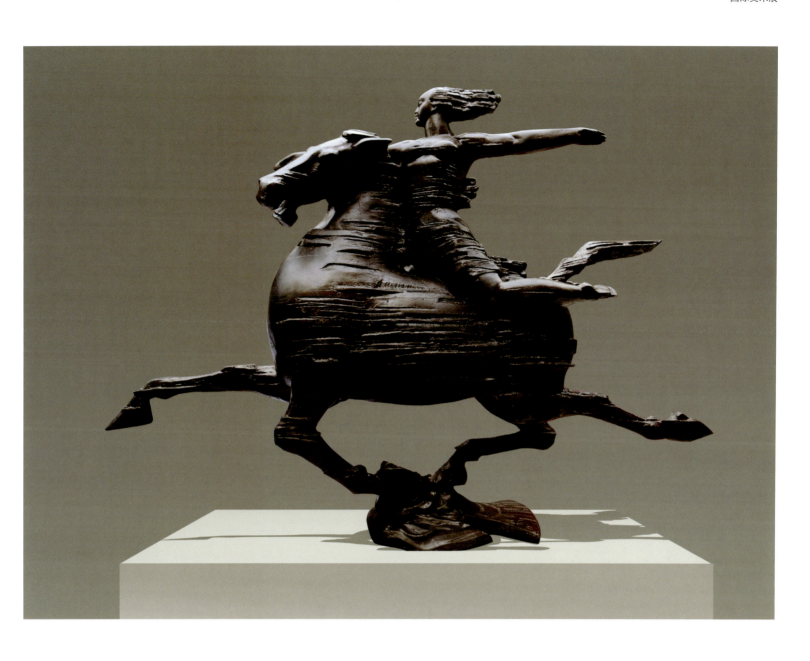

无题 / Unnamed

景育民　｜　Yumin Jing
中国　　｜　China
雕塑　　｜　Sculpture

| Work Collection of Arts | The Sixth Silk Road International Arts Festival | China |
| 美术作品集 | 第六届丝绸之路国际艺术节 | 中国 |

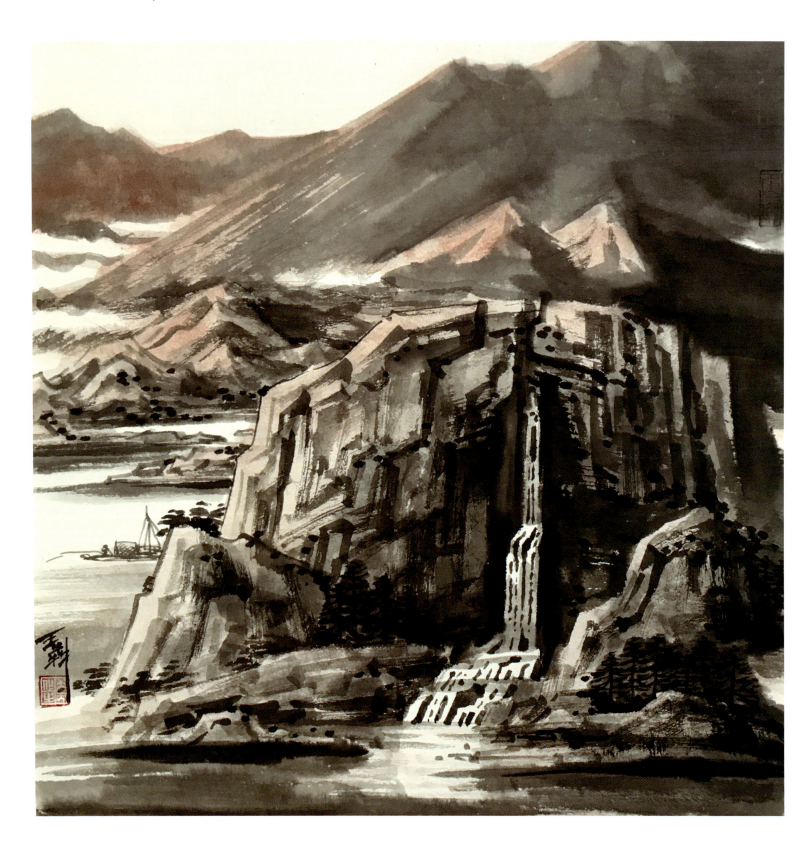

无题 / Unnamed

1380mm x 690mm

王犇	Ben Wang
中国	China
绘画	Painting

China / 中国 — International Art Exhibition / 国际美术展

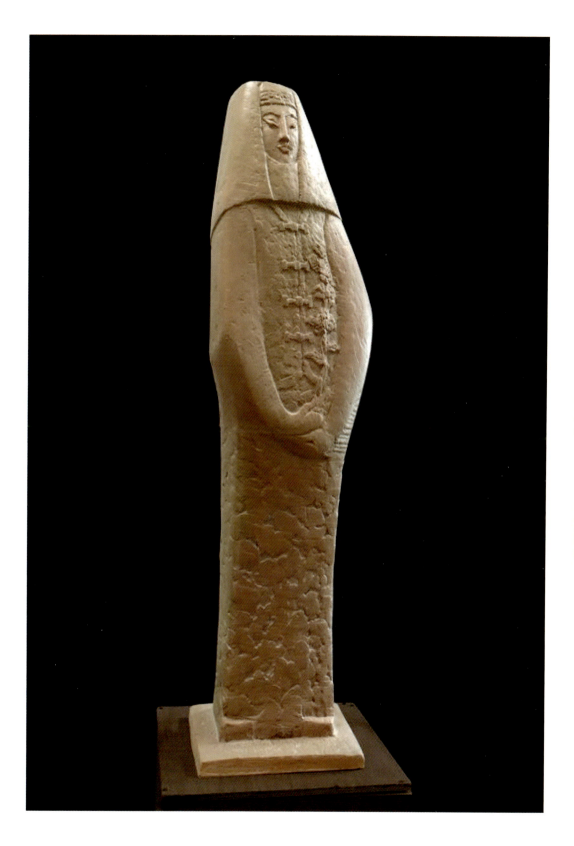

索菲亚 / Sophia
1380mm x 690mm

张琨 | Kun Zhang
中国 | China
雕塑 | Sculpture

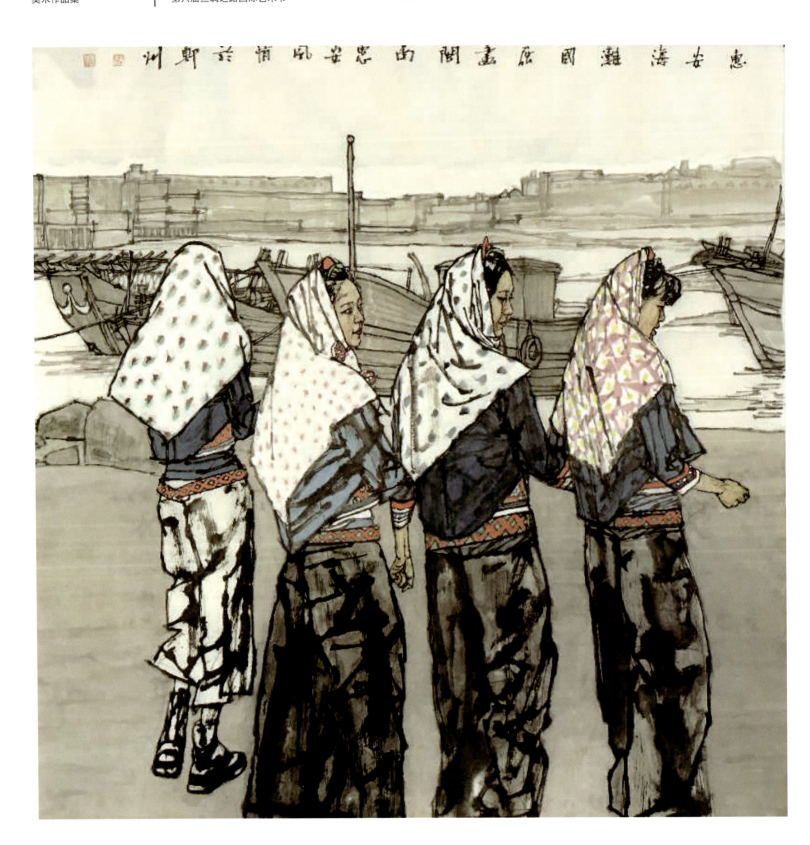

无题 / Unnamed

马国强 | Guoqiang Ma
中国 | China
绘画 | Painting

China | International Art Exhibition
中国 | 国际美术展

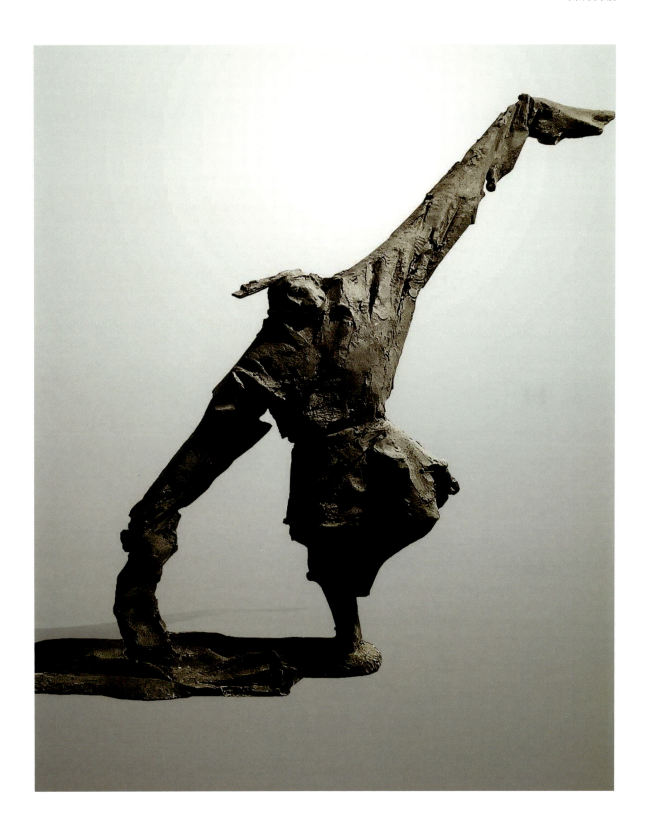

春之舞 / Spring Dance
800mm x 850mm x 500mm

鲍海宁 | Haining Bao
中国 | China
雕塑 | Sculpture

| Work Collection of Arts | The Sixth Silk Road International Arts Festival | China |
| 美术作品集 | 第六届丝绸之路国际艺术节 | 中国 |

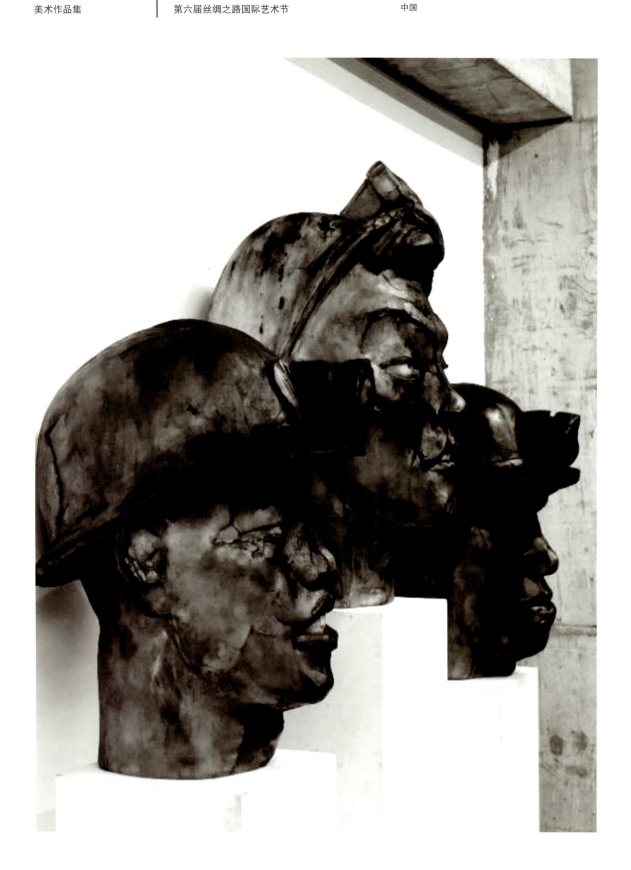

薪火 / Fire

罗小平	Xiaoping Luo
中国	China
雕塑	Sculpture

China International Art Exhibition
中国 国际美术展

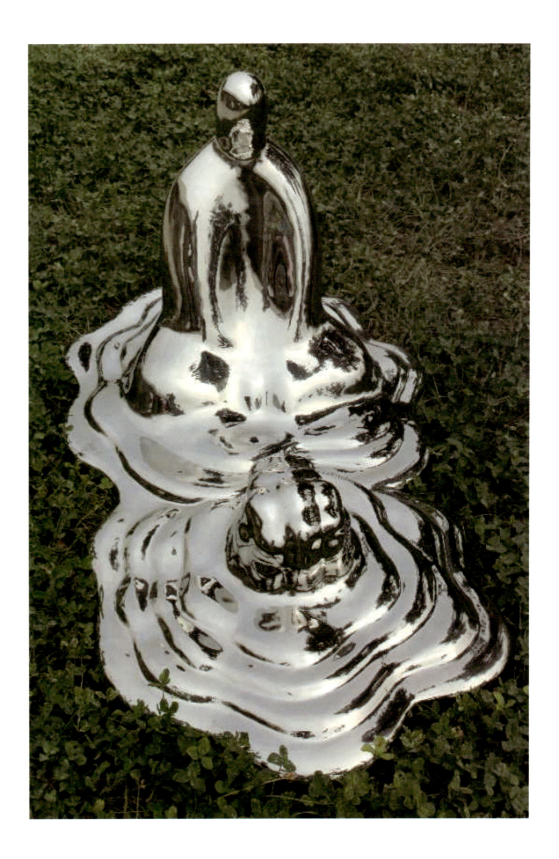

莲语 / Lotus
1500mm x 800mm x 750mm

王志刚	Zhigang Wang
中国	China
雕塑	Sculpture

| Work Collection of Arts | The Sixth Silk Road International Arts Festival | China |
| 美术作品集 | 第六届丝绸之路国际艺术节 | 中国 |

平衡的温度 / Balanced Temperature

5000mm x 1500mm x 600mm

赵莉	Li Zhao
中国	China
雕塑	Sculpture

058

China　　　　　　　　　　　　　　　　　　　　　　　　International Art Exhibition
中国　　　　　　　　　　　　　　　　　　　　　　　　　国际美术展

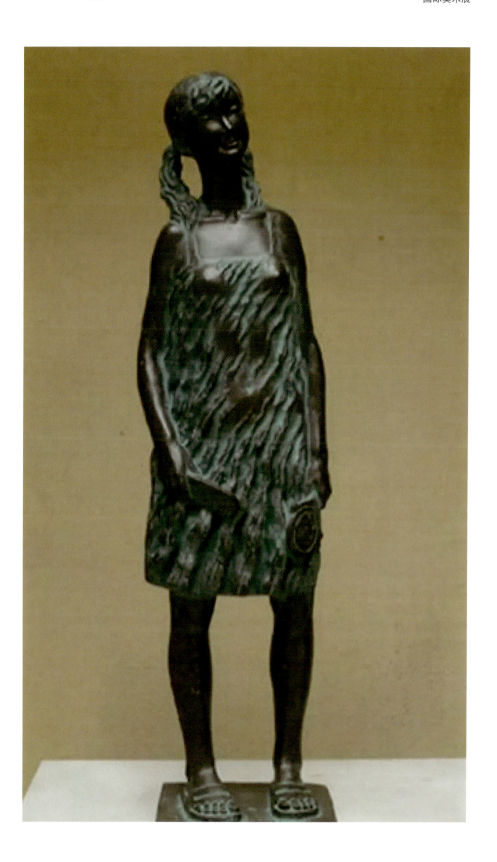

晨雀 / Morning Bird

石村　｜　Cun Shi
中国　｜　China
雕塑　｜　Sculpture

Work Collection of Arts
美术作品集 | The Sixth Silk Road International Arts Festival　第六届丝绸之路国际艺术节　China　中国

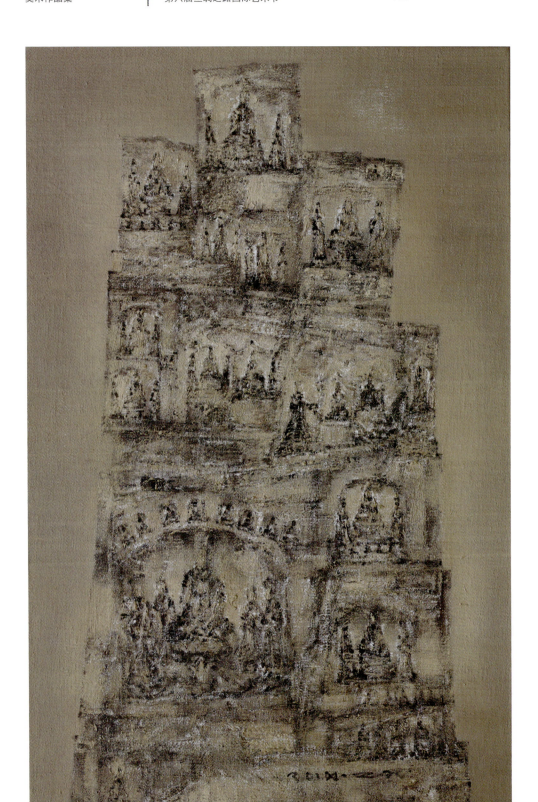

《佛光》之二 / Buddha Light II

1250mm x 800mm

李章惠	Zhanghui Li
中国	China
绘画	Painting

China　　　　　　　　　　　　　　　　　　International Art Exhibition
中国　　　　　　　　　　　　　　　　　　国际美术展

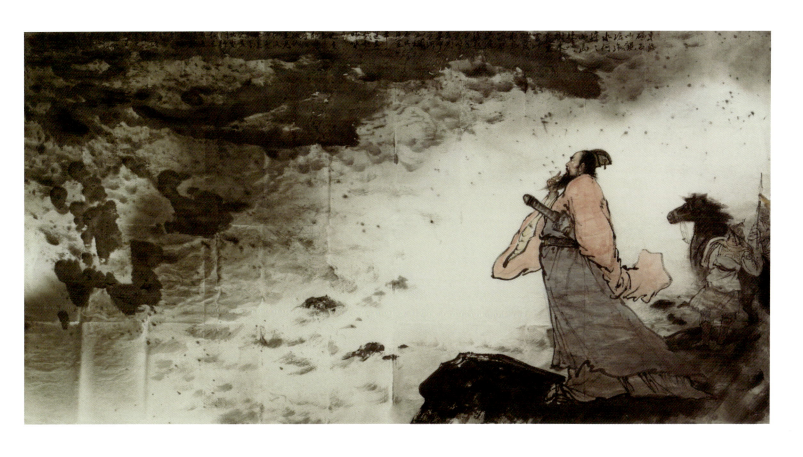

观沧海 合 / Guanlan He
1800mm x 970mm

王志平　｜　Zhiping Wang
中国　　｜　China
绘画　　｜　Painting

Work Collection of Arts	The Sixth Silk Road International Arts Festival	China
美术作品集	第六届丝绸之路国际艺术节	中国

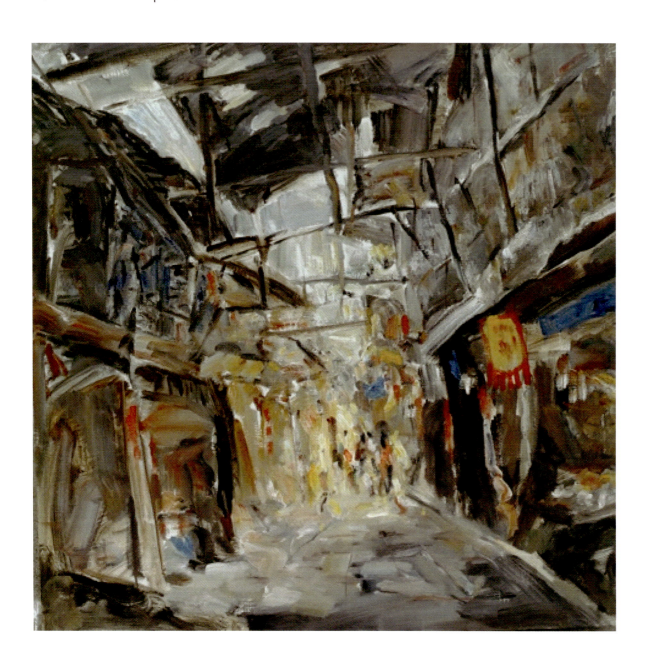

古驿今昔 / Current Sane of an Ancient Station

750mm x 750mm

高筠	Yun Gao
中国	China
绘画	Painting

China　　　　　　　　　　　　　　　　　　　　　　　　　　　　　　　International Art Exhibition
中国　　　　　　　　　　　　　　　　　　　　　　　　　　　　　　　　国际美术展

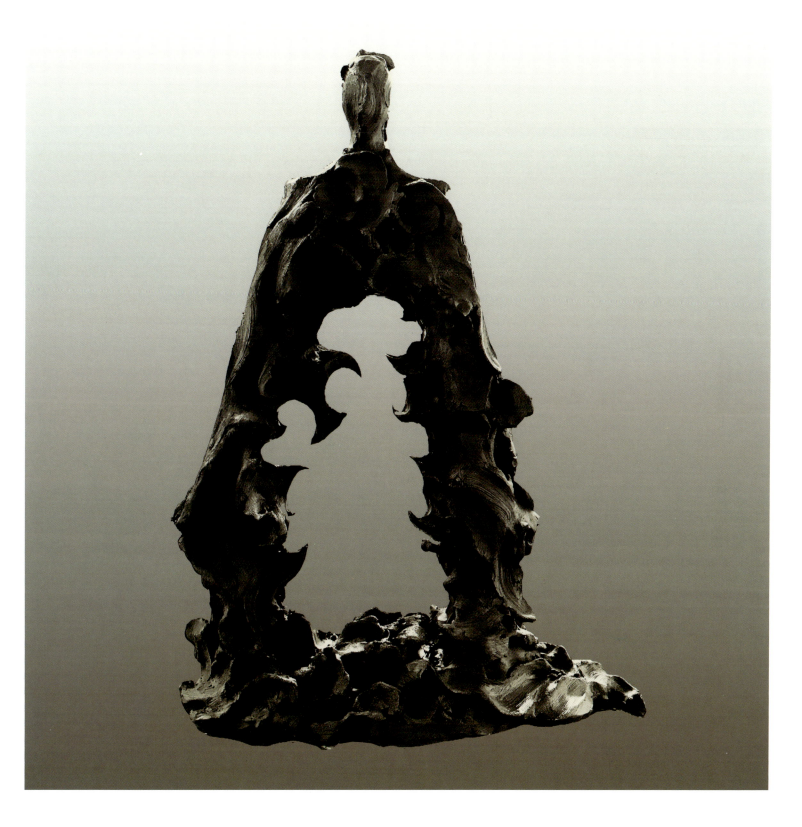

士大夫 / Scholar
H:760mm

姜涛　　Tao Jiang
中国　　China
雕塑　　Sculpture

| Work Collection of Arts | The Sixth Silk Road International Arts Festival | China |
| 美术作品集 | 第六届丝绸之路国际艺术节 | 中国 |

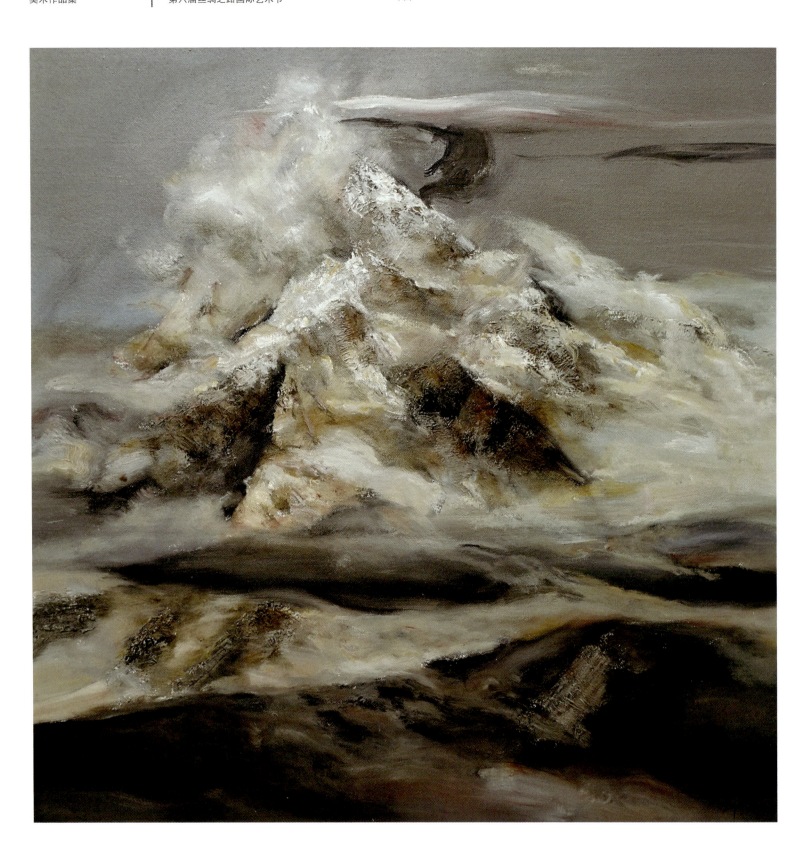

西路漫漫 / Long Road to the West

1000mm x 1000mm

司小刚	Xiaogang Si
中国	China
绘画	Painting

China
中国

International Art Exhibition
国际美术展

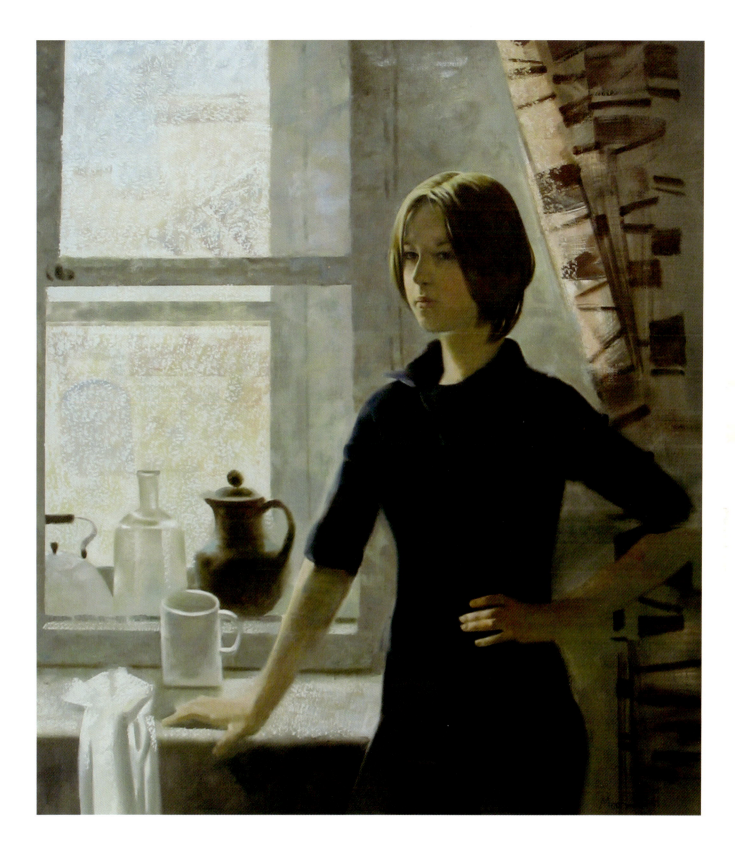

第一场雪 / First Snow
1200 x 700mm

韩禹锋	Yufeng Han
中国	China
绘画	Painting

065

| Work Collection of Arts | The Sixth Silk Road International Arts Festival | China |
| 美术作品集 | 第六届丝绸之路国际艺术节 | 中国 |

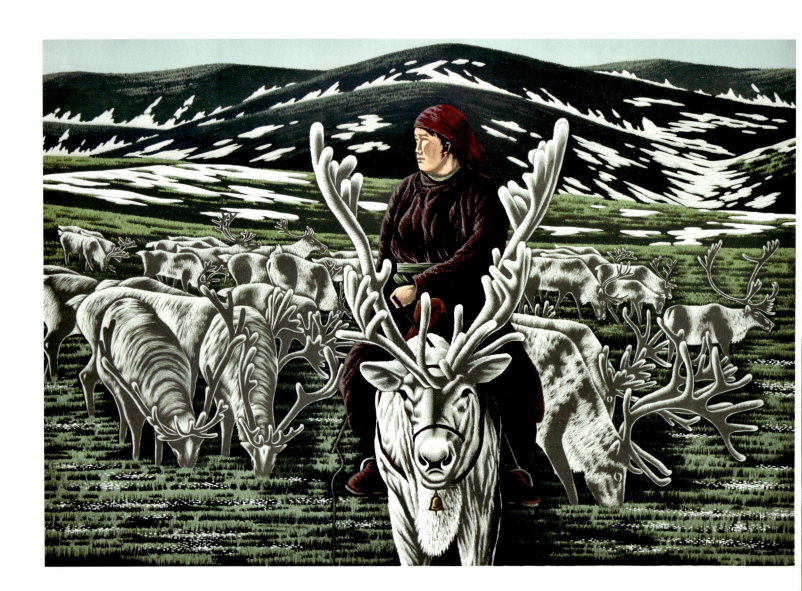

兴安岭上牧歌 / Xing'an Mountain Pastoral Song

700mm x 1005mm

张士勤	Shiqin Zhang
中国	China
版画	Printing

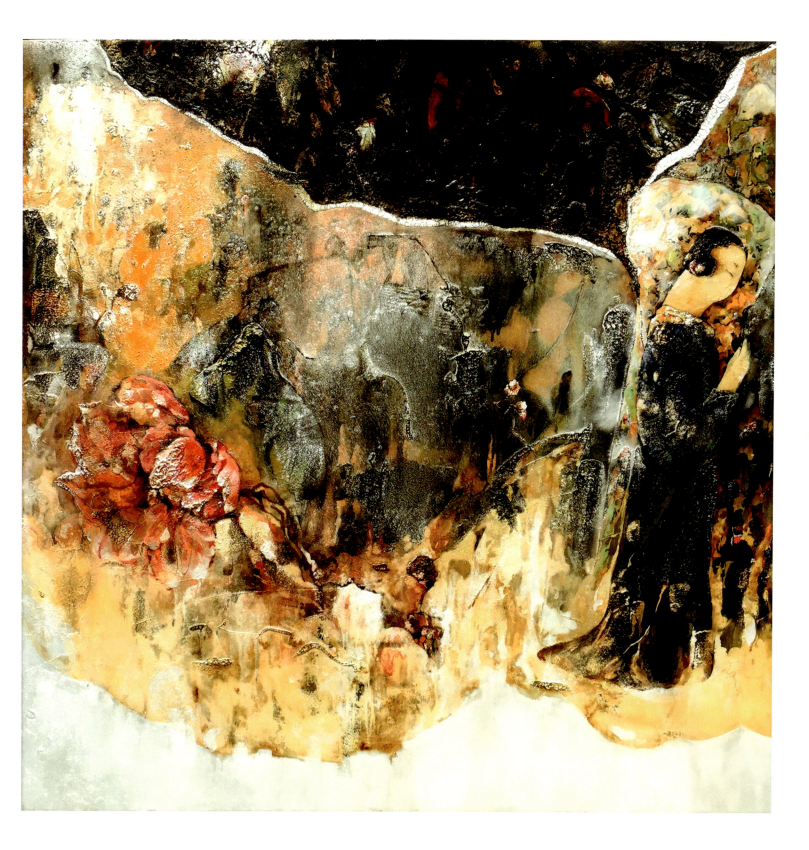

诗经·变奏的文化记忆之十 / Ten of Cultural Memories of the Change of the Book of Songs

1200mm x 1200mm

陈艺方	Yifang Chen
中国	China
绘画	Painting

| Work Collection of Arts | The Sixth Silk Road International Arts Festival | China |
| 美术作品集 | 第六届丝绸之路国际艺术节 | 中国 |

实验水墨 / The Experimental Ink Painting

金冈	Gang Jin
中国	China
绘画	Painting

China
中国

International Art Exhibition
国际美术展

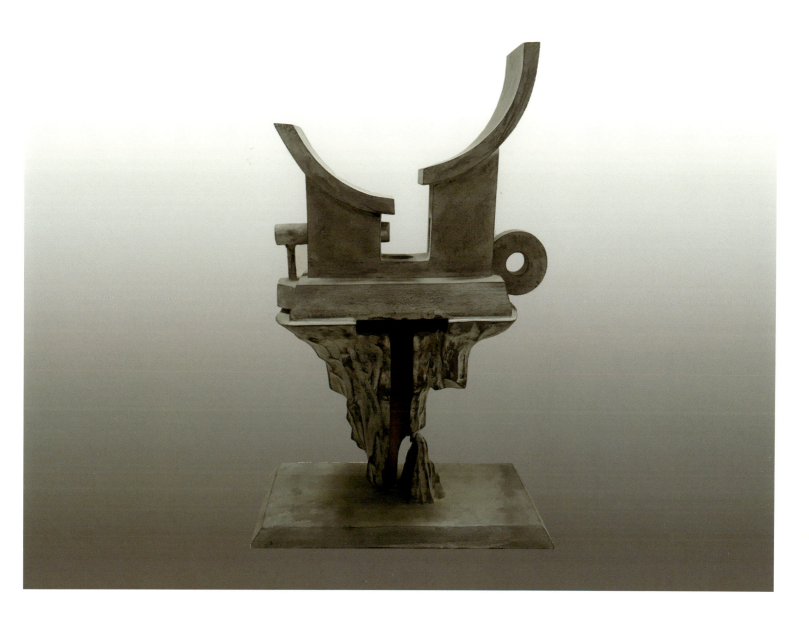

无题 / Unnamed

刘福龙 | Fulong Liu
中国 | China
雕塑 | Sculpture

| Work Collection of Arts | The Sixth Silk Road International Arts Festival | China |
| 美术作品集 | 第六届丝绸之路国际艺术节 | 中国 |

圣宴 / Banquet
800mm x 600mm

李哲虎	Zhehu Li
中国	China
绘画	Painting

China　　　　　　　　　　　　　　　　　　　　　　　International Art Exhibition
中国　　　　　　　　　　　　　　　　　　　　　　　　国际美术展

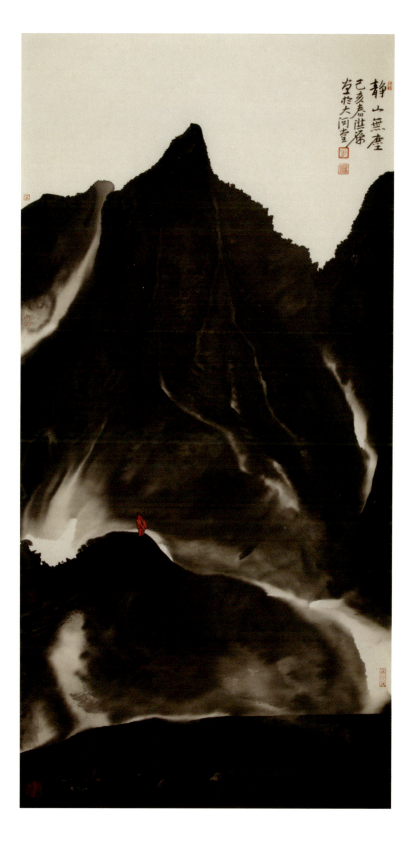

静山无尘 / Quiet Mountain

1380mm x 690mm

张洪源	Hongyuan Zhang
中国	China
绘画	Painting

| Work Collection of Arts | The Sixth Silk Road International Arts Festival | China |
| 美术作品集 | 第六届丝绸之路国际艺术节 | 中国 |

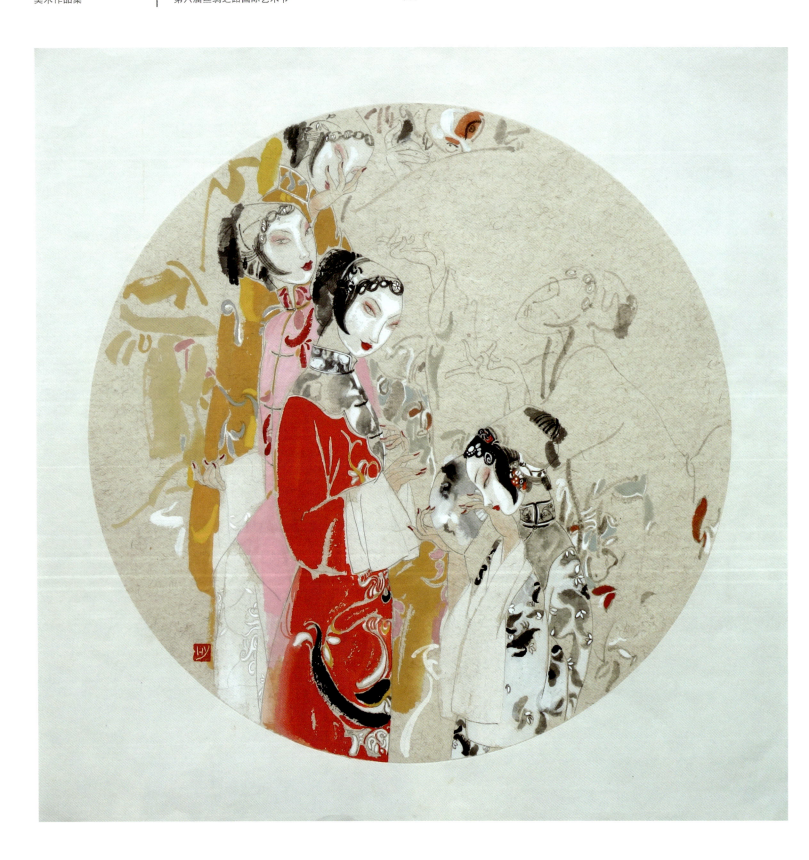

游龙戏凤 / Dragon and Phoenix

680mm x 680mm

王海燕	Haiyan Wang
中国	China
绘画	Painting

China | International Art Exhibition
中国 | 国际美术展

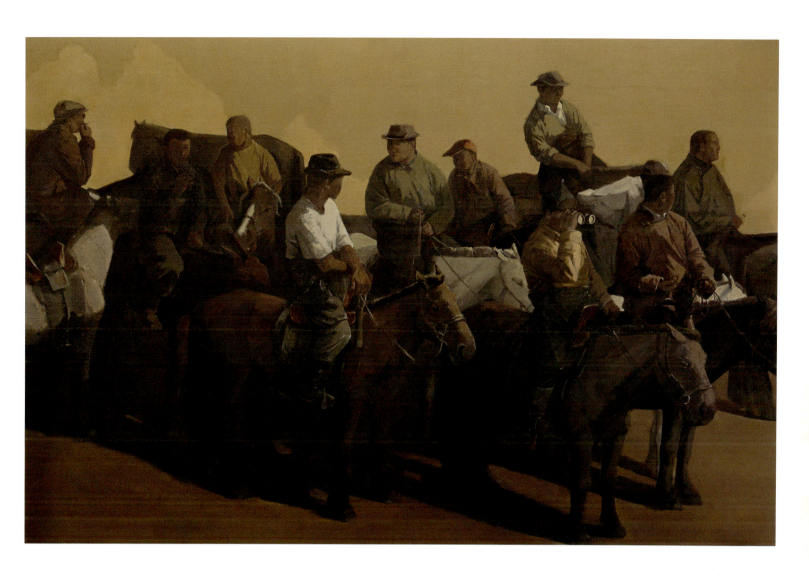

天地间 / Heaven and Earth
1600mm x 1200mm

胡日查 | Richa Hu
中国 | China
绘画 | Painting

Work Collection of Arts
美术作品集 | The Sixth Silk Road International Arts Festival
第六届丝绸之路国际艺术节 | China
中国

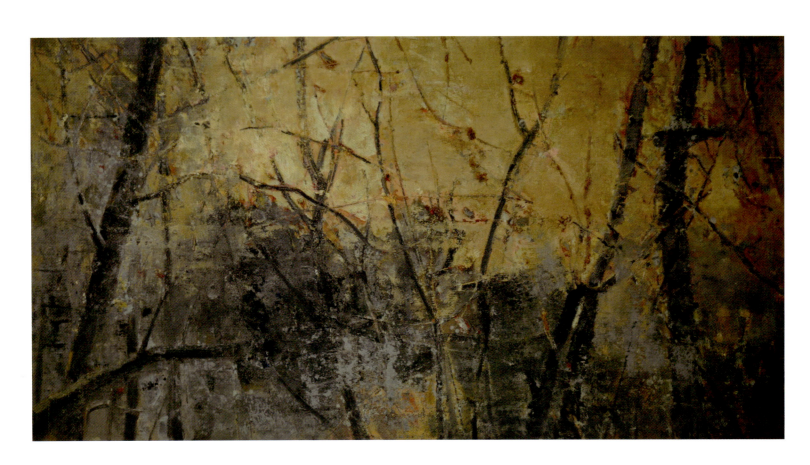

秋日夕照 / Autumn Evening

1500mm x 750mm

杜力	Li Du
中国	China
绘画	Painting

China International Art Exhibition
中国 国际美术展

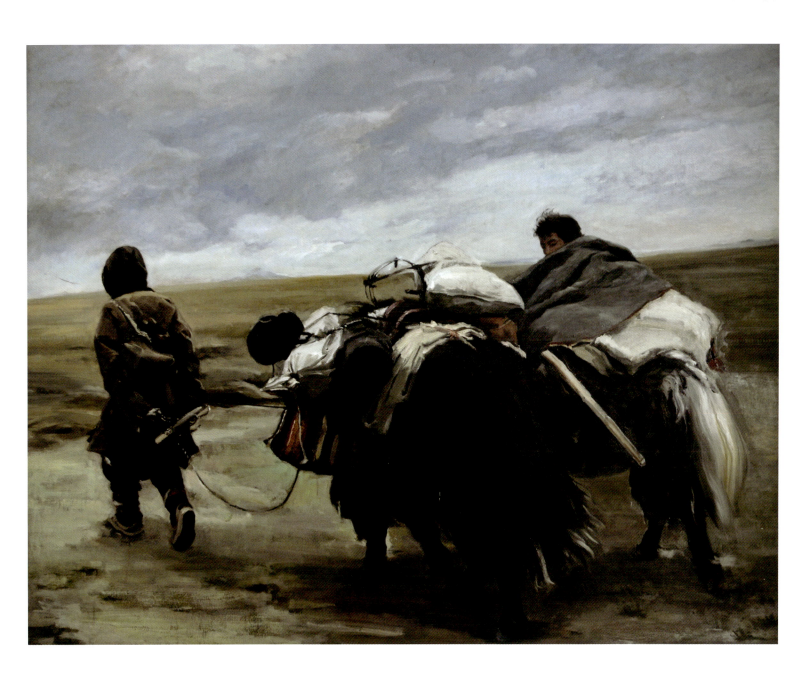

归 / Go Back Home

1200mm x 1500mm

高子期 | Ziqi Gao
中国 | China
绘画 | Painting

Work Collection of Arts	The Sixth Silk Road International Arts Festival	China
美术作品集	第六届丝绸之路国际艺术节	中国

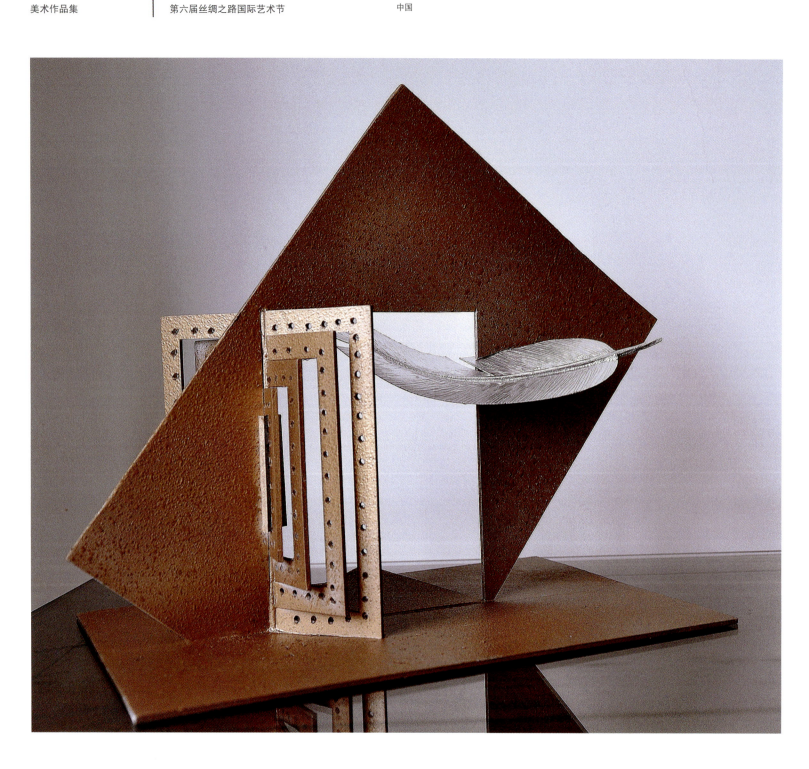

古风今韵 / Ancient Style and Modern Charm

500mm x 380mm x 420mm

李东亮	Dongliang Li
中国	China
雕塑	Sculpture

China　　　　　　　　　　　　　　　　　　　　　　　　International Art Exhibition
中国　　　　　　　　　　　　　　　　　　　　　　　　国际美术展

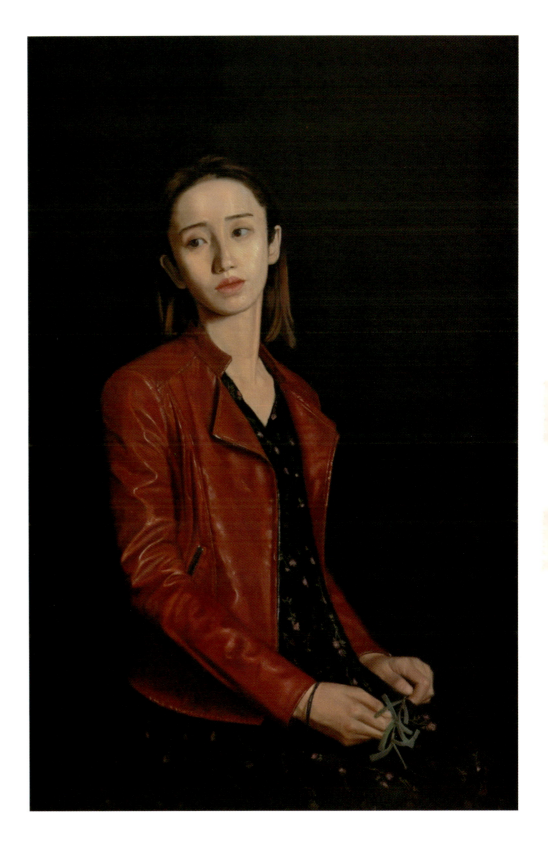

东方姑娘 / Oriental Girl
800mm x 1200mm

李东升	Dongsheng Li
中国	China
绘画	Painting

| Work Collection of Arts | The Sixth Silk Road International Arts Festival | China |
| 美术作品集 | 第六届丝绸之路国际艺术节 | 中国 |

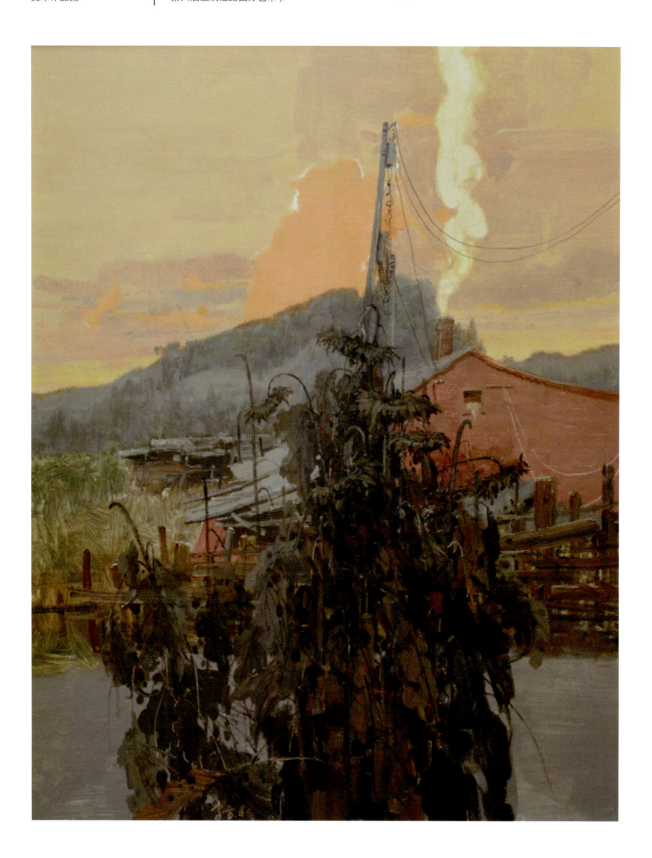

落日炊烟 / Sunset Smoke
1000mm x 800mm

李方明	Fangming Li
中国	China
绘画	Painting

078

China / 中国 — International Art Exhibition / 国际美术展

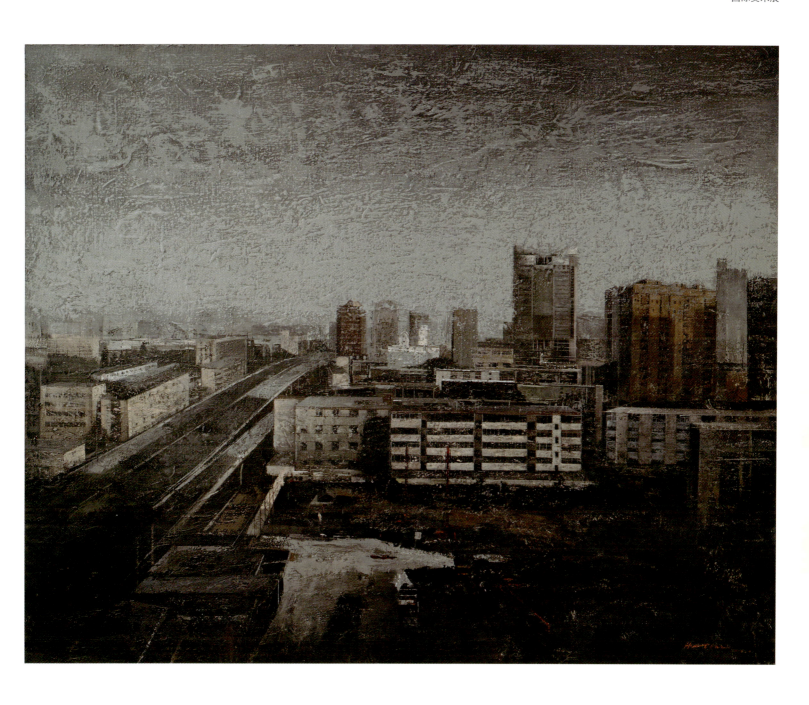

城市之光 / Light of the City
1200mm x 800mm

刘昊天	Haotian Liu
中国	China
绘画	Painting

| Work Collection of Arts | The Sixth Silk Road International Arts Festival | China |
| 美术作品集 | 第六届丝绸之路国际艺术节 | 中国 |

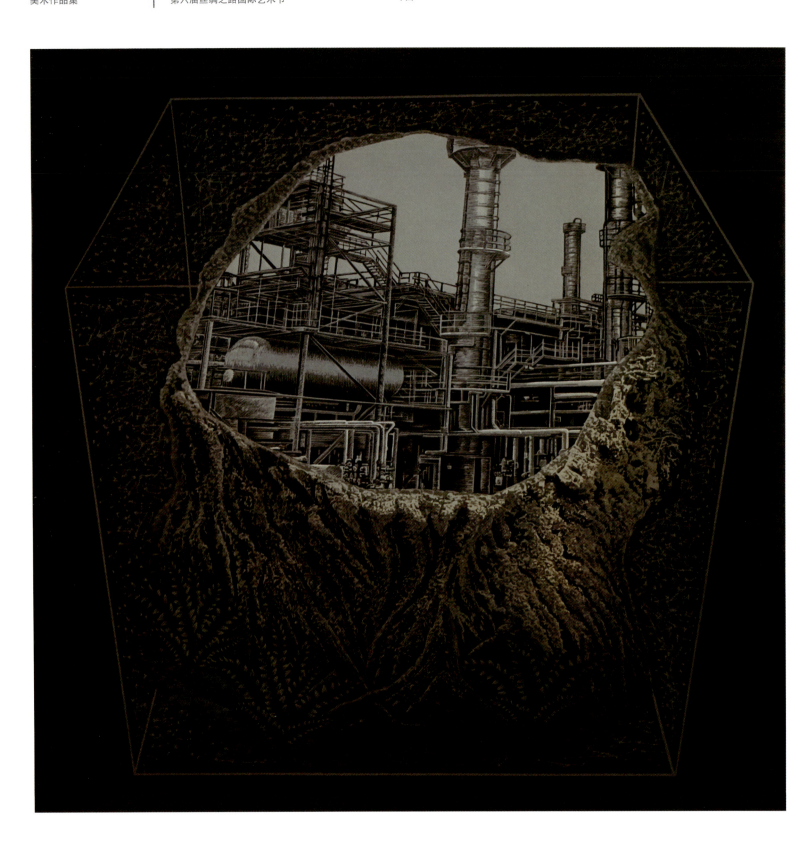

能量空间 / Energy Space
900mm x 910mm

彭佳林	Jialin Peng
中国	China
版画	Printing

China | International Art Exhibition
中国 | 国际美术展

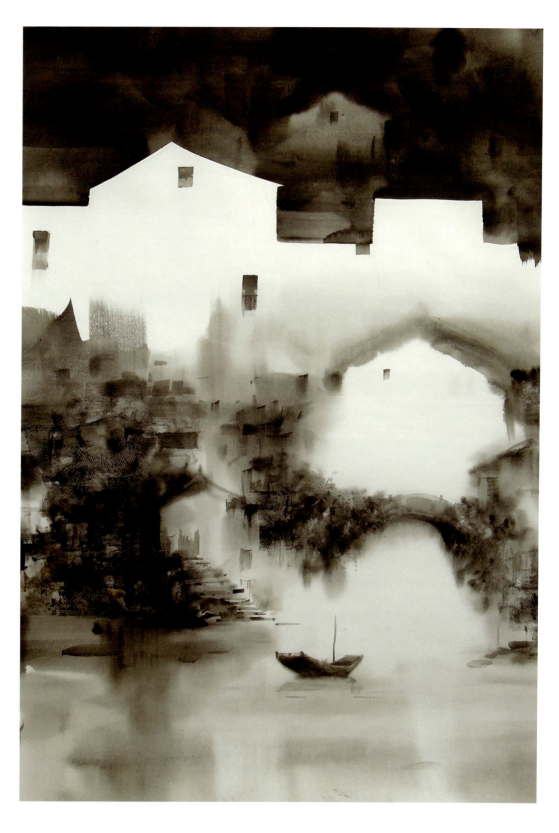

江南故事 / Jiangnan Story
2000mm x 1500mm

宋朝 吴景贤　Chao Song, Jingxian Wu
中国 澳大利亚　China Australia
绘画　Painting

| Work Collection of Arts | The Sixth Silk Road International Arts Festival | China |
| 美术作品集 | 第六届丝绸之路国际艺术节 | 中国 |

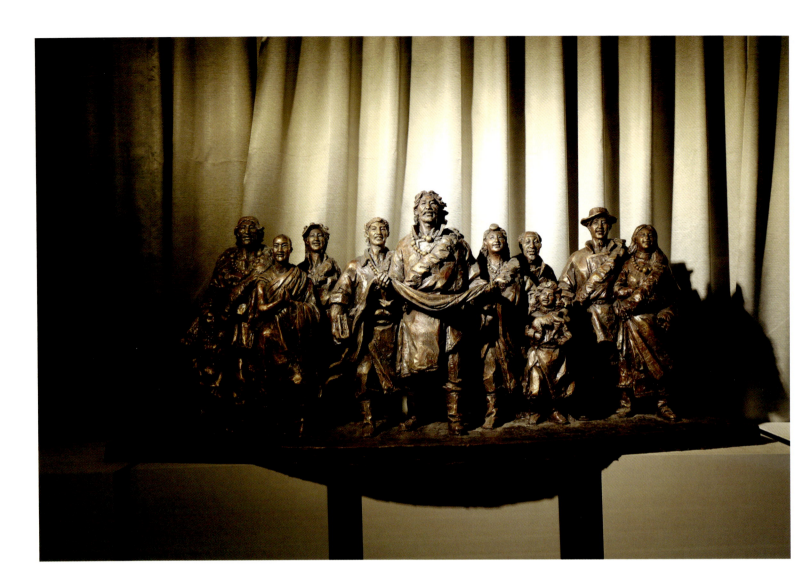

迎接新时代 / Meeting the New Era
1700mm x 600mm x 600mm

王威	Wei Wang
中国	China
雕塑	Sculpture

China / 中国 — International Art Exhibition / 国际美术展

丝路花海 / Silk Road Flower Sea
650mm x 650mm

王运泽 | Yunze Wang
中国 | China
绘画 | Painting

| Work Collection of Arts | The Sixth Silk Road International Arts Festival | China |
| 美术作品集 | 第六届丝绸之路国际艺术节 | 中国 |

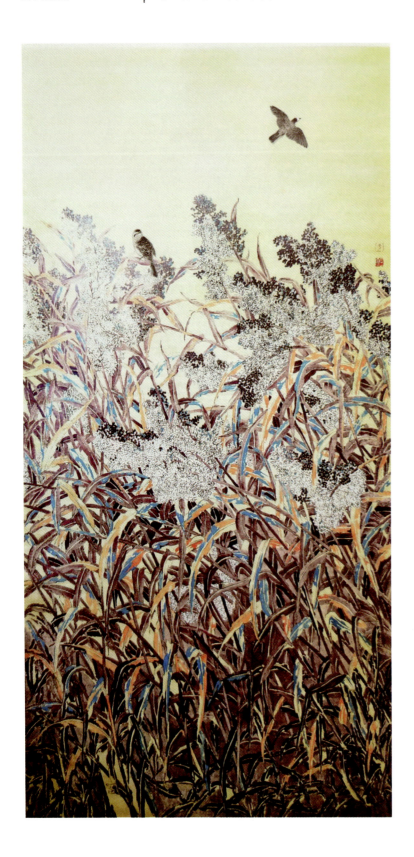

秋瑟 / Bleak Autumn

1850mm x 880mm

于立宁 | Lining Yu
中国 | China
绘画 | Painting

China
中国

International Art Exhibition
国际美术展

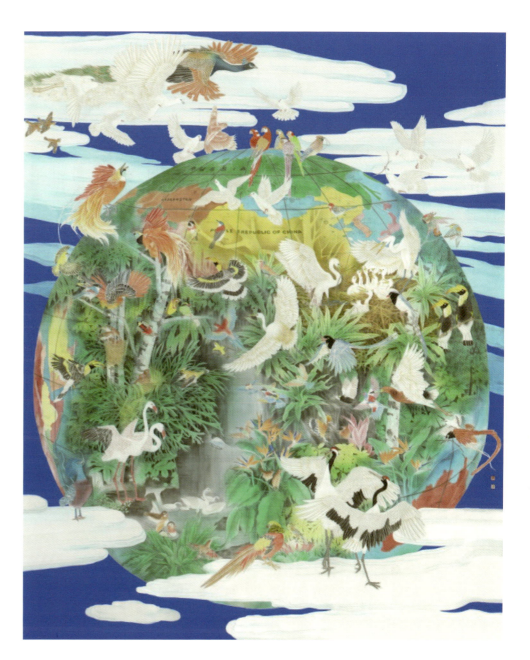

炫彩筑梦 – 和谐家园 / Colorful Dreams - Harmonious Home

1760mm x 2170mm

周莲荣 周绪行	Lianrong Zhou, Xuxing Zhou
中国	China
绘画	Painting

期望远方 / Expecting a Distance

左海瑛	Haiying Zuo
中国	China
绘画	Painting

China / 中国 International Art Exhibition / 国际美术展

乌镇晨辉 / The Glory of Wuzhen Morning

600mm x 800mm

朱建成 | Jiancheng Zhu
中国 | China
绘画 | Painting

| Work Collection of Arts | The Sixth Silk Road International Arts Festival | China |
| 美术作品集 | 第六届丝绸之路国际艺术节 | 中国 |

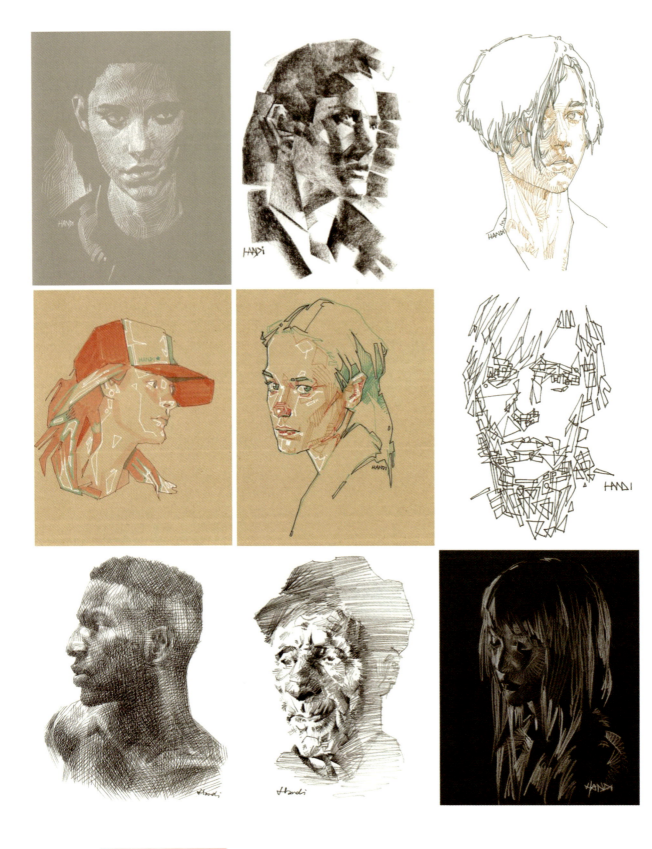

众像 / Public Image

600mm x 600mm

宋翰笛 — Handi Song
中国 — China
混合材料 — Comprehensive Material

Hong Kong, China 中国香港

International Art Exhibition 国际美术展

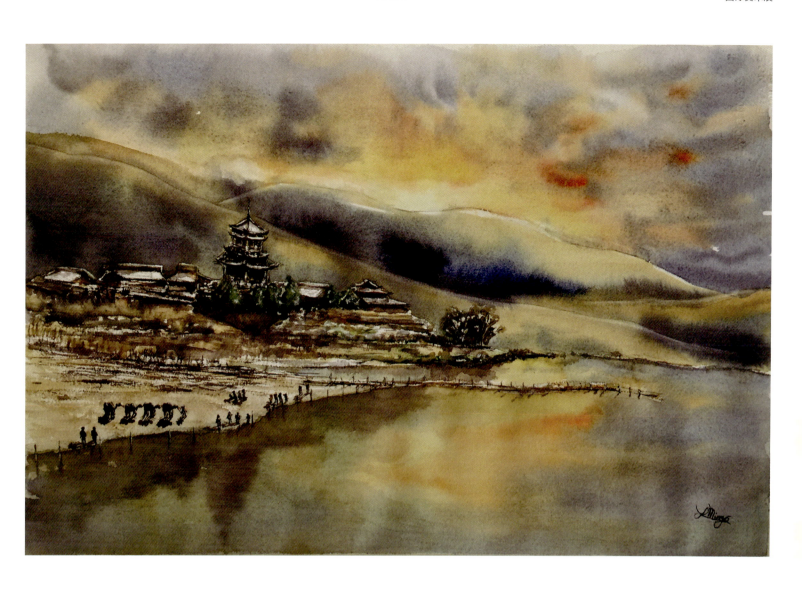

印象月牙泉 / Impression Crescent Spring

380mm x 560mm

李伟明 | Mingo Li
中国香港 | Hong Kong, China
绘画 | Painting

| Work Collection of Arts | The Sixth Silk Road International Arts Festival | Macao, China |
| 美术作品集 | 第六届丝绸之路国际艺术节 | 中国澳门 |

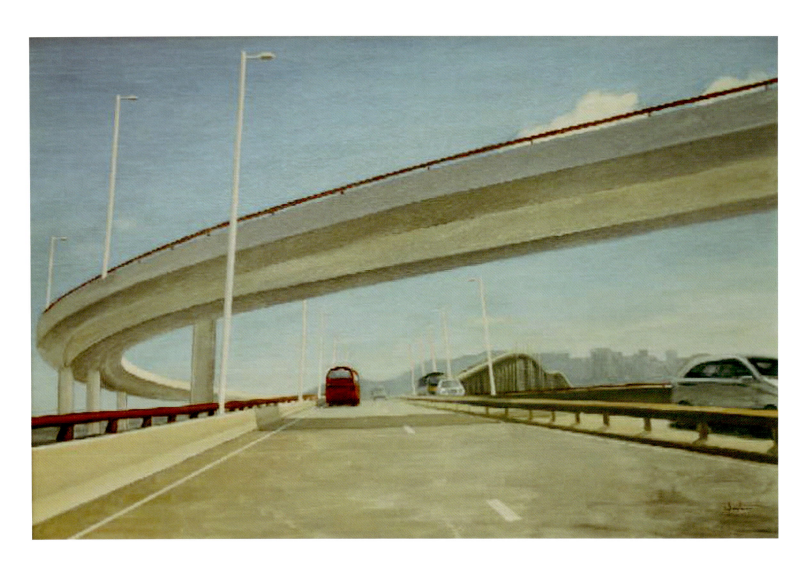

无题 / Unnamed

汪蓝 — Lan Wang
中国澳门 — Macao, China
绘画 — Painting

Taiwan, China | International Art Exhibition
中国台湾 | 国际美术展

飞掠 / Flying
380mm x 230mm x 145mm

李宝龙 | Baolong Li
中国台湾 | Taiwan, China
雕塑 | Sculpture

| Work Collection of Arts | The Sixth Silk Road International Arts Festival | Taiwan, China |
| 美术作品集 | 第六届丝绸之路国际艺术节 | 中国台湾 |

山水 – 飞行 / Landscape - Flight

420mm x 250mm x 420mm

张书玮	Shuwei Zhang
中国台湾	Taiwan, China
雕塑	Sculpture

Taiwan, China
中国台湾

International Art Exhibition
国际美术展

旧街斜影 / Old Street Shadow
270mm x 380mm

杨治伟 | Zhiwei Yang
中国台湾 | Taiwan, China
绘画 | Painting

| Work Collection of Arts | The Sixth Silk Road International Arts Festival | Taiwan, China |
| 美术作品集 | 第六届丝绸之路国际艺术节 | 中国台湾 |

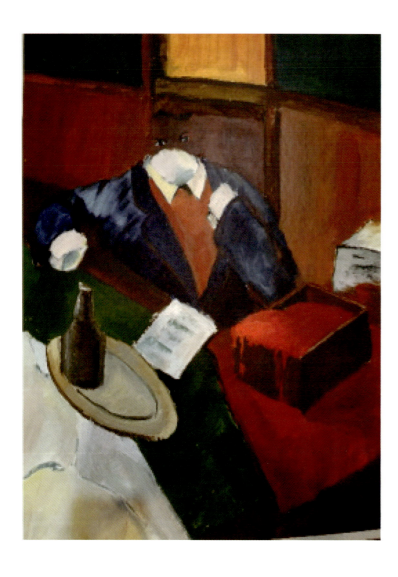

消失 / Disappear

420mm x 250mm x 420mm

陈子伊	Ziyi Chen
中国台湾	Taiwan, China
绘画	Painting

Colombia
哥伦比亚

International Art Exhibition
国际美术展

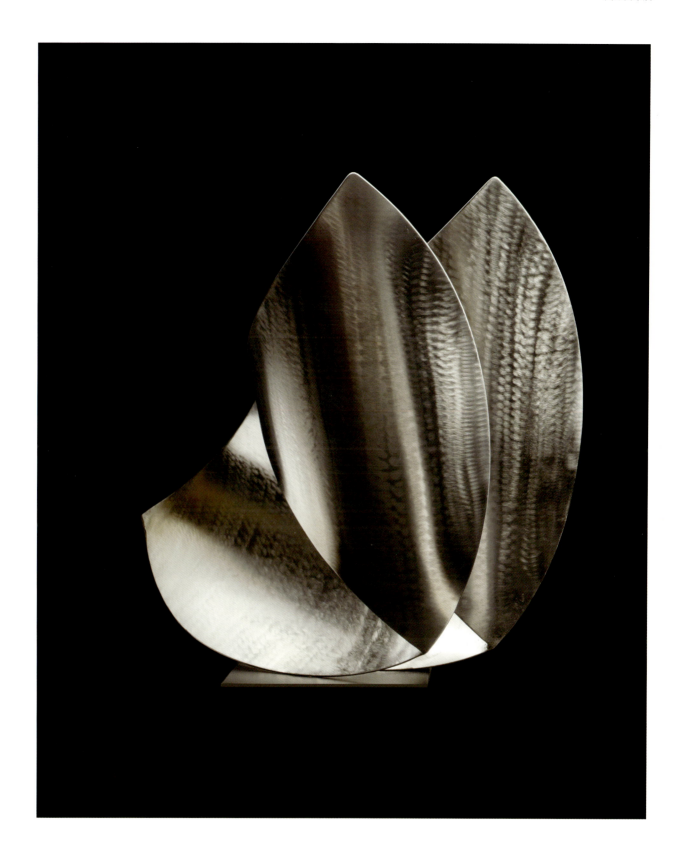

塞蒂奥 / Cetacio
1360mm x 1700mm x 960mm

杰西·加布里埃尔·贝尔特伦 | Jesus Gabriel Beltran
哥伦比亚 | Colombia
雕塑 | Sculpture

| Work Collection of Arts | The Sixth Silk Road International Arts Festival | Costa Rica |
| 美术作品集 | 第六届丝绸之路国际艺术节 | 哥斯达黎加 |

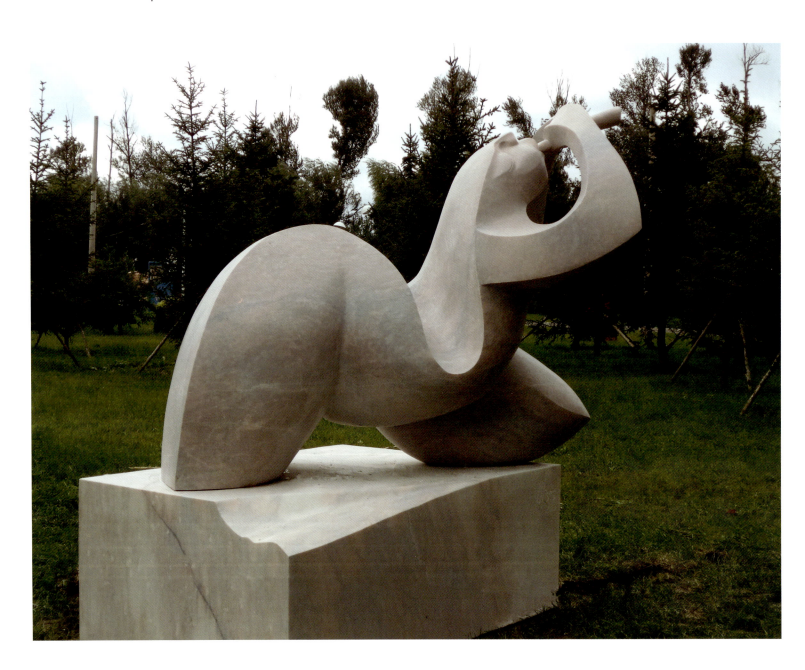

森林的旋律 / Melody of the Forest

400mm x 700mm x 250mm

尤利西斯·希门尼斯	Ulises Jimenez
哥斯达黎加	Costa Rica
雕塑	Sculpture

Côte d'Ivoire / 科特迪瓦

International Art Exhibition / 国际美术展

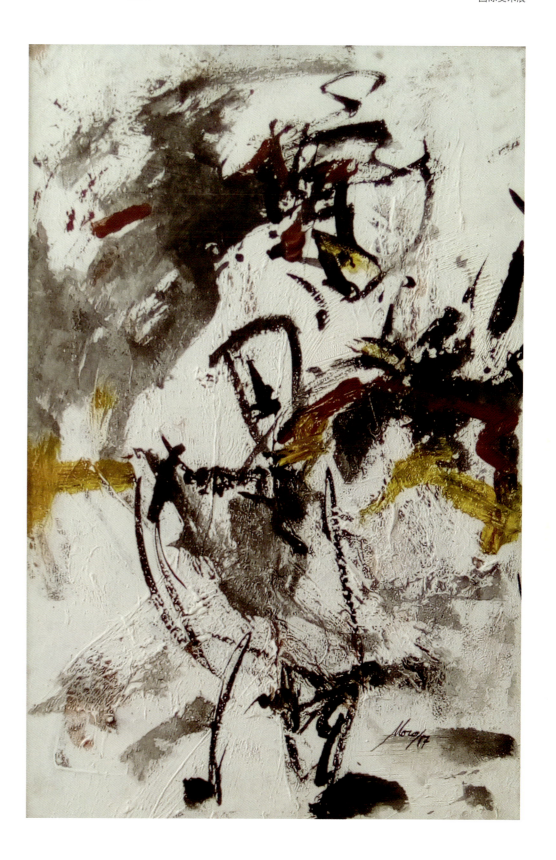

舞蹈 / La Danse
750mm x 510mm

马蒂尔德·莫劳 | Mathilde Moreau
科特迪瓦 | Côte d'Ivoire
绘画 | Painting

| Work Collection of Arts | The Sixth Silk Road International Arts Festival | Côte d'Ivoire |
| 美术作品集 | 第六届丝绸之路国际艺术节 | 科特迪瓦 |

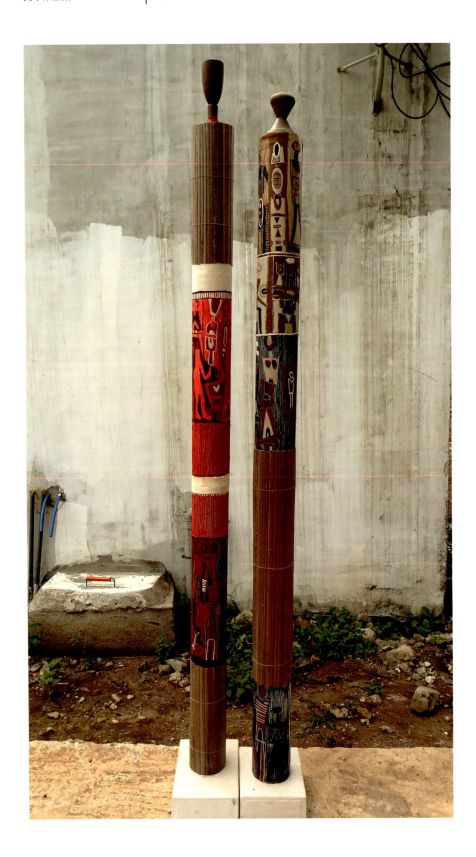

寺庙花园 / Gardiens Du Temple

H:2000mm

雅宝·雅宝·帕特里克	Yapo Yapo Patrick
科特迪瓦	Côte d'Ivoire
雕塑	Sculpture

Croatia
克罗地亚

International Art Exhibition
国际美术展

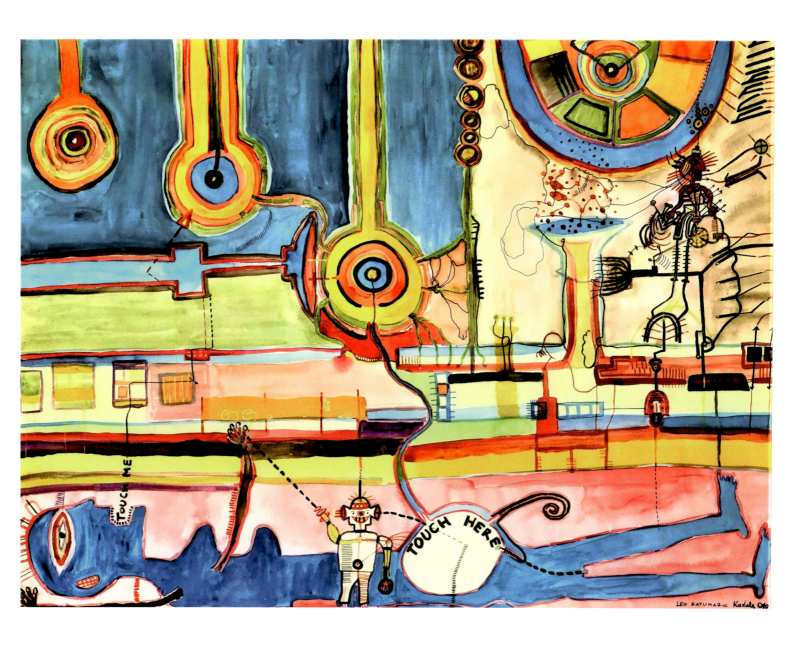

触摸屏幕可以在里面创造一个生活序列 / Touching the Screen may Create a Life Sequence inside

750mm x 550m

利奥·卡图纳里克	Leo Katunaric
克罗地亚	Croatia
绘画	Painting

| Work Collection of Arts | The Sixth Silk Road International Arts Festival | Croatia |
| 美术作品集 | 第六届丝绸之路国际艺术节 | 克罗地亚 |

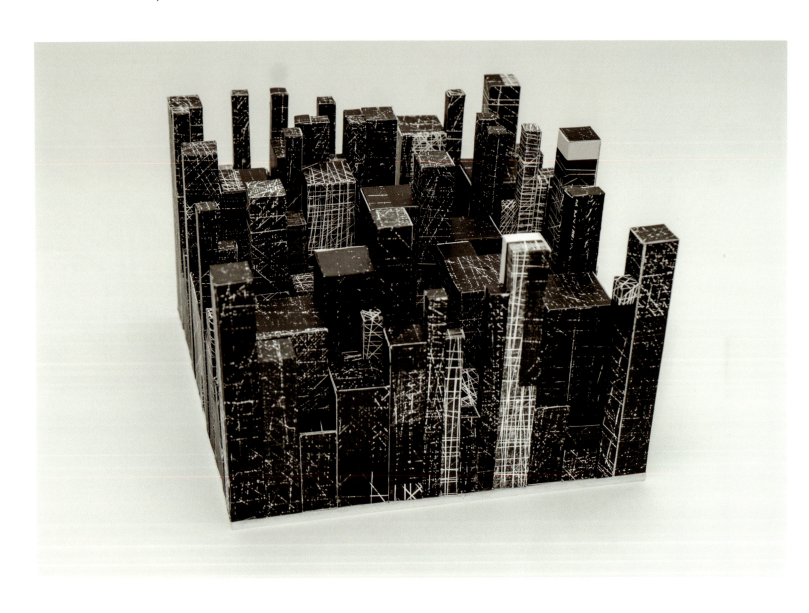

超级建筑 #133 / Megastructure #133

250mm x 250mm x 150mm

佩特拉·格里莱蒂克	Petra Kriletić
克罗地亚	Croatia
雕塑	Sculpture

Cuba 古巴 | International Art Exhibition 国际美术展

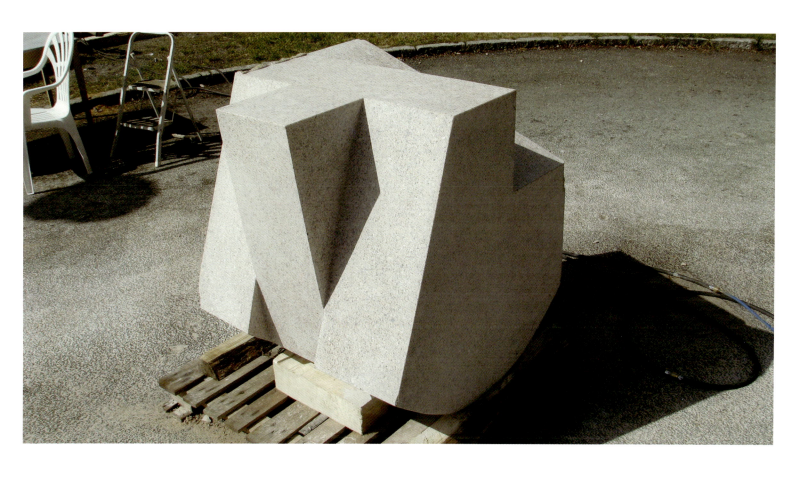

奥斯卡·劳瑞兰诺·艾格瑞·卡门达都
古巴
雕塑

发音的斜坡 / Pronounced Slopes
1000mm x 1000mm x 1000mm
Oscar Laurelino Aguirre Comendador
Cuba
Sculpture

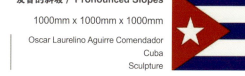

| Work Collection of Arts | The Sixth Silk Road International Arts Festival | Cyprus |
| 美术作品集 | 第六届丝绸之路国际艺术节 | 塞浦路斯 |

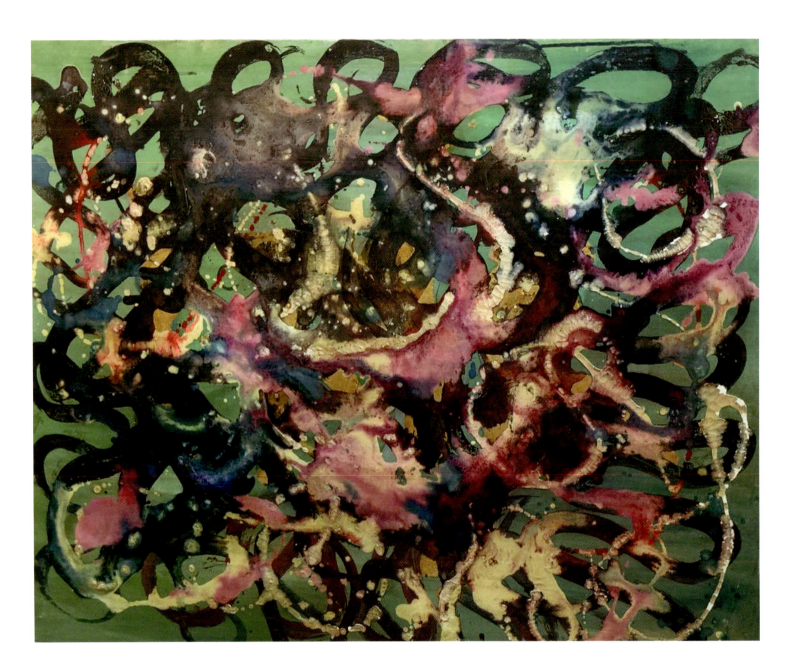

章鱼 / Octopus
800mm x 600mm

希尔达·凯莱基安 | Hilda Kelekian
塞浦路斯 | Cyprus
绘画 | Painting

Czech / 捷克 International Art Exhibition / 国际美术展

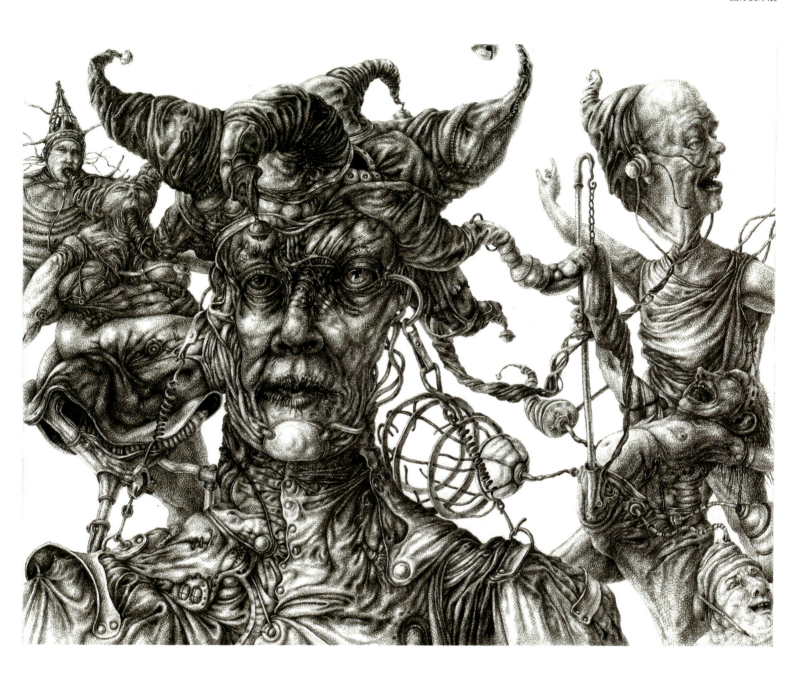

操纵器 / The Manipulator
500mm x 400mm

吉里·斯塔姆费斯特 | Jiri Stamfest
捷克 | Czech
绘画 | Painting

| Work Collection of Arts | The Sixth Silk Road International Arts Festival | Czech |
| 美术作品集 | 第六届丝绸之路国际艺术节 | 捷克 |

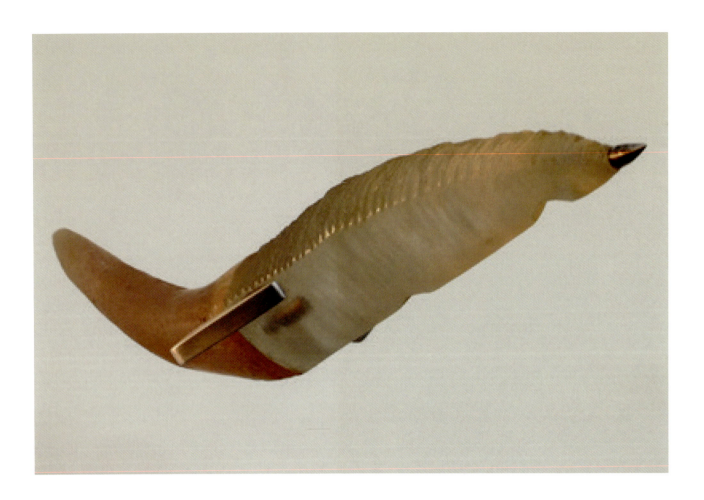

猛禽 1 / Raptor 1

550mm x 110mm x 80mm

马丁·库查尔	Martin Kuchař
捷克	Czech
雕塑	Sculpture

Denmark
丹麦

International Art Exhibition
国际美术展

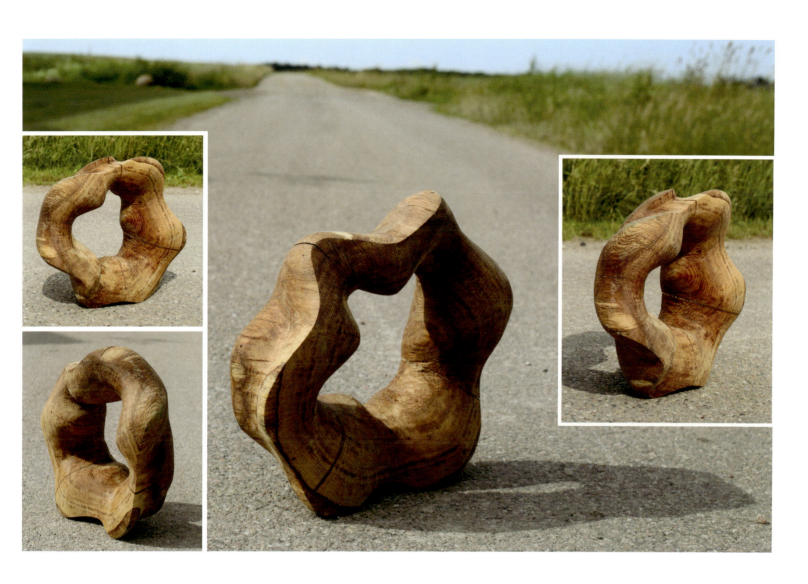

多元化 / Diversified

500mm x 520mm x200mm

斯蒂芬·佩德森	Steffie Pedersen
丹麦	Denmark
雕塑	Sculpture

时间和空间 / Time and Space
1000mm x 600mm

本琦·克恁噶	Benj Kinenga
刚果（金）	D.R.Congo
绘画	Painting

D.P.R.Korea 朝鲜 — International Art Exhibition 国际美术展

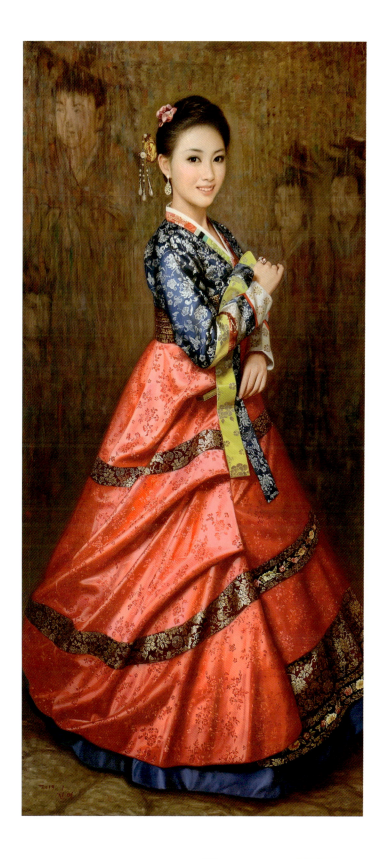

阿里郎少女 / Arirang Girl
1460mm x 660mm
陈明 | Ming Chen
朝鲜 | D.P.R.Korea
绘画 | Painting

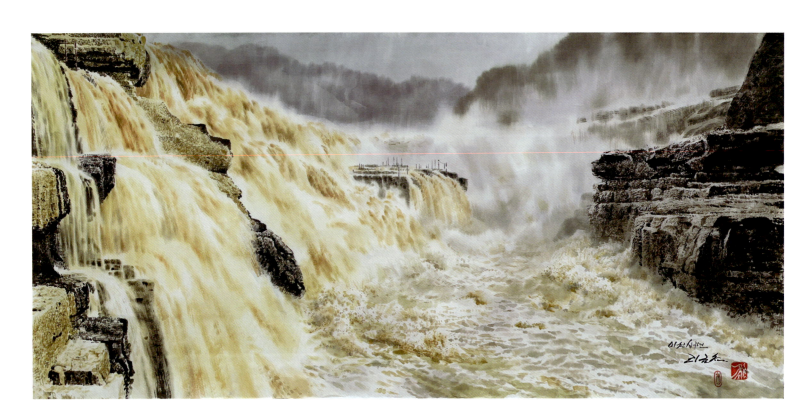

壶口瀑布 / Hukou Waterfall

580mm x 1240mm

李景天	Jingtian Li
朝鲜	D.P.R.Korea
绘画	Painting

D.P.R.Korea / 朝鲜 — International Art Exhibition / 国际美术展

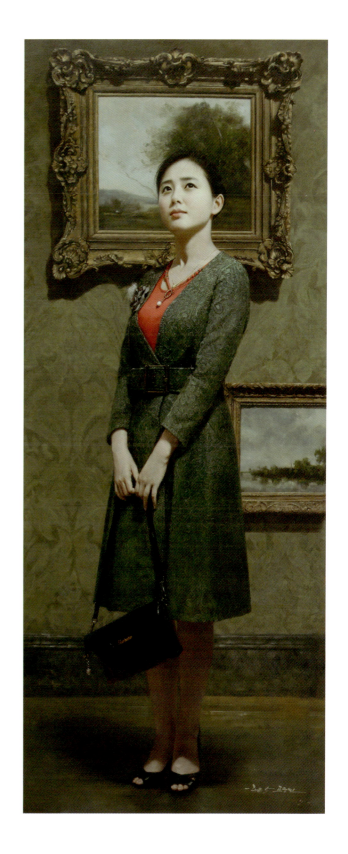

憧憬 / Expectancy
1610mm x 655mm

朴英民 | Yingmin Piao
朝鲜 | D.P.R.Korea
绘画 | Painting

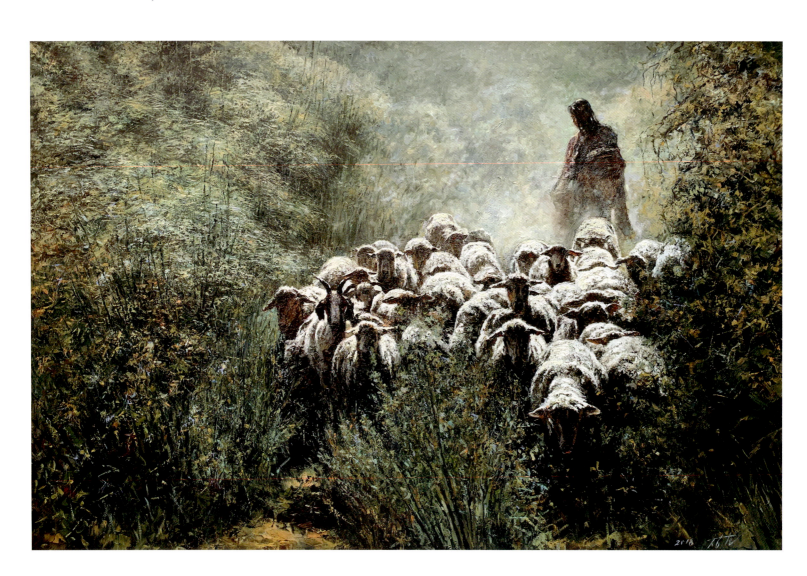

牧羊女 / Shepherdess

1110mm x 1640mm

张贤哲 — Xianzhe Zhang
朝鲜 — D.P.R.Korea
绘画 — Painting

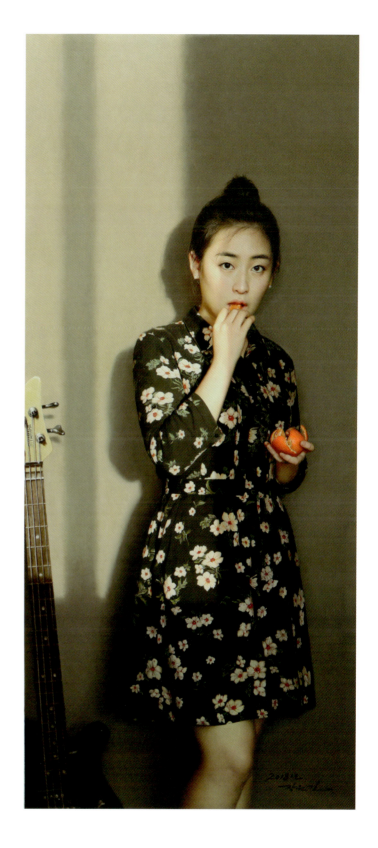

橘子少女 / Orange Girl
1280mm x 560mm

张元吉 | Yuanji Zhang
朝鲜 | D.P.R.Korea
绘画 | Painting

| Work Collection of Arts | The Sixth Silk Road International Arts Festival | Ecuador |
| 美术作品集 | 第六届丝绸之路国际艺术节 | 厄瓜多尔 |

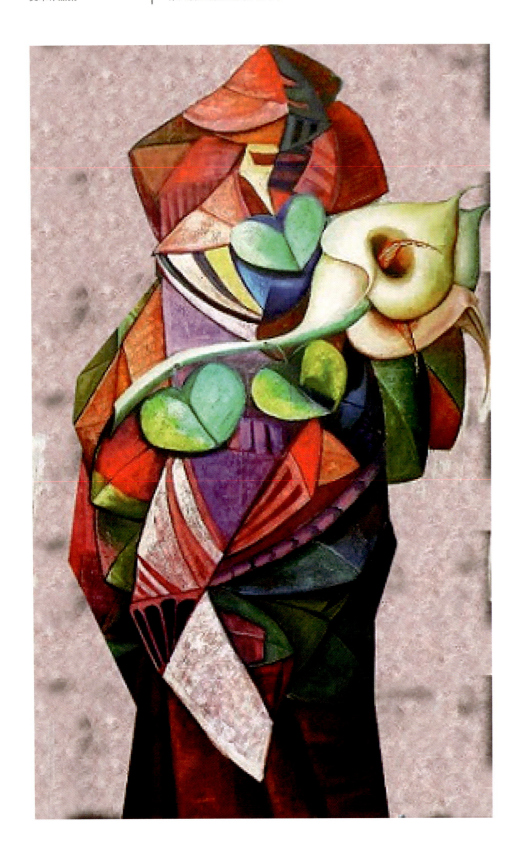

阿莫尔 / Fryto Del Amor

7600mm x 1060mm

玛丽亚·德·洛德丝·巴拉雷索	María de Lourdes Balarezo
厄瓜多尔	Ecuador
绘画	Painting

Egypt
埃及

International Art Exhibition
国际美术展

自然的韵律 / Rhythms of Nature
400mm x 500mm

法蒂玛·艾勒曼 | Fatma Abd Elrahman
埃及 | Egypt
绘画 | Painting

Work Collection of Arts | The Sixth Silk Road International Arts Festival | Egypt
美术作品集 | 第六届丝绸之路国际艺术节 | 埃及

家庭 / Family

1000mm x 1000mm

马哈茂德 | Mahmoud
埃及 | Egypt
绘画 | Painting

Egypt
埃及

International Art Exhibition
国际美术展

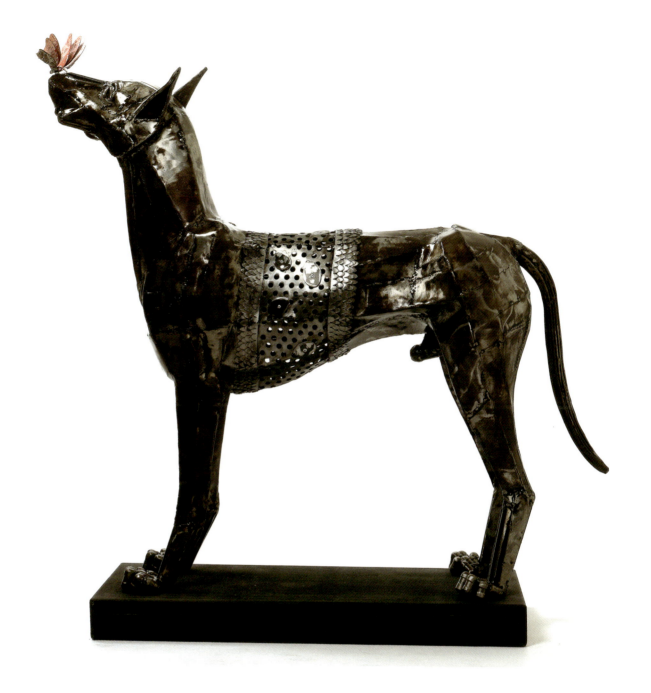

橙色的蝴蝶 / The Orange Butterfly
1100mm x 1000mm x 350mm

内维尼·法尔加利	Nevine Farghaly
埃及	Egypt
雕塑	Sculpture

Work Collection of Arts | The Sixth Silk Road International Arts Festival | Egypt
美术作品集 | 第六届丝绸之路国际艺术节 | 埃及

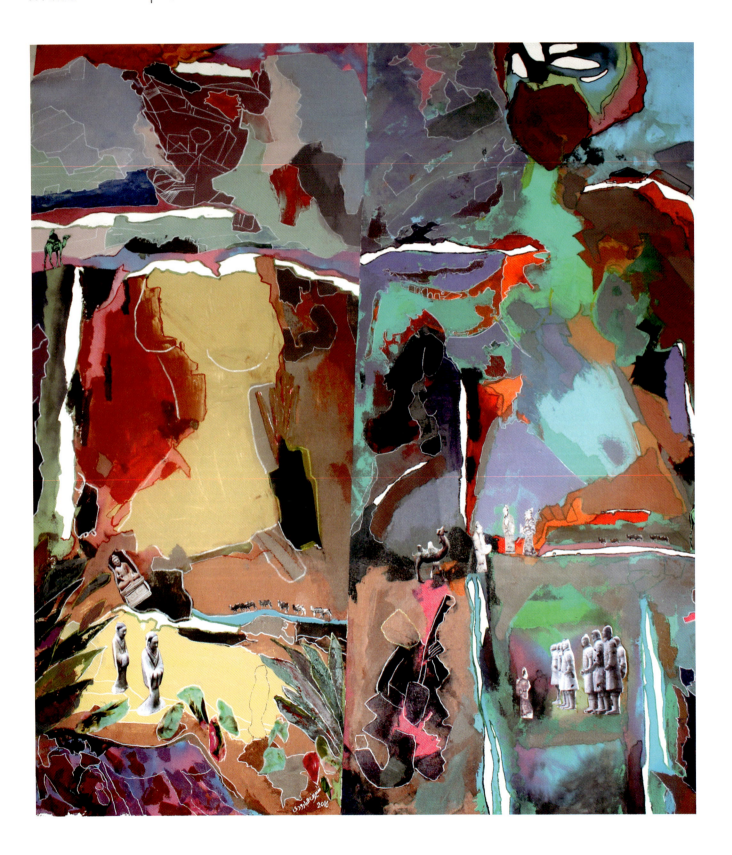

从过去到现在 / Between the Past and Today

1500mm x 1200mm

希林·阿尔布罗蒂 | Sherin Elbaroudi
埃及 | Egypt
绘画 | Painting

Egypt / 埃及 — International Art Exhibition / 国际美术展

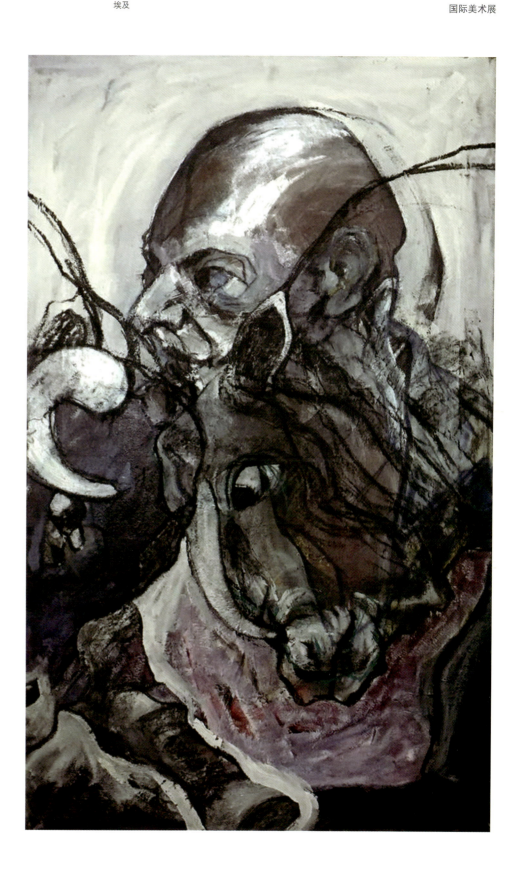

文化斗争 / Culture Struggle
100mm x 600mm

维亚姆·埃玛斯里 / Weaam ElMasry
埃及 / Egypt
绘画 / Painting

Work Collection of Arts	The Sixth Silk Road International Arts Festival	Eritrea
美术作品集	第六届丝绸之路国际艺术节	厄立特里亚

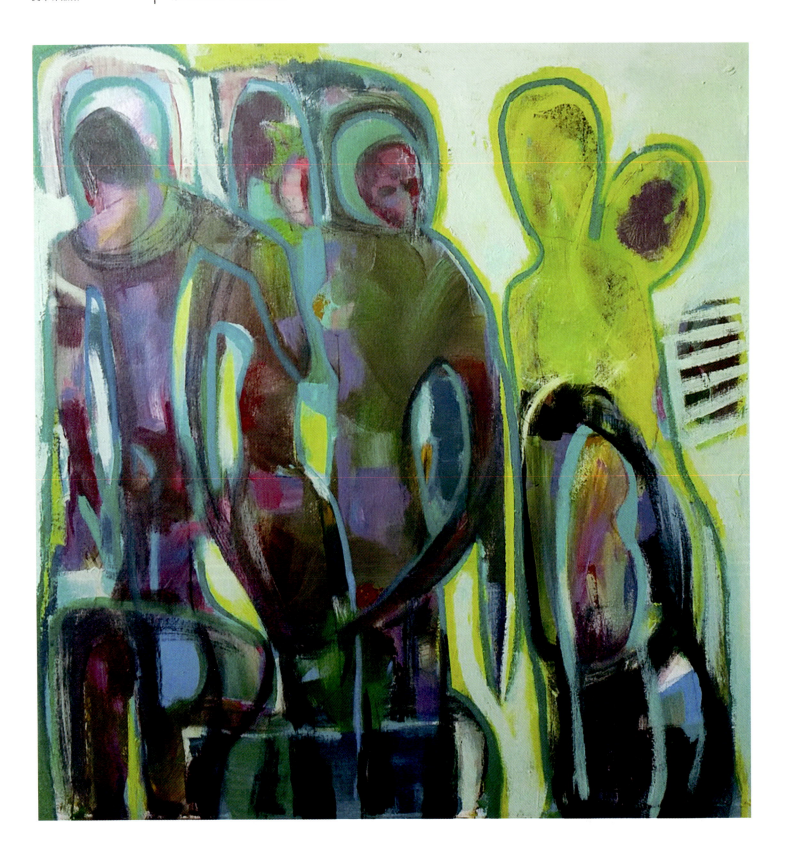

陌生人 / The Strangers
685mm x 685mm

亚伯拉罕·阿瓦罗	Abraham Awalom
厄立特里亚	Eritrea
绘画	Painting

Eritrea 厄立特里亚

International Art Exhibition 国际美术展

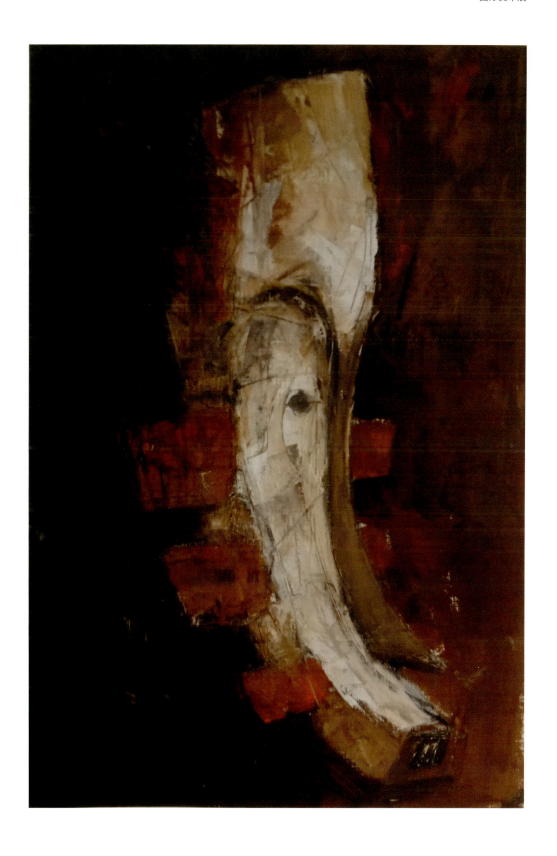

愿景 / Vision
500mm x 600mm

贝尔哈内·采格约翰娜·格布雷梅谢尔
厄立特里亚
绘画

Berhane Tsegeyohannes Gebremicheal
Eritrea
Painting

Work Collection of Arts | The Sixth Silk Road International Arts Festival | Estonia
美术作品集 | 第六届丝绸之路国际艺术节 | 爱沙尼亚

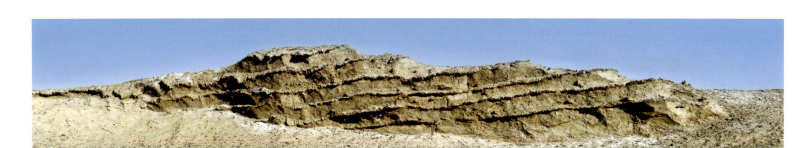

汉长城系列 / Great Wall of Han Series

990mm x 530mm

洛伊特·卓卡达	Loit Joekalda
爱沙尼亚	Estonia
雕塑	Sculpture

Estonia / 爱沙尼亚 — International Art Exhibition / 国际美术展

吻雪系列 / Kissing Snow Series
700mm x 1000mm

维格·卓卡达	Virge Joekalda
爱沙尼亚	Estonia
绘画	Painting

| Work Collection of Arts | The Sixth Silk Road International Arts Festival | Finland |
| 美术作品集 | 第六届丝绸之路国际艺术节 | 芬兰 |

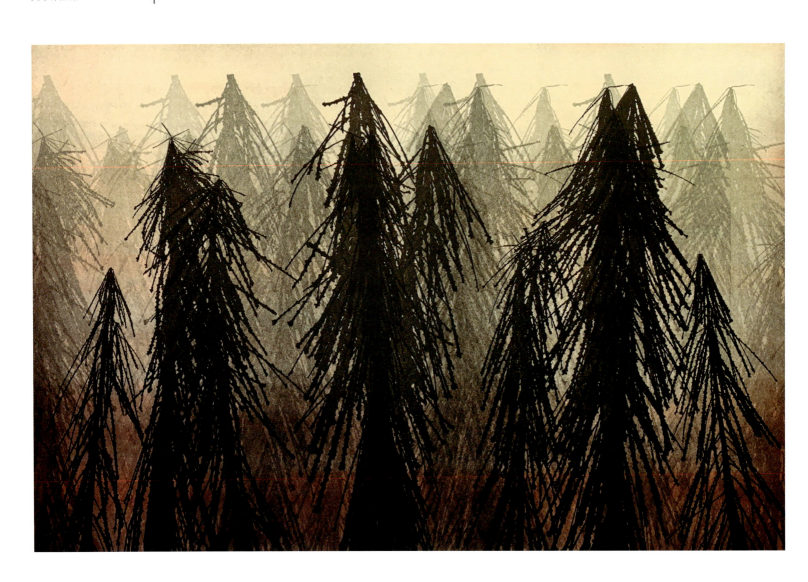

未知丛林 / Unknown Jungle

385mm x 585mm

詹妮·莱恩	Janne Laine
芬兰	Finland
绘画	Painting

Georgia
格鲁吉亚

International Art Exhibition
国际美术展

无题 / Unnamed
1500mm x 2000mm x 1700mm

约翰·戈戈别什维利 | Jhon Gogaberishvili
格鲁吉亚 | Georgia
雕塑 | Sculpture

123

Work Collection of Arts	The Sixth Silk Road International Arts Festival	Germany
美术作品集	第六届丝绸之路国际艺术节	德国

红罂粟系列 / Roter Mohn Series

265mm x 260mm; 305mm x 230mm

阿泽米娜·柏冉池	Azemina Bruch
德国	Germany
绘画	Painting

Germany / 德国 — International Art Exhibition / 国际美术展

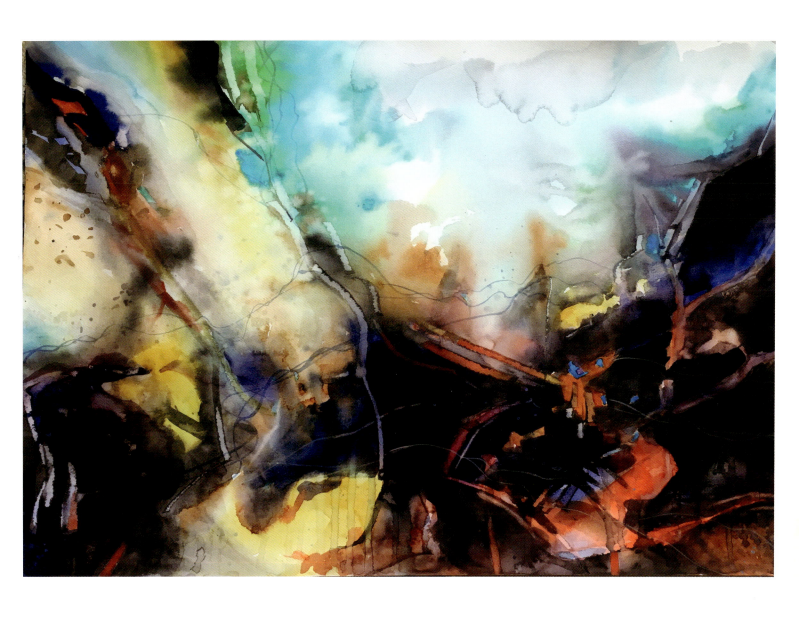

宇宙 / Cosmic
500mm x 650mm

迪特尔·韦斯特普 | Dieter Wystemp
德国 | Germany
绘画 | Painting

Work Collection of Arts	The Sixth Silk Road International Arts Festival	Germany
美术作品集	第六届丝绸之路国际艺术节	德国

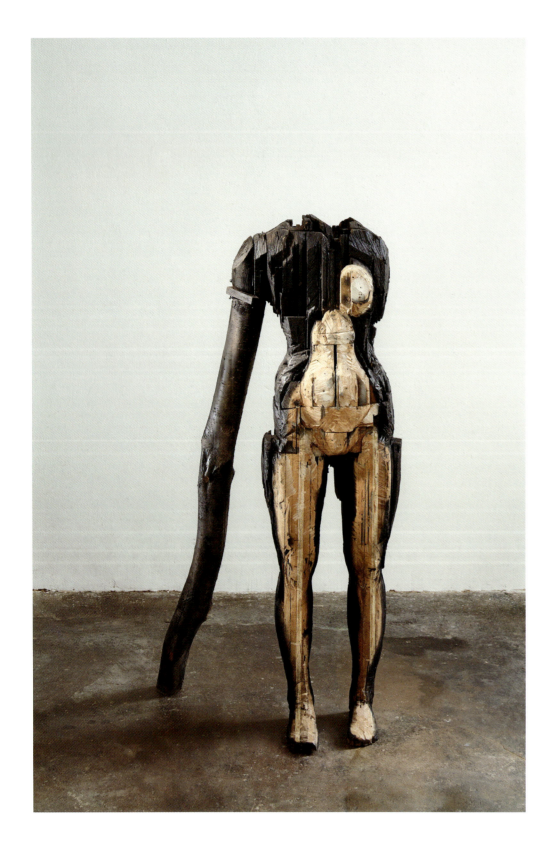

彭特西勒亚 / Penthesilea

1800mm x 1000mm x 600mm

埃克勒·劳拉	Eckerl Laura
德国	Germany
雕塑	Sculpture

Germany / 德国 — International Art Exhibition / 国际美术展

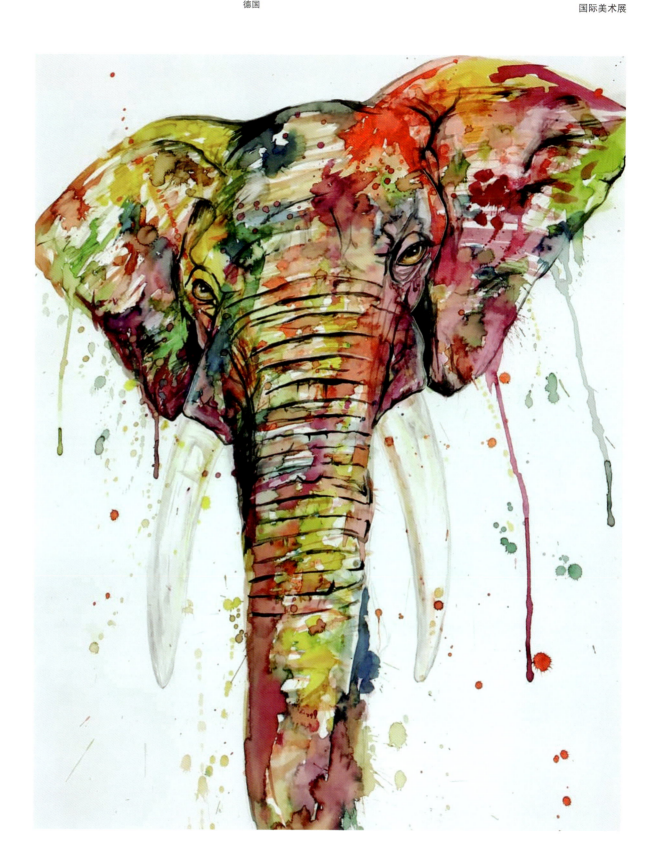

多彩多姿的大象 / Multicolour Elepha
800mm x 500mm

弗里安·沃尔夫	Florian Wolf
德国	Germany
绘画	Painting

| Work Collection of Arts | The Sixth Silk Road International Arts Festival | Germany |
| 美术作品集 | 第六届丝绸之路国际艺术节 | 德国 |

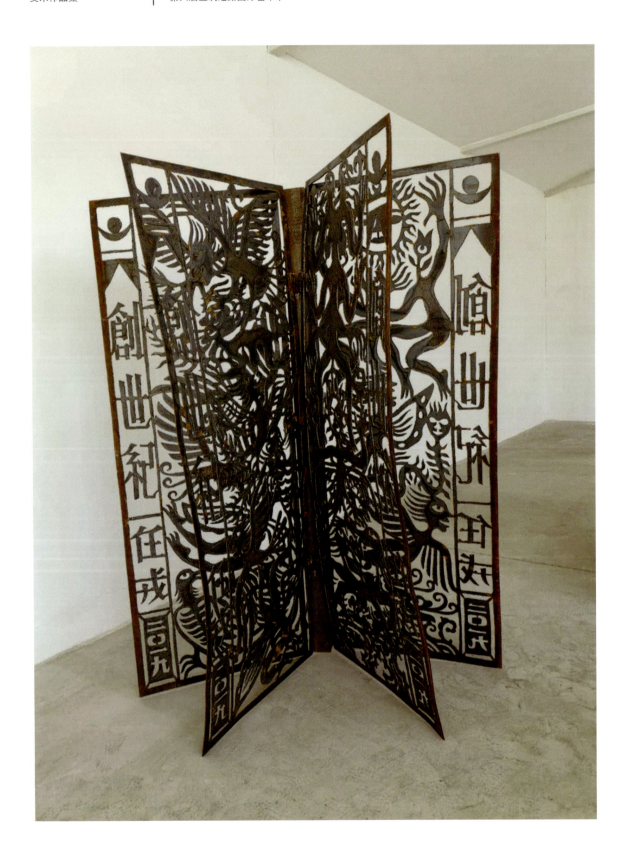

无题 / Unnamed

1380mm x 690mm

任戎	Rong Ren
德国	Germany
雕塑	Sculpture

Germany 德国 International Art Exhibition 国际美术展

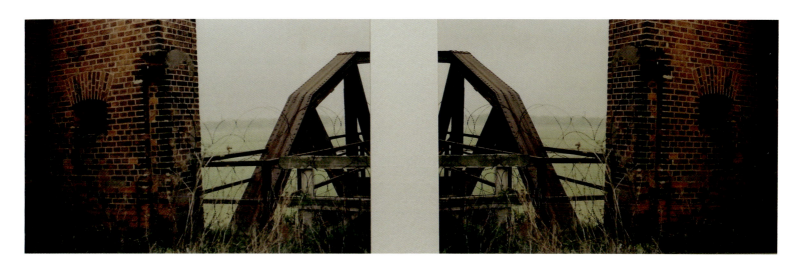

桥，不再是一座桥 /Bridge, No Longer Functioning Bridge

600mm x 300mm

斯特凡·米茨拉夫 | Stefan Mitzlaff
德国 | Germany
绘画 | Painting

Work Collection of Arts	The Sixth Silk Road International Arts Festival	Ghana
美术作品集	第六届丝绸之路国际艺术节	加纳

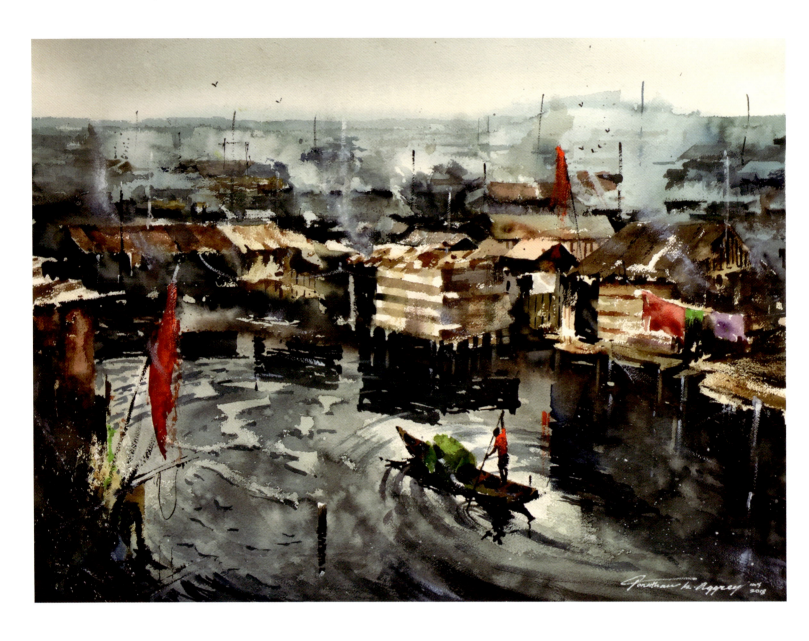

我们的威尼斯 / Our Venice

560mm x 760mm

乔纳森·肯瓦吉亚·安格里	Jonathan Kwegyir Aggrey
加纳	Ghana
绘画	Painting

Greece
希腊

International Art Exhibition
国际美术展

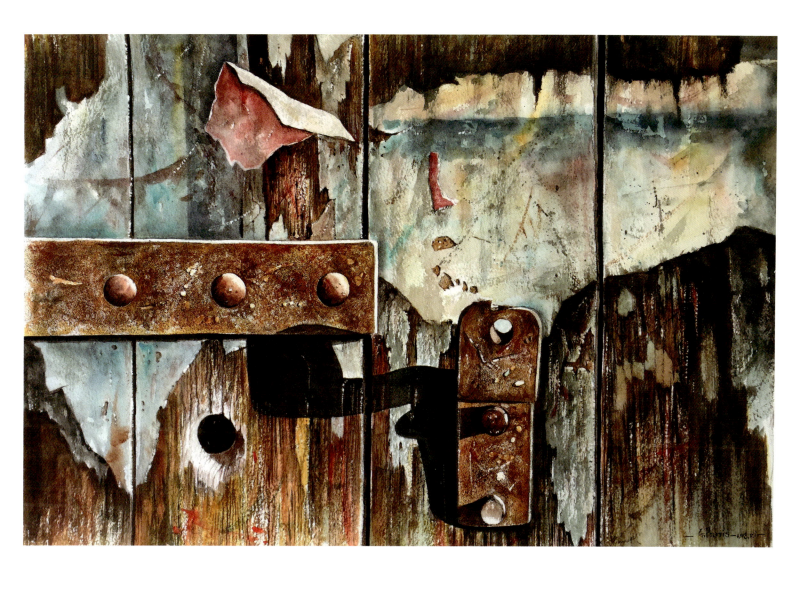

麦索福的旧门 / Old Door in Metsovo

380mm x 560mm

乔治·波利提斯 | George Politis
希腊 | Greece
绘画 | Painting

Work Collection of Arts	The Sixth Silk Road International Arts Festival	Greece
美术作品集	第六届丝绸之路国际艺术节	希腊

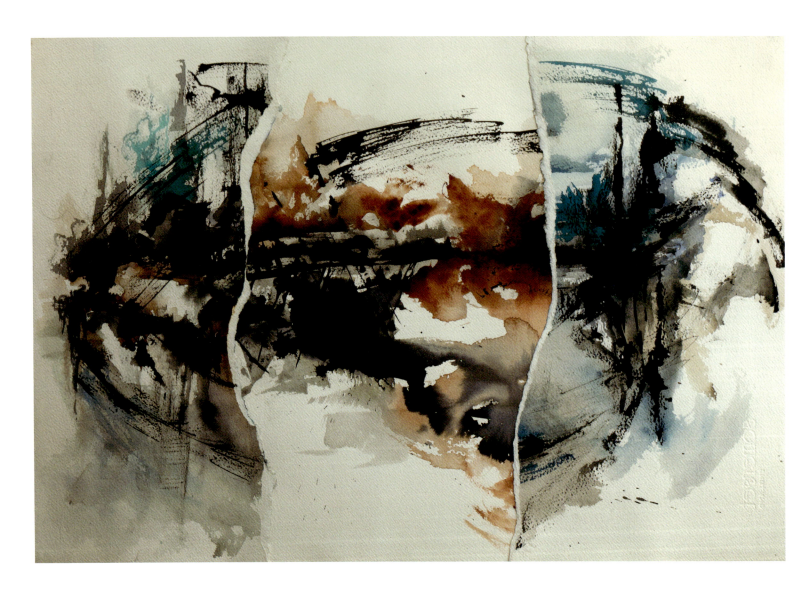

我的路 / My Way

400mm x 600mm

莉娜·莫尔菲格尼 | Lena Morfogeni
希腊 | Greece
绘画 | Painting

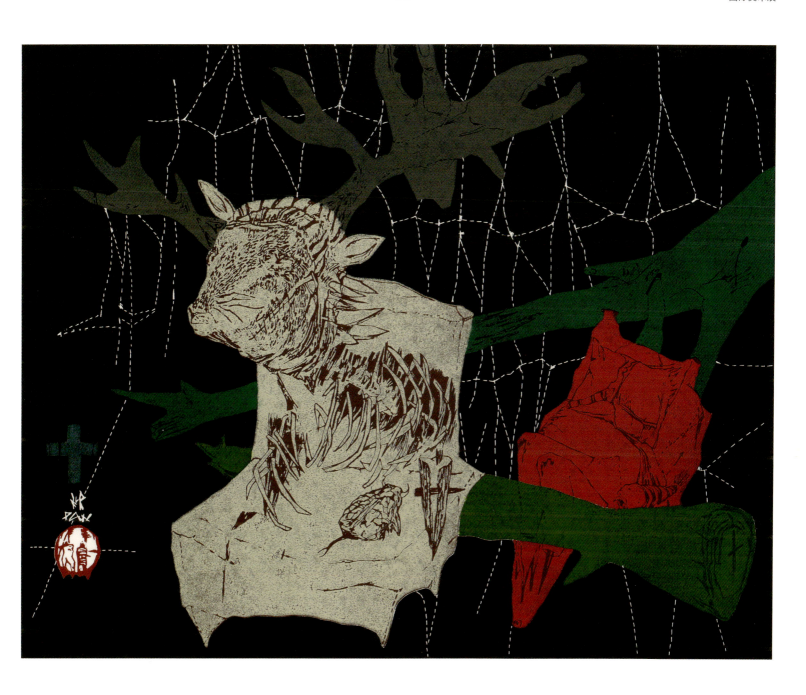

上帝的羔羊 / The Lamb of God

400mm x 500mm

乌拉尼亚·弗拉格口里多 | Ourania Fragkoulidou
希腊 | Greece
绘画 | Painting

| Work Collection of Arts | The Sixth Silk Road International Arts Festival | Grenada |
| 美术作品集 | 第六届丝绸之路国际艺术节 | 格林纳达 |

千日之旅 / Journey of a Thousand Sunsets

500mm x 500mm

泰瑞西娅·毕索	Tricia Bethel
格林纳达	Grenada
绘画	Painting

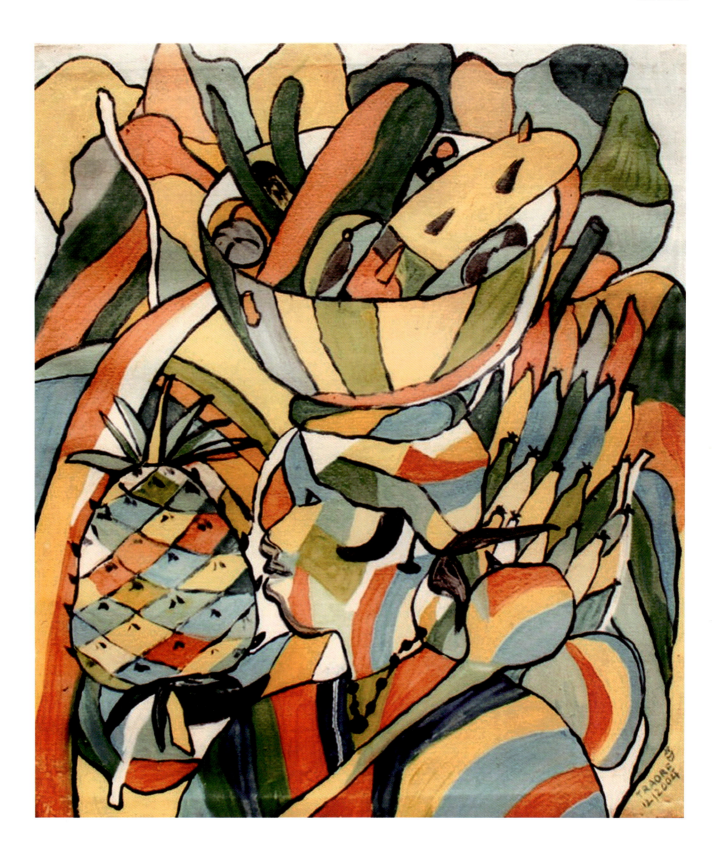

女权 / Women in Charge

600mm x 500mm

特劳雷·卡巴	Traore Kaba
几内亚	Guinea
绘画	Painting

| Work Collection of Arts | The Sixth Silk Road International Arts Festival | Hungary |
| 美术作品集 | 第六届丝绸之路国际艺术节 | 匈牙利 |

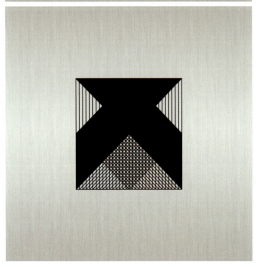

奥卡姆剃刀系列 / Occam's Razor Series

500mm x 500mm

多拉·埃兹特·莫纳尔	Dora Eszter Molnar
匈牙利	Hungary
绘画	Painting

Hungary
匈牙利

International Art Exhibition
国际美术展

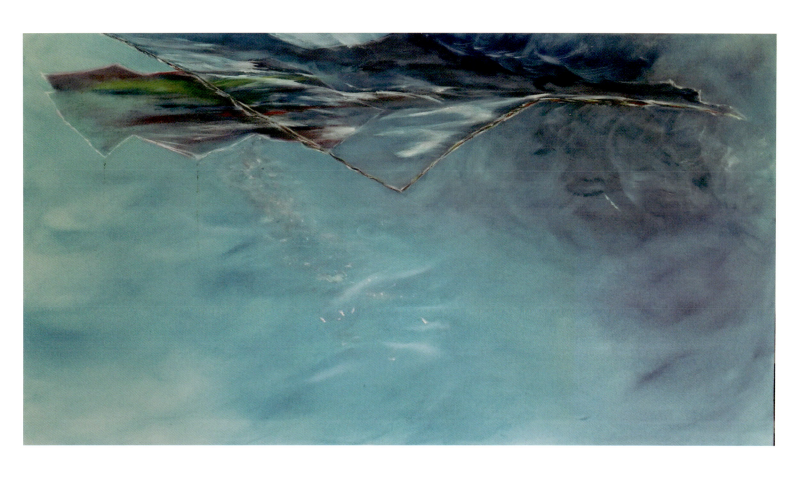

海德·林德·马丁·特罗特
匈牙利
绘画

障碍 / Barrieren
1500mm x 800mm
Heide Linde Martin Traber
Hungary
Painting

| Work Collection of Arts | The Sixth Silk Road International Arts Festival | Iceland |
| 美术作品集 | 第六届丝绸之路国际艺术节 | 冰岛 |

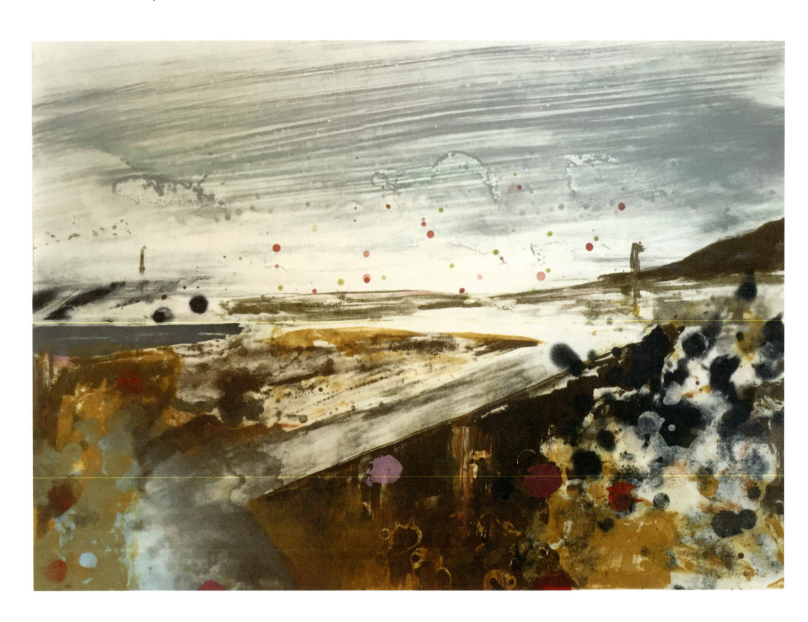

历史守护者 / History Keeper

520mm x 630mm

约翰·菲茨西蒙斯	John Fitzsimons
冰岛	Iceland
绘画	Painting

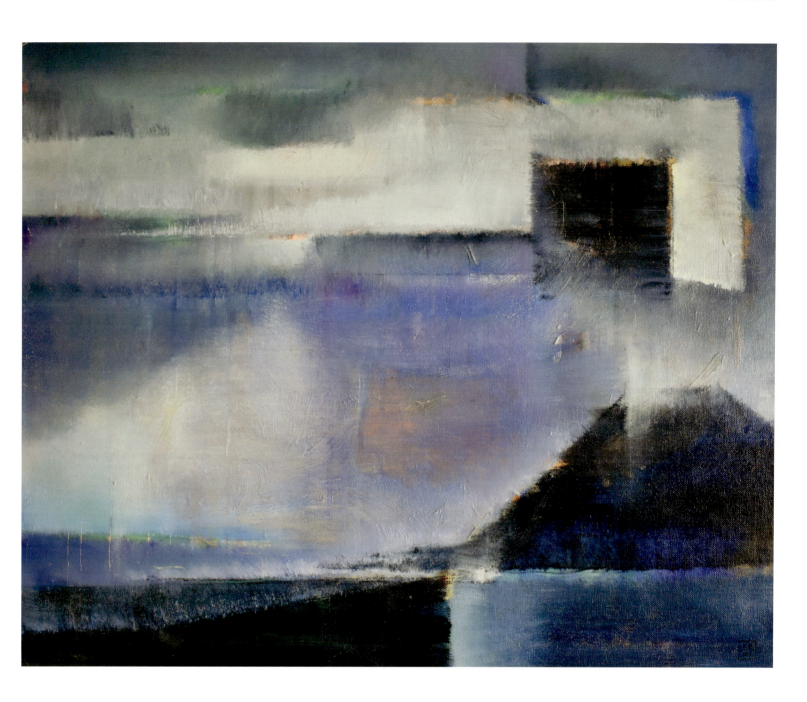

冰岛 /Iceland
600mm x 500mm

西比利亚·比亚纳森 | Sibilla Bjarnason
冰岛 | Iceland
绘画 | Painting

| Work Collection of Arts | The Sixth Silk Road International Arts Festival | India |
| 美术作品集 | 第六届丝绸之路国际艺术节 | 印度 |

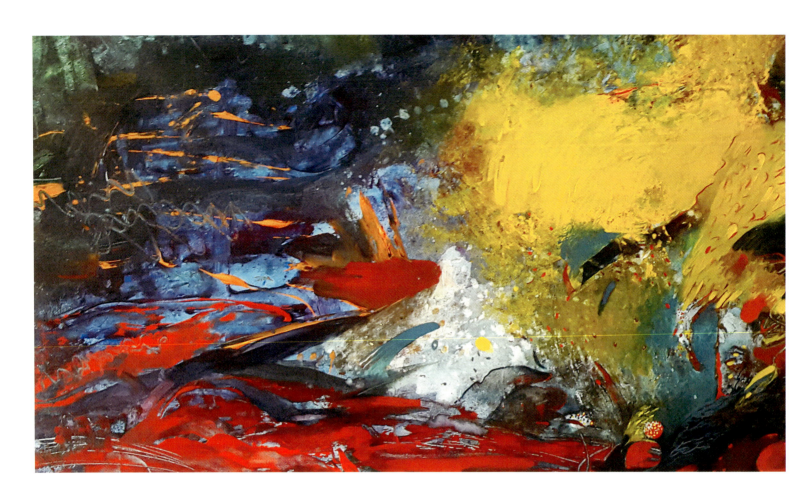

克雷勒·马勒的影响 / Impact of Kroller Muller

762mm × 407mm

巴比塔·塔莎	Babita Das
印度	India
绘画	Painting

India
印度

International Art Exhibition
国际美术展

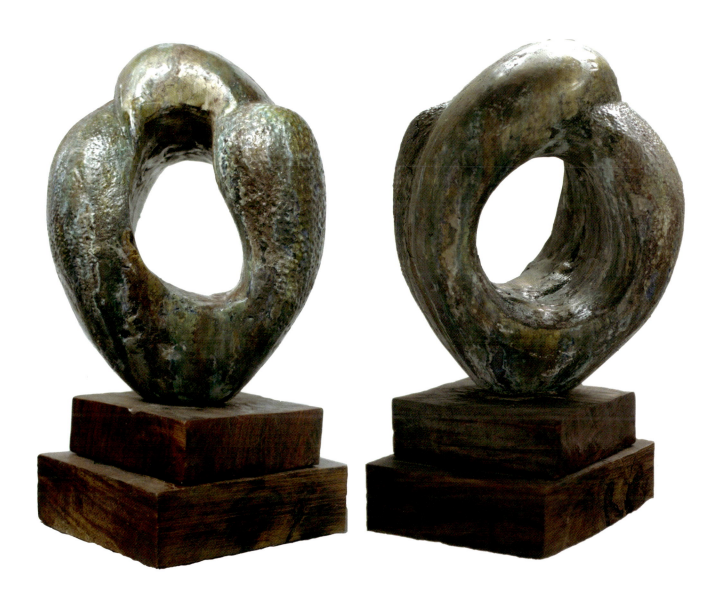

静 / Peace within

400mm x 310mm x 150mm

哈马尼·阿拉瓦特 | Himani Ahlawat
印度 | India
雕塑 | Sculpture

Work Collection of Arts	The Sixth Silk Road International Arts Festival	India
美术作品集	第六届丝绸之路国际艺术节	印度

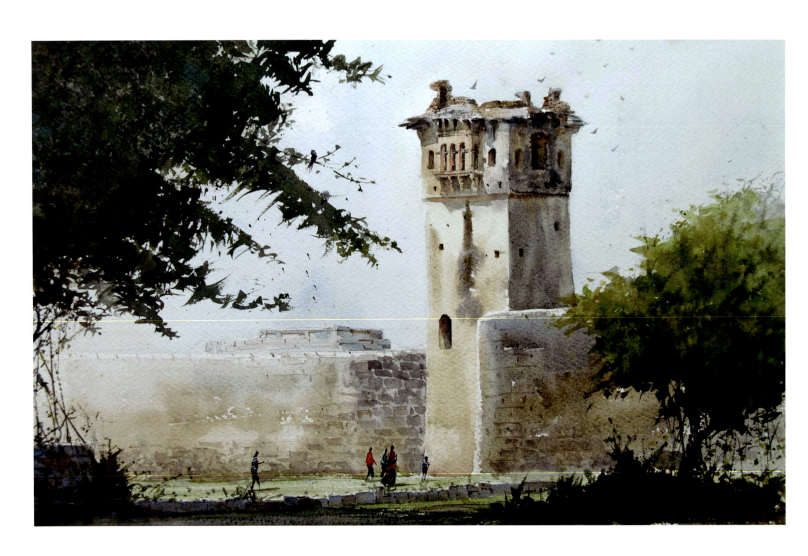

亨比眺望台 / Watch Tower Hampi

210mm x 140mm

马杜·库马尔	Madhu Kumar
印度	India
绘画	Painting

India / 印度 — International Art Exhibition / 国际美术展

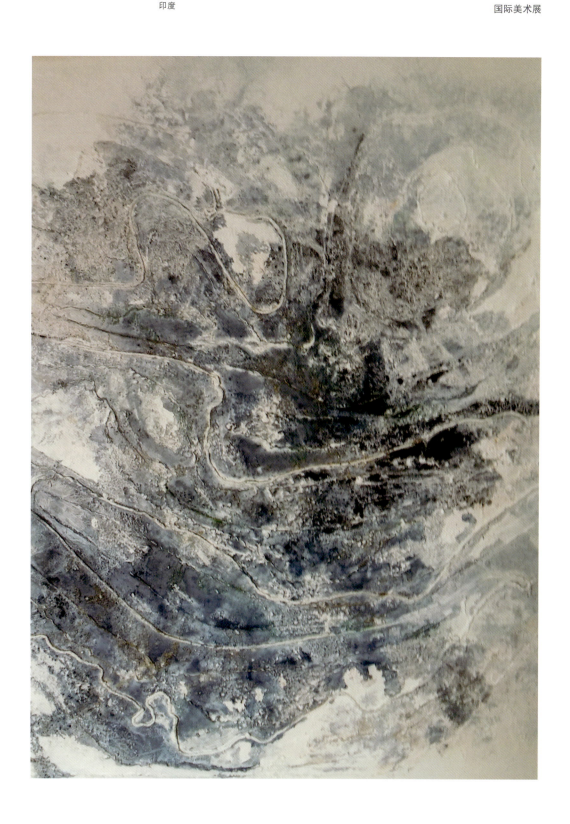

泡沫人生 / **Mood Indigo**
1000mm x 1000mm

普蕾米拉·辛格 | Premila Singh
印度 | India
绘画 | Painting

| Work Collection of Arts | The Sixth Silk Road International Arts Festival | India |
| 美术作品集 | 第六届丝绸之路国际艺术节 | 印度 |

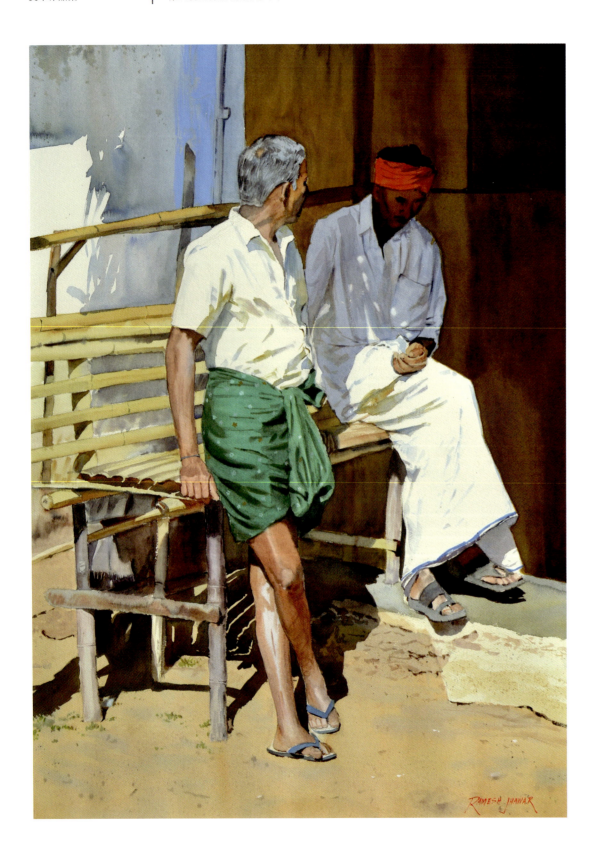

质朴的谈话 / Rustic Conversation

740mm x 530mm

拉玛什·库玛·贾沃	Ramesh Kumar Jhawar
印度	India
绘画	Painting

India
印度

International Art Exhibition
国际美术展

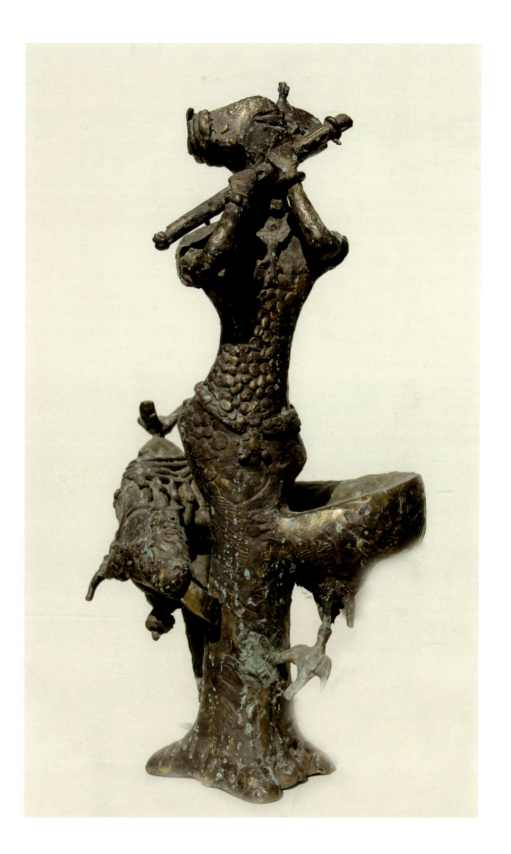

花园里的情侣 / Couple in the Garden
320mm x 230mm x 170mm

桑吉瓦·库马尔	Sanjeev Kumar
印度	India
雕塑	Sculpture

| Work Collection of Arts / 美术作品集 | The Sixth Silk Road International Arts Festival / 第六届丝绸之路国际艺术节 | Indonesia / 印度尼西亚 |

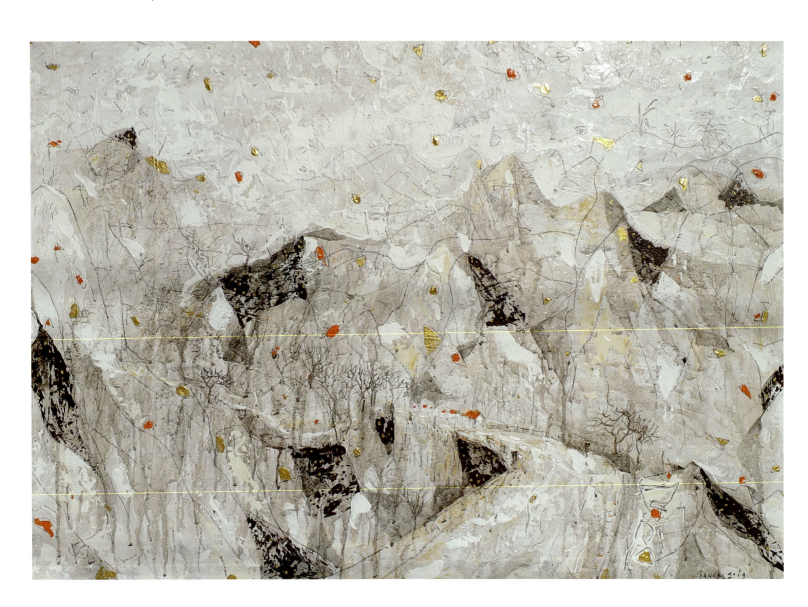

丝绸之路, 2019 / Silk Road, 2019
750mm x 1000mm

亚努拉	Januri
印度尼西亚	Indonesia
绘画	Painting

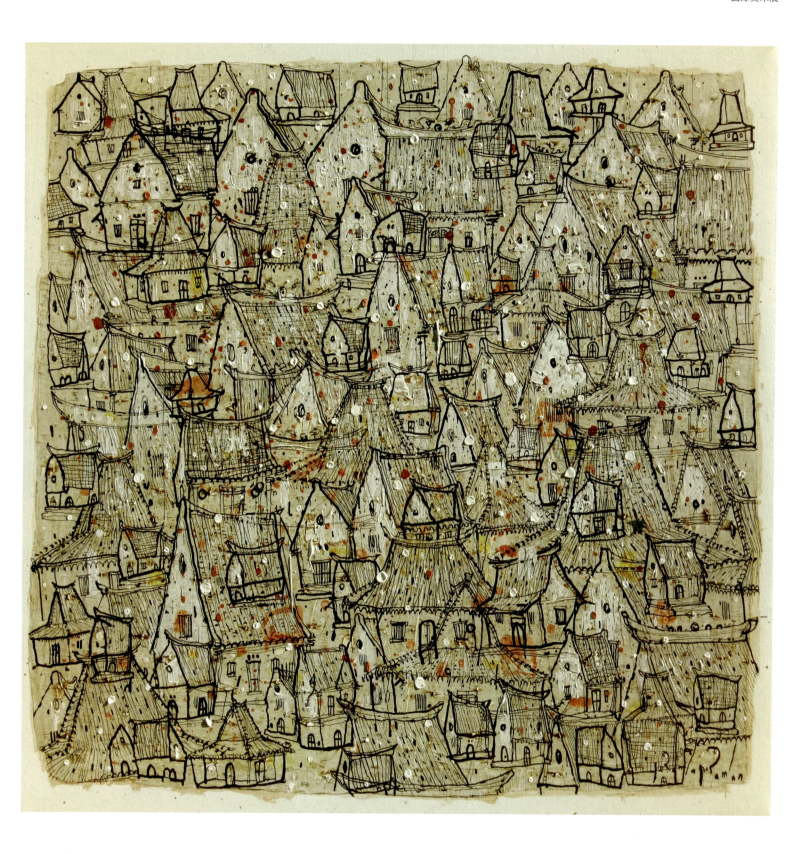

两种和谐的文化 / Two Harmonious Culture

1000mm x 1000mm

乔尼·拉梅兰·沃诺
印度尼西亚
绘画

Joni Ramlan Wiono
Indonesia
Painting

| Work Collection of Arts | The Sixth Silk Road International Arts Festival | Indonesia |
| 美术作品集 | 第六届丝绸之路国际艺术节 | 印度尼西亚 |

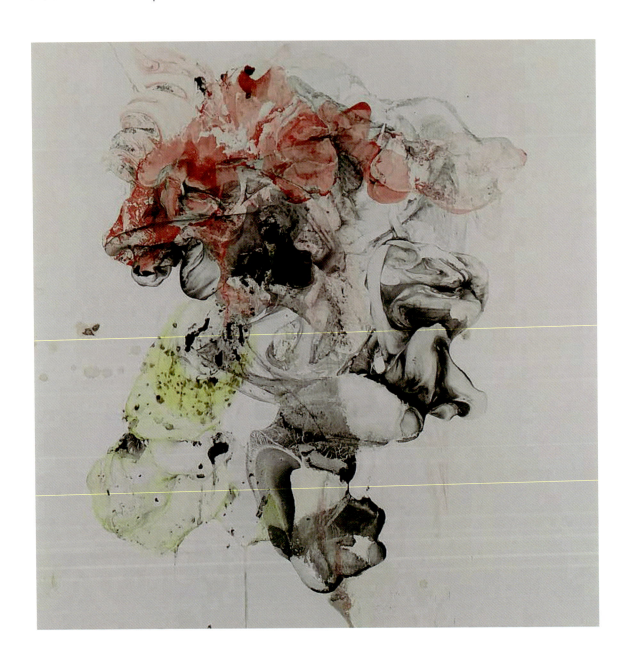

BE234se / BE234se

1010mm x 980mm

韦恩·苏达索诺·扬森 | Wayan Sudarsana Yansen
印度尼西亚 | Indonesia
绘画 | Painting

Iran
伊朗

International Art Exhibition
国际美术展

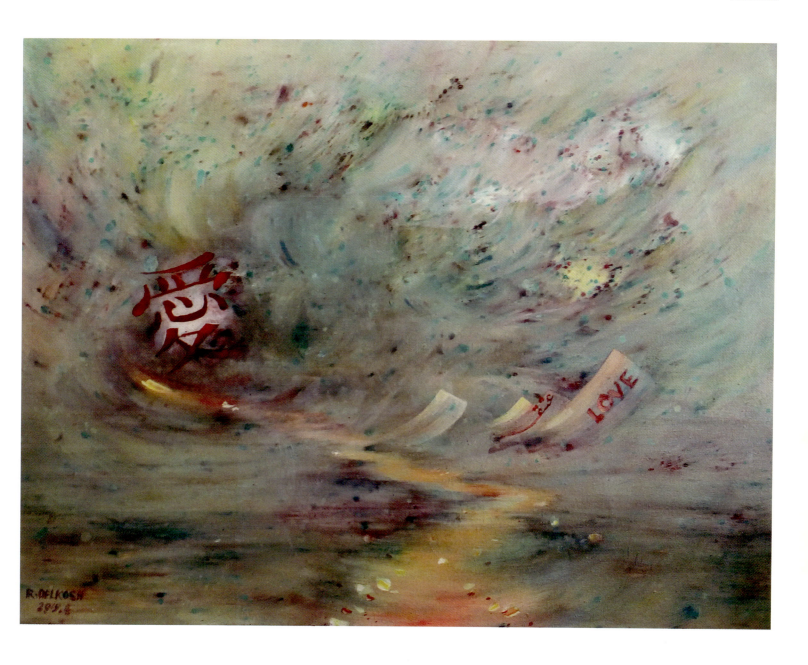

丝绸之路 / Silk Road
800mm x 600mm

罗巴贝·德尔科什 | Robabeh Delkhosh
伊朗 | Iran
绘画 | Painting

Work Collection of Arts — The Sixth Silk Road International Arts Festival — Iraq

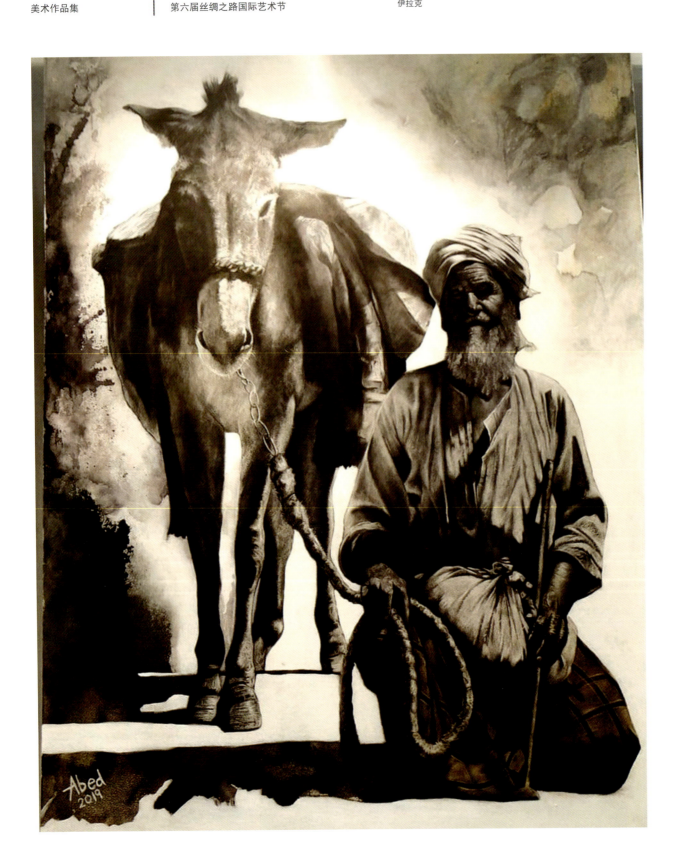

乡村之路 / On the Way to the Village

1200mm x 1000mm

艾博德·奥贝德	Abed Obed
伊拉克	Iraq
绘画	Painting

矩阵系列 / Matrix Series
730mm x 590mm

露丝·奥·唐纳 | Ruth O Donnell
爱尔兰 | Ireland
绘画 | Painting

Work Collection of Arts	The Sixth Silk Road International Arts Festival	Israel
美术作品集	第六届丝绸之路国际艺术节	以色列

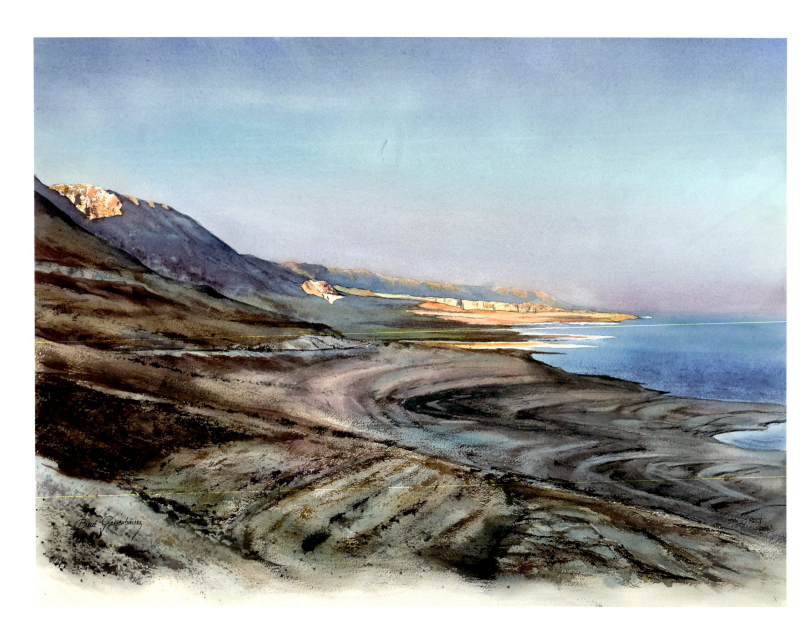

死海 / Dead Sea

560mm x 760mm

本尼·加森鲍尔	Beni Gassenbauer
以色列	Israel
绘画	Painting

Italy | International Art Exhibition
意大利 | 国际美术展

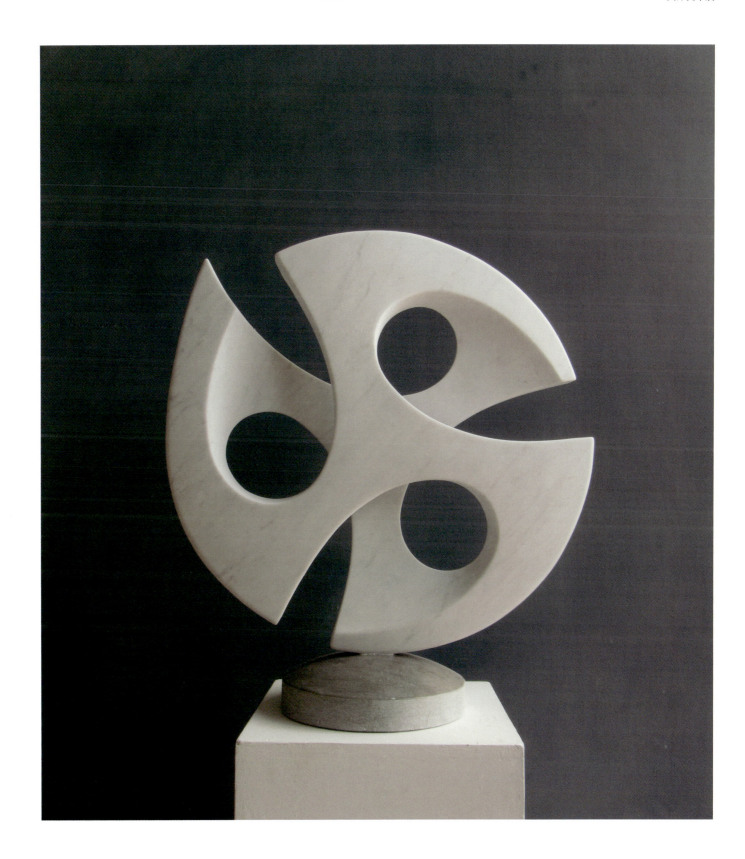

固执和相反的方向 / In Stubborn and Contrary Direction

400mm x 350mm x 180mm

迪·普洛斯彼罗·马里诺 | Di Prospero Marino
意大利 | Italy
雕塑 | Sculpture

Work Collection of Arts	The Sixth Silk Road International Arts Festival	Italy
美术作品集	第六届丝绸之路国际艺术节	意大利

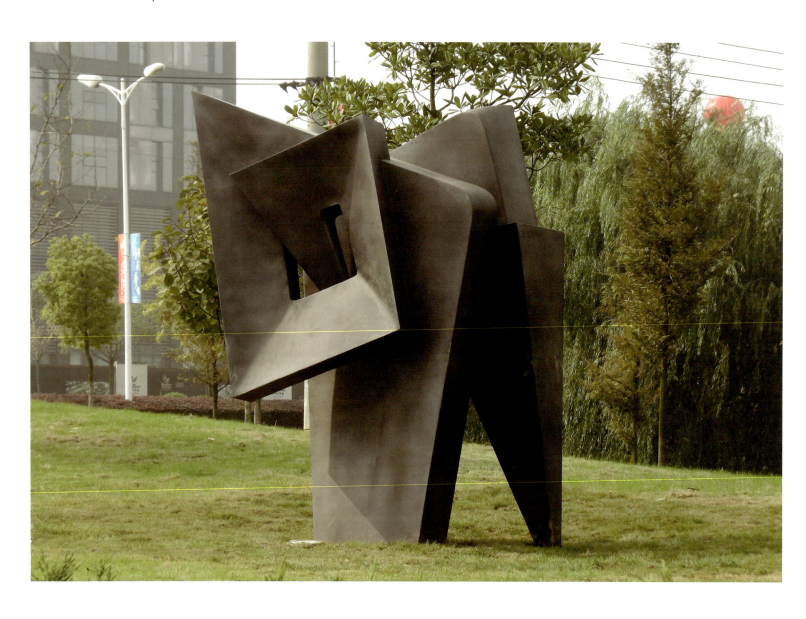

永恒 / Eternity

H: 3000mm

格蒂·塔万克修 Genti Tavanxhiu
意大利 Italy
雕塑 Sculpture

Italy
意大利

International Art Exhibition
国际美术展

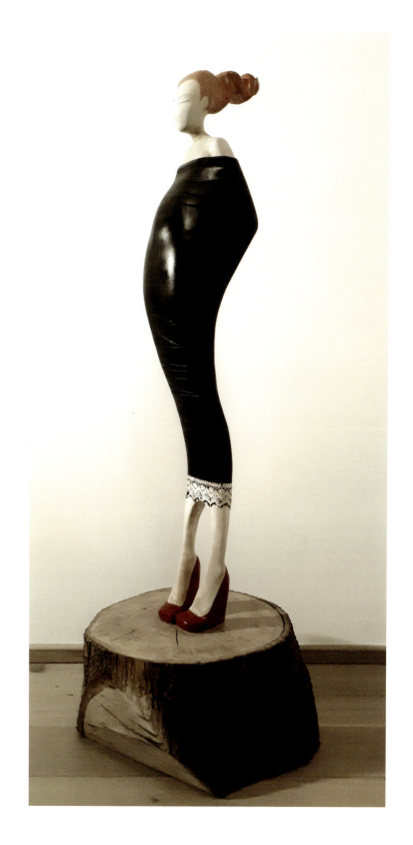

茧 / Cocoon
H：1500mm

拉拉·史蒂夫 | Lara Steffe
意大利 | Italy
雕塑 | Sculpture

Work Collection of Arts	The Sixth Silk Road International Arts Festival	Jamaica
美术作品集	第六届丝绸之路国际艺术节	牙买加

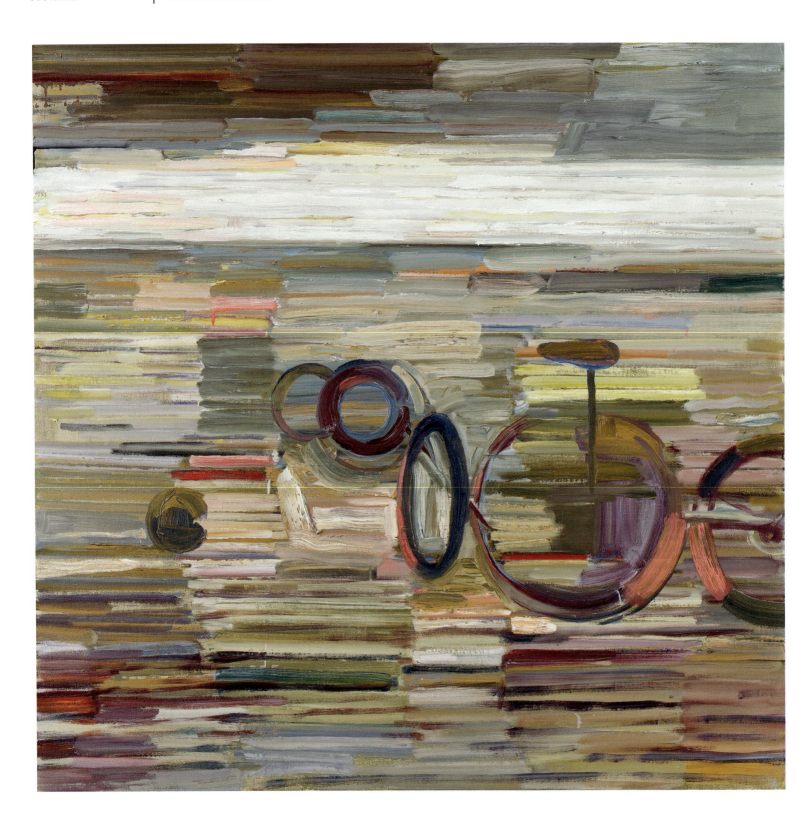

丝绸之路在四个轮子上 / Silk Road on Four Wheels

920mm x 1020mm

布莱恩·马克·法兰	Bryan Mc Farlane
牙买加	Jamaica
绘画	Painting

Japan

日本

International Art Exhibition

国际美术展

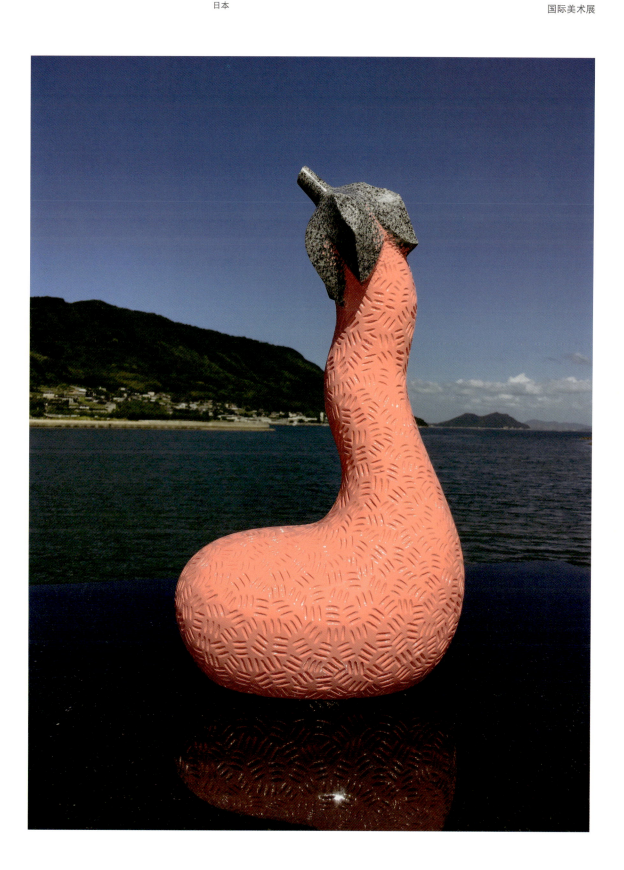

粉红茄子·拥抱 / Pink Eggplant·Hug

2100mm x 1250mm x 800mm

明甫多多	Akiho Tata
日本	Japan
雕塑	Sculpture

| Work Collection of Arts | The Sixth Silk Road International Arts Festival | Japan |
| 美术作品集 | 第六届丝绸之路国际艺术节 | 日本 |

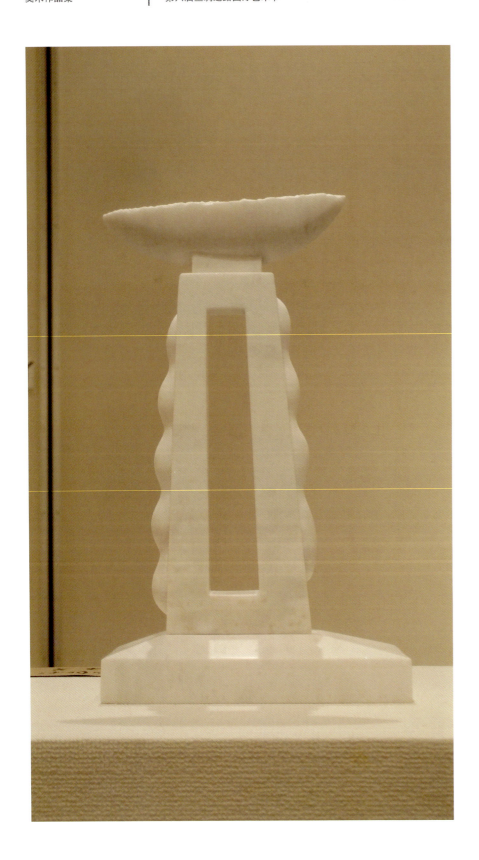

露水 / Moon Drops

500mm x 330mm x 170mm

田中等	Hitoshi Tanaka
日本	Japan
雕塑	Sculpture

Japan
日本

International Art Exhibition
国际美术展

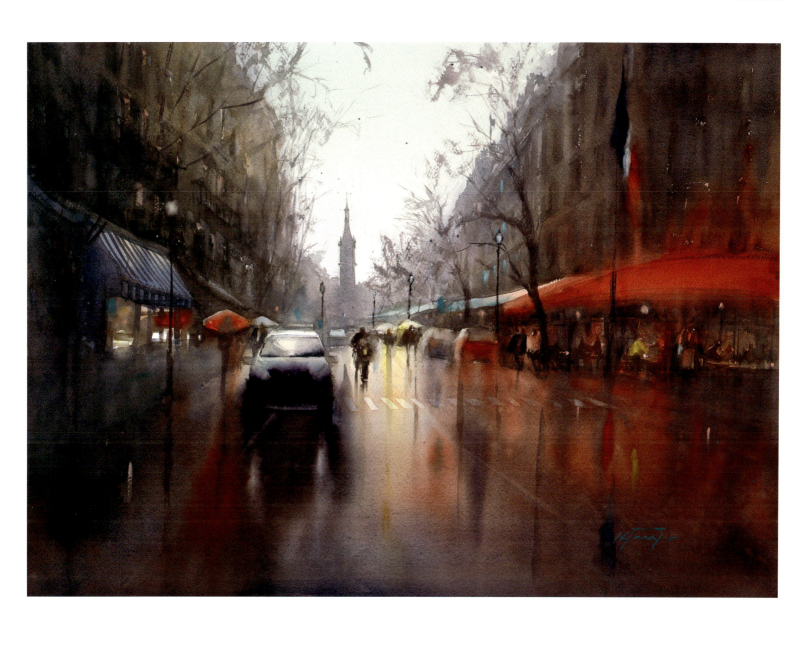

红伞 II / Red Umbrella II
550mm x 750mm

计子田边	Keiko Tanabe
日本	Japan
绘画	Painting

| Work Collection of Arts | The Sixth Silk Road International Arts Festival | Japan |
| 美术作品集 | 第六届丝绸之路国际艺术节 | 日本 |

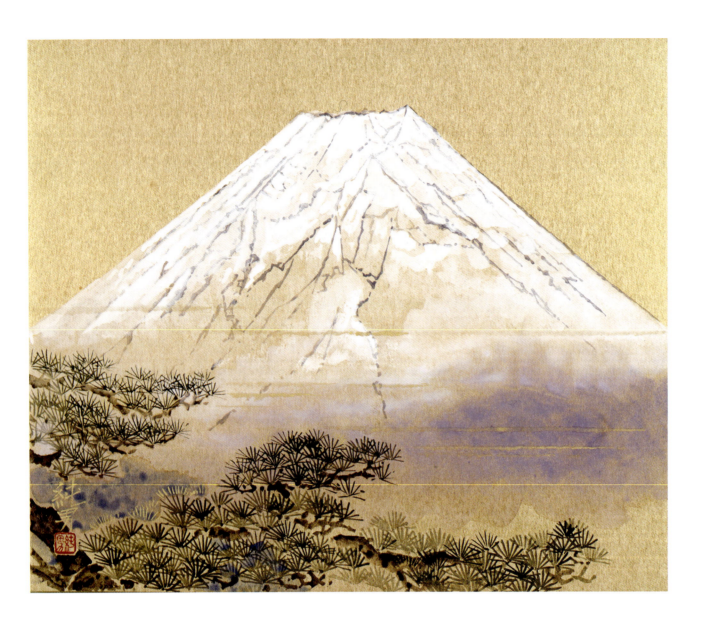

富士 / Fuji
580mm x 448mm

后藤纯男	Smi'omio Goto
日本	Japan
绘画	Painting

Jordan
约旦

International Art Exhibition
国际美术展

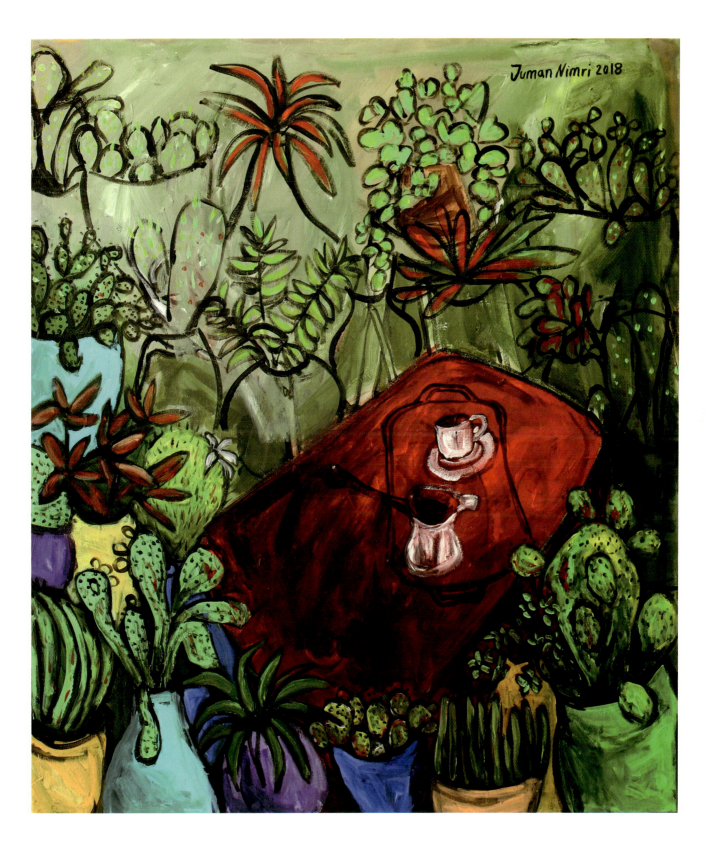

休憩时间 / Coffee Time
650mm x 750mm

朱曼·阿拉·尼米尔　Juman Al Nemr
约旦　Jordan
绘画　Painting

沉默 / Silence
500mm x 600mm

马拉·比克也 | Marat Bekeyev
哈萨克斯坦 | Kazakhstan
绘画 | Painting

Kenya
肯尼亚

International Art Exhibition
国际美术展

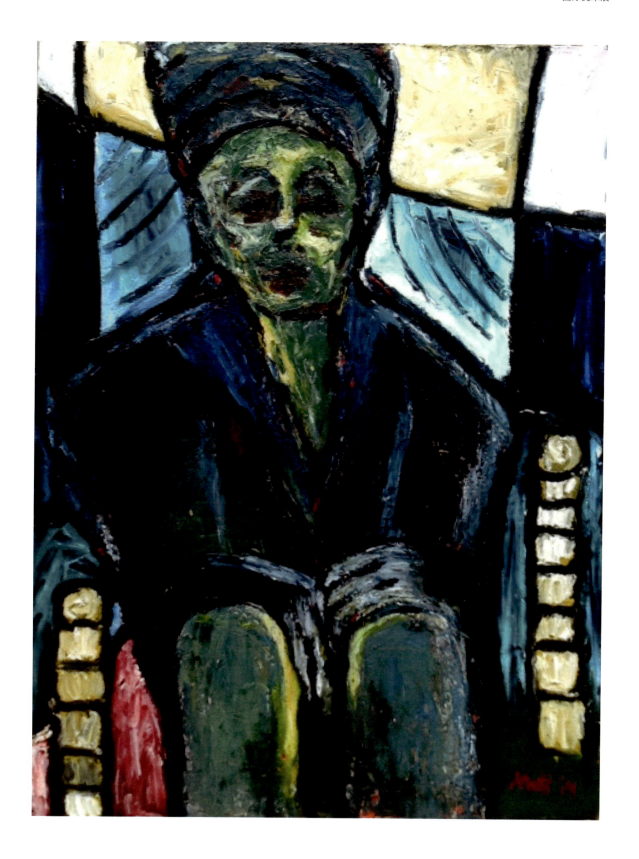

姆威蒂 / Mwiti
800mm x 600mm

安妮·姆威蒂 | Ainine Mwiti
肯尼亚 | Kenya
绘画 | Painting

Work Collection of Arts	The Sixth Silk Road International Arts Festival	Korea
美术作品集	第六届丝绸之路国际艺术节	韩国

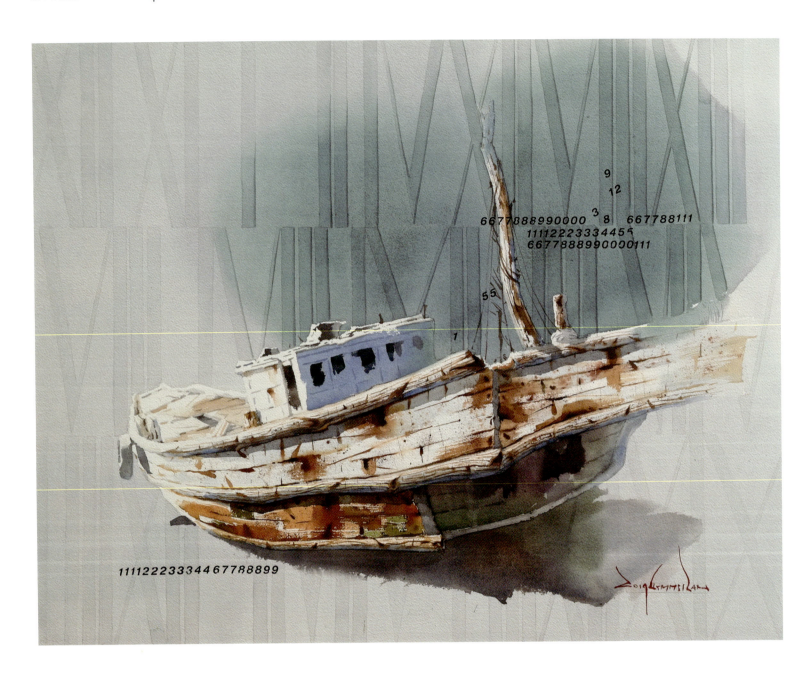

时间之旅 / Time Travel

900mm x 720mm

金美兰	Kim Mi Ran
韩国	Korea
绘画	Painting

Korea
韩国

International Art Exhibition
国际美术展

无题 / Unnamed
722mm x 606mm

李范宪 | Lee Bum Hun
韩国 | Korea
绘画 | Painting

| Work Collection of Arts | The Sixth Silk Road International Arts Festival | Korea |
| 美术作品集 | 第六届丝绸之路国际艺术节 | 韩国 |

花开 / Blooming
420mm x 620mm

李成玉	Lee Seong Ok
韩国	Korea
绘画	Painting

Korea // 韩国 // International Art Exhibition // 国际美术展

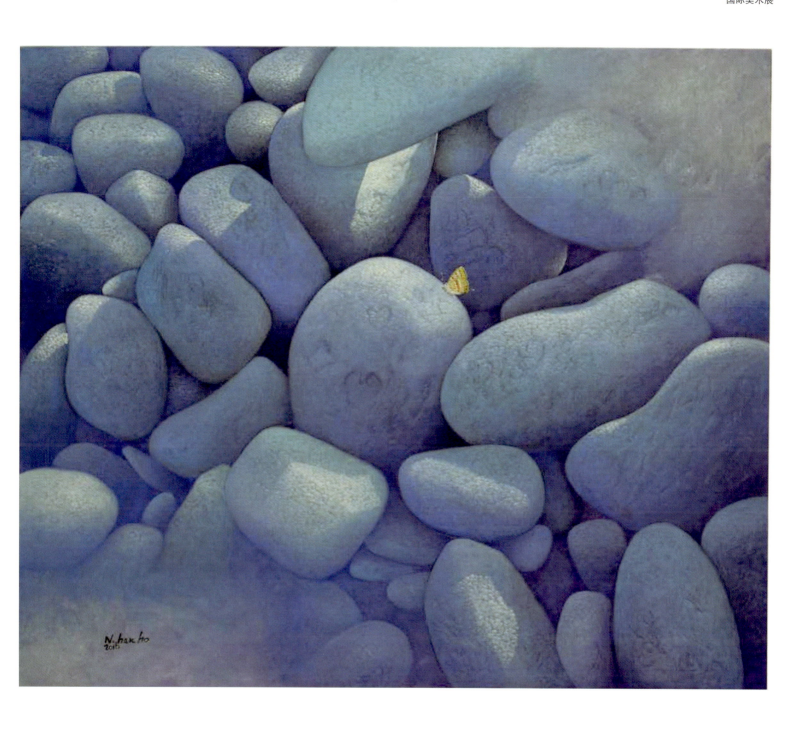

石心（生命）/ Stone Heart (Life)

南鹤浩 | Nan Hak Ho
韩国 | Korea
绘画 | Painting

| Work Collection of Arts | The Sixth Silk Road International Arts Festival | Korea |
| 美术作品集 | 第六届丝绸之路国际艺术节 | 韩国 |

梦想空间 / Dreaming of Space

4000mm x 4000mm x 3600mm

吴顺美	Oh Soonmi
韩国	Korea
混合材料	Composite Material

Kuwait 科威特 | International Art Exhibition 国际美术展

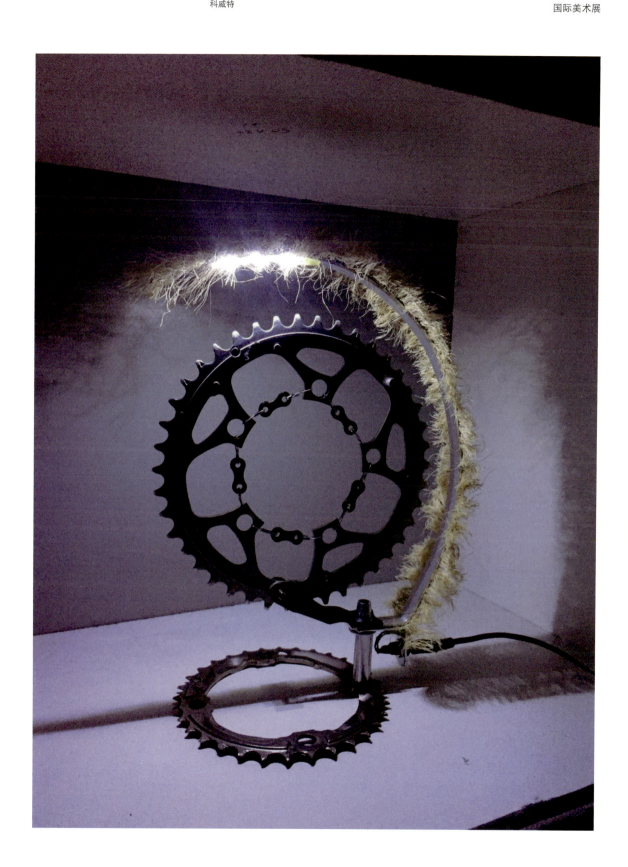

无题 / Unnamed
H:500mm

阿卜杜拉·阿纳瑟 / Abdulla Alnaser
科威特 / Kuwait
雕塑 / Sculpture

| Work Collection of Arts | The Sixth Silk Road International Arts Festival | Kyrgyzstan |
| 美术作品集 | 第六届丝绸之路国际艺术节 | 吉尔吉斯斯坦 |

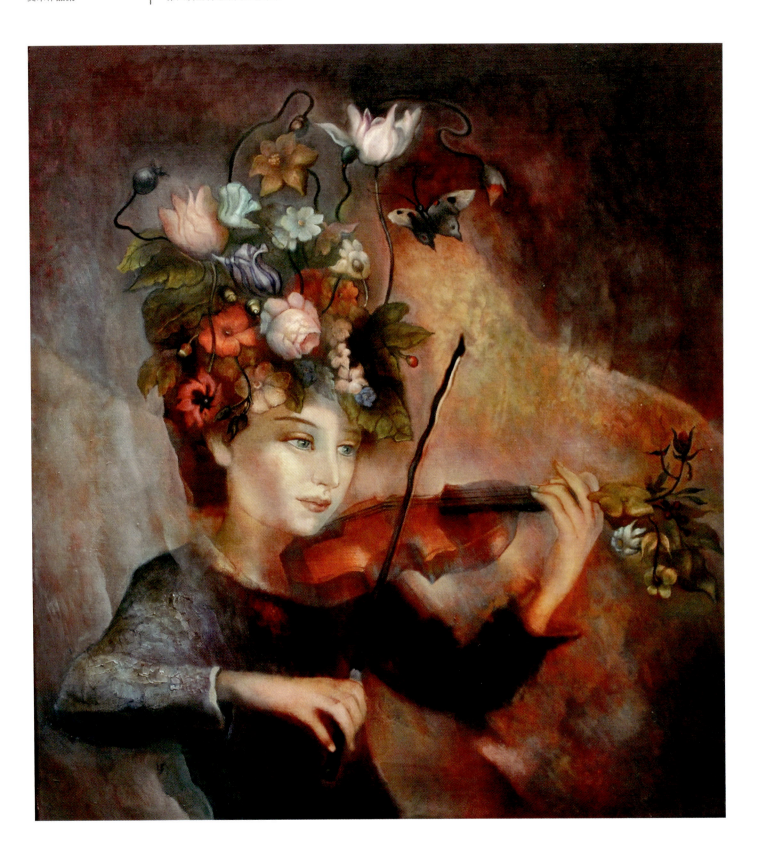

花·女孩 / Flower Girl
550mm x 600mm

弗拉基米尔·巴兰茨基科夫	Wladimir Barantschikov
吉尔吉斯斯坦	Kyrgyzstan
绘画	Painting

Latvia
拉脱维亚

International Art Exhibition
国际美术展

字符系列 / Characters Series
170mm x 130mm

冈塔拉斯·西丁斯 | Guntars Sietins
拉脱维亚 | Latvia
绘画 | Painting

湖 / The Lake

500mm x 600mm

艾策·斯米尔丁	Ilze Smildzin
拉脱维亚	Latvia
绘画	Painting

Lebanon / 黎巴嫩 — International Art Exhibition / 国际美术展

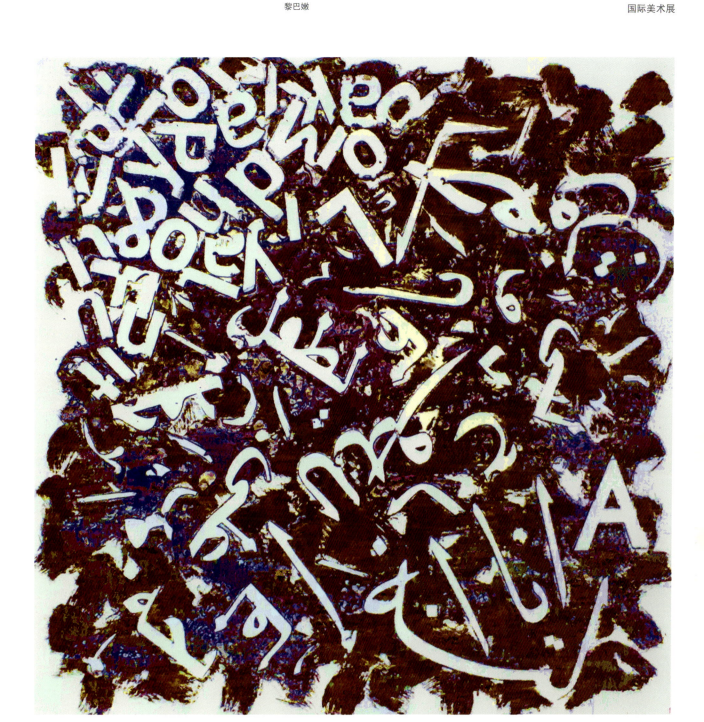

一带文化之旅 / Cultural Journey of the Belt

800mm x 800mm

列纳·凯勒基安 | Lena Kelekian
黎巴嫩 | Lebanon
绘画 | Painting

| Work Collection of Arts | The Sixth Silk Road International Arts Festival | Lebanon |
| 美术作品集 | 第六届丝绸之路国际艺术节 | 黎巴嫩 |

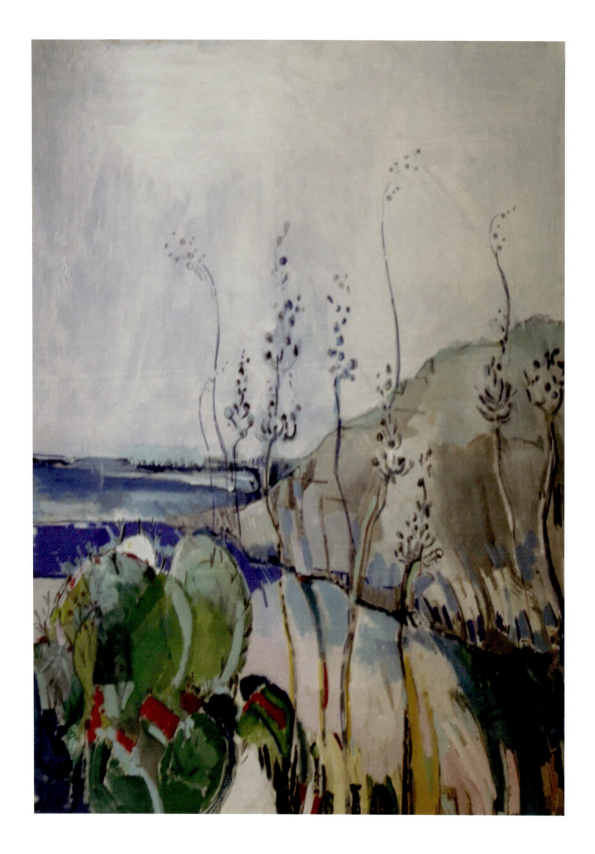

岛 / Island

500mm x 600mm

诺哈·萨姆斯丁 | Noha Shamseddine
黎巴嫩 | Lebanon
绘画 | Painting

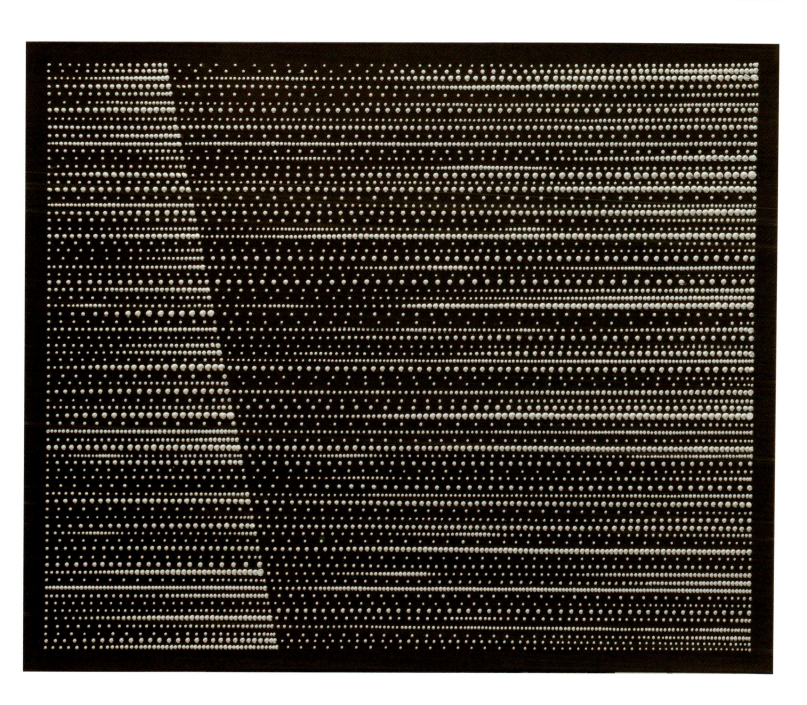

亚克力文字 –XX / Acrylic Scripts - XX
810mm x 1000mm

安塔纳斯·奥博卡萨斯 | Antanas Obcarskas
立陶宛 | Lithuania
绘画 | Painting

| **Work Collection of Arts** | The Sixth Silk Road International Arts Festival | Lithuania |
| 美术作品集 | 第六届丝绸之路国际艺术节 | 立陶宛 |

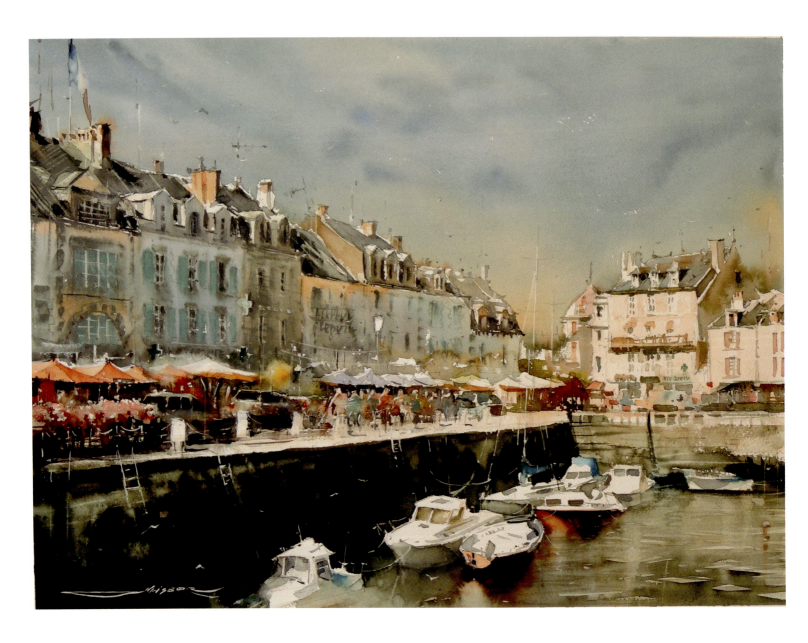

阿维尼翁，法国 / Avignon, France

490mm x 640mm

谢尔盖·雷瑟	Sergiy Lysyy
立陶宛	Lithuania
绘画	Painting

Luxembourg
卢森堡

International Art Exhibition
国际美术展

舞蹈系列 / The Dance Series
500mm x 500mm

谢尔盖·科赫 | Serge Koch
卢森堡 | Luxembourg
绘画 | Painting

Work Collection of Arts	The Sixth Silk Road International Arts Festival	Macedonia
美术作品集	第六届丝绸之路国际艺术节	马其顿

新兴形式 / Emerging Form

330mm x 330mm x 330mm

安德烈·米特夫斯基	Andrej Mitevski
马其顿	Macedonia
雕塑	Sculpture

Malaysia
马来西亚

International Art Exhibition
国际美术展

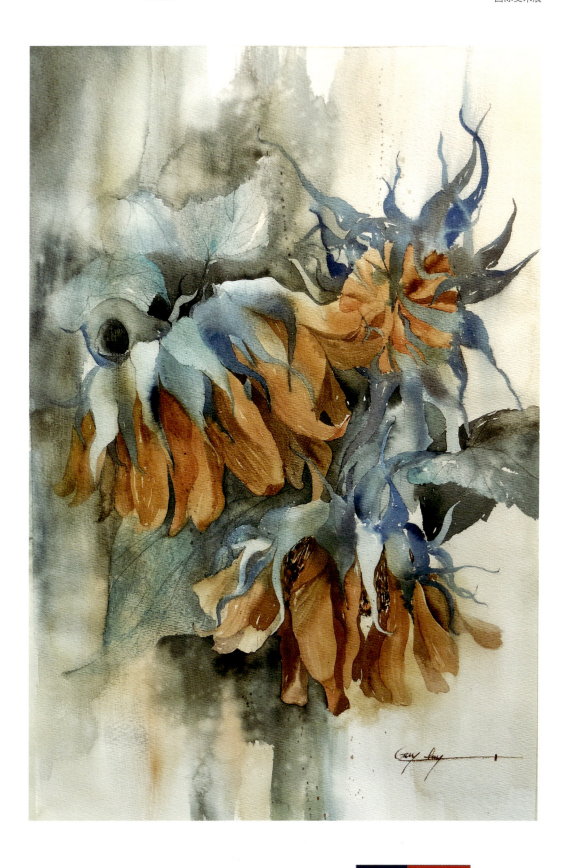

阳 #2 / The Sun #2
380mm x 560mm

郑伟翔 | Gray Tay Wei Xiang
马来西亚 | Malaysia
绘画 | Painting

Work Collection of Arts | The Sixth Silk Road International Arts Festival | Malaysia
美术作品集 | 第六届丝绸之路国际艺术节 | 马来西亚

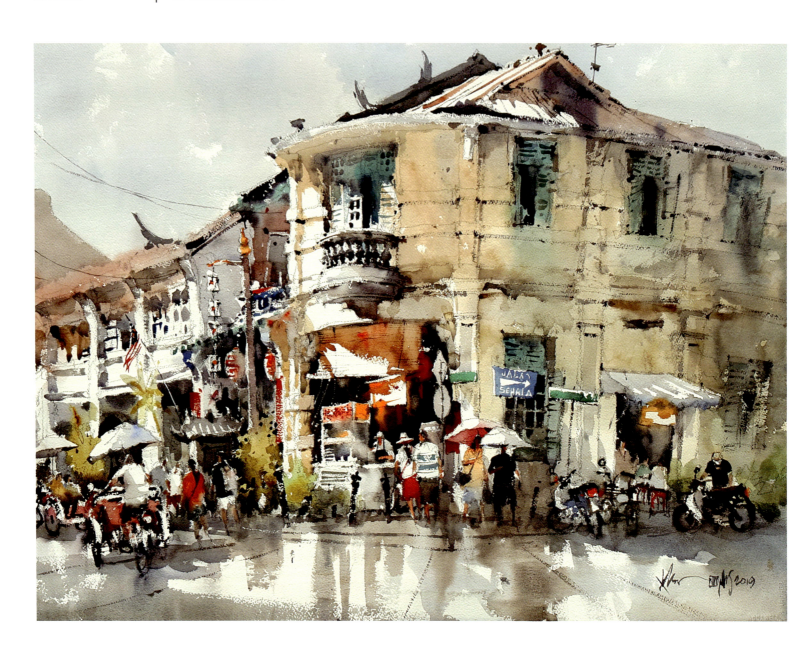

槟城老街 / Penang Heritage Street

560mm x 760mm

邱昌仁	Khoo Cheang Jin
马来西亚	Malaysia
绘画	Painting

Malaysia
马来西亚

International Art Exhibition
国际美术展

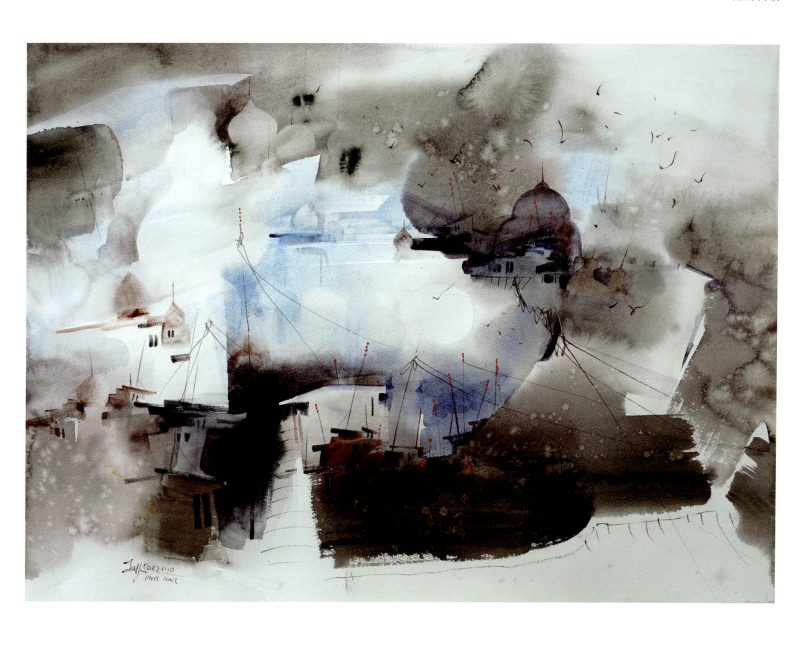

形色自如 #27 / Liberty #27
760mm x 560mm

杨觉昇 | Yeon Choon Seng
马来西亚 | Malaysia
绘画 | Painting

| Work Collection of Arts | The Sixth Silk Road International Arts Festival | Mexico |
| 美术作品集 | 第六届丝绸之路国际艺术节 | 墨西哥 |

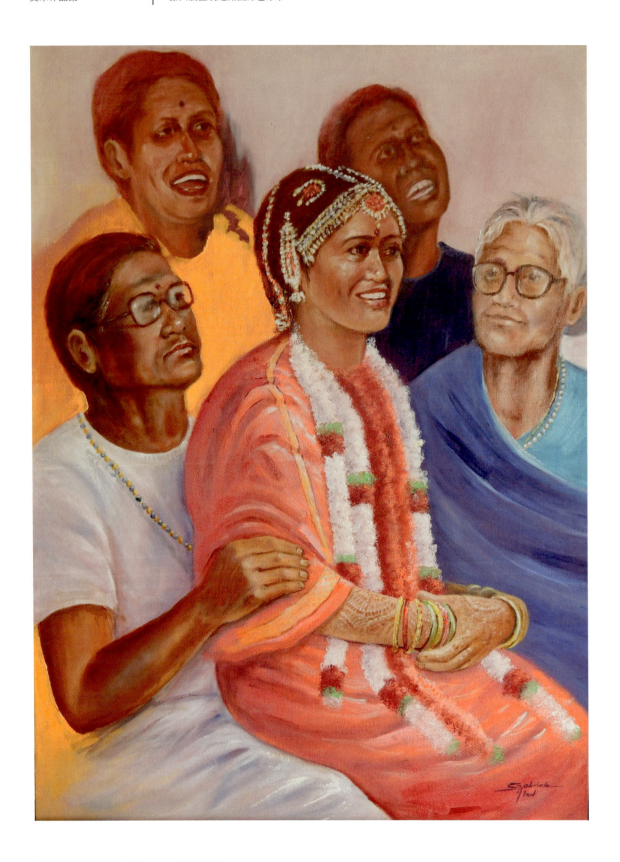

印度丝绸婚纱 / Indian Wedding with Silk Dress Crow

900mm x 600mm

加布里埃拉·阿布德	Gabriela Abud
墨西哥	Mexico
绘画	Painting

无题 / Unnamed

戈特弗里德·霍尔沃思
墨西哥
雕塑

Gottfried Hoellwarth
Mexico
Sculpture

| Work Collection of Arts | The Sixth Silk Road International Arts Festival | Mexico |
| 美术作品集 | 第六届丝绸之路国际艺术节 | 墨西哥 |

唱歌 / Canto a La Lue

8400mm x 5100mm x 5100mm

豪尔赫·埃利桑多	Jorge Elizondo
墨西哥	Mexico
雕塑	Sculpture

Mexico / 墨西哥 — International Art Exhibition / 国际美术展

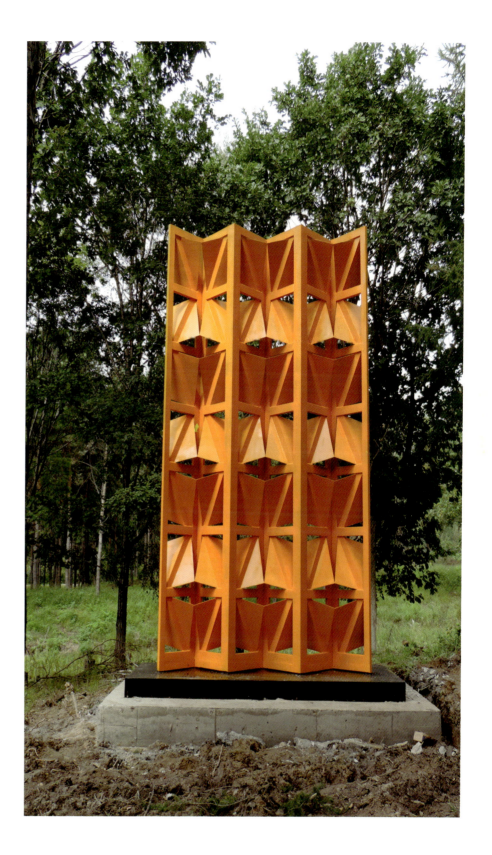

通河蝴蝶墙 / Tonghe Butterfly Wall
4200mm x 3050mm x 1220mm

佩德罗·马尔蒂斯 | Pedro Martinez
墨西哥 | Mexico
雕塑 | Sculpture

| Work Collection of Arts | The Sixth Silk Road International Arts Festival | Mexico |
| 美术作品集 | 第六届丝绸之路国际艺术节 | 墨西哥 |

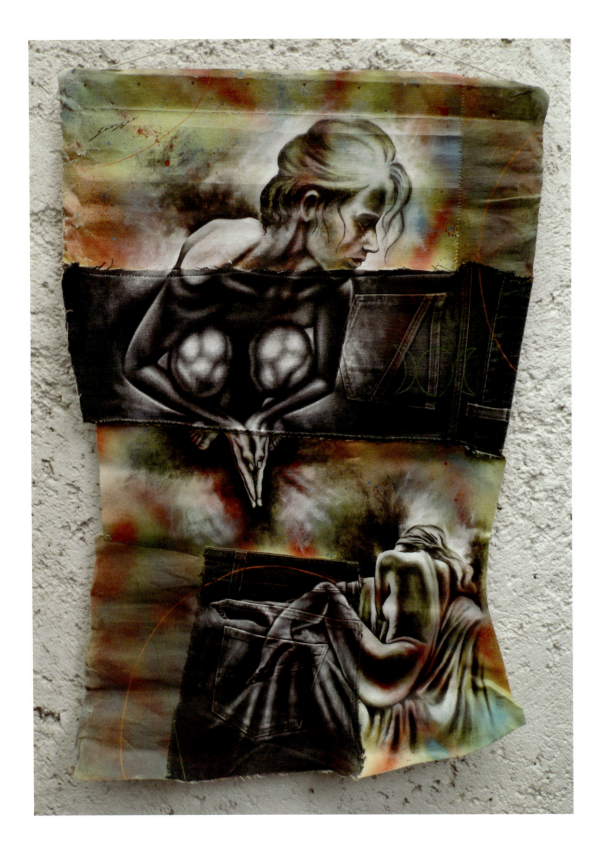

女神——秘密 / Goddess - Secrets

1000mm x 850mm

罗伯托·乔治	Roberto Georgge
墨西哥	Mexico
绘画	Painting

Moldova
摩尔多瓦

International Art Exhibition
国际美术展

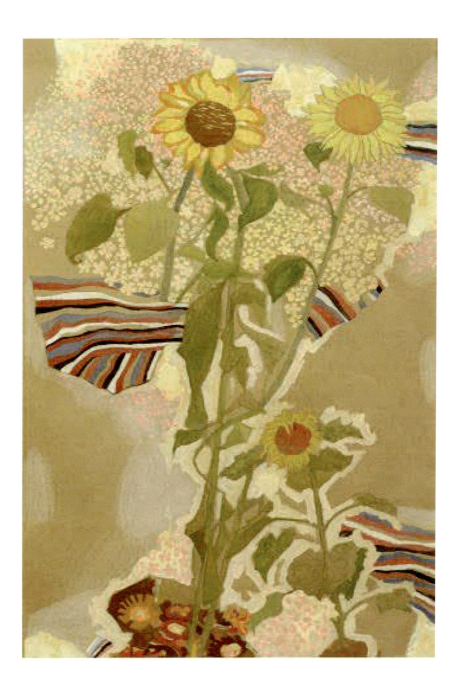

无题 / Unnamed

700mm x 430 mm

加霍斯·阿德里安娜·米拉贝拉　Gajos Adriana Mirabela
摩尔多瓦　Moldova
绘画　Painting

| Work Collection of Arts | The Sixth Silk Road International Arts Festival | Mongolia |
| 美术作品集 | 第六届丝绸之路国际艺术节 | 蒙古 |

内体星系 89 / Innerbody Galaxy 89

1000mm x 1000mm

恩科图夫辛·巴托尔	Enkhtuvshink Batbaatar
蒙古	Mongolia
绘画	Painting

Mongolia / 蒙古 — International Art Exhibition / 国际美术展

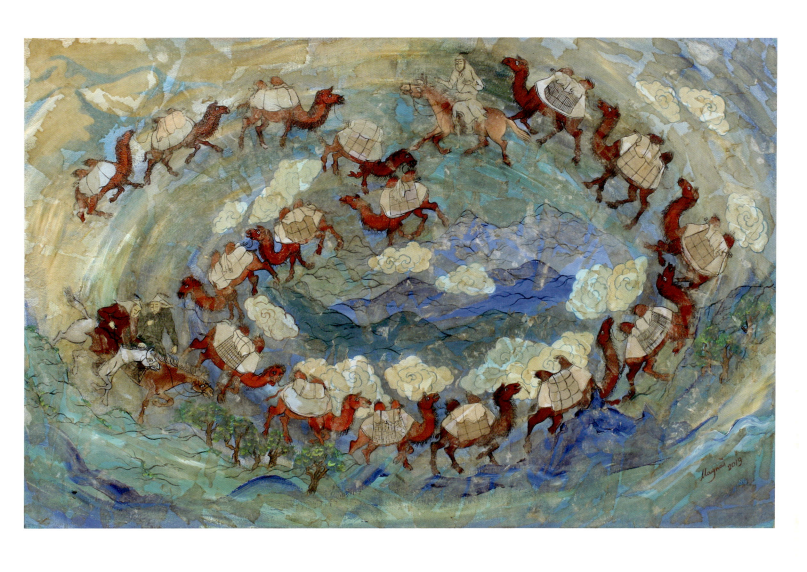

商队 / Caravan
500mm x 800mm

巴亚马尼亚·米亚格玛 | Bayarmagnai Myagmar
蒙古 | Mongolia
绘画 | Painting

Work Collection of Arts	The Sixth Silk Road International Arts Festival	Mongolia
美术作品集	第六届丝绸之路国际艺术节	蒙古

出行前 / Before Go out

500mm x 500mm

明安特塞格·L | Myangantsetseg L
蒙古 | Mongolia
绘画 | Painting

Mongolia / 蒙古 — International Art Exhibition / 国际美术展

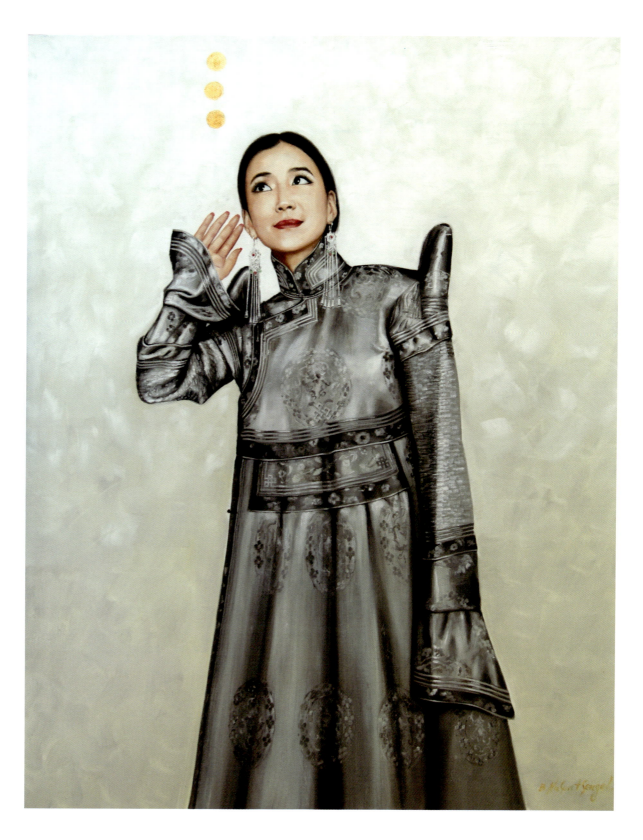

倾听 / Listening
899mm x 699mm

纳桑登格尔·巴颜喀拉 / Nasantsengel Bayanjargal
蒙古 / Mongolia
绘画 / Painting

Work Collection of Arts | The Sixth Silk Road International Arts Festival | Mongolia
美术作品集 | 第六届丝绸之路国际艺术节 | 蒙古

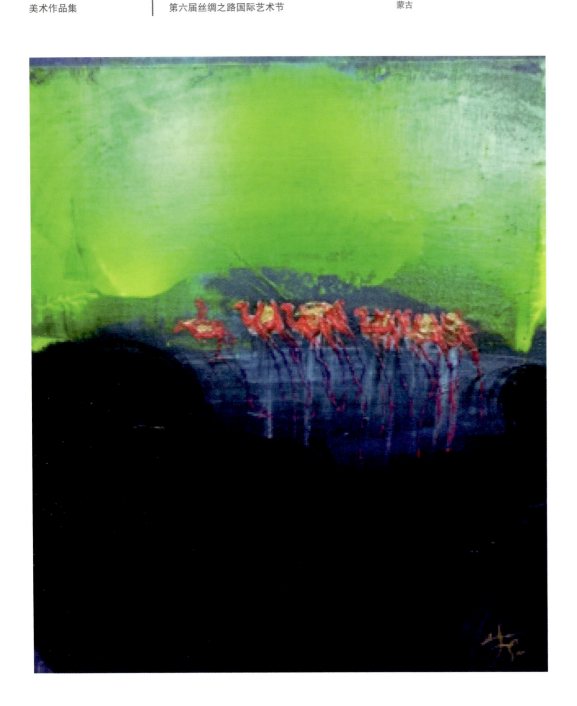

回家的路 / Way Back Home
300mm x 300mm

特塞格巴丹·巴巴亚尔 | Tsetsegbadam Batbayar
蒙古 | Mongolia
绘画 | Painting

Montenegro
黑山共和国

International Art Exhibition
国际美术展

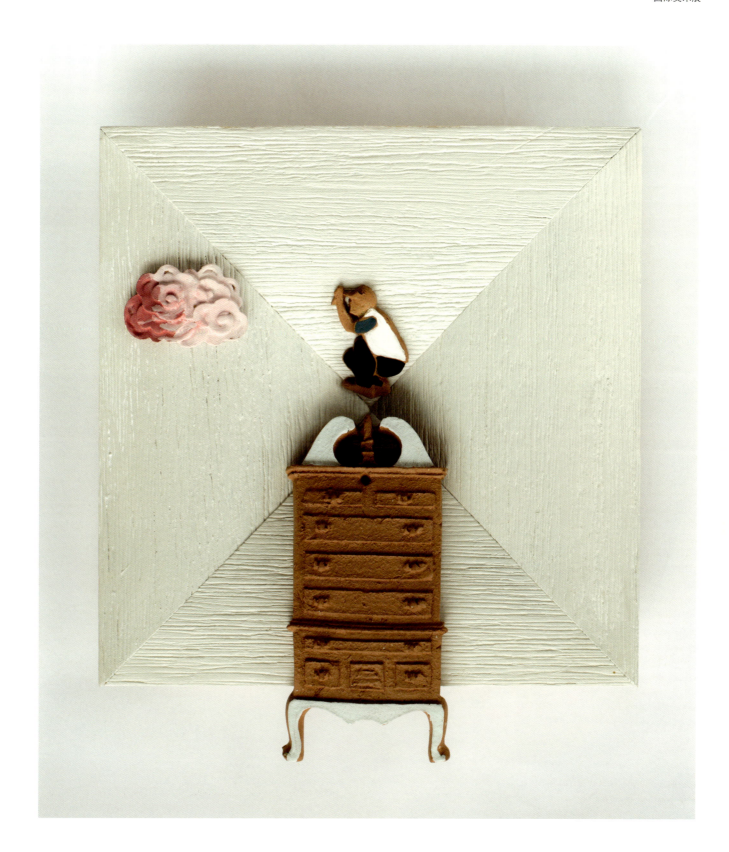

关于我自己 / About Myself
140mm x 155mm

米尔科娃	Miljkovac
黑山共和国	Montenegro
混合材料	Composite Material

超越表面 / Au-dela Des Apparences
1000mm x 1000mm

布塔勒·蒙尼亚 | Boutaleb Mounia
摩洛哥 | Morocco
绘画 | Painting

Myanmar / 缅甸

International Art Exhibition / 国际美术展

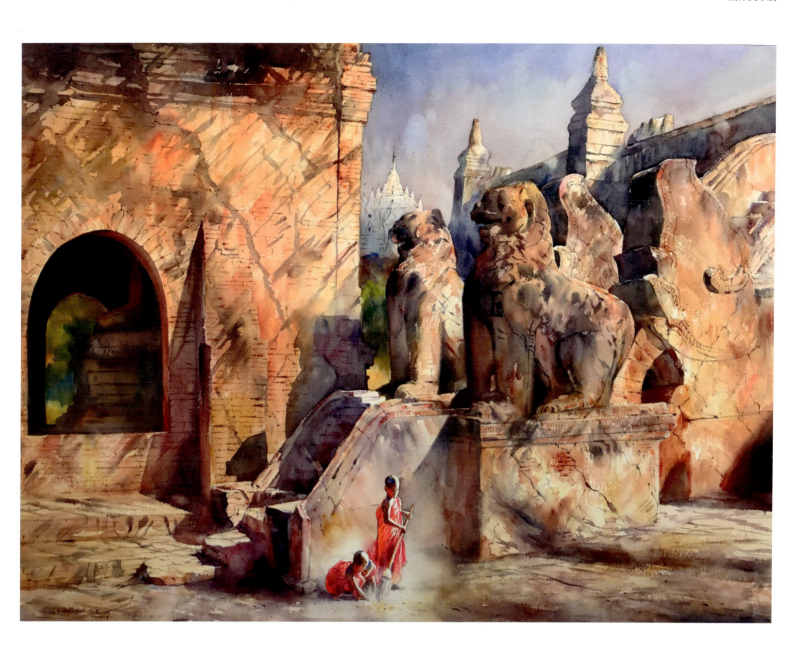

午后的蒲甘 / Afternoon in Bagan
750mm x 1000mm

琴芒皂 | Khin Maung Zaw
缅甸 | Myanmar
绘画 | Painting

Work Collection of Arts	The Sixth Silk Road International Arts Festival	Myanmar
美术作品集	第六届丝绸之路国际艺术节	缅甸

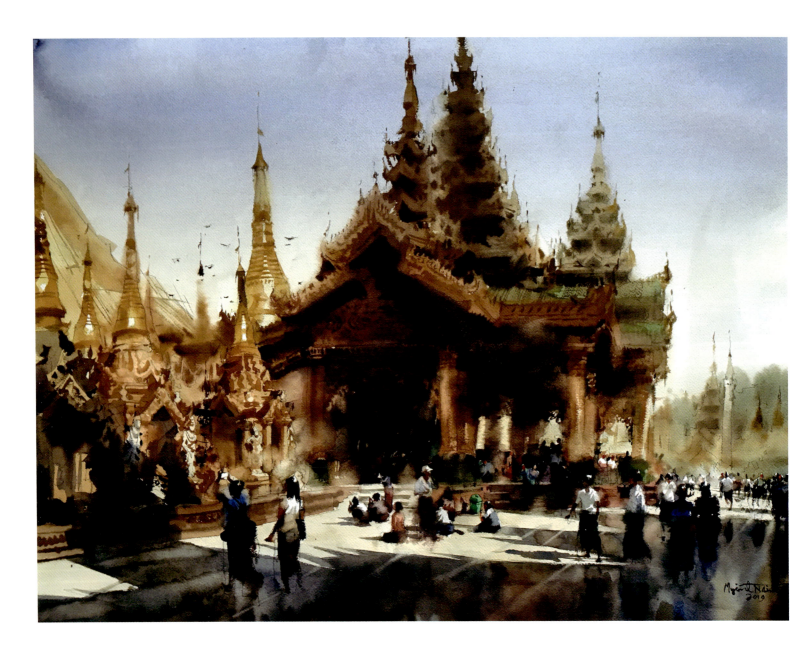

仰光大金塔平台 / Shwedagon Platform

550mm x 750mm

木因特·那英	Myint Naing
缅甸	Myanmar
绘画	Painting

Nepal / 尼泊尔　　　　International Art Exhibition / 国际美术展

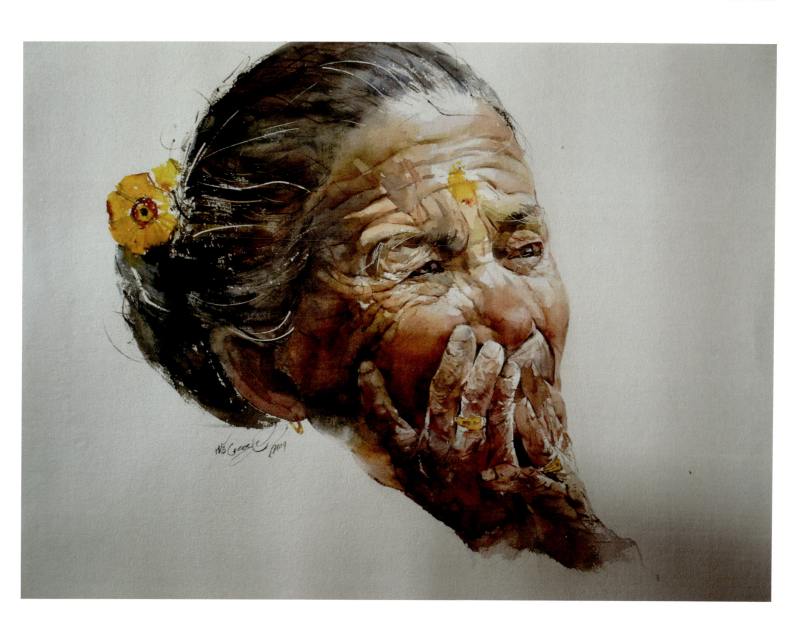

一位老妇人的画像 / Portrait of an Old Woman

560mm x 750mm

NB 高隆	NB Gurung
尼泊尔	Nepal
绘画	Painting

| Work Collection of Arts | The Sixth Silk Road International Arts Festival | Nepal |
| 美术作品集 | 第六届丝绸之路国际艺术节 | 尼泊尔 |

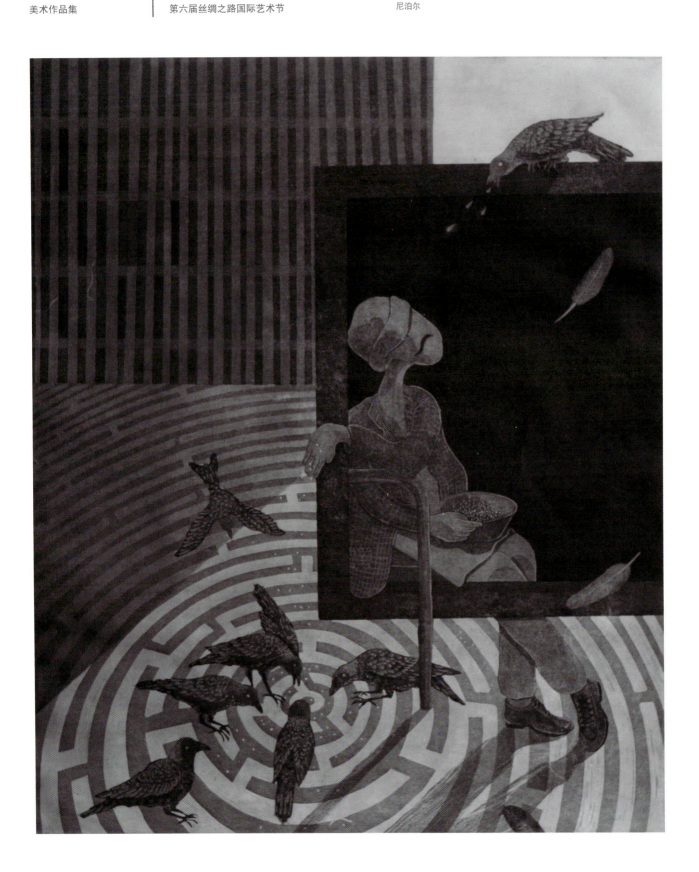

迷宫 / Maze
500mm x 600mm

金晖	Rabindra Khaniya
尼泊尔	Nepal
绘画	Painting

New Zealand / 新西兰 — International Art Exhibition / 国际美术展

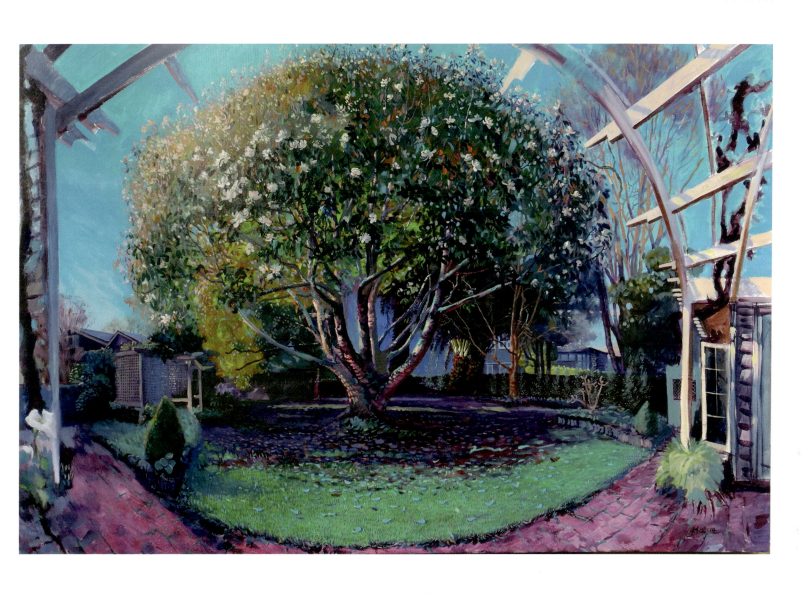

无题 / Unnamed

陈坚 | Jian Chen
新西兰 | New Zealand
绘画 | Painting

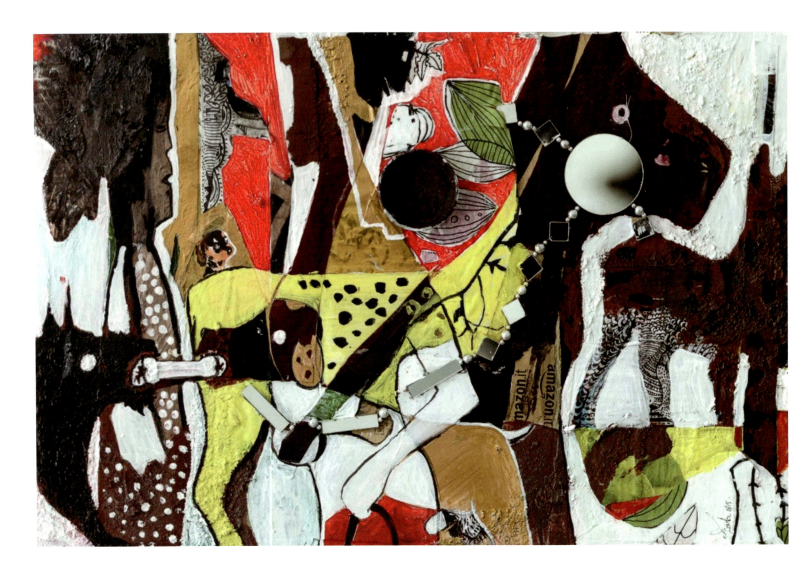

无题 / Unnamed

1200mm x 790mm

奥拉扬朱·达达	Olayanju Dada
尼日利亚	Nigeria
绘画	Painting

Nicaragua
尼加拉瓜

International Art Exhibition
国际美术展

LAT12N/LONG86W 系列 / LAT12N/ LONG86W Series

900mm x 600mm

帕特丽夏·维拉洛波斯·埃切弗里亚	Patricia Villalobos Echeverria
尼加拉瓜	Nicaragua
版画	Printing

| Work Collection of Arts | The Sixth Silk Road International Arts Festival | Nicaragua |
| 美术作品集 | 第六届丝绸之路国际艺术节 | 尼加拉瓜 |

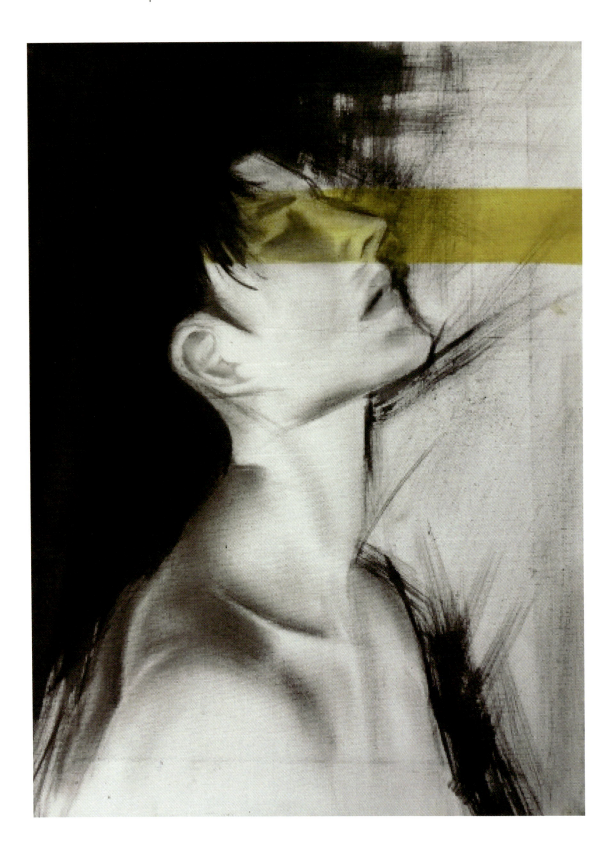

相亲 / Cita a Ciegas

300mm x 400mm

葛杉明　　　　Samuel Gadea
尼加拉瓜　　　Nicaragua
绘画　　　　　Painting

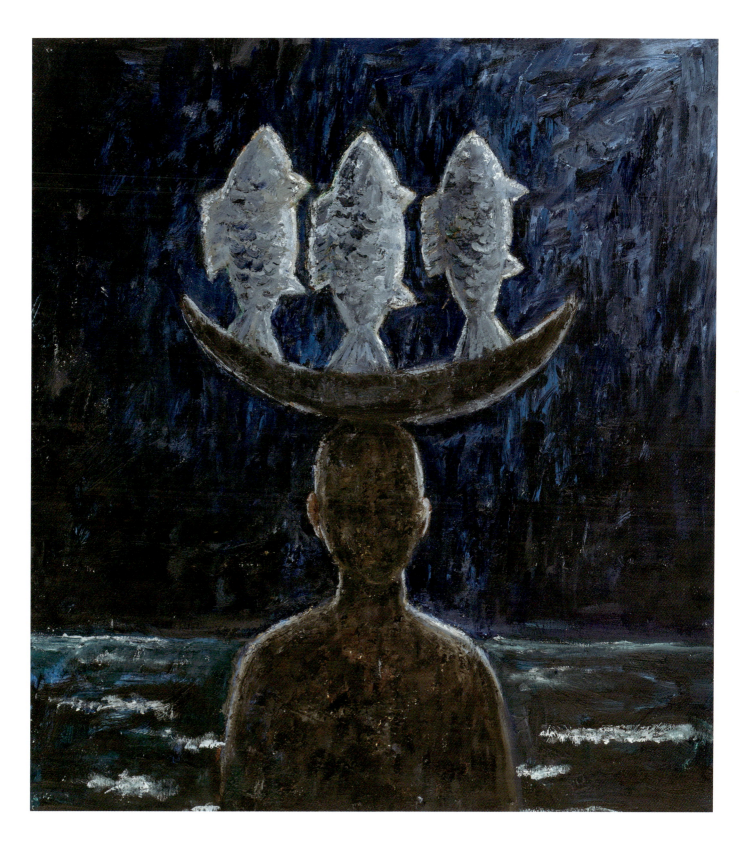

鱼 / Fish
850mm x 800mm

安琪·金 | Anki King
挪威 | Norway
绘画 | Painting

| Work Collection of Arts | The Sixth Silk Road International Arts Festival | Oman |
| 美术作品集 | 第六届丝绸之路国际艺术节 | 阿曼 |

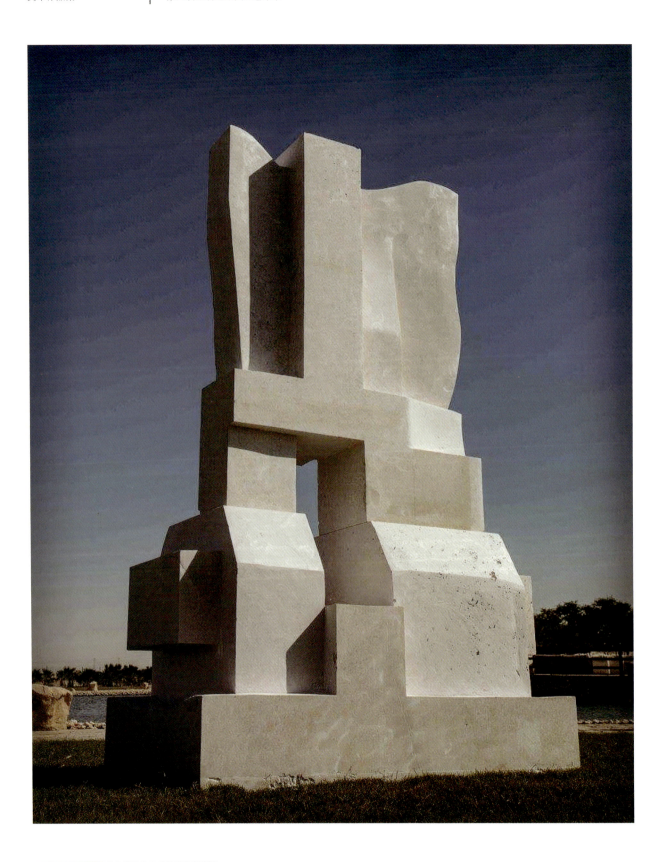

希望的斗争 / The Struggle of Hope

2300mm x 1900mm x 900mm

阿卜杜勒克勒姆	Abdulkareem
阿曼	Oman
雕塑	Sculpture

Oman / 阿曼 International Art Exhibition / 国际美术展

指南针 / Compass
2100mm x 1800mm x 1400mm

阿里·阿尔贾布里 | Ali Aljabri
阿曼 | Oman
雕塑 | Sculpture

Work Collection of Arts	The Sixth Silk Road International Arts Festival	Panama
美术作品集	第六届丝绸之路国际艺术节	巴拿马

逃生计划 / Plan de Escape

安东尼·乔司·古兹曼　　　　Antonio José Guzman
巴拿马　　　　　　　　　　Panama
版画　　　　　　　　　　　Printing

Paraguay
巴拉圭

International Art Exhibition
国际美术展

缺席 / Absent
570mm x 390mm

卢维埃·卡萨利 | Luvier Casali
巴拉圭 | Paraguay
绘画 | Painting

| Work Collection of Arts | The Sixth Silk Road International Arts Festival | Pakistan |
| 美术作品集 | 第六届丝绸之路国际艺术节 | 巴基斯坦 |

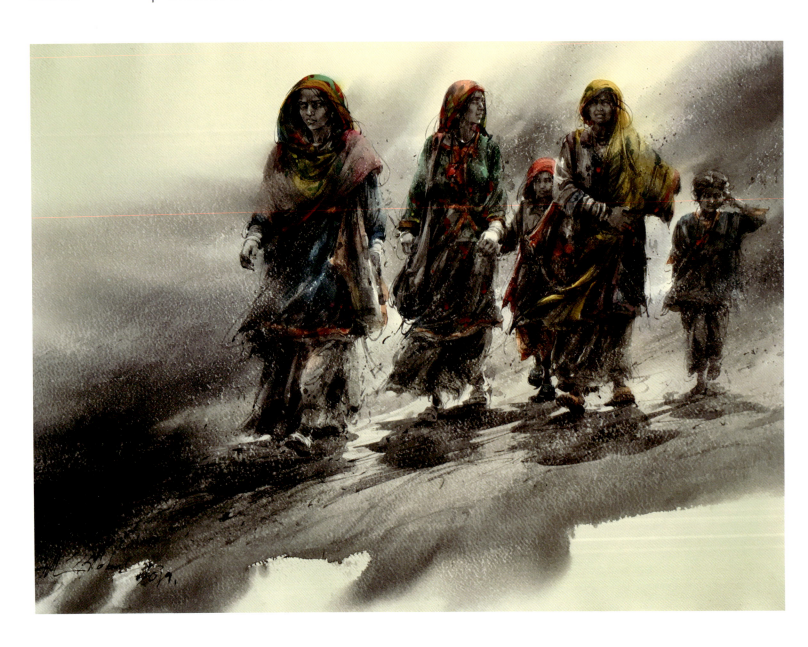

尘土飞扬的风 / Dusty Windy

220mm x 300mm

阿里·阿巴斯·赛义德	Ali Abbas Syed
巴基斯坦	Pakistan
绘画	Painting

Pakistan　　　　　　　　　　　　　　　　　　　　　　International Art Exhibition
巴基斯坦　　　　　　　　　　　　　　　　　　　　　　国际美术展

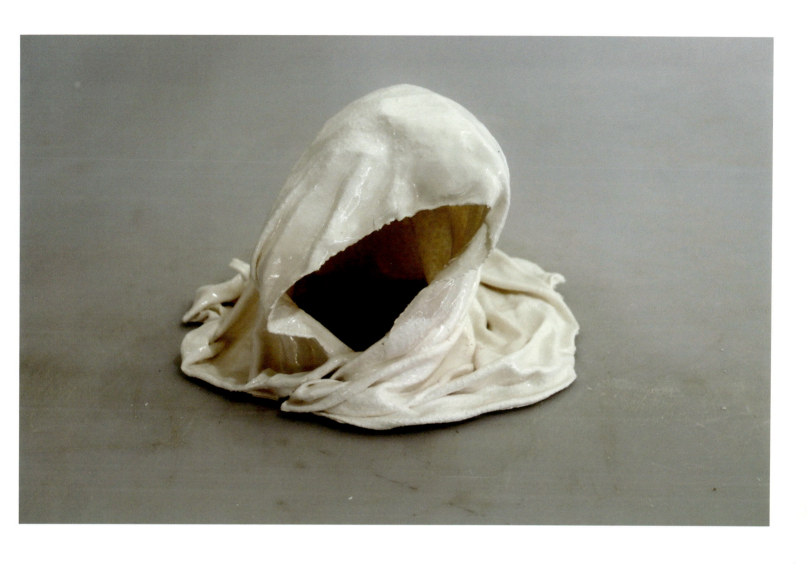

身份 / Identity
1600mm x 2600mm

安雪梅	Qurat ul Ain
巴基斯坦	Pakistan
雕塑	Sculpture

Work Collection of Arts	The Sixth Silk Road International Arts Festival	Peru
美术作品集	第六届丝绸之路国际艺术节	秘鲁

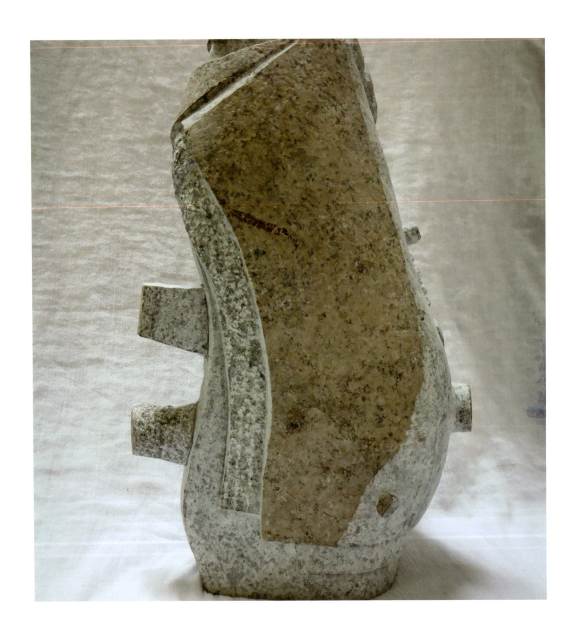

安第斯祖先的记忆 / Anden Ancestral Memory

430mm x 250mm x 180mm

巴伯罗·叶塔约	Pablo Yactayo
秘鲁	Peru
雕塑	Sculpture

Philippines / 菲律宾 — International Art Exhibition / 国际美术展

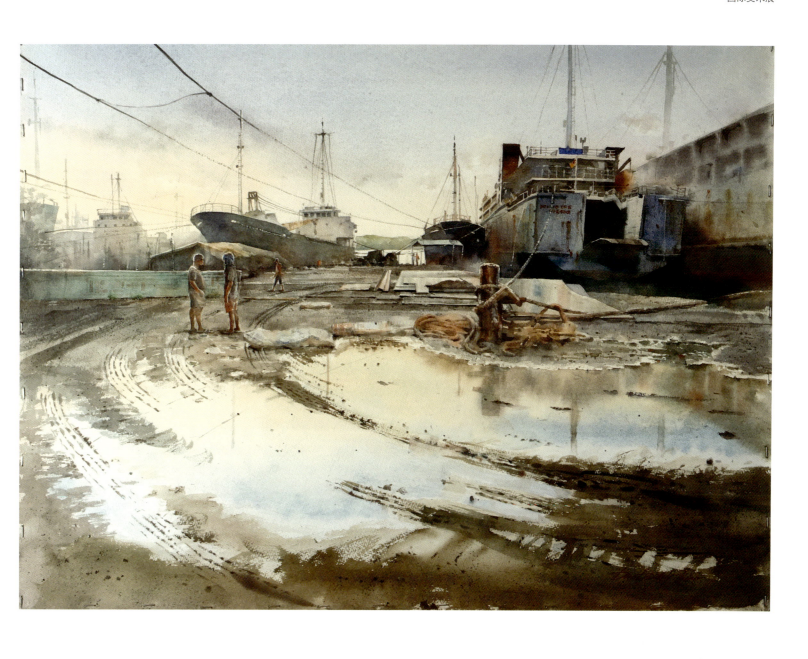

巴约·迪诺·但丁
菲律宾
绘画

蓝 / Blue
760mm x 560mm
Pajao Dino Dante
Philippines
Painting

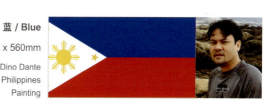

| Work Collection of Arts | The Sixth Silk Road International Arts Festival | Poland |
| 美术作品集 | 第六届丝绸之路国际艺术节 | 波兰 |

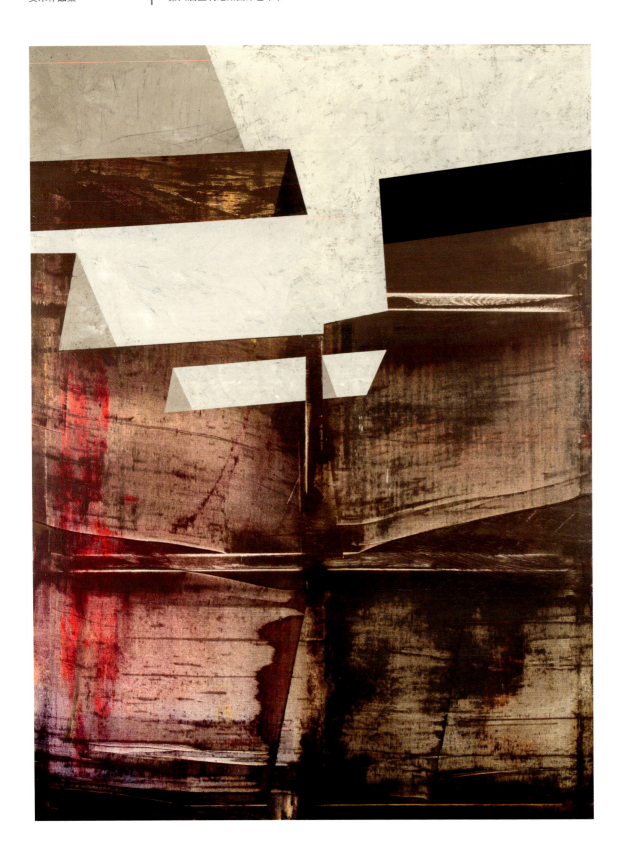

陆上逃生 – 01 / Land Escape - 01

640mm x 920mm

克孜斯托夫·莫伦达	Krzysztof Molenda
波兰	Poland
绘画	Painting

Poland
波兰

International Art Exhibition
国际美术展

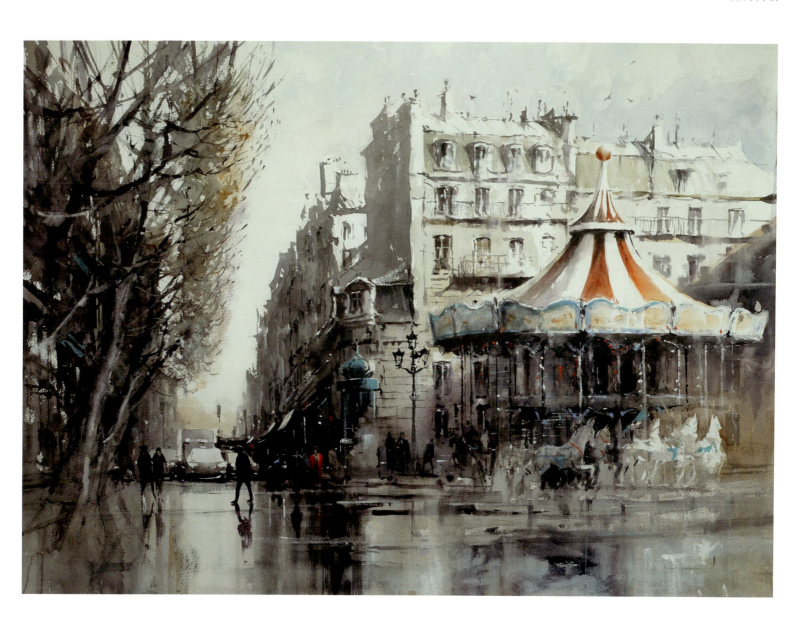

旋转木马 / Merry-Go-Round

500mm x 700mm

麦克·加斯威克斯 | Michal Jasiewicz
波兰 | Poland
绘画 | Painting

| Work Collection of Arts / 美术作品集 | The Sixth Silk Road International Arts Festival / 第六届丝绸之路国际艺术节 | Portugal / 葡萄牙 |

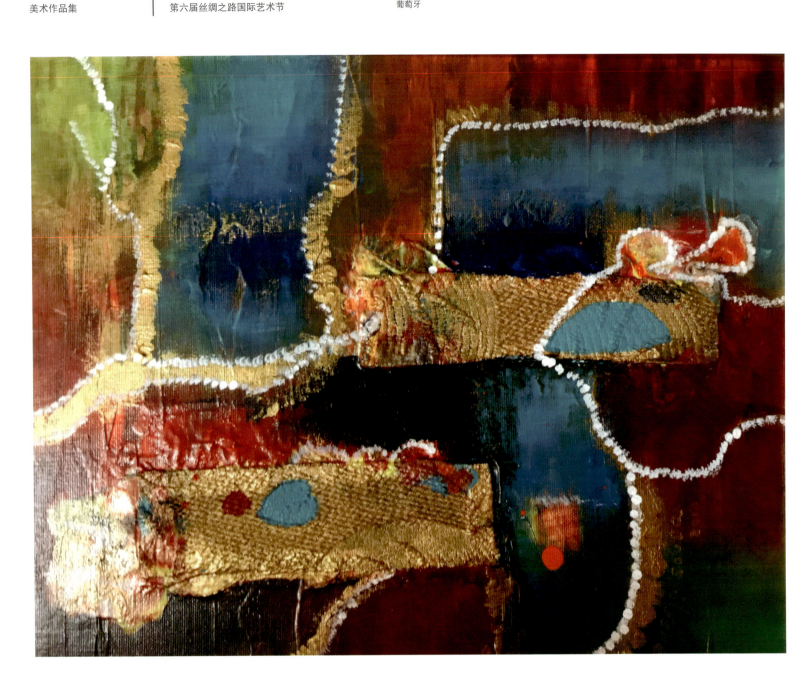

埃斯特拉达·达·塞达 / Estrada Da Seda

300mm x 400mm

伊洛·苏萨　　　Josefa Sousa
葡萄牙　　　　　Portugal
绘画　　　　　　Painting

Portugal / 葡萄牙 — International Art Exhibition / 国际美术展

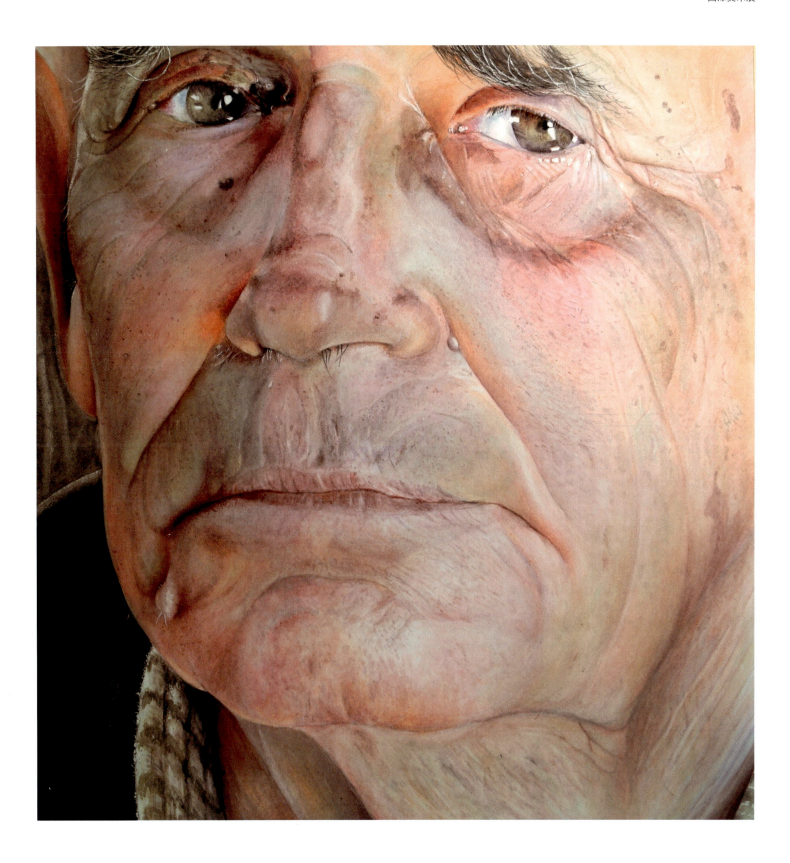

面对我的村庄 / **Faces of My Village**
420mm x 440mm

朱利奥·豪尔赫 | Júlio Jorge
葡萄牙 | Portugal
绘画 | Painting

Work Collection of Arts	The Sixth Silk Road International Arts Festival	Romania
美术作品集	第六届丝绸之路国际艺术节	罗马尼亚

我们到了么？/ Are We Where Yet?

1000mm x 500mm

克里斯蒂·法卡斯	Cristi Farcas
罗马尼亚	Romania
绘画	Painting

Romania / 罗马尼亚 — International Art Exhibition / 国际美术展

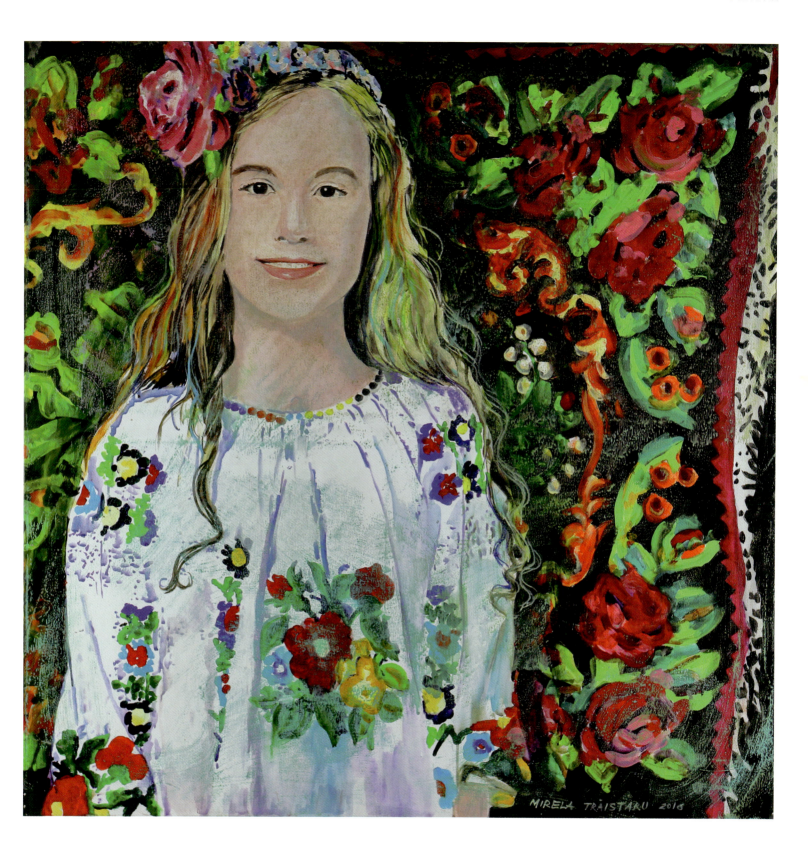

遗产 2 / Heritaje 2
1000mm x 1000mm

米雷拉·特雷斯塔鲁 | Mirela Traistaru
罗马尼亚 | Romania
绘画 | Painting

Work Collection of Arts	The Sixth Silk Road International Arts Festival	Romania
美术作品集	第六届丝绸之路国际艺术节	罗马尼亚

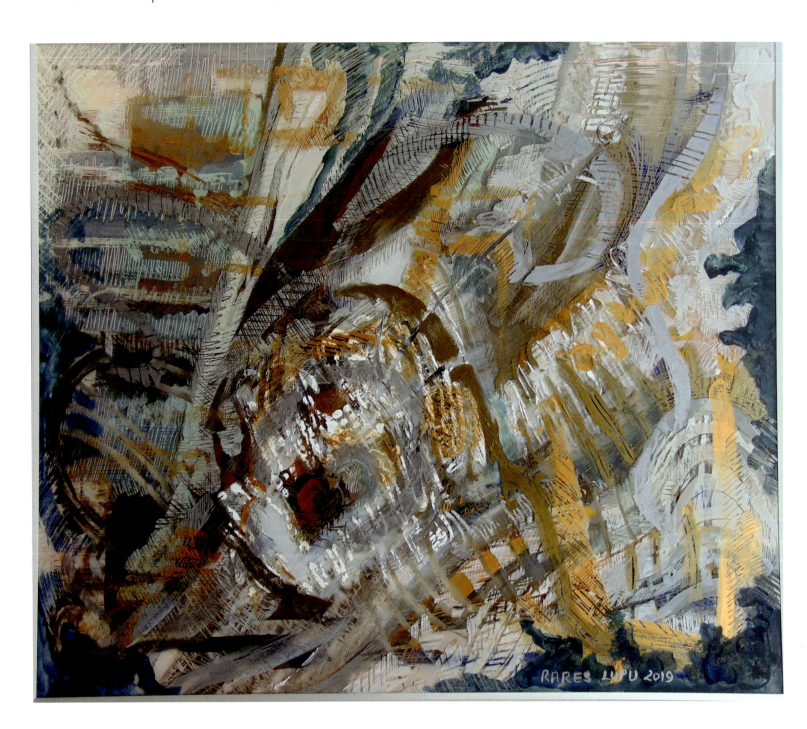

金色地图 / Golden Map

500mm x 700mm

拉鲁·普普	Rares Lupu
罗马尼亚	Romania
绘画	Painting

Russia / 俄罗斯 — International Art Exhibition / 国际美术展

家庭 / **Family**
6000mm x 1000mm x 400mm

格列博·杜萨维茨基 | Gleb Dusavitskiy
俄罗斯 | Russia
雕塑 | Sculpture

Work Collection of Arts	The Sixth Silk Road International Arts Festival	Russia
美术作品集	第六届丝绸之路国际艺术节	俄罗斯

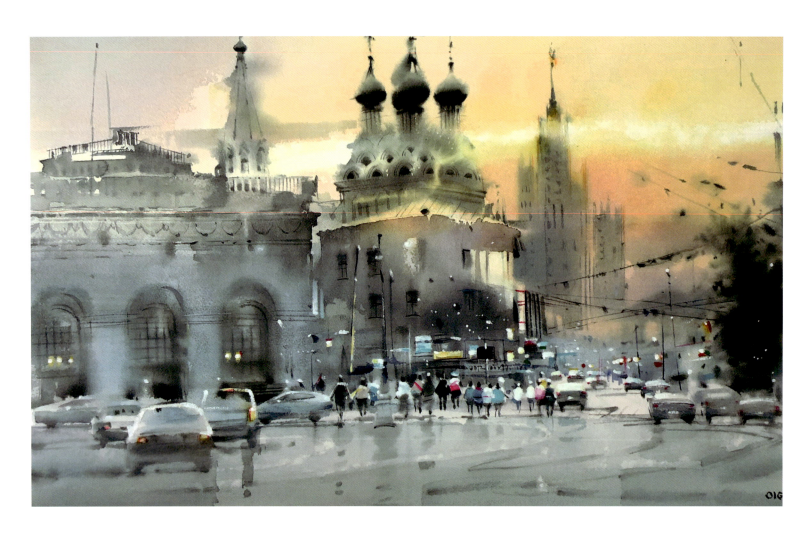

塔甘斯卡亚广场日落 / Sunset on Taganskaya Square

500mm x 720mm

利特维年科·奥尔加　　Litvinenko Olga
俄罗斯　　　　　　　　Russia
绘画　　　　　　　　　Painting

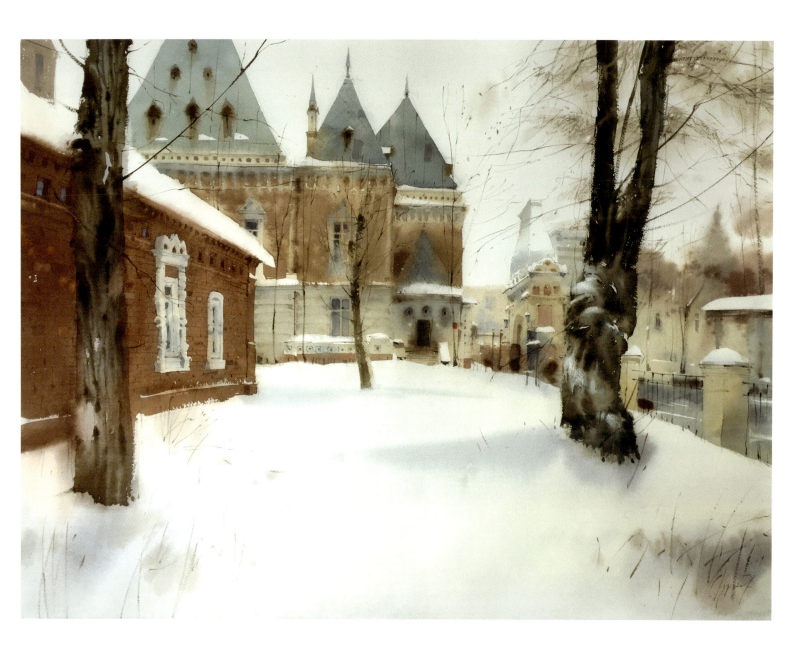

三月初拜访舒金先生 / Visit to Mr. Schukin at the Beginning of March

540mm x 730mm

谢尔盖·库尔巴托夫 | Sergei Kurbatov
俄罗斯 | Russia
绘画 | Painting

Work Collection of Arts	The Sixth Silk Road International Arts Festival	Russia
美术作品集	第六届丝绸之路国际艺术节	俄罗斯

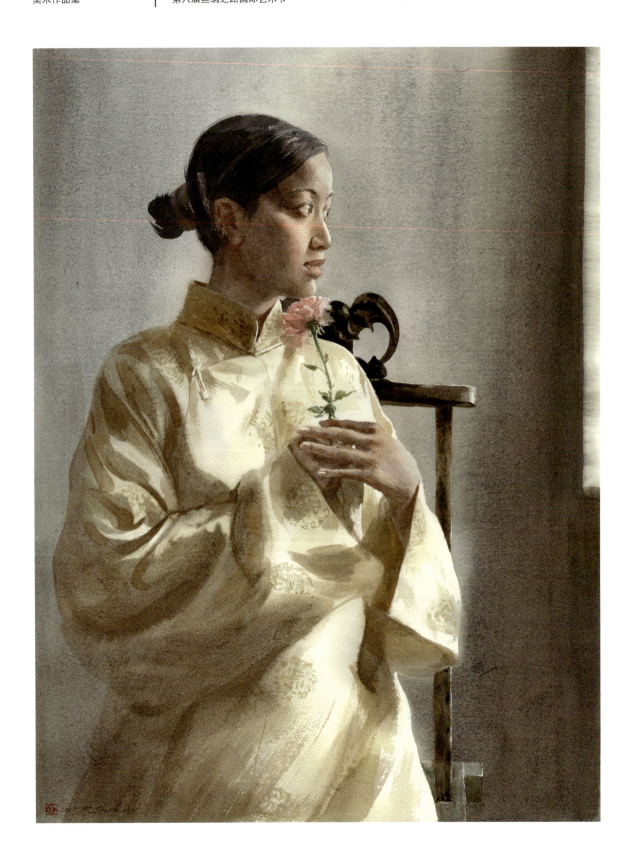

丝绸之路回忆 –1 / Silk Road Reminiscences-1

530mm x 730mm

斯特霍夫·康斯坦丁	Sterkhov Konstantin
俄罗斯	Russia
绘画	Painting

Rwanda / 卢旺达

International Art Exhibition / 国际美术展

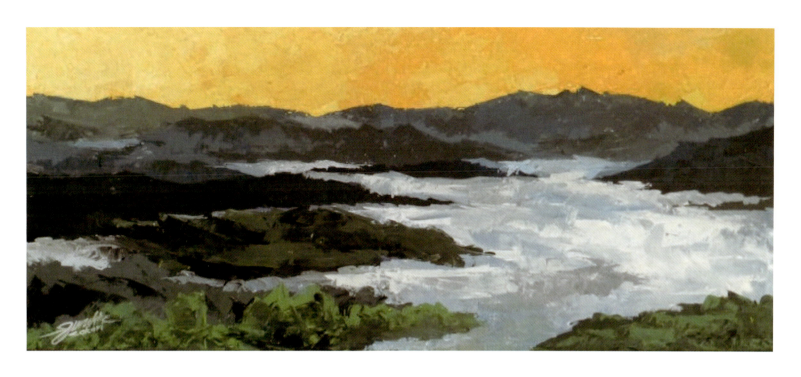

风景 / Landscape
2000mm x 800mm

尤马希尔·艾萨卡里 | Umuhire Isakari
卢旺达 | Rwanda
绘画 | Painting

| Work Collection of Arts | The Sixth Silk Road International Arts Festival | Saudi Arabia |
| 美术作品集 | 第六届丝绸之路国际艺术节 | 沙特阿拉伯 |

无题 / Unnamed

云芸	Aisha Yun
沙特阿拉伯	Saudi Arabia
绘画	Painting

Saudi Arabia
沙特阿拉伯

International Art Exhibition
国际美术展

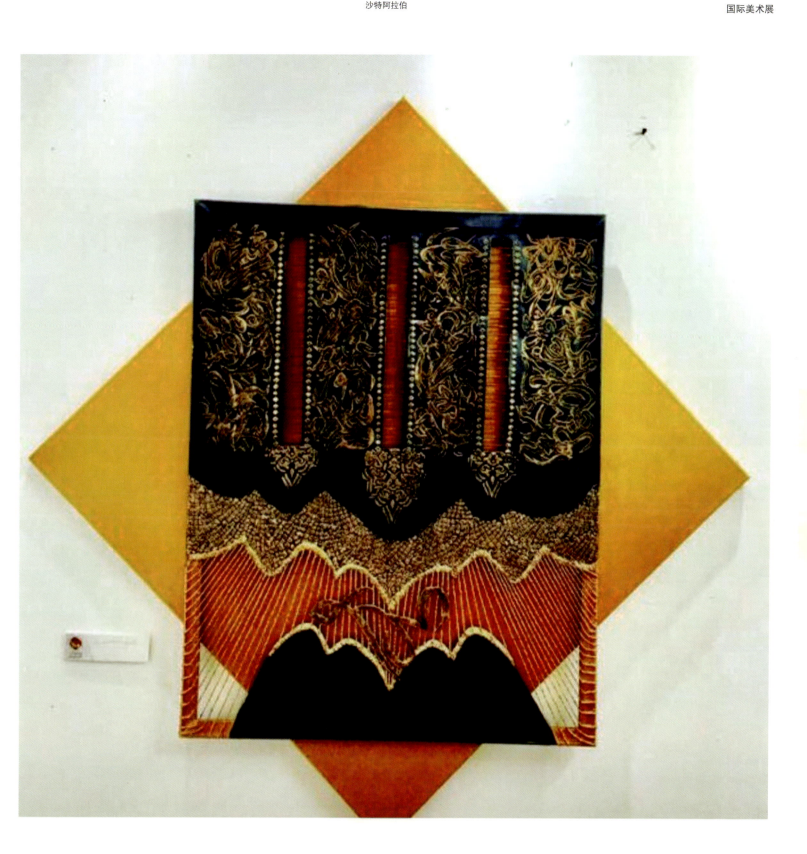

生命之门 / The Door of Life
600mm x 800mm

纳希瓦·拉希德 | Najwa Rasheed
沙特阿拉伯 | Saudi Arabia
绘画 | Painting

Work Collection of Arts	The Sixth Silk Road International Arts Festival	Serbia
美术作品集	第六届丝绸之路国际艺术节	塞尔维亚

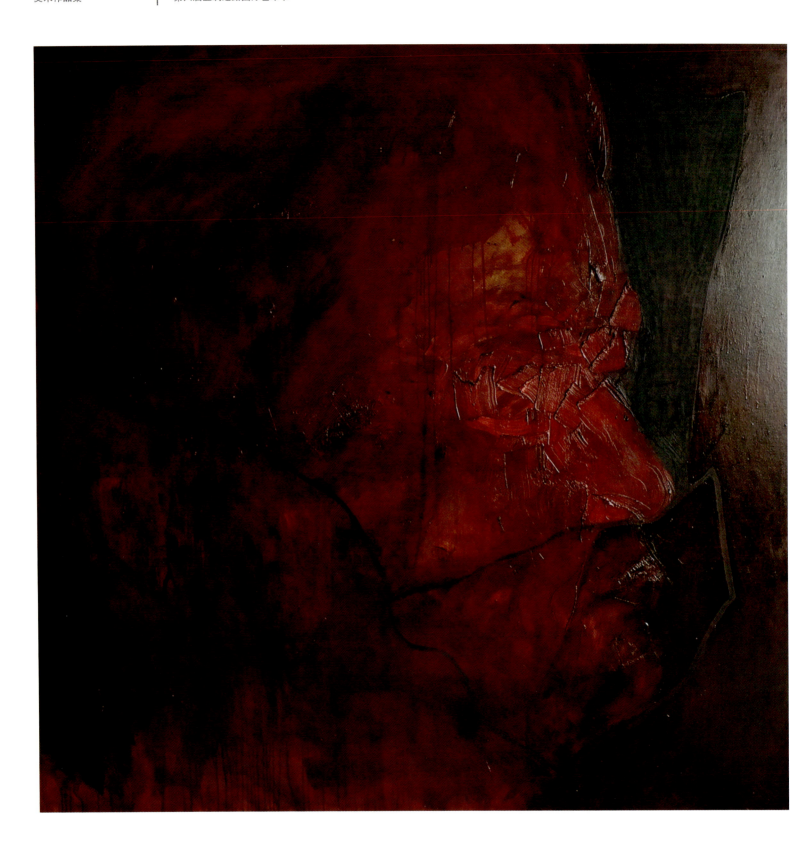

 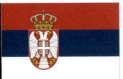

父亲 / Father
1600mm x 1600mm

伽拉·卡克	Gala Caki
塞尔维亚	Serbia
绘画	Painting

Serbia 塞尔维亚 International Art Exhibition 国际美术展

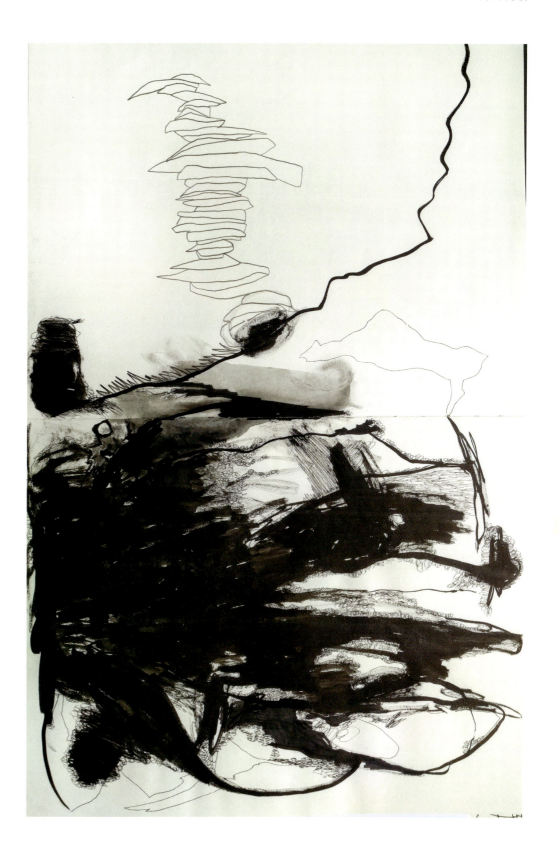

花园 / Garden
750mm x 1000mm

伊娃·扬科维奇 | Iva Jankovic
塞尔维亚 | Serbia
绘画 | Painting

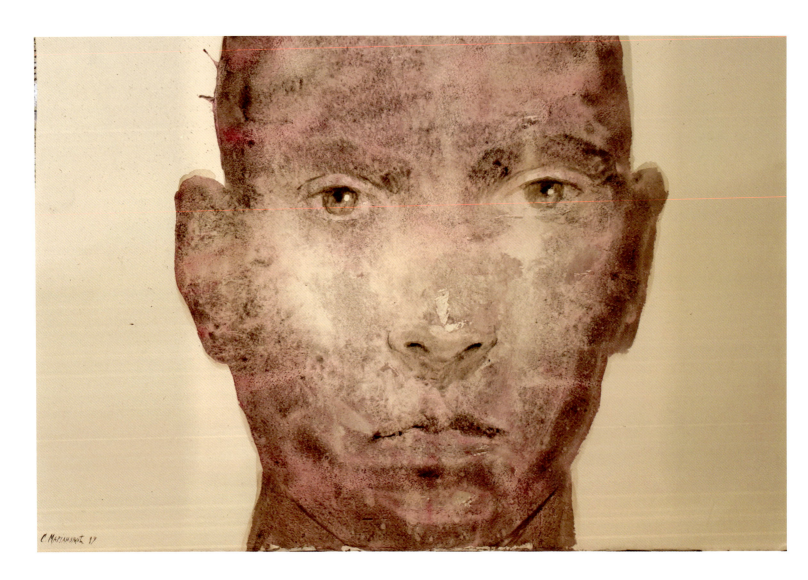

头 / Head
380mm x 560mm

萨萨·马里亚诺维奇 | Sasa Marjanovic
塞尔维亚 | Serbia
绘画 | Painting

Singapore
新加坡

International Art Exhibition
国际美术展

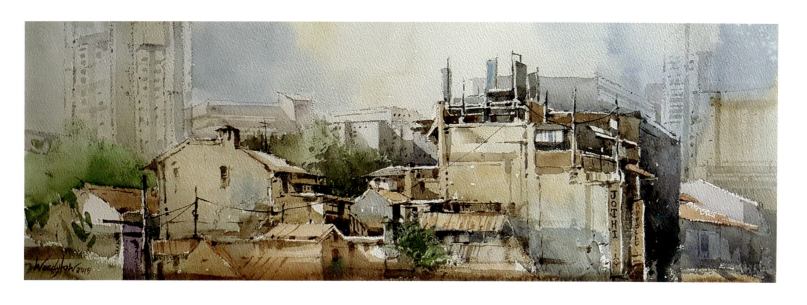

新加坡小印度 / Singapore Little Indian
240mm x 680mm

刘奕村 | Wendy Low Nyet Choon
新加坡 | Singapore
绘画 | Painting

| Work Collection of Arts | The Sixth Silk Road International Arts Festival | Slovakia |
| 美术作品集 | 第六届丝绸之路国际艺术节 | 斯洛伐克 |

SONDE – 在她之前 / SONDE – She before

1000mm x 700mm

马丁·埃夫·奥维 | Martin Ševčovič
斯洛伐克 | Slovakia
绘画 | Painting

Slovenia / 斯洛文尼亚 — International Art Exhibition / 国际美术展

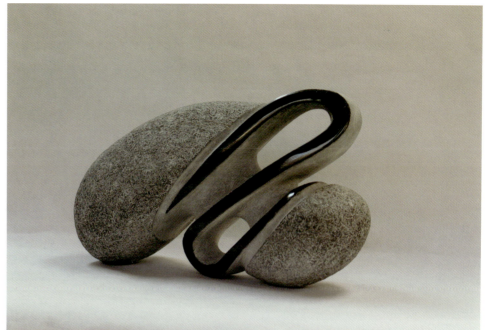

灵魂影响力系列 / Soul Impact Series

阿里耶尔·斯特鲁凯尔 | Arijel Strukelj
斯洛文尼亚 | Slovenia
雕塑 | Sculpture

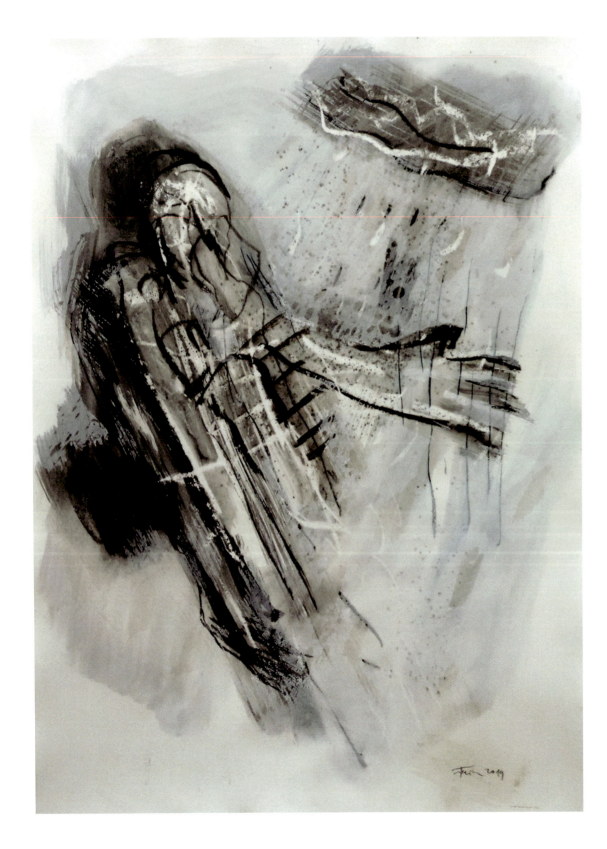

在雨中 / In the Rain

760mm x 560mm

克托米尔·弗里希 | Črtomir Frelih
斯洛文尼亚 | Slovenia
绘画 | Painting

Slovenia
斯洛文尼亚

International Art Exhibition
国际美术展

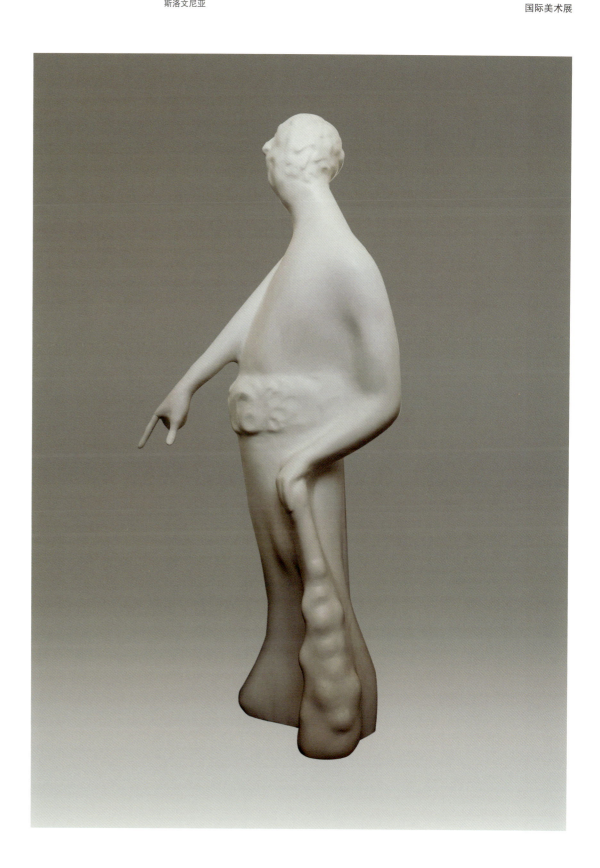

无题 / Unnamed

米尔科·布拉图沙　｜　Mirko Bratuša
斯洛文尼亚　　　　　Slovenia
雕塑　　　　　　　　Sculpture

Work Collection of Arts
美术作品集 | The Sixth Silk Road International Arts Festival 第六届丝绸之路国际艺术节 | South Africa 南非

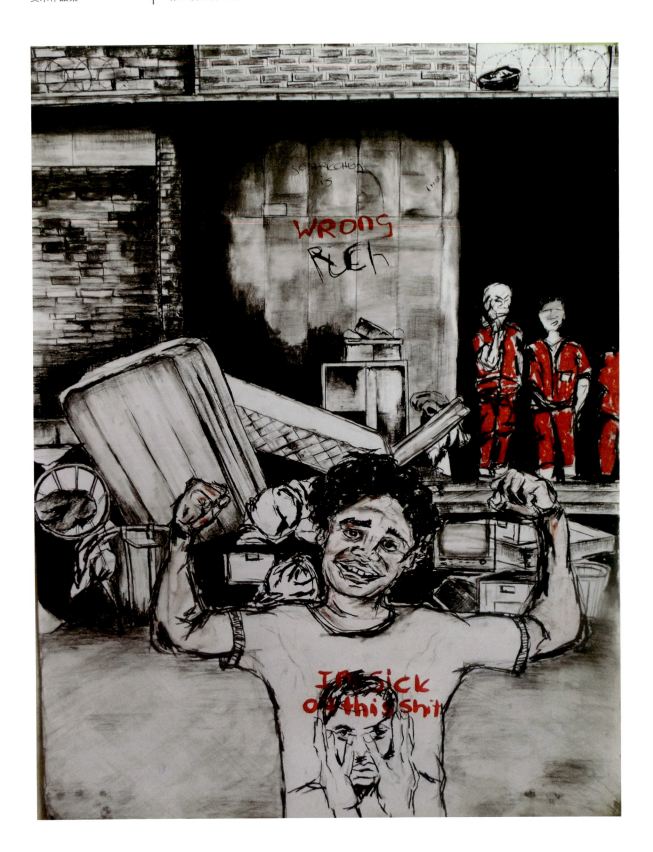

并不是所有的南非人都是贫穷的 / Not Everyone in SA Is Destitute

653mm x 850mm

卫斯理·佩珀 | Wesley Pepper
南非 | South Africa
绘画 | Painting

Spain | International Art Exhibition
西班牙 | 国际美术展

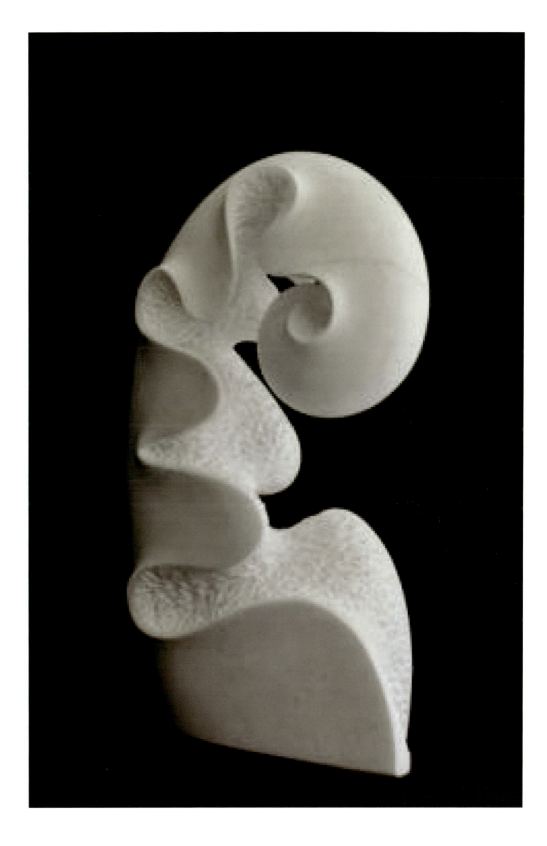

春 / Spring
560mm x 350mm x 130mm

南多·阿尔瓦雷斯 | Nando Alvarez
西班牙 | Spain
雕塑 | Sculpture

| Work Collection of Arts | The Sixth Silk Road International Arts Festival | Spain |
| 美术作品集 | 第六届丝绸之路国际艺术节 | 西班牙 |

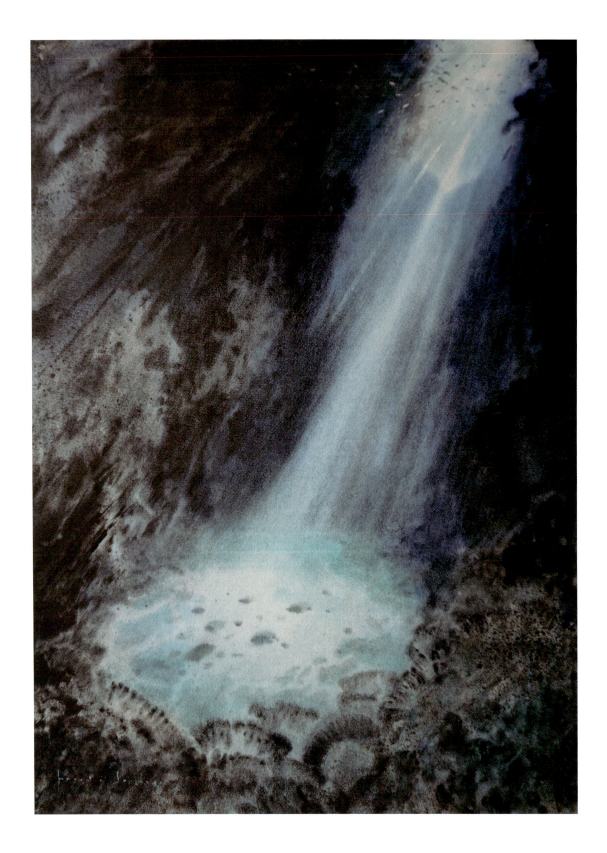

水下洞穴 / Underwater Cave

760mm x 560mm

塞斯克·法雷	Cesc Farré
西班牙	Spain
绘画	Painting

Spain
西班牙

International Art Exhibition
国际美术展

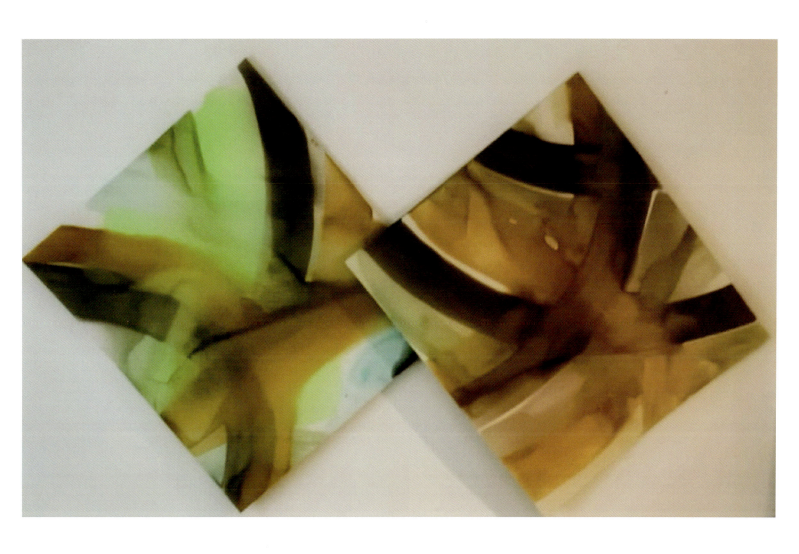

费尔南多·巴里昂诺夫
西班牙
混合材料

空气 / Aire
800mm x 1800mm
Fernando Barrionuevo
Spain
Comprehensive material

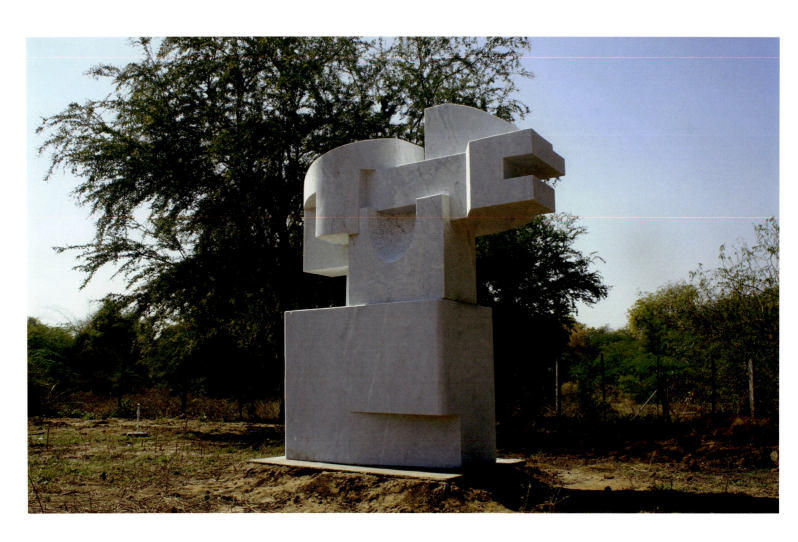

哨兵 / Sentinel

500mm x 180mm x 300mm

吉玛·多明戈斯	Gemma Dominguez
西班牙	Spain
雕塑	Sculpture

Spain / 西班牙 | International Art Exhibition / 国际美术展

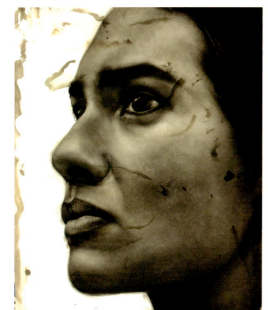 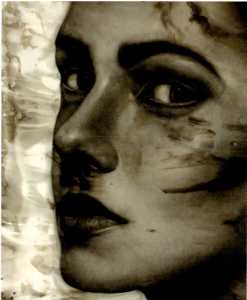 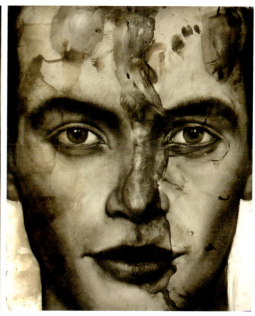

人类系列 / Humana Series
510mm x 610mm

胡安·佩迪盖罗 | Juan Perdiguero
西班牙 | Spain
绘画 | Painting

| Work Collection of Arts | The Sixth Silk Road International Arts Festival | Spain |
| 美术作品集 | 第六届丝绸之路国际艺术节 | 西班牙 |

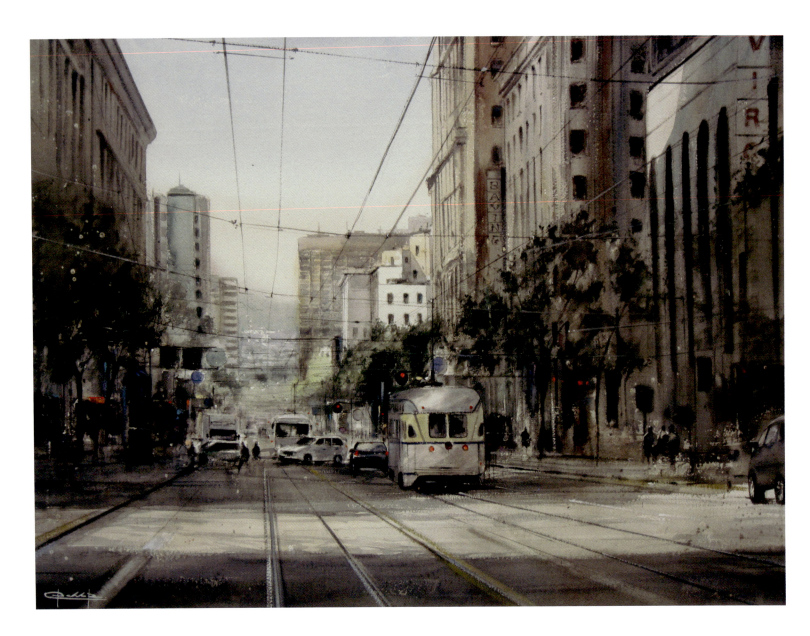

市场街七号 / Market Street VII

700mm x 1000mm

巴勃罗·鲁本·洛佩斯·桑兹	Pablo Ruben Lopez Sanz
西班牙	Spain
绘画	Painting

Sri Lanka / 斯里兰卡

International Art Exhibition / 国际美术展

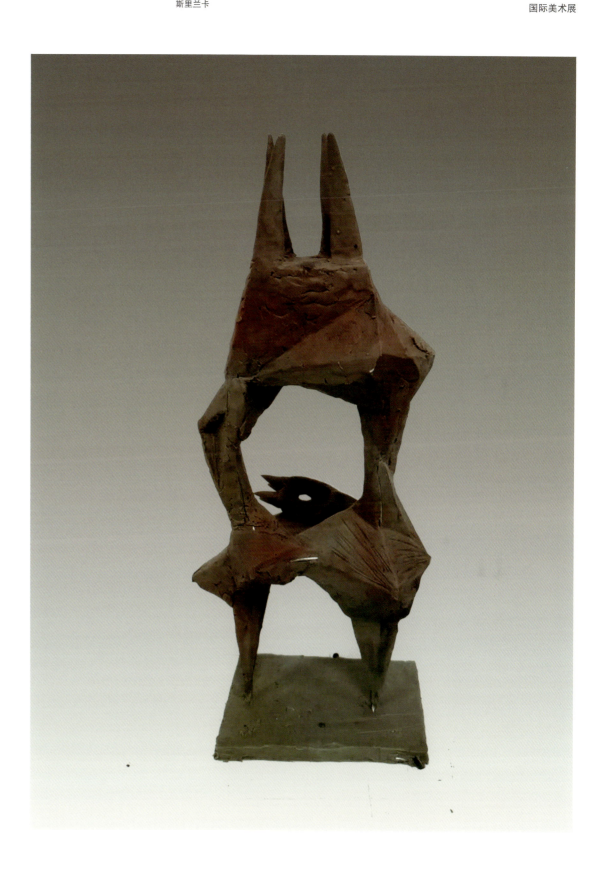

母亲 / Mom

达尔玛 | Dharma
斯里兰卡 | Sri Lanka
雕塑 | Sculpture

| Work Collection of Arts | The Sixth Silk Road International Arts Festival | Sri Lanka |
| 美术作品集 | 第六届丝绸之路国际艺术节 | 斯里兰卡 |

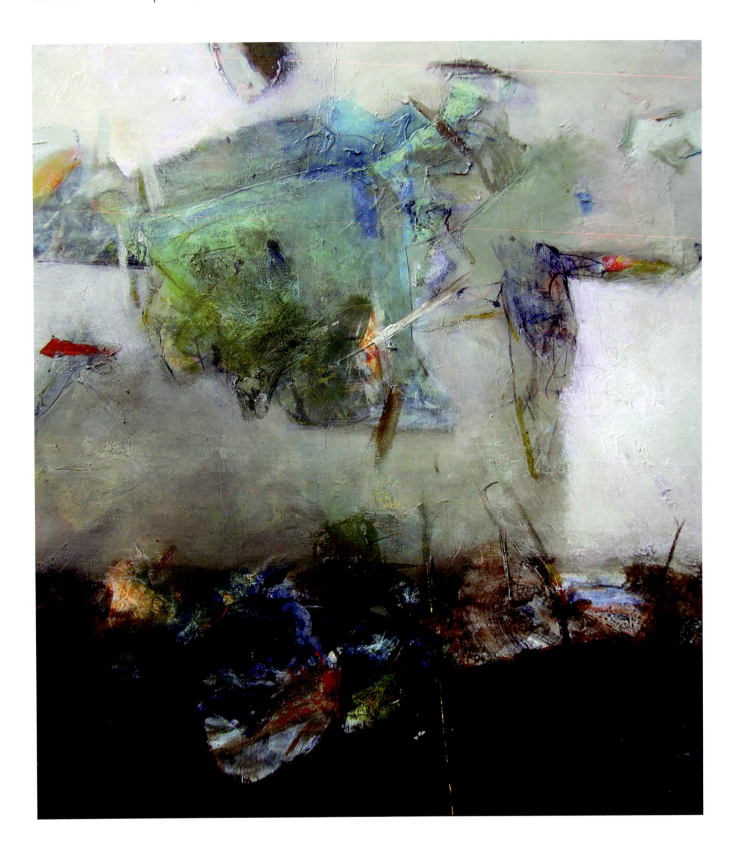

时间、精神和空间 – 3 / Time, Mind & Space - 3
900mm x 800mm

贾加思·拉文德拉
斯里兰卡
绘画

Jagath Ravindra
Sri Lanka
Painting

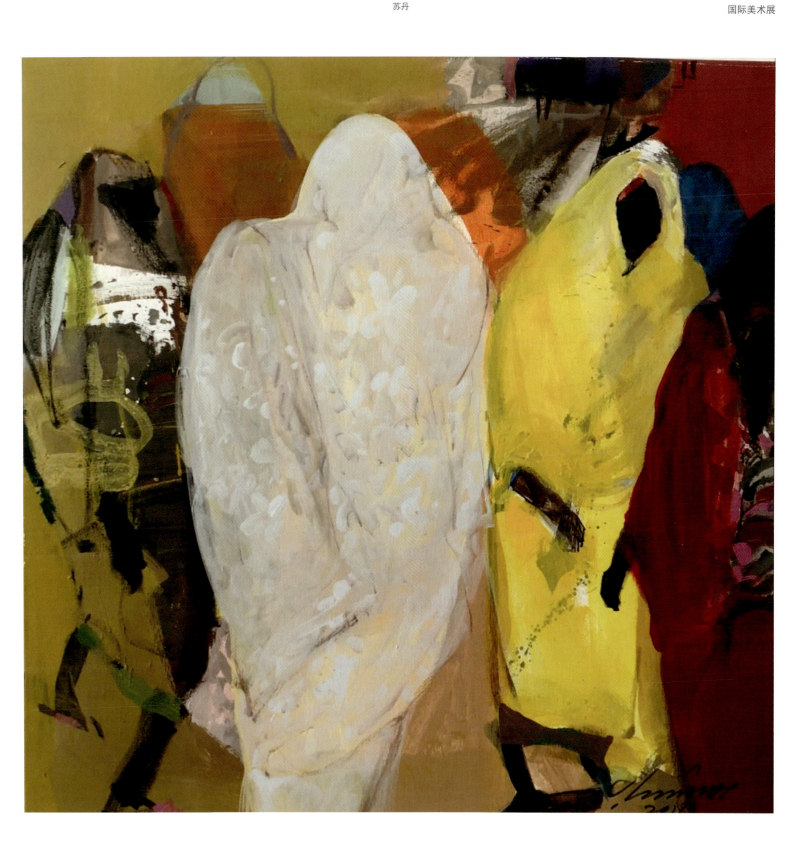

白衣女人 / Women in White
1000mm x 1000mm

艾哈迈德·拉希德·穆巴拉克·迪亚卜 | Ahmad Rashid Mubarak Diab
苏丹 | Sudan
绘画 | Painting

| Work Collection of Arts | The Sixth Silk Road International Arts Festival | Sweden |
| 美术作品集 | 第六届丝绸之路国际艺术节 | 瑞典 |

无题 / Unnamed

420mm x 620mm

艾哈迈德·莫迪尔 | Ahmed Modhir
瑞典 | Sweden
混合材料 | Comprehensive material

Switzerland 瑞士 | International Art Exhibition 国际美术展

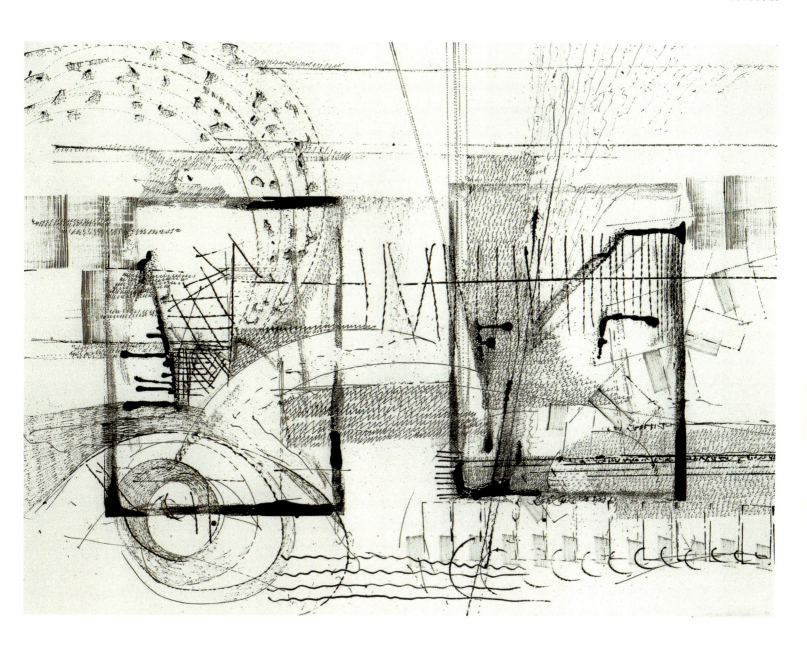

25+1 / 25+1
25000mm x 3000mm

克里斯托夫·提曼 | Christoph Rütimann
瑞士 | Switzerland
绘画 | Painting

| Work Collection of Arts | The Sixth Silk Road International Arts Festival | Syrian |
| 美术作品集 | 第六届丝绸之路国际艺术节 | 叙利亚 |

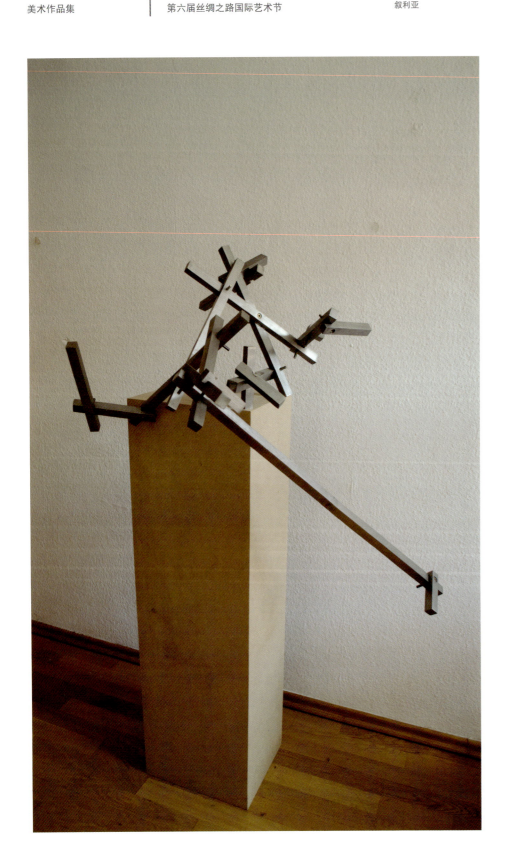

平衡 19 / Balance 19

710mm x 770mm x 620mm

塔列克·阿尔法	Tareq Alghamian
叙利亚	Syrian
雕塑	Sculpture

Thailand
泰国

International Art Exhibition
国际美术展

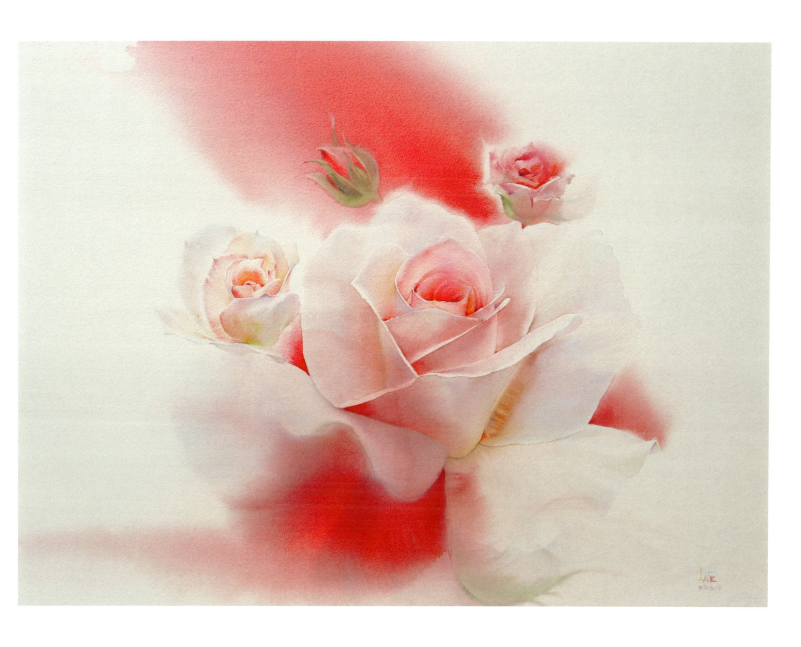

玫瑰 / Rose
500mm x 650mm

莱夫 | Lafe
泰国 | Thailand
绘画 | Painting

| Work Collection of Arts | The Sixth Silk Road International Arts Festival | Thailand |
| 美术作品集 | 第六届丝绸之路国际艺术节 | 泰国 |

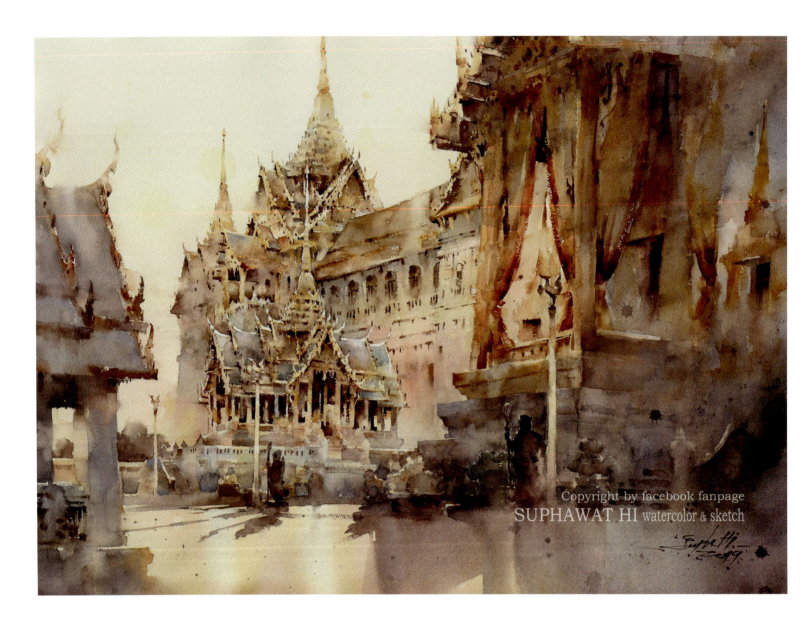

大皇宫 / The Grand Palace

560mm x 760mm

苏比霍沃特·希兰塔维沃特	Suphawat Hiranthanawiwat
泰国	Thailand
绘画	Painting

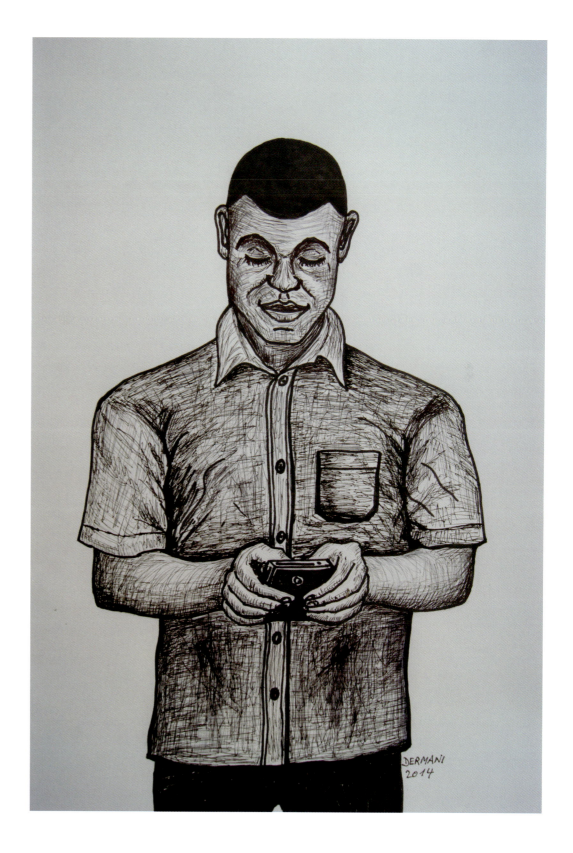

玩智能手机 / Fiddling with Smartphone
300mm x 420mm

阿卜杜勒·加尼·德曼尼 | Abdoul Ganiou Dermani
多哥 | Togo
绘画 | Painting

| Work Collection of Arts | The Sixth Silk Road International Arts Festival | Tunisia |
| 美术作品集 | 第六届丝绸之路国际艺术节 | 突尼斯 |

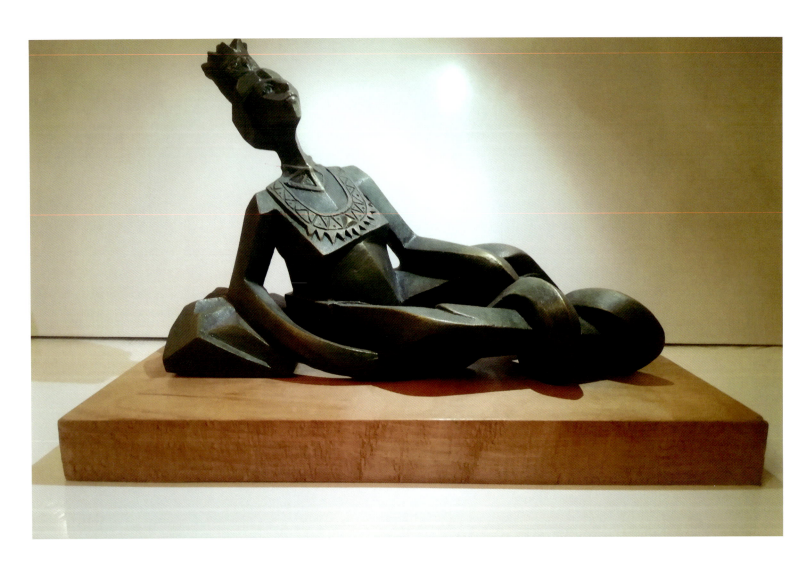

爱丽莎 / Alisa
230mm x 220mm x 360mm

穆罕默德・博阿茨兹 Mohamed Bouaziz
突尼斯 Tunisia
雕塑 Sculpture

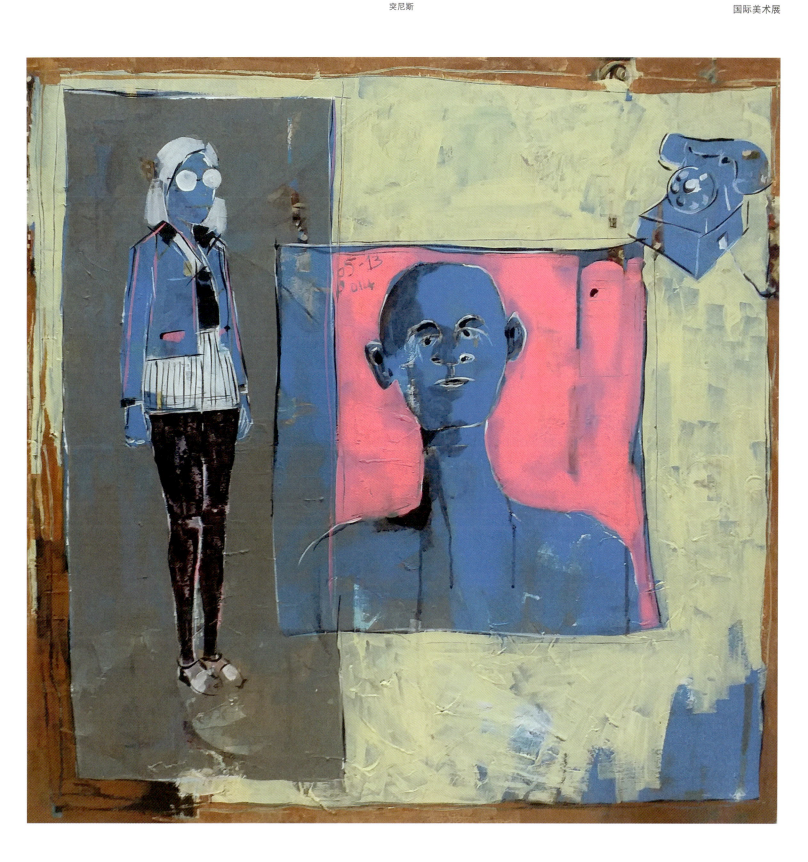

蓝色的 / Zrog(Blues)
1000mm x 1000mm

耐洁特·德阿碧 | Najet Dhahbi
突尼斯 | Tunisia
绘画 | Painting

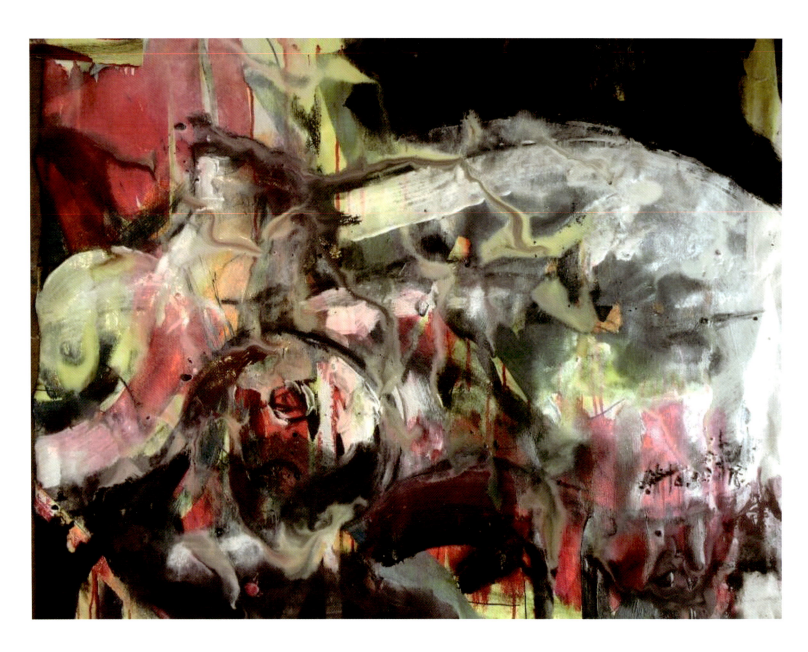

青年女士 / Young Lady
800mm x 600mm

里姆·阿亚里 　Rim Ayari
突尼斯　　　　Tunisia
绘画　　　　　Painting

Tunisia — International Art Exhibition

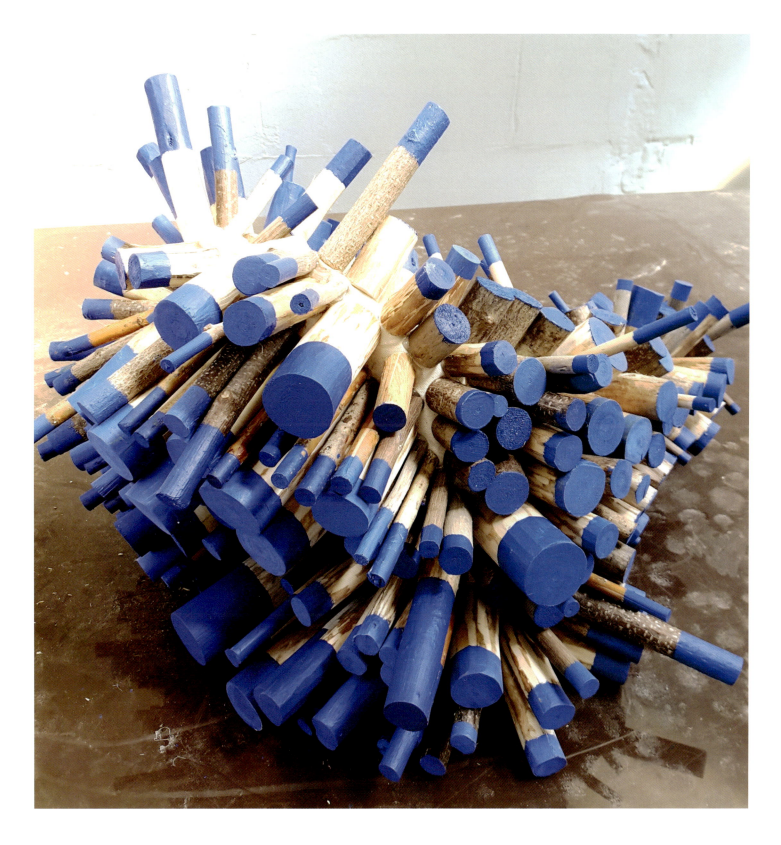

呼吸 / Breath
600mm x 450mm x 500mm

瓦罗·托帕可 | Varol Topaç
突尼斯 | Tunisia
雕塑 | Sculpture

| Work Collection of Arts | The Sixth Silk Road International Arts Festival | Turkey |
| 美术作品集 | 第六届丝绸之路国际艺术节 | 土耳其 |

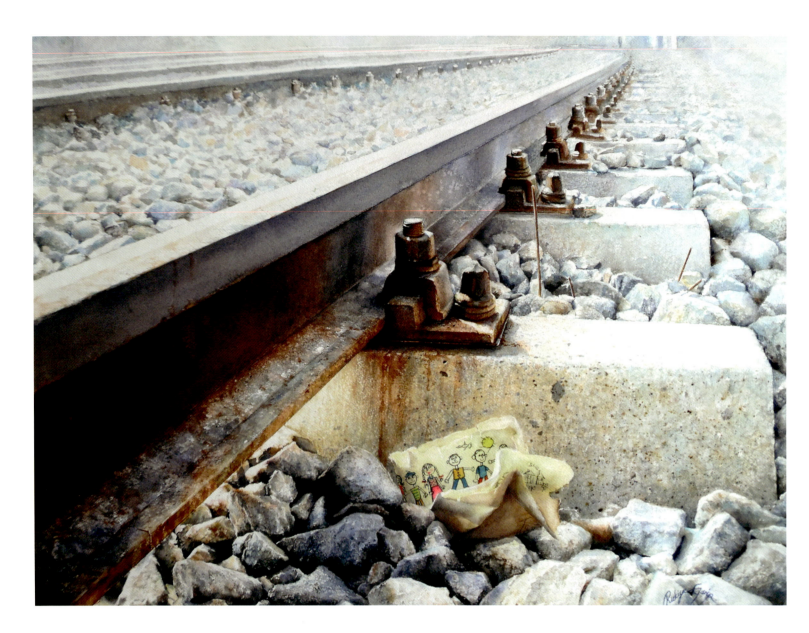

铁路 / Railway
560mm x 760mm

路基·贾丽普 | Rukiye Garip
土耳其 | Turkey
绘画 | Painting

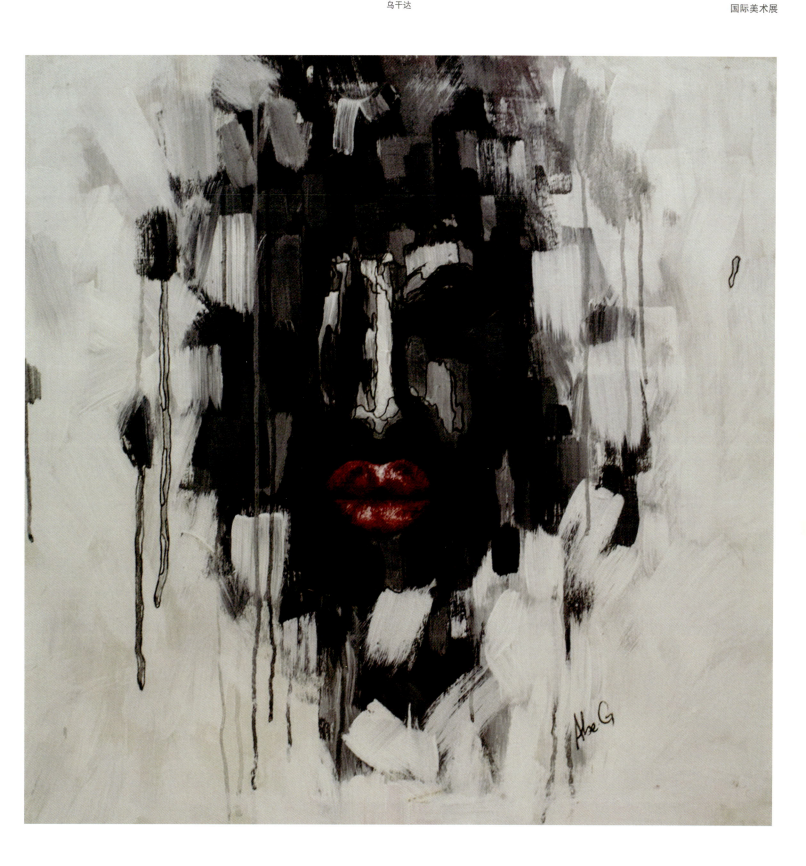

魅 / Succubus
800mm x 800mm

吉莉安·斯泰西·安倍
乌干达
绘画

Gillian Stacey Abe
Uganda
Painting

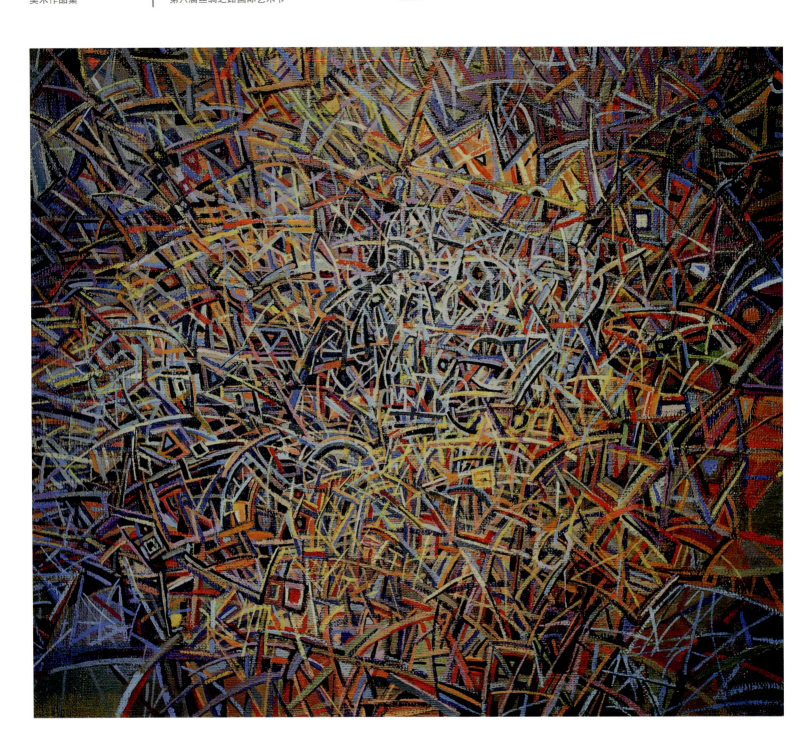

蜘蛛网 / Cobwebs
650mm x 750mm

亚历克斯·鲁巴诺夫
乌克兰
绘画

Alex Rubanov
Ukraine
Painting

Ukraine / 乌克兰 — International Art Exhibition / 国际美术展

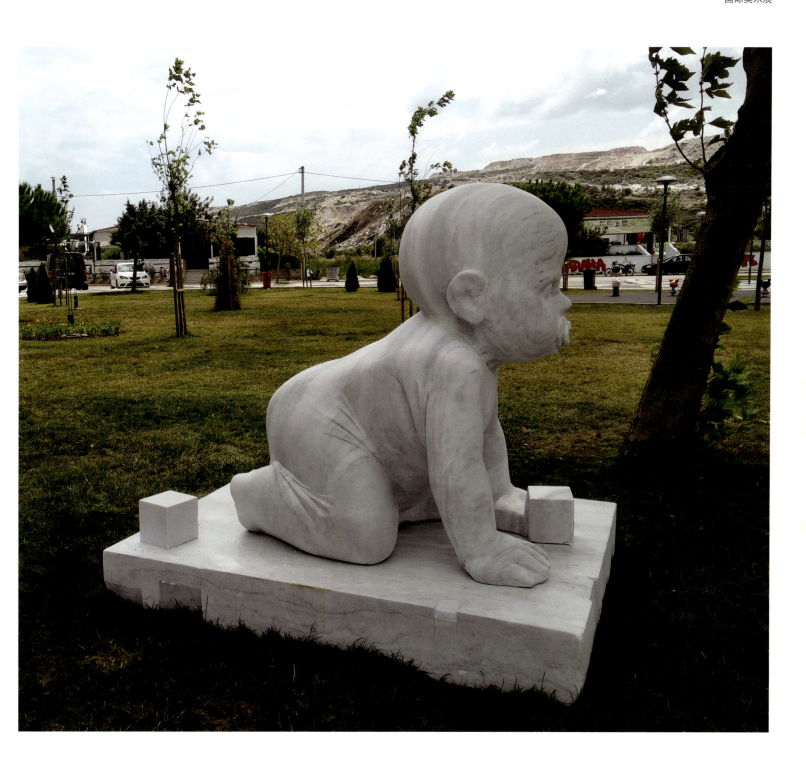

第一场比赛 / First Game

1650mm x 1900mm x 1400mm

奥莱纳·多达克 | Olena Dodatk
乌克兰 | Ukraine
雕塑 | Sculpture

| Work Collection of Arts | The Sixth Silk Road International Arts Festival | Ukraine |
| 美术作品集 | 第六届丝绸之路国际艺术节 | 乌克兰 |

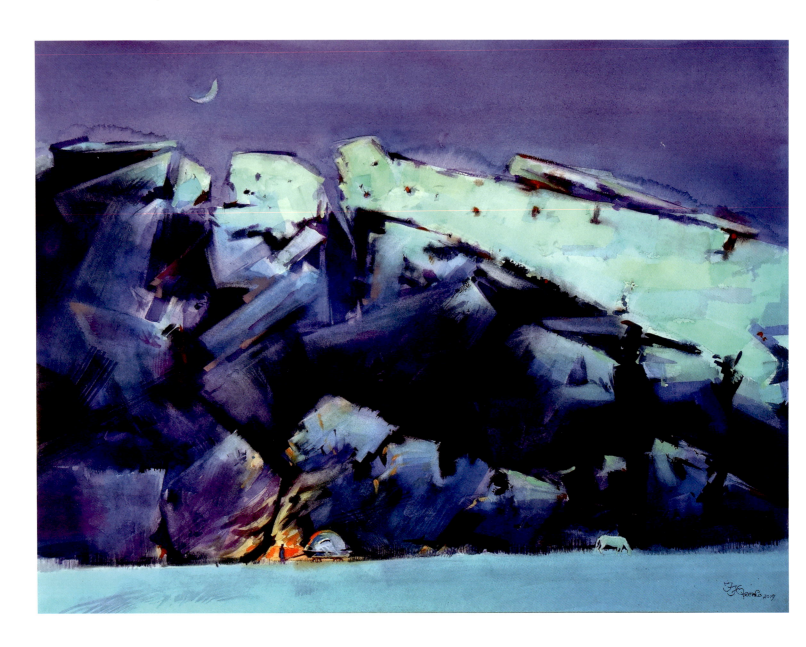

月亮之夜 / Moonlight Night

760mm x 560mm

尤尔琴科·伊霍尔　　　　Yurchenko Ihor
乌克兰　　　　　　　　　Ukraine
绘画　　　　　　　　　　Painting

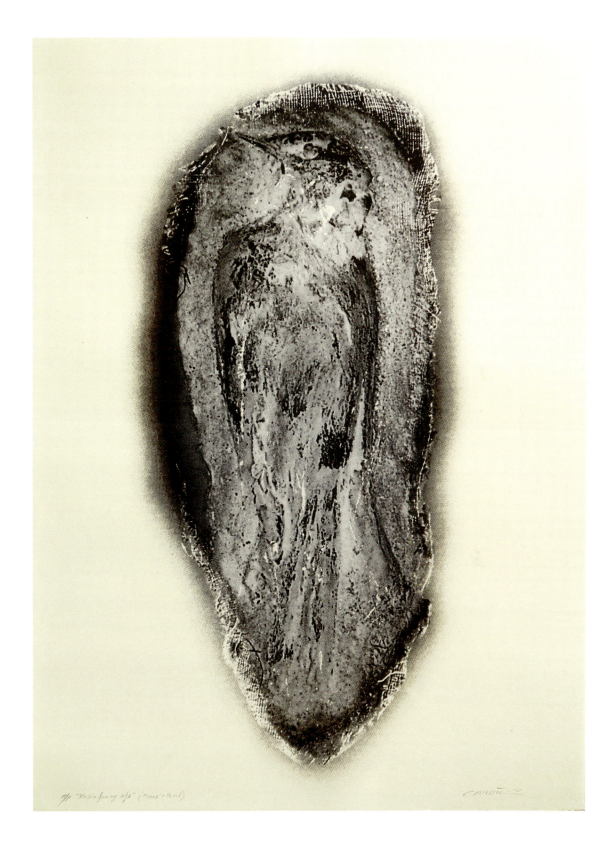

罗宾 – 面向左 / Robin – Facing Left
765mm x 570mm

里默·卡迪洛 / Rimer Cardillo
乌拉圭 / Uruguay
绘画 / Painting

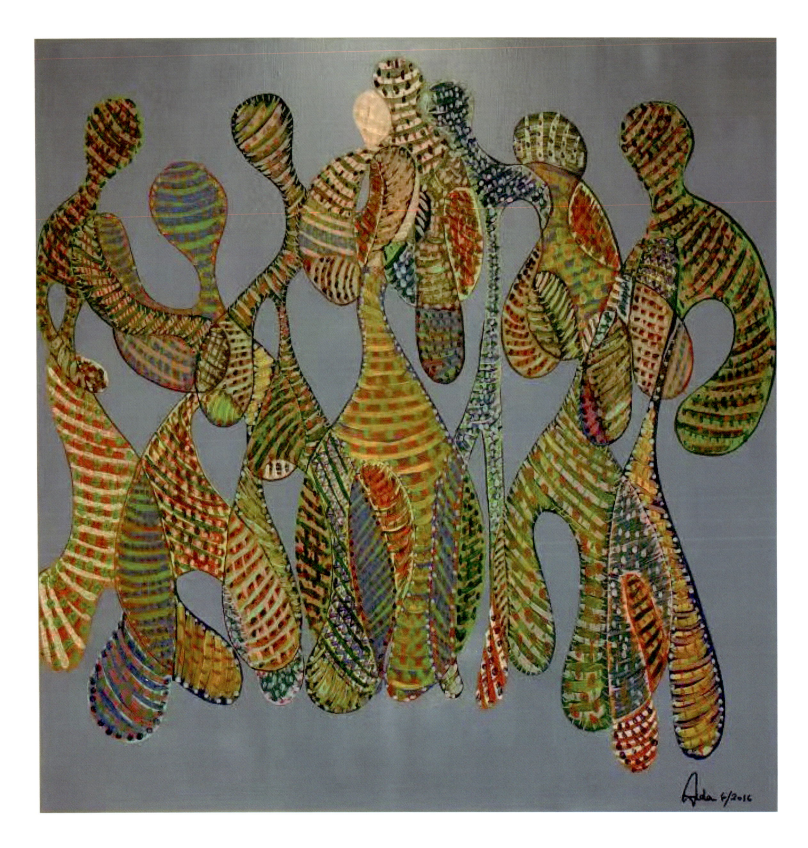

现代传播学 / Modern Communication

1000mm x 1000mm

苏珊娜·维达 | Susana Vida
乌拉圭 | Uruguay
绘画 | Painting

United Kingdom / 英国

International Art Exhibition / 国际美术展

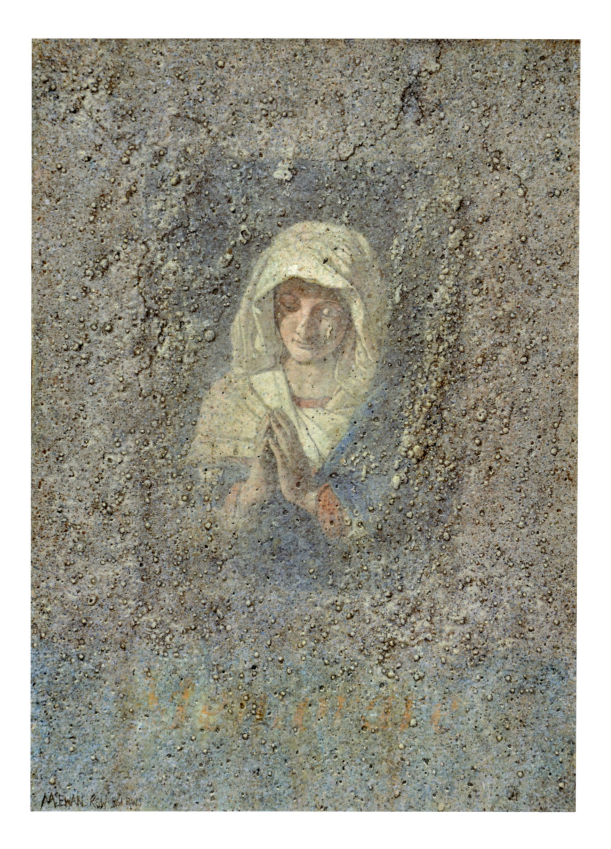

褪色的记忆 / Fading Memory

395mm x 285mm

安古斯·麦克尤恩 / Angus McEwan
英国 / United Kingdom
绘画 / Painting

| Work Collection of Arts | The Sixth Silk Road International Arts Festival | United Kingdom |
| 美术作品集 | 第六届丝绸之路国际艺术节 | 英国 |

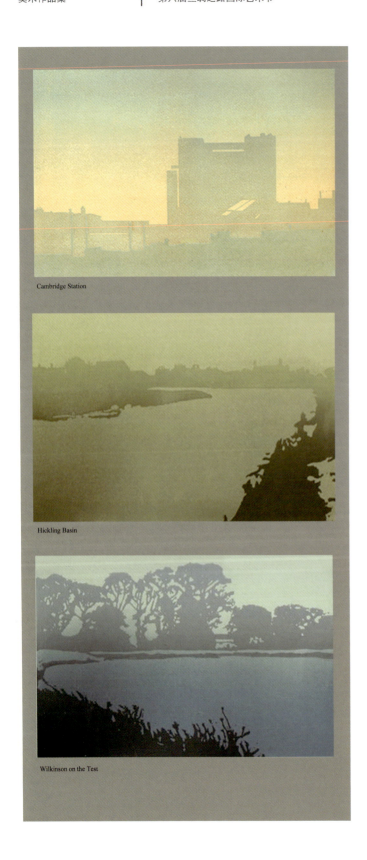

Cambridge Station

Hickling Basin

Wilkinson on the Test

剑桥大学站，希克林盆地，威尔金森在测试中 / Cambridge Station, Hickling Basin, Wilkinson on the Test

鲍勃·斯帕汉	Bob Sparham
英国	United Kingdom
绘画	Painting

United Kingdom | International Art Exhibition
英国 | 国际美术展

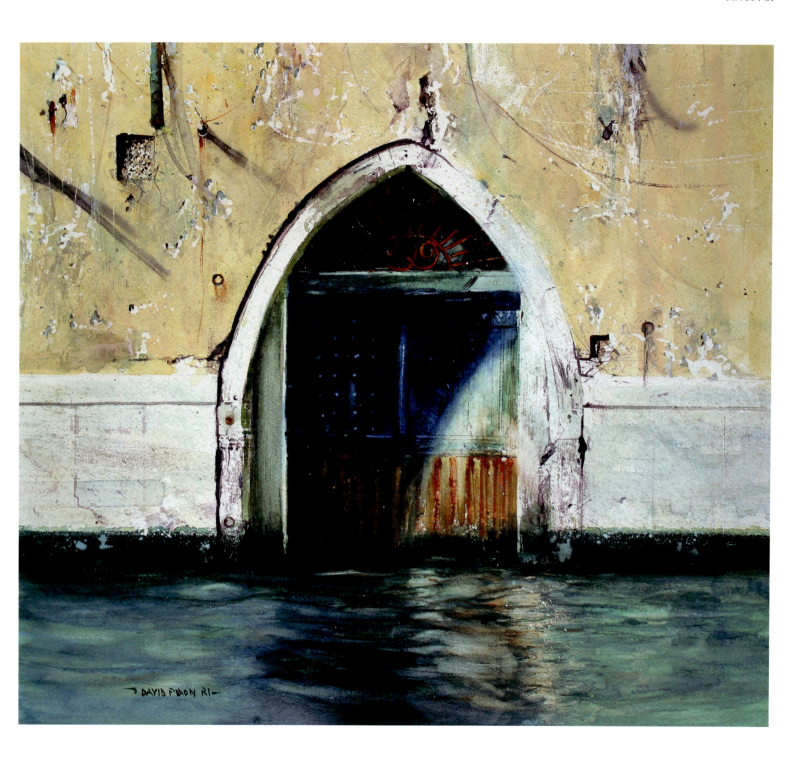

静如止水 / Quiet Waters

500mm x 560mm

戴维·伯克森 | David Poxon
英国 | United Kingdom
绘画 | Painting

Work Collection of Arts	The Sixth Silk Road International Arts Festival	United Kingdom
美术作品集	第六届丝绸之路国际艺术节	英国

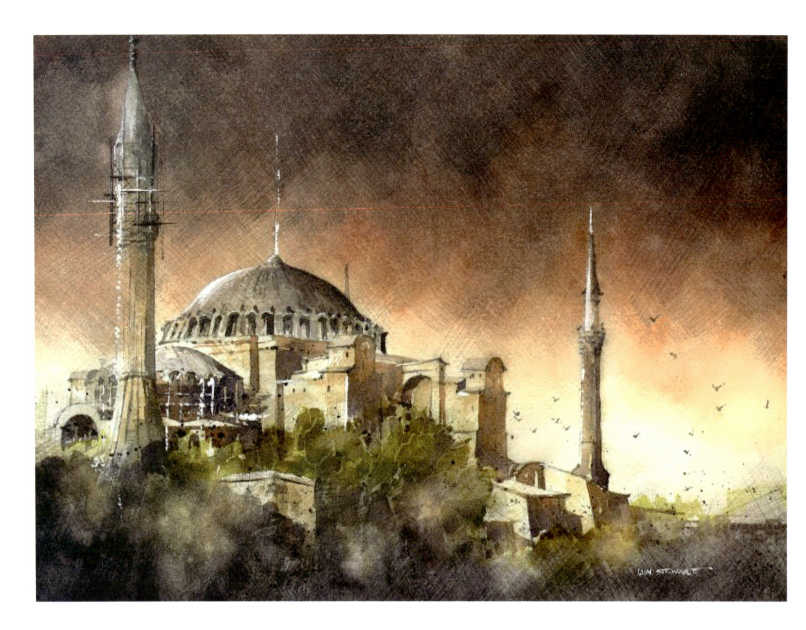

伊斯坦布尔 – 圣索菲亚 / Hagia Sofia-Istanbul

240mm x 335mm

伊恩·斯图尔特	Iain Stewart
英国	United Kingdom
绘画	Painting

United States
美国

International Art Exhibition
国际美术展

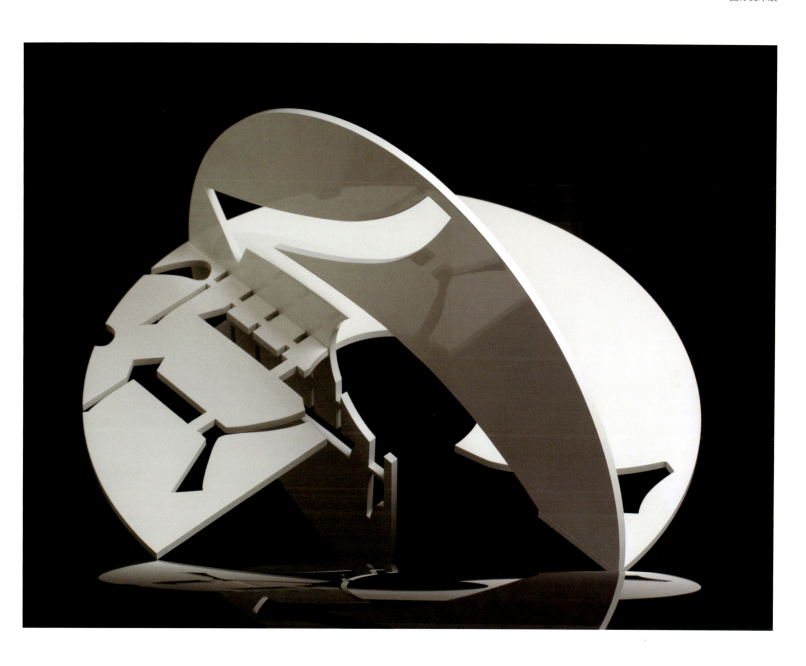

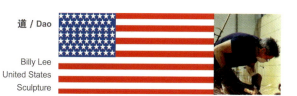

道 / Dao

比利·李 | Billy Lee
美国 | United States
雕塑 | Sculpture

| Work Collection of Arts | The Sixth Silk Road International Arts Festival | United States |
| 美术作品集 | 第六届丝绸之路国际艺术节 | 美国 |

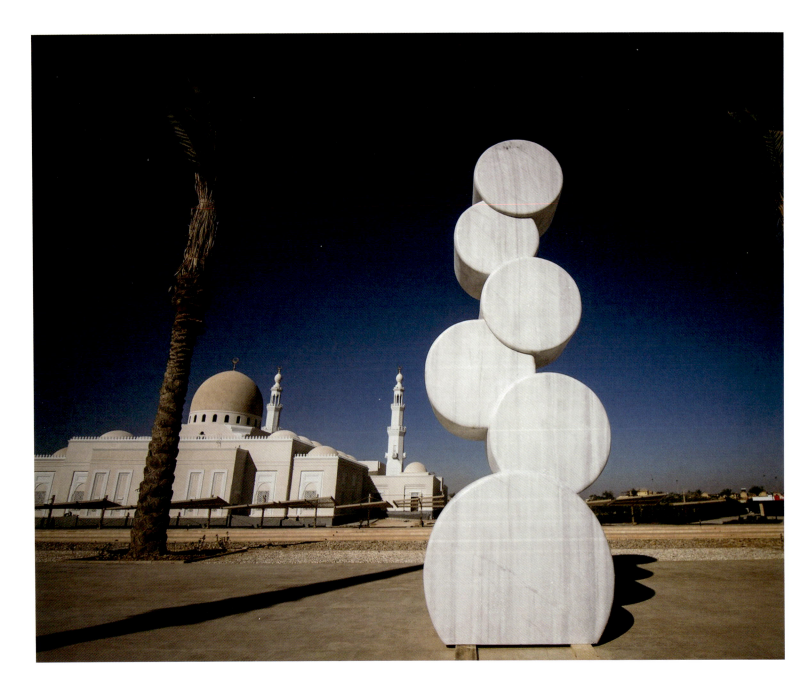

月落 / Moonset

3050mm x 1200mm x 800mm

卡罗尔·特纳	Carole Turner
美国	United States
雕塑	Sculpture

United States / 美国 — International Art Exhibition / 国际美术展

恩家·琳达·海永 美国 绘画	无题 / Unnamed 609mm x 457mm Eunjong Linda Hyong United States Painting

| Work Collection of Arts | The Sixth Silk Road International Arts Festival | United States |
| 美术作品集 | 第六届丝绸之路国际艺术节 | 美国 |

无限 IV / Immenduring IV

H:1000mm

哈德森·乔恩·巴洛	Hudson Jon Barlow
美国	United States
雕塑	Sculpture

United States / 美国 — International Art Exhibition / 国际美术展

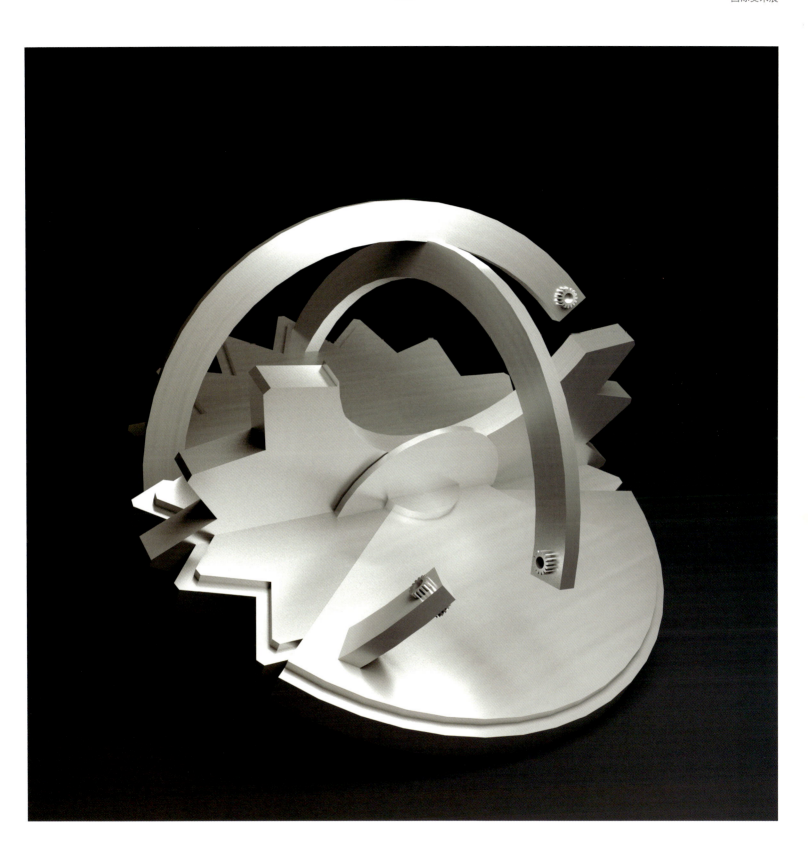

金牛座的月亮 / Moon of Taurus

594mm x 841mm

约翰·阿特金	John Atkin
美国	United States
雕塑	Sculpture

Work Collection of Arts
美术作品集

| The Sixth Silk Road International Arts Festival
第六届丝绸之路国际艺术节

United States
美国

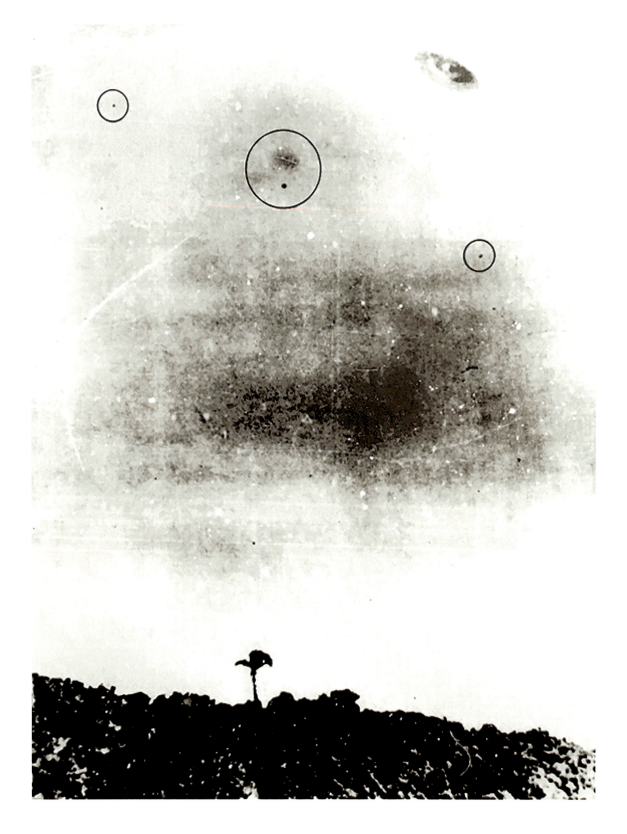

板 29 / Plate 29

810mm x 610mm

纳达·科拉佐·洛伦斯 — Nayda Collazo Llorens
美国 — United States
混合材料 — Comprehensive Material

United States
美国

International Art Exhibition
国际美术展

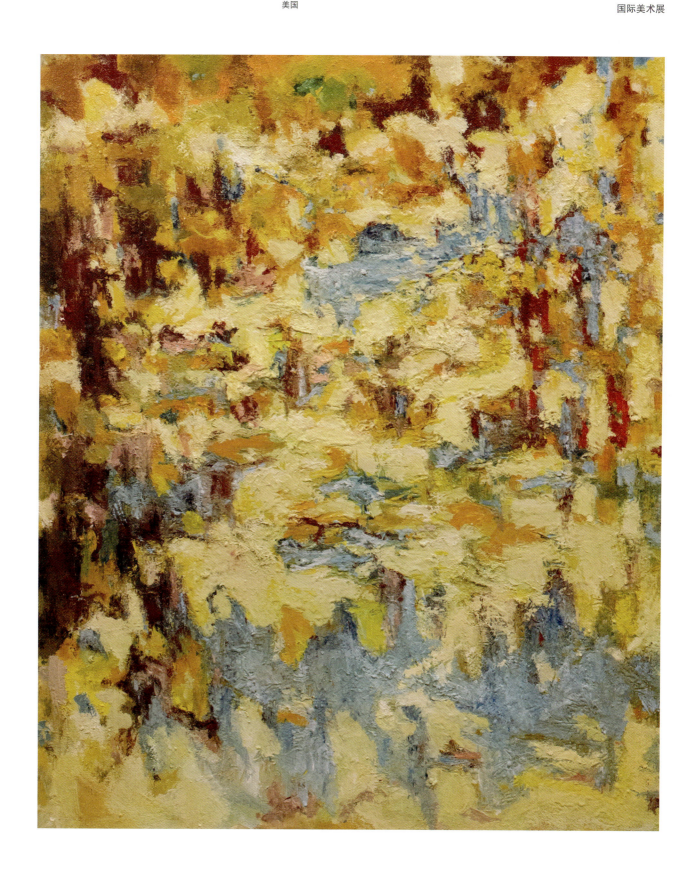

青蓝色的滑音 / Glissando in Blue
510mm x 610mm

那蓝 | Robert Najlis
美国 | United States
绘画 | Painting

271

Work Collection of Arts	The Sixth Silk Road International Arts Festival	United States
美术作品集	第六届丝绸之路国际艺术节	美国

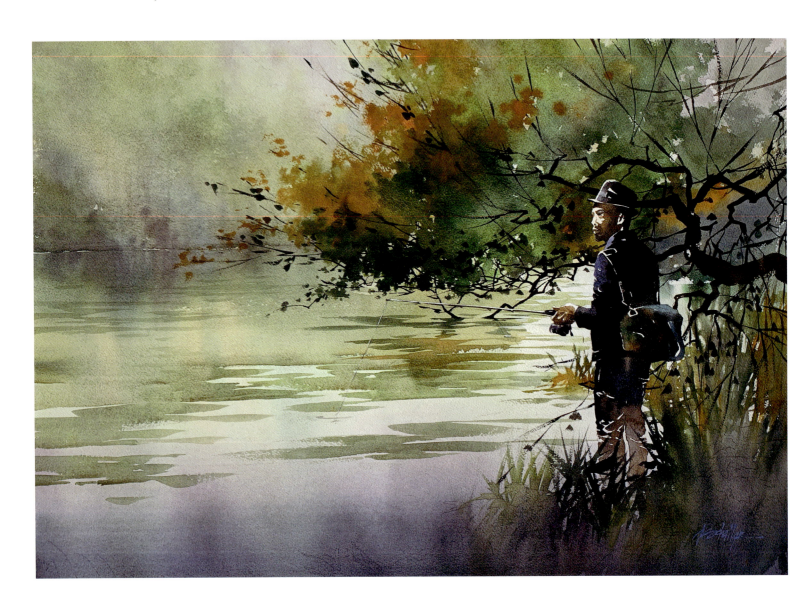

风景 / Landscape
560mm x 760mm

托马斯·W·夏尔 | Thomas W Schaller
美国 | United States
绘画 | Painting

Uzbekistan
乌兹别克斯坦

International Art Exhibition
国际美术展

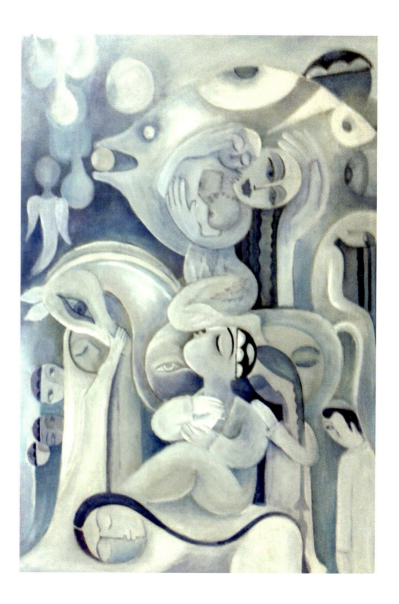

天使的梦 / The Dream of an Angel
900mm x 600mm

古尔佐尔·苏塔诺娃 | Gulzor Sultanova
乌兹别克斯坦 | Uzbekistan
绘画 | Painting

Work Collection of Arts	The Sixth Silk Road International Arts Festival	Venezuela
美术作品集	第六届丝绸之路国际艺术节	委内瑞拉

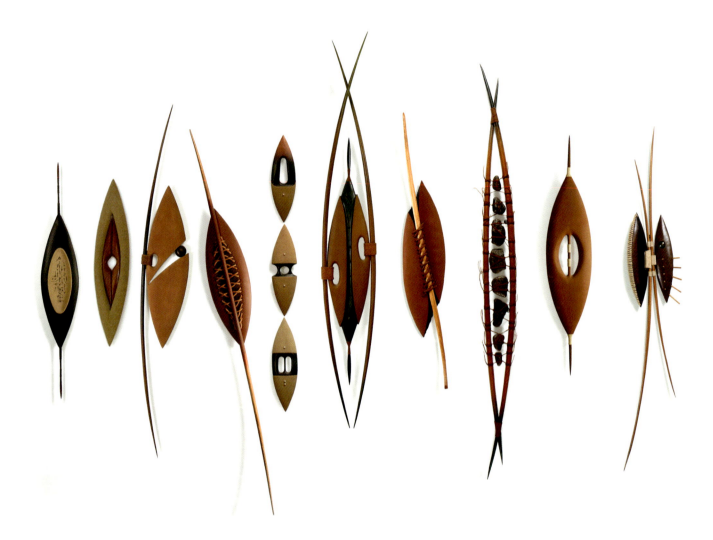

部落元素 / From the Tribe

3000 mm x 5000 mm

拉蒙·莫拉雷斯	Ramon Morales
委内瑞拉	Venezuela
雕塑	Sculpture

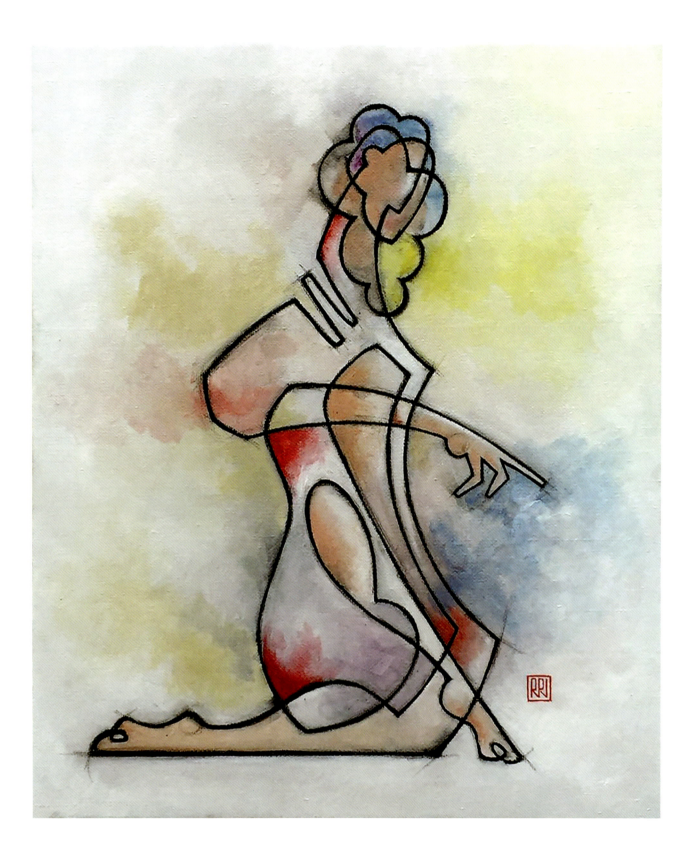

俯瞰西方 / Glance at the West
500mm x 600mm

罗纳德·杰·帕雷德斯·瓦佳斯 | Ronald J Paredes Vargas
委内瑞拉　　　　　　　　　　Venezuela
绘画　　　　　　　　　　　　Painting

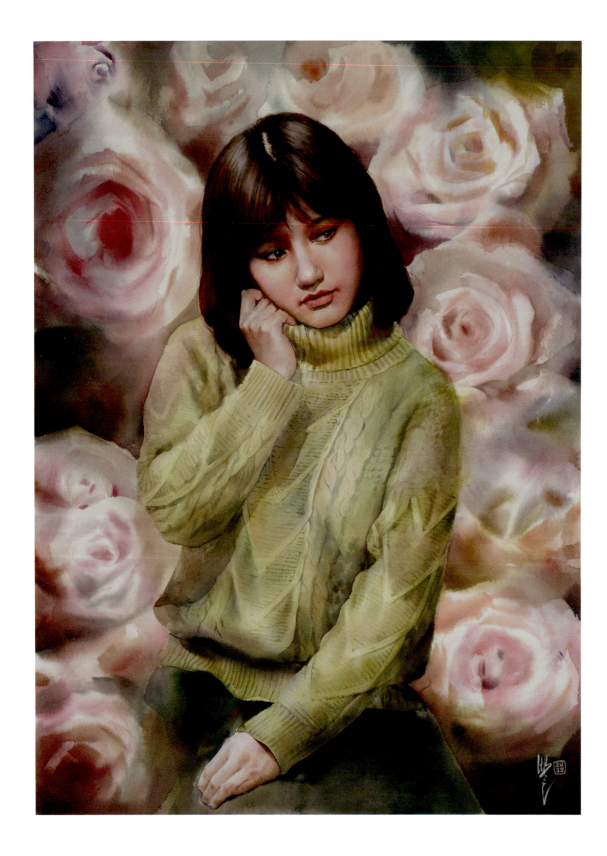

翠 / Thuy

600mm x 1200mm

隆平		Luong Binh
越南		Viet Nam
绘画		Painting

Viet Nam
越南

International Art Exhibition
国际美术展

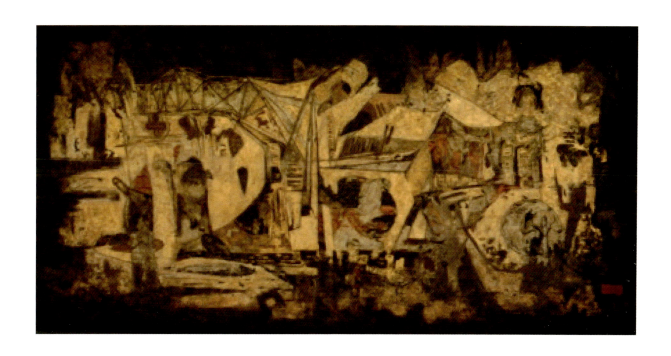

长长的美好回忆 / Long Bien Memories

600mm x 1200mm

倪苟·万东	Ngo Van Dung
越南	Viet Nam
绘画	Painting

Work Collection of Arts	The Sixth Silk Road International Arts Festival	Viet Nam
美术作品集	第六届丝绸之路国际艺术节	越南

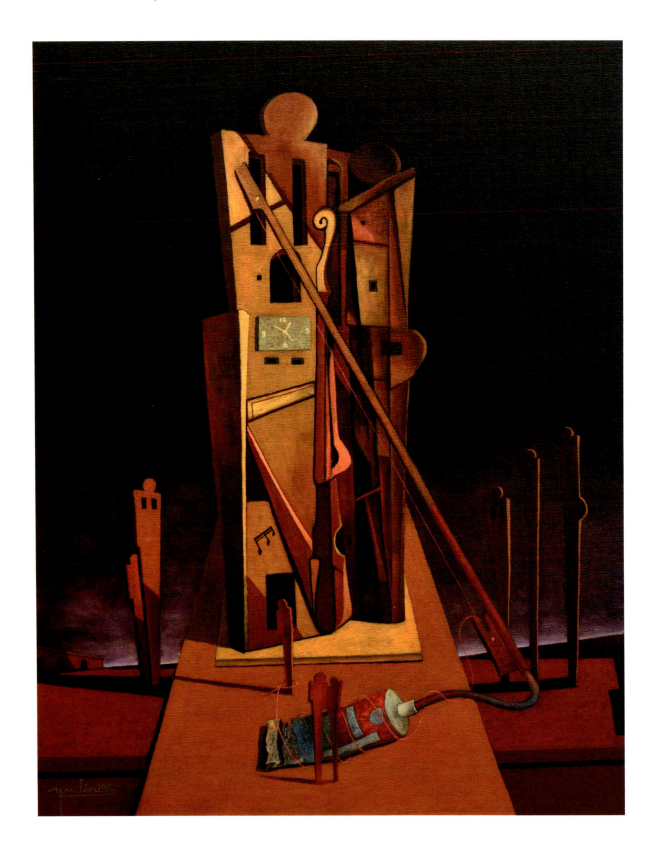

夜晚的音乐 / Night Music

920mm x 730mm

阮敏丹	Nguyen Minh Tan
越南	Viet Nam
绘画	Painting

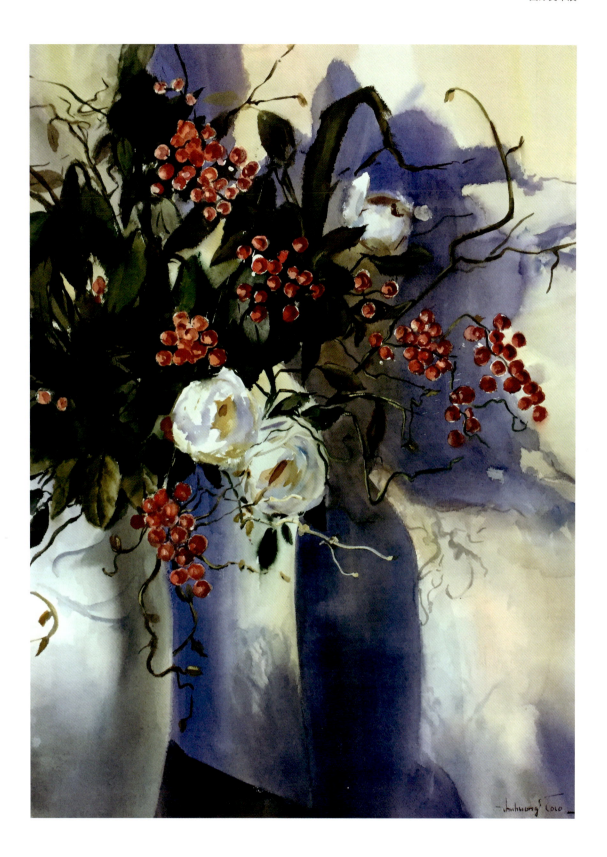

影 / The Shadow
560mm x 760mm

阮图红　　Thu Huong Nguyen
越南　　　Viet Nam
绘画　　　Painting

| Work Collection of Arts | The Sixth Silk Road International Arts Festival | Viet Nam |
| 美术作品集 | 第六届丝绸之路国际艺术节 | 越南 |

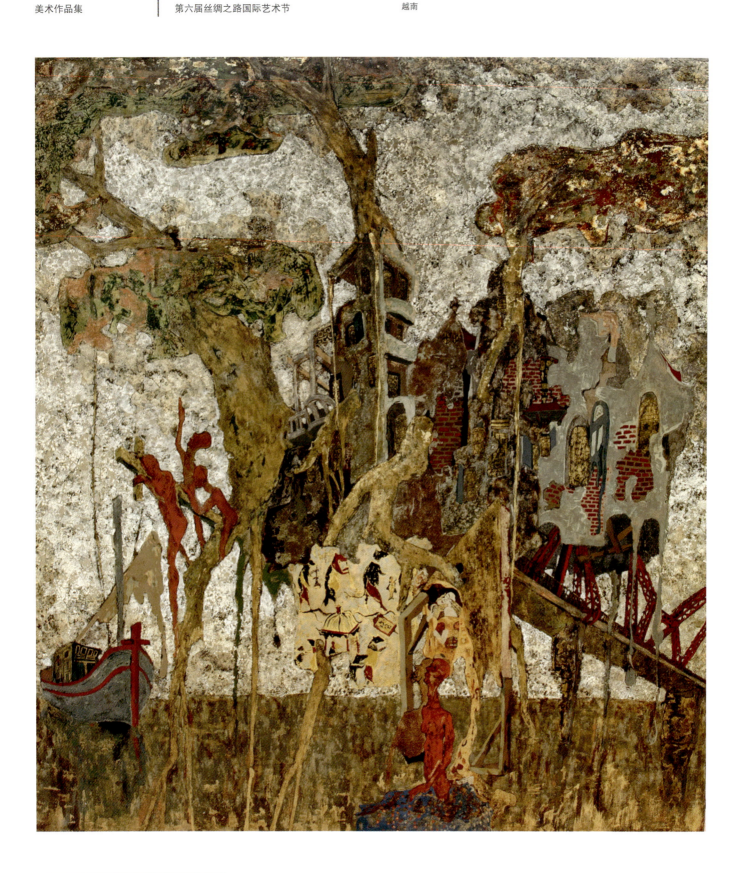

生命树 6 / Cay Doi 6

1000mm x 900mm

特兰范尼恩	Tran Van Ninh
越南	Viet Nam
绘画	Painting

Zimbabwe
津巴布韦

International Art Exhibition
国际美术展

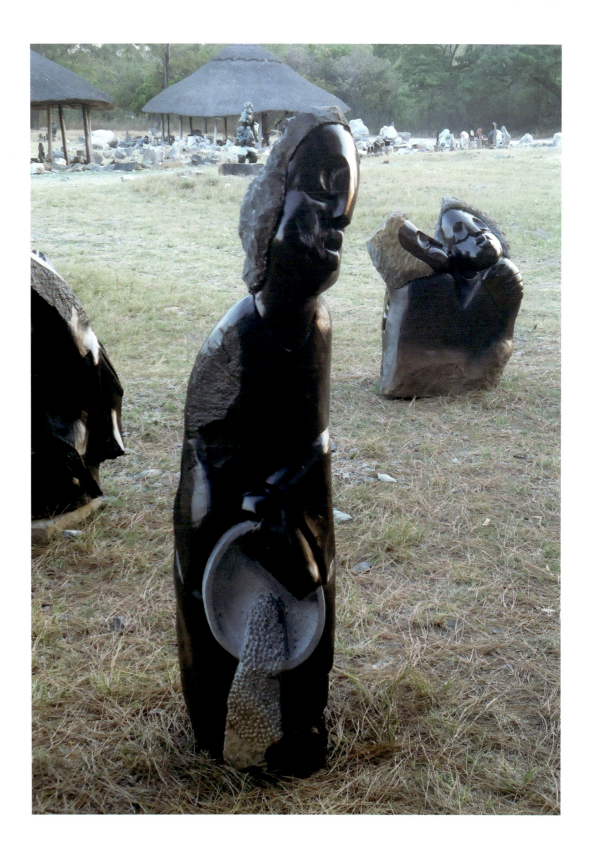

玛丽安·尼安·洪戈 – 温努女子弹簧石 2 / Marian Nyanhongo - Winowing Woman Springstone 2

1560mm x 440mm x 450mm

玛利亚·南亚行谷	Marian S.Nyanhnbgo
津巴布韦	Zimbabwe
雕塑	Sculpture

第六届丝绸之路国际艺术展《今日丝绸之路》国际美术展
Sixth International Art Exhibition of the Silk Road "Today's Silk Road" International Art Exhibition

荷兰 & 法国联合特展作品
A Special Exhibition of Netherlands and France Joint works

Netherlands International Art Exhibition
荷兰 国际美术展

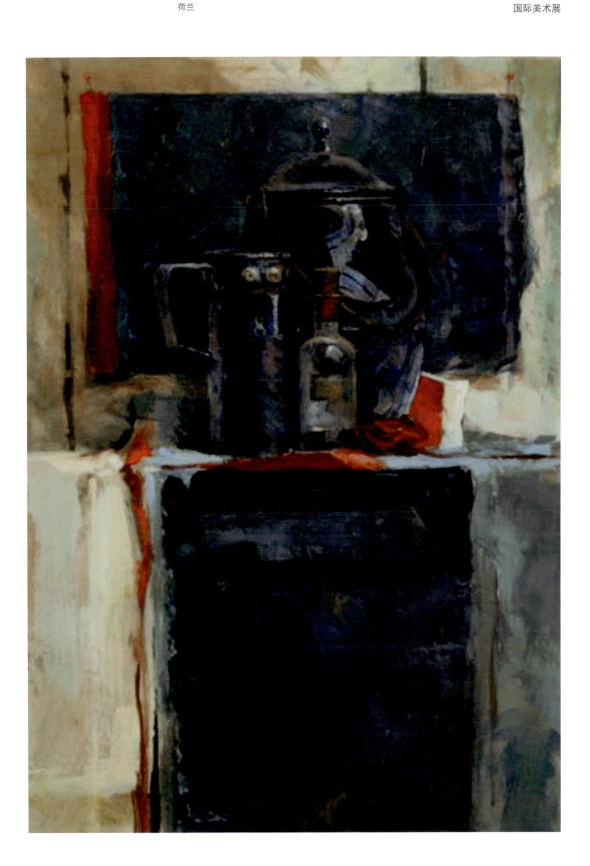

蓝色线圈 / Blauw Emaille
510mm x 410mm

本·斯尼杰德斯 | Ben Snijders
荷兰 | Netherlands
绘画 | Painting

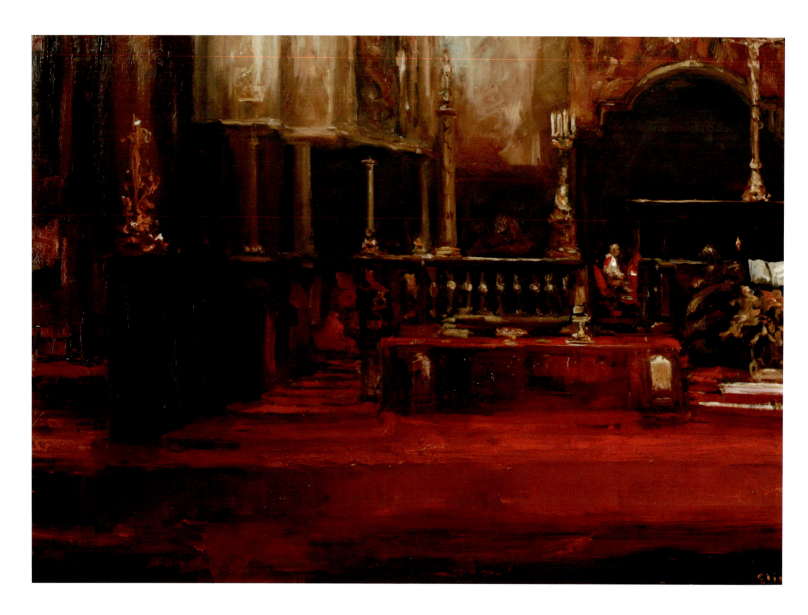

教堂 / Church

1300mm x 1700mm

杜威·埃利亚斯	Douwe Elias
荷兰	Netherlands
绘画	Painting

Netherlands
荷兰

International Art Exhibition
国际美术展

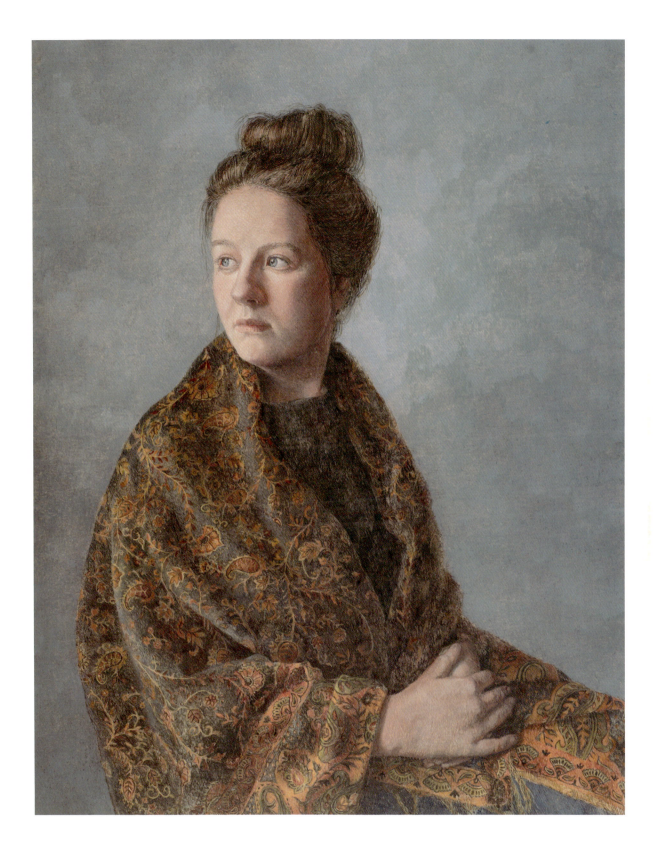

朱莉 / Juli
720 mm x 555 mm

埃丝特·勒维宁 | Esther Leuvenink
荷兰 | Netherlands
绘画 | Painting

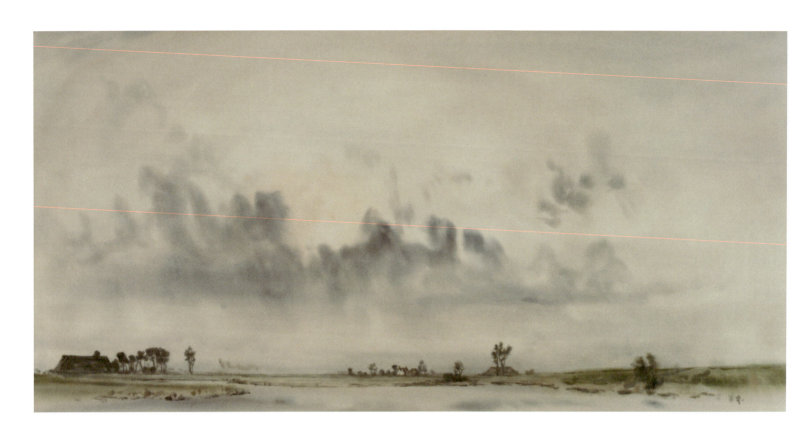

赖特迪普仪式 –1 / Staatsie Reitdiep-1

120mm x 230mm

格鲁特·巴瑟	Geurt Busser
荷兰	Netherlands
绘画	Painting

Netherlands
荷兰

International Art Exhibition
国际美术展

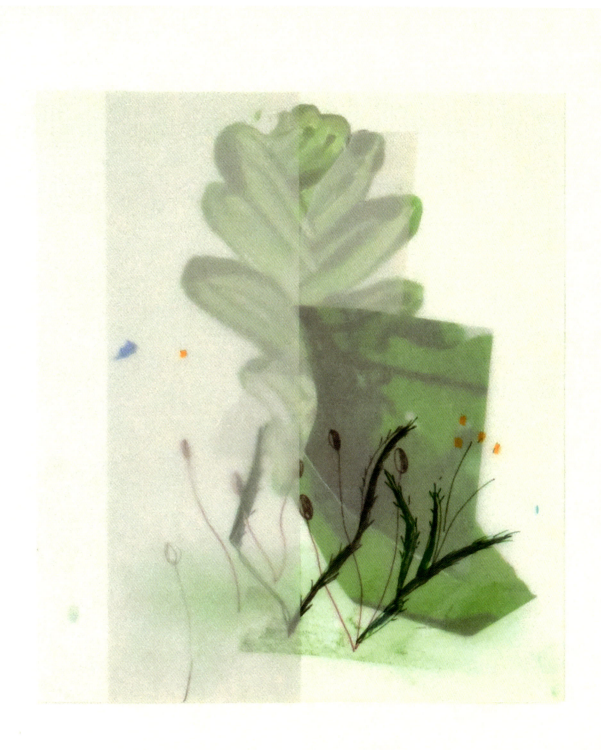

栎 2 / Quercus 2
400mm x 400mm

吉塔·帕多尔 | Gitta Pardoel
荷兰 | Netherlands
绘画 | Painting

| Work Collection of Arts | The Sixth Silk Road International Arts Festival | Netherlands |
| 美术作品集 | 第六届丝绸之路国际艺术节 | 荷兰 |

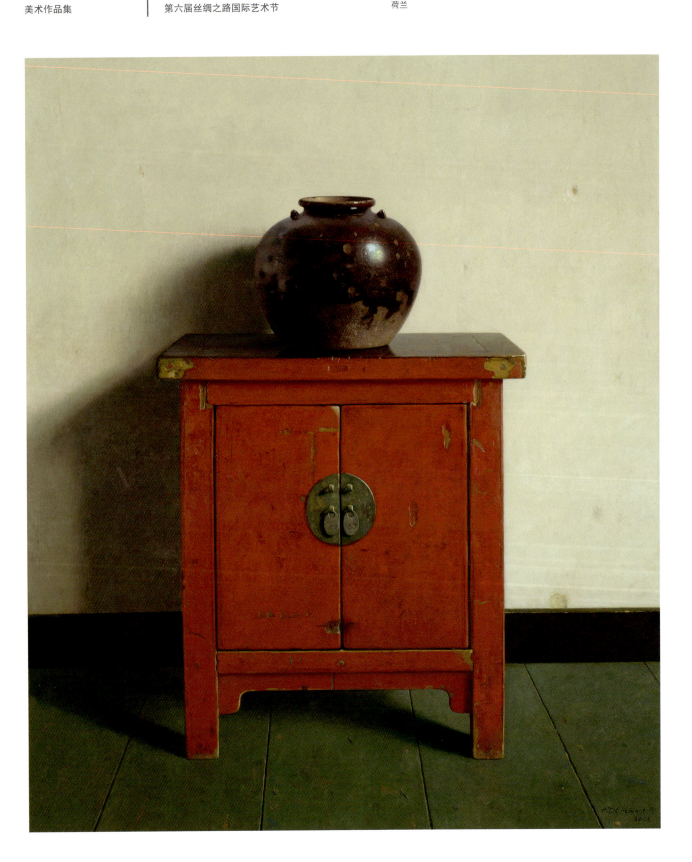

中式柜子 / Chinese Cabinet

1220mm x 1050mm

亨克·海尔曼特尔　　Henk Helmantel
荷兰　　　　　　　　Netherlands
绘画　　　　　　　　Painting

Netherlands
荷兰

International Art Exhibition
国际美术展

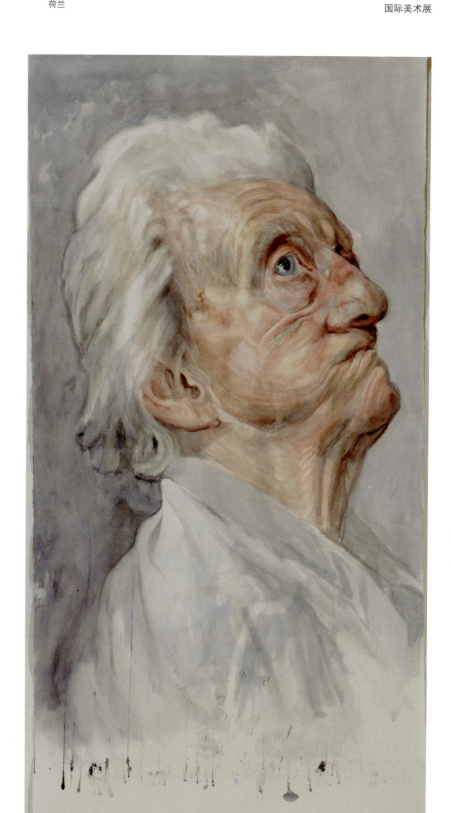

赫尔曼肖像 / Herman Portret
1130mm x 2200mm

赫尔曼·范·胡格达伦
荷兰
绘画

Herman Van Hoogdalem
Netherlands
Painting

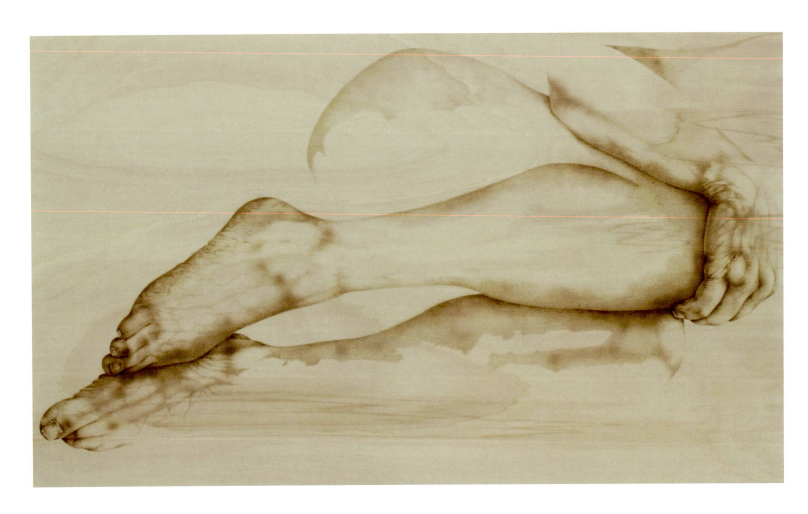

蒂姆·哈曼 / Tim Hamann
1100mm x 600mm

尼克·威廉　　Nick Willems
荷兰　　　　　Netherlands
绘画　　　　　Painting

Netherlands 荷兰 International Art Exhibition 国际美术展

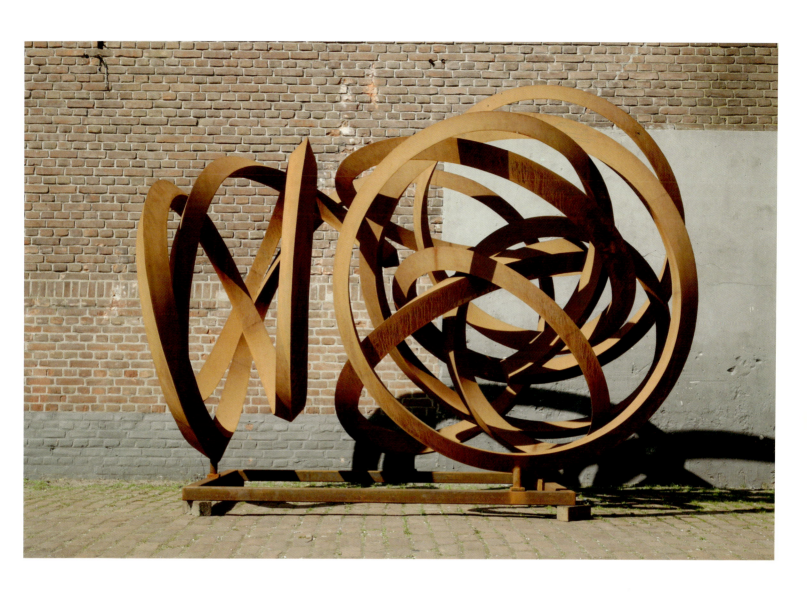

闪耀的光芒 / Sparking Light

3500mm x 2300mm x 3300mm

奥贝尔斯·皮特	Obels Pieter
荷兰	Netherlands
雕塑	Sculpture

Work Collection of Arts
美术作品集

The Sixth Silk Road International Arts Festival
第六届丝绸之路国际艺术节

Netherlands
荷兰

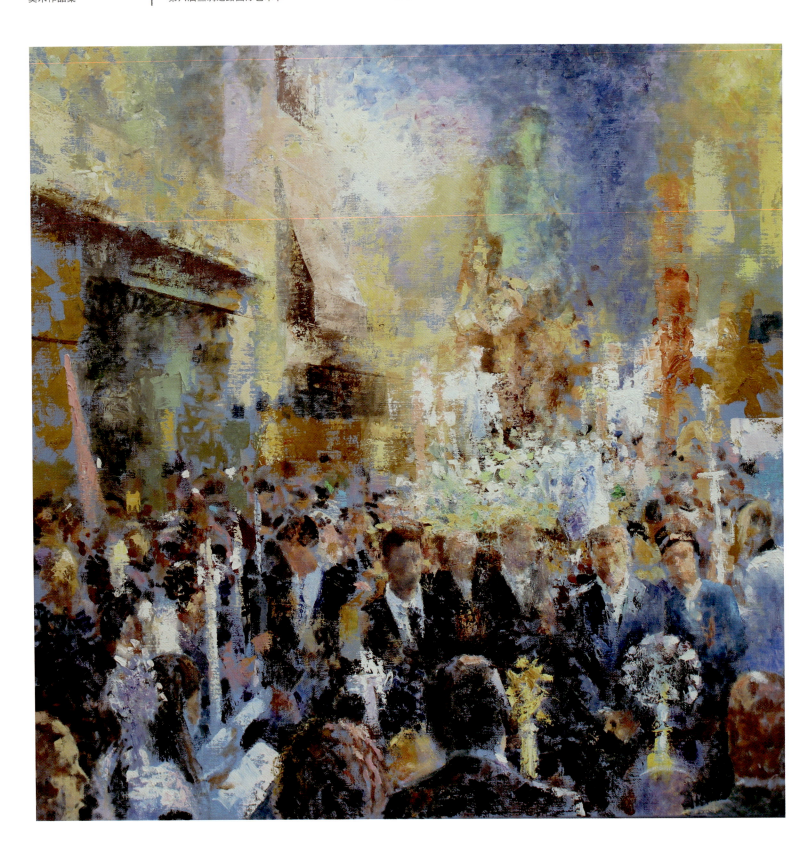

游行 / Procession

1000mm x 1000mm

彼得·哈特维格	Peter Hartwig
荷兰	Netherlands
绘画	Painting

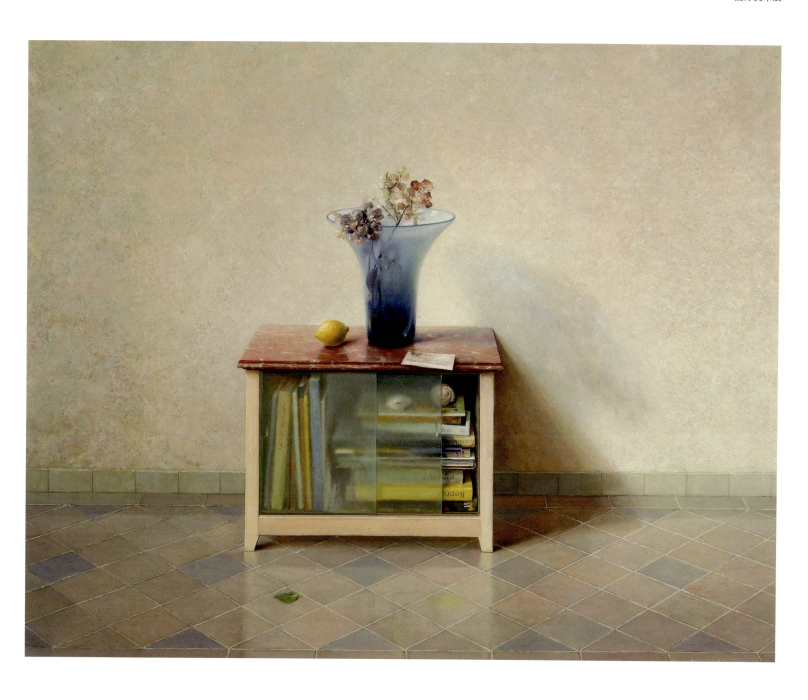

艺术书柜 / Cabinet with Art Book
1200mm x 1440mm

赖因·波尔 | Rein Pol
荷兰 | Netherlands
绘画 | Painting

| Work Collection of Arts | The Sixth Silk Road International Arts Festival | Netherlands |
| 美术作品集 | 第六届丝绸之路国际艺术节 | 荷兰 |

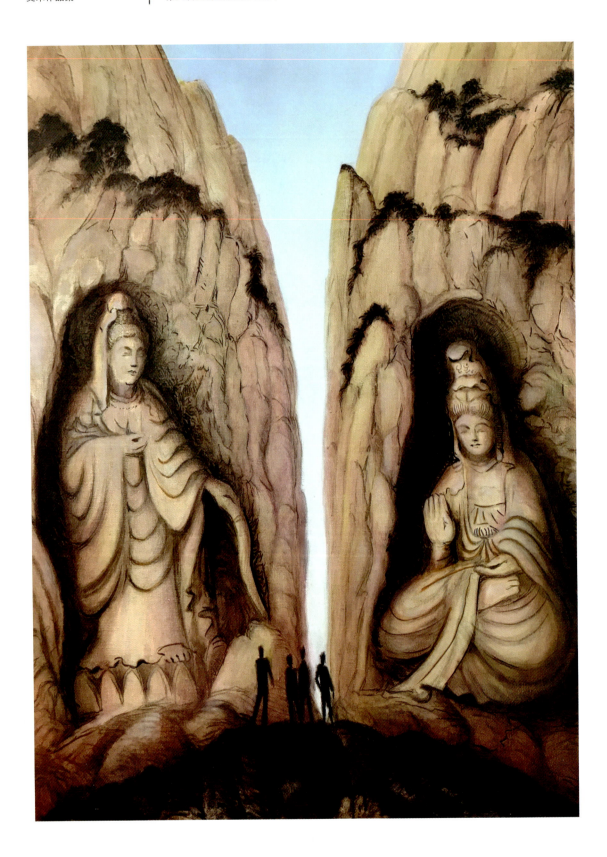

观音风景 / Landscape with Quang Yins

700mm x 1000mm

汤姆·哈格曼	Tom Hageman
荷兰	Netherlands
绘画	Painting

Netherlands
荷兰

International Art Exhibition
国际美术展

忙碌三角关系 / Busy Triangular Relationship

维姆·琼克曼 | Wim Jonkman
荷兰 | Netherlands
绘画 | Painting

Work Collection of Arts	The Sixth Silk Road International Arts Festival	Netherlands
美术作品集	第六届丝绸之路国际艺术节	荷兰

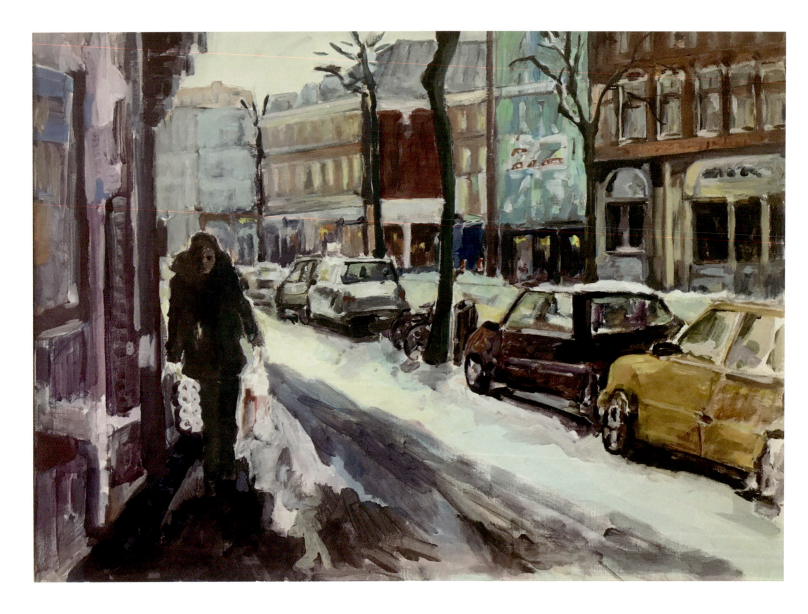

宾能威，鹿特丹 / Binnenweg, Rotterdam

700mm x 500mm

扎瓦恩·斯托克 — Zwaan Stoker
荷兰 — Netherlands
绘画 — Painting

France / 法国 — International Art Exhibition / 国际美术展

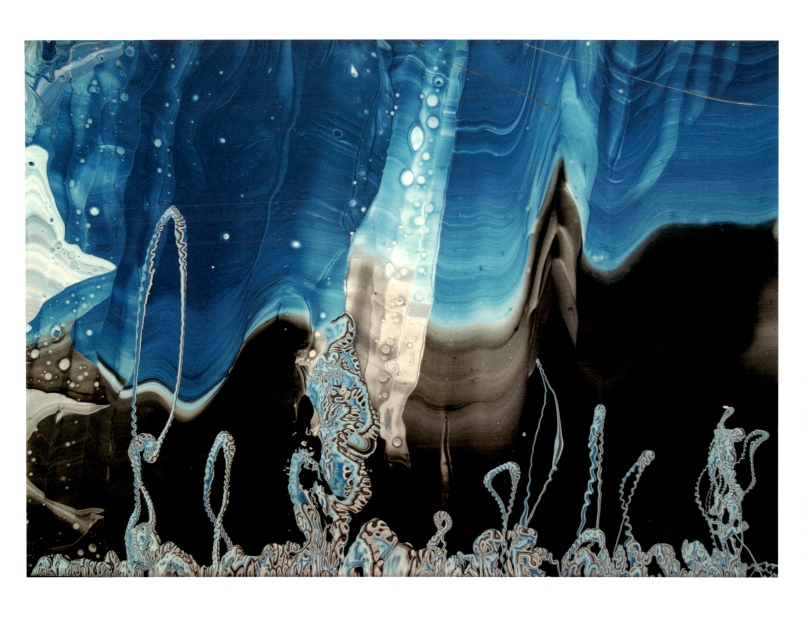

未知的景观 / Landscape of the Unknown
240mm x 350mm

鲍弗雷·马克	Baufrère Marc
法国	France
绘画	Painting

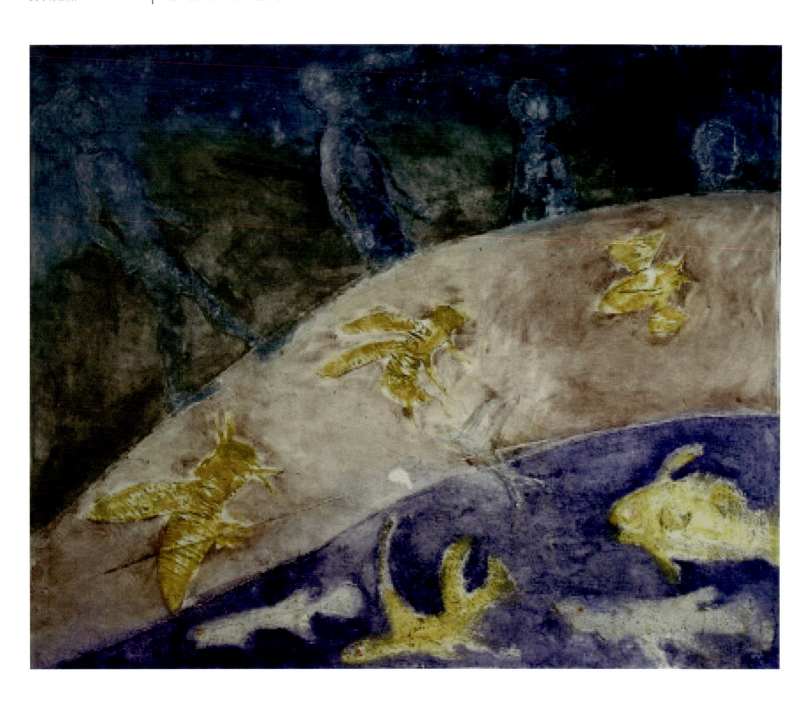

逃到未知的地方 / Flee to the Unknown

800mm x 700mm

布勒让·霍普夫纳·埃德维热 | Bregent Hopfner Edwige
法国 | France
绘画 | Painting

France | International Art Exhibition
法国 | 国际美术展

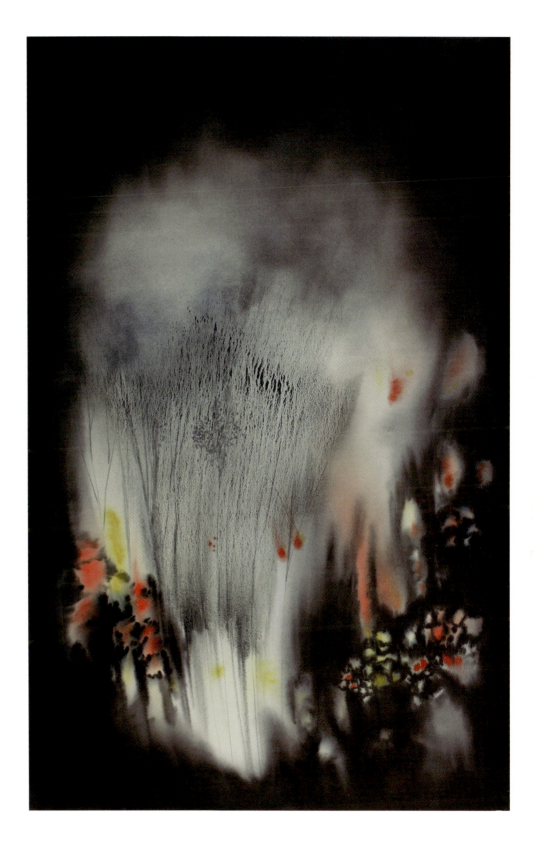

西安的夜晚回忆 / Xi'an Nights' Memories
650mm x 1000mm

比捷·沙尔特兰·穆里尔 | Buthier Chartrain Muriel
法国 | France
绘画 | Painting

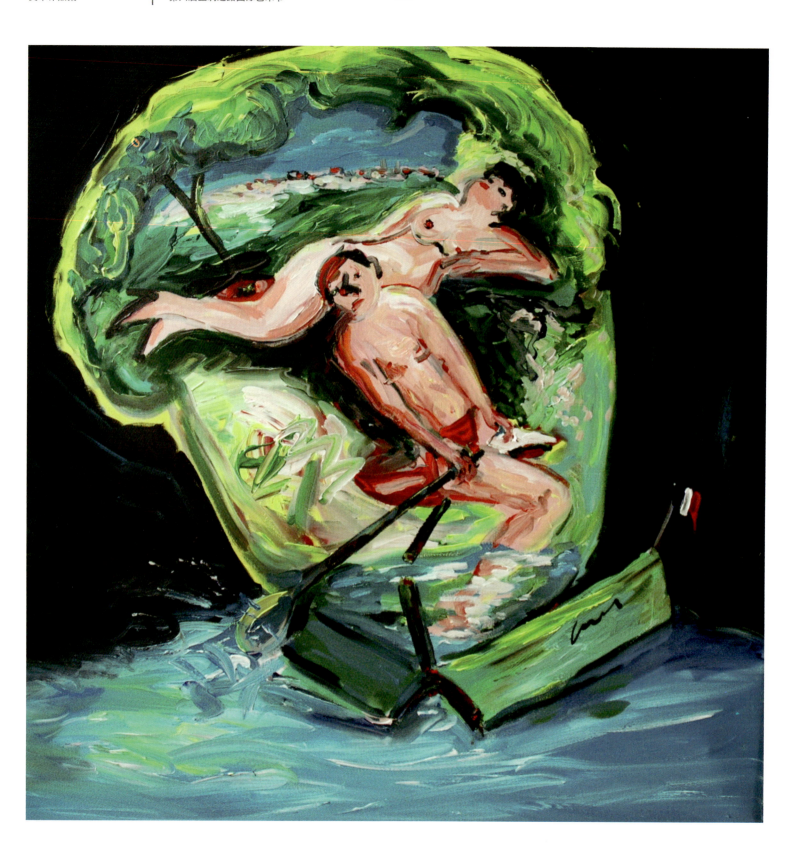

神经系统的治愈 / Neurologic Rescue

1000mm x 1000mm

克劳德·吉纳德 | Claude Guenard
法国 | France
绘画 | Painting

France / 法国 | International Art Exhibition / 国际美术展

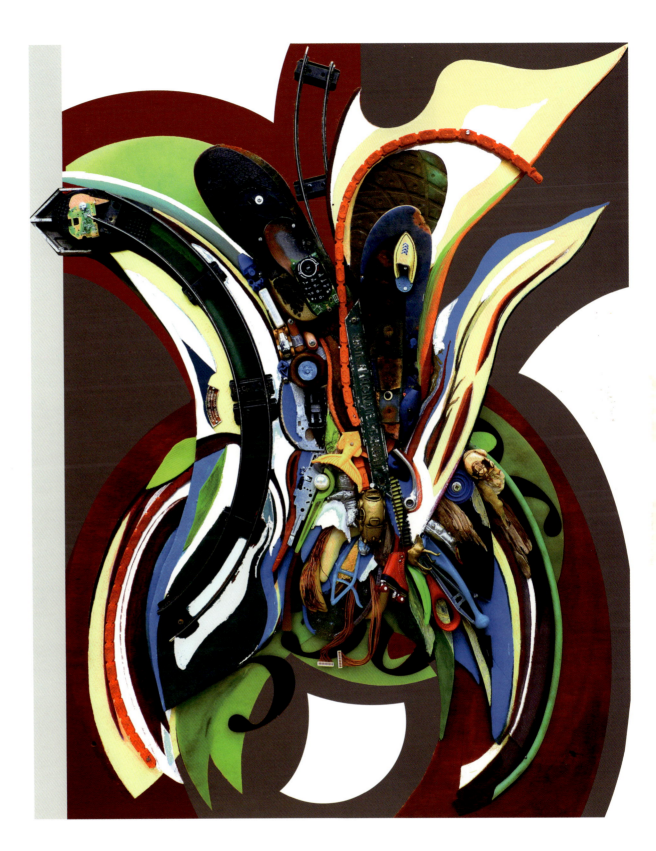

丝绸之路上的蝴蝶 / Butterfly on Silk Road
1000mm x 1000mm

埃马努埃莱·鲍丁 | Emmanuelle Baudin
法国 | France
绘画 | Painting

| Work Collection of Arts | The Sixth Silk Road International Arts Festival | France |
| 美术作品集 | 第六届丝绸之路国际艺术节 | 法国 |

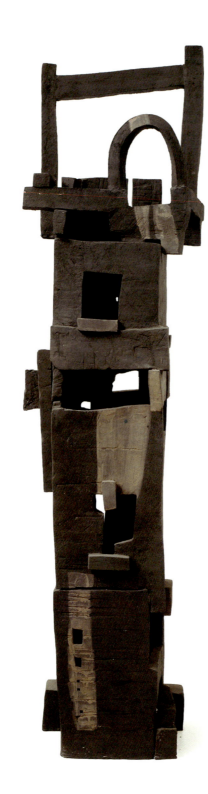

穆特鲁姆 / Mutterturm

1500mm x 400mm x 360mm

詹妮·科茨·温特罗普	Janine Kortz Waintrop
法国	France
雕塑	Sculpture

France 法国 | International Art Exhibition 国际美术展

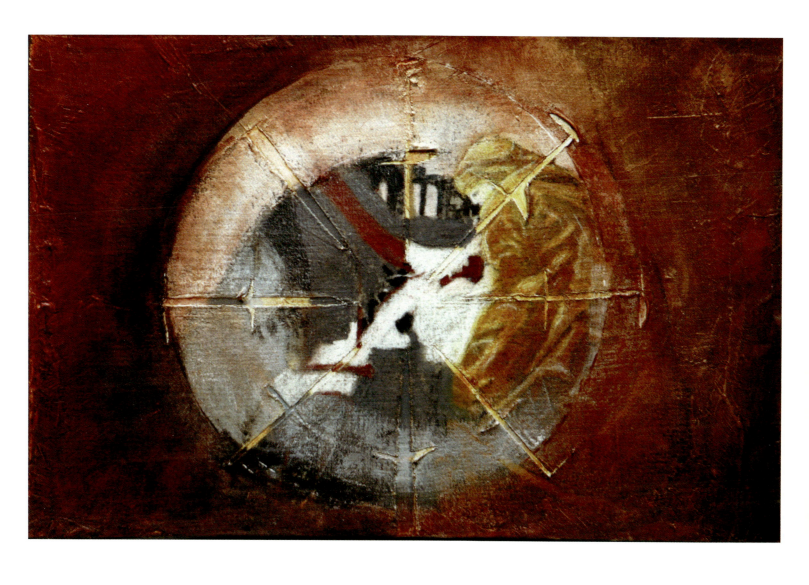

踪迹 / Traces
600mm x 900mm

罗梅罗·勒罗伊·米丽娅姆
法国
绘画

Romero Leroy Myriam
France
Painting

| Work Collection of Arts | The Sixth Silk Road International Arts Festival | France |
| 美术作品集 | 第六届丝绸之路国际艺术节 | 法国 |

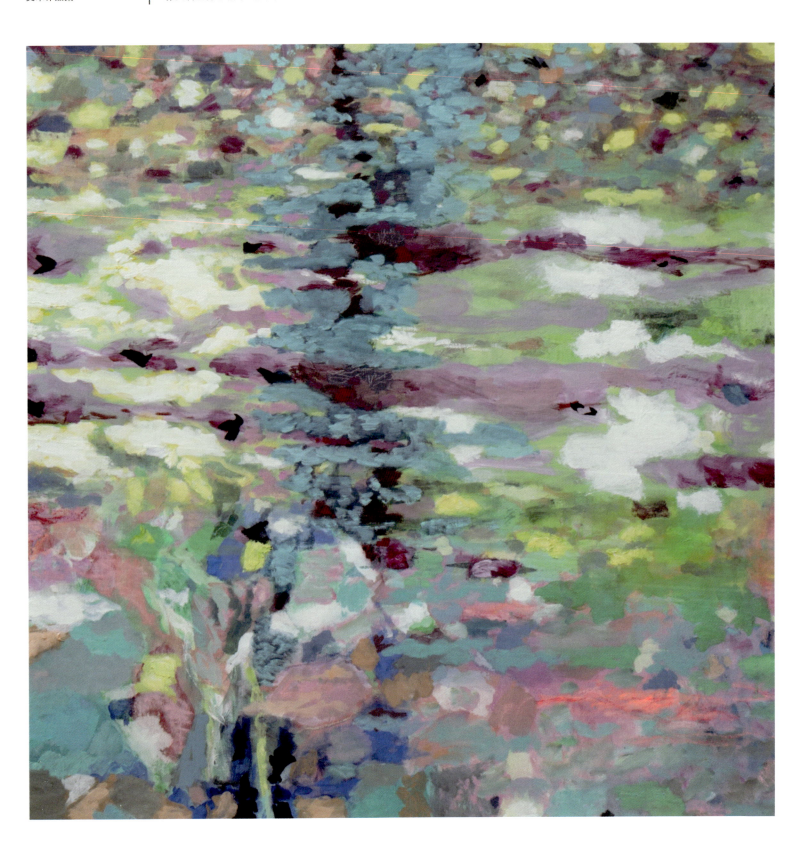

无题 / Unamed

马克·坦古伊	Marc Tanguy
法国	France
绘画	Painting

France
法国

International Art Exhibition
国际美术展

潮 / Tide

1400mm x 1200mm

藏渊 | Yuan Cang
法国 | France
绘画 | Painting

结语 / Conclusion

115 countries and more

304 works

绘画 / 雕塑 / 装置 / 影像

Painting / Sculpture / Installation / Image

丝路传文明，文化行天下。一年一度的丝绸之路国际艺术节又迎来了第6个年头。近三届连续百余国家的艺术家参与，使丝路艺术节更加丰富多彩。艺术节当下无疑已成为向外传播中国文明与文化重要的一个窗口。艺术节国际美术展也将继续秉承国际化、多元化、开放化的宗旨，更好地为艺术家们创造展示精彩纷呈的艺术作品的条件和机会，使展览不仅为艺术节增添艺术魅力，更重要的是让中国的文化传播到更多的国家，促进各国人民通过文化交流的同时，使文明相通、相融。每届的艺术节都有着许多感人的故事。艺术成为传播文明、传播文化，更是传播友谊的一座的桥梁。

艺术无国界，文化传文明。艺术家们用自己的画笔、自己的塑造诠释着这种文明，艺术节也成为艺术家们展现才华、传播友谊的大舞台。愿丝路艺术节永远持续着这种辉煌，续写着这种传奇。

9月7日，世界百余国家的艺术家将目光聚焦于中国美丽的古都城市西安——丝绸之路国际艺术节的国际美术展。

愿第六届今日丝绸之路国际艺术节：

擎起丝路文明之大旗，

彰显中华文化之重任，

架起世界交流之桥梁，

共叙各国人民之友谊。

陕西省美术家协会副主席 / 学术主持

International Art Exhibition

国际美术展

Silk Road spreads civilization and culture go all out. The annual Silk Road International Art Festival has ushered in its sixth year and has become an art event in China. The participation of artists from nearly three consecutive countries has added a richer color to the Silk Road Art Festival. The festival today has undoubtedly grown up to be an important window for the spread of Chinese civilization and culture. Each piece of beautiful work, rich colors and rigorously shaped work of art, especially those with rich imagination, is full of artistic effects. The Festival of the International Art Exhibition will continue to adhere to the principle of "internationalization, diversification and openness" to better create conditions and opportunities for artists to display brilliant work of art. Let the exhibition not only add artistic charm to the festival, but more importantly, spread Chinese culture to more countries. Promote communication and integration of civilizations among people of all countries through cultural exchanges. Each festival has a lot of touching stories, making art a bridge for spreading civilization, spreading culture, and spreading friendship.

Art does not have borders and culture spreads civilization. Artists interpret this civilization with their own brushes and their own shapes. It has also become a significant platform for artists to show their talents and spread friendship. May the Silk Road Art Festival: highlight the wind of a great country, show the beauty of art; release the soul, together create a civilization; forever continue this glory , continue to write this legend.

On September 7th 2019, artists from more than 100 countries around the world focused on the beautiful ancient capital city of China ,Xi'an—Today 6th International Silk Art Festival of the Silk Road.

Hope Silk Road International Arts Festival:

Raise the banner of the Silk Road civilization,

Highlight the important task of Chinese culture,

Building a bridge of world communication,

Co-report the friendship of the people of all countries.

Vice Chairman of Shaanxi Artists Association/Academic Chair: Baogang Lin

September 7, 2019

5th

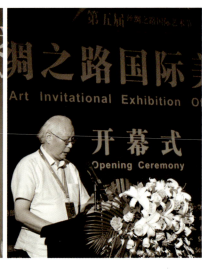

在第五届丝绸之路国际艺术节开幕式上的致辞
（全国政协常委、中国美术馆馆长、中国美术家协会副主席吴为山）

各位嘉宾、来自世界各地的艺术家朋友们：

大家好！在这金秋送爽、丹桂飘香的时节，我们很荣欣地与大家相聚在美丽的古城西安共同见证艺术的盛会。在此，我谨代表中国美术家协会对第五届丝绸之路国际艺术节的盛大开幕表示热烈祝贺！并向精心组织策划和积极参与本次艺术节的所有工作人员、艺术家们表示衷心感谢！

举办艺术节是贯彻落实习近平总书记关于共建"丝绸之路经济带"和"21世纪海上丝绸之路"战略构想的重要举措，是国家推进"一带一路"建设的重点文化品牌。作为国内唯一一个有关丝路文化的国家级综合性国际艺术节，丝绸之路国际艺术自2014起已成功举办了四届，已初步办成具有广泛影响性和代表性的国家级艺术盛会。本届艺术节由文化和旅游部、陕西省人民政府共同主办。

我与艺术节的缘分已久，自第二届开始已连续担任四届国际美术展的艺术总顾问，亲身经历和见证了国际美术展的快速成长与发展。近两届的今日丝绸之路国际美术展中，吸引了百余国家和地区的艺术家们积极参与，也为丝绸之路艺术节迈向国际化、讲好中国故事、传播中国文化、彰显"一带一路"精神架起了一座传播友谊的桥梁。更为世界各国的艺术家们建立起了一个文化与艺术交流更为广阔的学术平台。

纵然远隔山海，只要心灵相通，必将天涯比邻—最能叩开人类心灵之门的，非文化莫属。丝绸之路国际艺术节是一项极具亲和力、感召力和国际影响力的文化活动。当世界走进西安，文化因交流而精彩。最后，预祝第五届丝绸之路国际艺术节今日丝绸之路国际美术展圆满成功。

2018年9月6号于北京

The 5th Today Silk Road International Atrs Exhibition Tidbit of the Academic Forum
第五届今日丝绸之路国际美术邀请展学术论坛花絮

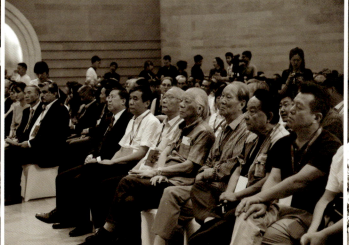

图书在版编目(CIP)数据

2019第六届丝绸之路国际艺术节 今日丝绸之路国际美术展作品集/任宗哲，蔺宝钢主编．—北京：中国建筑工业出版社，2019.8
 ISBN 978-7-112-24050-0

Ⅰ.①2… Ⅱ.①任…②蔺… Ⅲ.①艺术-作品综合集-世界-现代 Ⅳ.①J111

中国版本图书馆CIP数据核字（2019）第158156号

责任编辑：费海玲 张幼平
责任校对：芦欣甜

2019第六届丝绸之路国际艺术节
今日丝绸之路国际美术展作品集
任宗哲 蔺宝钢 主编

*

中国建筑工业出版社出版、发行（北京海淀三里河路9号）
各地新华书店、建筑书店经销
北京富诚彩色印刷有限公司印刷

*

开本：965×1270毫米 1/16 印张：21 插页：1 字数：534千字
2019年8月第一版 2019年8月第一次印刷
定价：248.00元
ISBN 978-7-112-24050-0
　　　（34528）

版权所有　翻印必究
如有印装质量问题，可寄本社退换
（邮政编码 100037）